HEALTH INFORMATION SEEKING

Gary L. Kreps, *General Editor*

Vol. 4

This series is part of the Peter Lang Media and Communication list.
Every volume is peer reviewed and meets
the highest quality standards for content and production.

PETER LANG
New York • Washington, D.C./Baltimore • Bern
Frankfurt • Berlin • Brussels • Vienna • Oxford

J. David Johnson & Donald O. Case

HEALTH
INFORMATION
SEEKING

PETER LANG
New York • Washington, D.C./Baltimore • Bern
Frankfurt • Berlin • Brussels • Vienna • Oxford

Library of Congress Cataloging-in-Publication Data
Johnson, J. David.
Health information seeking / J. David Johnson, Donald O. Case.
p. ; cm. — (Health communication; v. 4)
Includes bibliographical references and index.
1. Health—Information services. 2. Information retrieval.
I. Case, Donald Owen. II. Title.
III. Series: Health communication (New York, N.Y.); v. 4. 2153-1277
[DNLM: 1. Consumer Health Information. 2. Information Seeking Behavior.
3. Health Communication. WA 590]
RA773.6J64 613—dc23 2012014493
ISBN 978-1-4331-1825-8 (hardcover)
ISBN 978-1-4331-1824-1 (paperback)
ISBN 978-1-4539-0879-2 (e-book)
ISSN 2153-1277

Bibliographic information published by **Die Deutsche Nationalbibliothek.**
Die Deutsche Nationalbibliothek lists this publication in the "Deutsche
Nationalbibliografie"; detailed bibliographic data is available
on the Internet at http://dnb.d-nb.de/.

© 2012 Peter Lang Publishing, Inc., New York
29 Broadway, 18th floor, New York, NY 10006
www.peterlang.com

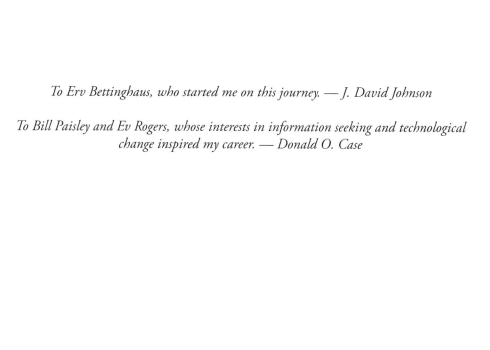

To Erv Bettinghaus, who started me on this journey. — J. David Johnson

To Bill Paisley and Ev Rogers, whose interests in information seeking and technological change inspired my career. — Donald O. Case

CONTENTS

FIGURES AND TABLES

ACRONYMS

ACS: American Cancer Society
CDC: Centers for Disease Control & Prevention
CHESS: Comprehensive Health Enhancement Support System
CIS: Cancer Information Service
CISRC: Cancer Information Service Research Consortium
CMIS: Comprehensive Model of Information Seeking
EAP: Employee Assistance Program
EHR: Electronic Health Records
EMR: Electronic Medical Records
EPPM: Extended Parallel Processing Model
HBM: Health Belief Model
HC: Health Communication
HHS: U.S. Department of Health & Human Services
HIAM: Health Information Acquisition Model
HIB: Human Information Behavior
HIE: Health Information Exchange
HINTS: Health Information National Trends Survey
HIPAA: Health Insurance Portability and Accountability Act
HIT: Health Information Technology
HITECH: Health Information Technology for Economic and Clinical Health Act
HON: Health on the Net

ICT: Information and Communication Technologies
ISP: Information Search Process
KM: Knowledge Management
KMS: Knowledge Management Systems
MEA: Media Exposure and Appraisal
NCI: National Cancer Institute
NIH: National Institutes of Health
NNT: Number Needed to Treat
OCC: Office of Cancer Communications
PDQ: Physician Data Query
PHR: Personal Health Records
PLM: Patients Like Me
PRISM: Planned Risk Information-Seeking Model
RISP: Risk Information Seeking and Processing (model)
SES: Socio-Economic Status
TIA: Total Information Awareness
TPB: Theory of Planned Behavior
TRA: Theory of Reasoned Action
TTM: Transtheoretical Model
UMLS: Unified Medical Language Systems
WHO: World Health Organization

PREFACE

The key to reaching Healthy People 2020 goals may lie in educating a notoriously obstinate public who have often been relatively immune to communication campaigns offered by health professionals. A greater understanding of their needs, especially why they seek information, may help us to accomplish the many behavioral changes that will lead towards improvement in morbidity and mortality rates and a more balanced approach to wellness and prevention. This is especially important in the context of the revolution in access to information brought about by the many recent advances in databases and telecommunication systems, perhaps best represented by the advent of the Internet.

Health information seeking has taken on enhanced importance in recent years because of the growing emphasis on the consumer/client in the health arena. Individuals increasingly find that they must choose between an array of alternatives in relationship to prevention, detection, and treatment. Thus, information seeking, quite literally, is an important survival tool for individuals, especially given advances in genomics and personalized medicine. In recent years, a broader view of health has emerged in part encouraged by increasingly active advocacy groups. We are also confronted with an aging population, and our focus is shifting to managing chronic diseases and multimorbidities. This is accompanied by the perception that the quality of our health-care system continues to deteriorate, or at the very least is becoming very complex, leaving individuals to rely on their own skills in navigating their care. These trends require reevaluation of the tra-

ditional approaches to communication theory and health behavior. It implies a shift away from the development of health campaigns with one unitary message toward a recognition that alternatives must be provided and options discussed. Indeed, health agencies are adopting the role of information-seeking facilitators through the creation of telephone services and sophisticated databases with a concomitant development of public health and consumer informatics.

J. David Johnson's Personal Statement

In the mid-1990s I wrote *Cancer-Related Information Seeking* for a combination of personal and professional reasons. First, I had conducted considerable research on information exposure and network analysis. Second, I am a long-term cancer survivor who would not have been able to write this book if it were not for the early detection of a melanoma in 1978. Interestingly, the cancer also had a direct impact on my professional development, only in part because my Ph.D. defense occurred only a month after the tumor was surgically removed. Cancer has many effects, some of them beneficial. I did not get serious about my profession or my writing until it was apparent that what looked like decades that stretched before me to accomplish my goals might be only years or months. So cancer focused my energies and was by and large responsible for any professional success I have had.

Unfortunately, many of my difficulties in adjustment were unnecessary, in part because the information environment that existed in the 1970s often denied or filtered access to information to patients. Thus, I wrote *Cancer-Related Information Seeking* with the benefit of hindsight: suggesting strategies that should be followed, with the full understanding that the psychological and emotional impacts of cancer make what appear to be rational suggestions often impossible to follow in individual circumstances. As my time and distance from cancer have grown, I am now able to recognize a more encompassing view of health, reflected in the broader title of this work, coming closer to the World Health Organization definition of health as "central to a flourishing life" (Freimuth, Edgar, & Fitzpatrick, 1993).

When I first started to investigate information seeking related to cancer, I was struck by the limited amount of research that was available on such an important issue. Especially lacking were systematic, in-depth theoretical treatments and associated rigorous empirical tests. Fortunately, with a grant from the Michigan Department of Public Health, my colleague Hendrika Meischke and I were able to engage in a series of research studies that provided the empirical foundation for many arguments presented in the original work. While there has been a considerable growth in the information-seeking literature in the last decade and a half, there has not necessarily been considerable progress in our depth of understanding of its fundamental nature, in part because the various disciplines that examine it start afresh, often unaware of developments elsewhere.

I have had the opportunity over the last two decades to address cancer on a pragmatic, professional level.Most importantly, for several years I was involved in the evaluation of a multi-year program project grant focusing on the Cancer Information Service summarized in my book *Innovation and Knowledge Management: The Cancer Information Services Research Consortium*. I have also been fortunate to have played a role in the development and maturation of two of the most successful health communication programs in the U.S. and the founding of a College of Public Health at the University of Kentucky, where I currently teach a course in health communication.

Several people have helped me in the writing of this book, especially my many collaborators on research involving the Comprehensive Model of Information Seeking. I also benefited from a weeklong course in biomedical informatics at Woods Hole in spring 2009 sponsored by the National Library of Medicine, as well as from the insights of my students in the following courses: Communication 454, Honors Class in Health Information Gathering; Communication, Journalism and Telecommunication 651, Communication Theory; and College of Public Health 942, Seminar in Public Health Communication, with whom I shared earlier draft sections of this work. Needless to say, we assume ultimate responsibility for what follows.

Donald Case's Personal Statement

When I was a university undergraduate, I was fascinated by what I believed were the powerful effects of television. However, in the late 1970s, while a graduate student at Syracuse University and later Stanford University, I gradually became convinced that individual choices had a lot more to do with outcomes than did broadcast messages. I remember being uncomfortable with the persuasion bent of much of the literature I read, which seemed to assume that the public would know nothing about health if the mass media did not tell them what to think. Stanford, in particular, was a thrilling venue in the early 1980s, as developments in computing and telecommunications steadily improved the ability of individuals to create and retrieve information.

Flash forward about two decades, and much of the "new media" that I studied in graduate school is commonplace. Spurred on by growth in media channels, and particularly by the development of the World Wide Web and its vast content, many individuals have actively engaged the world of information sources: when they want to know something, they can find it quickly; when they don't want to know something, they can often avoid exposure. The result is much more of a "uses and gratifications" model, in which traditional mass media are much less important than they were back in the day. Today's world is one of active information seeking rather than passive reception.

In 2002 I finished the first edition of a book titled *Looking for Information*, which reviewed hundreds of studies about information seeking in different contexts; while health-related information seeking was only a modest part of the literature at that time, it was a fast-growing segment. In writing the third edition of *Looking for Information*, it became obvious just how much more has been published in the last few years. It has been especially gratifying to see the shift in emphasis of the health literature from articles on "exposure to health issues in the mass media," to titles like "information seeking about genetics." This collaboration with J. David Johnson is an opportunity to examine that shift in how people learn—or do not learn—health-related information.

The Current Work

This book is meant for three primary audiences. First, it is intended for a scholarly audience. Second, this book would be most useful as a text for advanced undergraduate and graduate-level courses in health communication. Third, the book could be used by practitioners in the fields of health promotion, health education, and health marketing who seek to understand their publics. However, this book does not focus directly on the information-seeking practices of these professions. As a result of the number of different fields who are interested in this topic, we have tried to write this work to appeal to as many as possible, perhaps in the end not really completely satisfying any one of them. In short, this book should appeal to professionals in such fields as communication, information science, psychology, public health, health promotion, health behavior, and health marketing.

Unfortunately it is beyond the scope of this book to pursue specific how-to issues related to the application of many of its concepts. The interested reader can consult this book's references for many excellent introductions to such pragmatic issues as how to conduct an Internet search in very concrete terms. The literature on health is voluminous, and it contains many excellent works on issues such as: how individuals personally cope with cancer (Cousins, 1979), factors health professionals should be aware of when communicating with patients (Epstein & Street, 2007), and the basic biology and treatment of cancer historically (Mukherjee, 2010).

PART ONE

An Overview

Introduction to Health Information Seeking

The success of health system reform will depend in large part on the capacity of individuals, families and communities to make informed decisions about their health (U.S. Department of Health & Human Services, 2009, p. 8).

Overview

America has an ever-growing obsession with health at both the personal and national level. This in part stems from the substantial national investment in health, approaching one-fifth of our national budget. It also reflects an aging population as it confronts growing health problems with increasingly unrealistic expectations of their impact on their daily lives. These trends, coupled with advances in health information technology associated with the Internet, increase both interest in health information seeking as a remedy for many problems (e.g., increasing prevention to drive down both costs and morbidities) and possibilities for successful endings to our quest for answers.

State of Health Care

Perhaps the most stunning feature of the U.S. health-care system is its cost, creeping up to 17 percent of our GNP, and expected to reach 20 percent by 2016 (Marchibroda, 2009), making it by far the most expensive health-care system in the world (Bodenheimer, 2005a). Inevitably this investment in health has significant opportunity costs in terms of diminished investments in other aspects

of life that contribute to a broader view of health: recreation, culture, education, aesthetic surroundings, high standard of living, and so forth. But disturbingly, we do not seem to be getting much in return. Americans receive only about one-half of the medical care they need (Orleans, 2005) and over one-half of Americans are dissatisfied with their health care (Marchibroda, 2009). It has been estimated that approximately one-half of premature deaths in the U.S. are preventable through changes in various health behaviors (Noar, Banac, & Harris, 2007). Perhaps reflecting these trends, the popularity of complementary therapies and alternative medicine has grown (Gillaspy, 2005).

These issues are further exacerbated by unequal delivery of health care with increasing health disparities among shifting demographic groups and questions about whether the public truly understands health-related issues (Galarce, Ramanadhan, & Vishwanath, 2011; Ndiaye, Krieger, Warren, & Hecht, 2011). The U.S. has an increasingly diverse, aging population with about 50,000,000 residents for whom English is unfamiliar (Wright, Sparks, & O'Hair, 2008). These demographic trends are associated with co-morbidity, which has been seriously under-studied (Orleans, 2005); more than 125 million people have at least one chronic disease in the U.S. (Marchibroda, 2009).

Beyond costs, there are a number of flaws in our current health-care system. Medical errors, due to the very complexity of our system, are rampant. Unfortunately, the profit motive guides a great deal of communication about health (Parrott, 2011). So, physicians in managed-care environments have less time to devote to providing health information and education to patients (Gillaspy, 2005). Because of the growth of out-patient treatment—"take-out surgery"—patients need to be more aware of side effects and potential risks of treatment (Czaja, Manfredi, & Price, 2003). The recent shortage of drugs, especially those related to chemotherapies, has also been traced to their low profit margin when they become generic.

But there is hope. Increasingly individuals are being empowered to find the answers they need to solve their problems, in part through the explosive growth of health information technology. There also has been a shift away from a narrow, biomedical approach to health, to one that encourages palliative and hospice care for the very sick and wellness approaches for others. The growing emphasis on palliative care occurs in part because the needs (e.g., pain control) of people at the end of life are often unmet, recognizing the reality of death. It seeks to relieve symptoms and suffering (Wright et al., 2008). It has also been suggested that improved health outcomes will result from more patient-centered health care (Pescosolido, Croghan, & Howell, 2009). As Table 1-1 details, which we will come back to when we discuss the importance of information seeking later in this chapter, these trends can be directly related to the increased importance of health information seeking.

Table 1-1: Health Trends and Information Seeking

Trend	Information Seeking
Aging Population	Decreased interest
	More compliant
	Fewer questions
	Unfamiliar with Internet
	Cognitive impairment more likely
Chronic Disease	Constant surveillance
	Changing information fields
Changing Models of Health Care	Greater diversity of sources
	Greater range of issues
	Enhanced responsibility
Co-morbidity	Multitasking
	Prioritizing
Personalized Medicine	One size does not fit all
Genomics	Idiosyncratic needs
Overhyped medical advances	Reality checks
Consumerism	Greater individual responsibility
	Disintermediation
Increased costs, scarcity for society	Consumers need to weigh costs against benefits
Cultural diversity, disparities	Information gaps
	Health-literacy issues
Health information technology	Increased possibilities for information retrieval and cost containment
Doctor, health professional shortage	Individual self-service

Today's Information Environment

One central element of our contemporary world is the explosive growth of information coupled with the ready access instantiated in the Internet. Individuals have free access to an often bewildering wealth of information. They have to choose between a variety of information sources. There are literally millions of articles published every year in the technical literature, making it impossible for even the most dedicated individual to keep abreast of recent advances. For example, it has been calculated that physicians need to read an average of 19 original articles each day to keep abreast of their fields (Choi, 2005). This overload of information forces decentralization of effort, with increasing responsibility passing to individuals, with their effectiveness determined by their ability to gather, then intelligently act on, health information.

We live in an information age and are still struggling with how to cope with turning this information into action. This is most clearly seen in the growing problem with translating research findings into applications in medicine. There is a widely held view that the U.S. is not receiving the full value for its investment in biomedical research (Colditz, Emmons, Vishwanath, & Kerner, 2008; Lee, 2007). While there are more than 10,000 randomized trials of new intervention approaches every year, very few innovations are ever widely adopted (Grol & Grimshaw, 2003). Audits suggest that across a number of national settings, evidence-based medical practices are not consistently applied. While there has been growth in evidence reviews that inform practice, there also is a growing gap in their implementation (Colditz et al., 2008).

There are complex and poorly understood reasons why it takes nearly two decades to transfer knowledge into routine medical practice. Translational research requires communication across disciplines; however, scientists often have trouble directly communicating their findings to others (Sussman, Valente, Rohrbach, Skara, & Pentz, 2006). Changes in practice are rarely easy, and require collaborations between disciplines, practitioners, and policymakers in complex systems (Grol & Grimshaw, 2003). In the 1970s and '80s, in recognition of the difficulties in knowledge translation, the dominant theory was that the inherent differences between the research and policymaking communities were intractable (Jacobson, Butterill, & Goering, 2003). Accurate transfer of scientific discoveries requires competent communication among researchers, practitioners, and policymakers.

Whose responsibility is it to ensure that what researchers learn is actually distributed to practice (Glasgow, Marcus, Bull, & Wilson, 2004)? If we build it, they won't necessarily come. The answers to such questions pose important issues for policymakers within agencies like the National Cancer Institute, which are increasingly focused on how best to translate all of their research products into practice (National Cancer Institute, 2003). As we will see in Chapter 8, policymakers at the NCI have focused on enhancing our information infrastructure and facilitating searches by concerned individuals as one solution to this problem. Indeed, there has been a more general recognition that often health professionals benefit by giving responsibility to individuals (Epstein & Street, 2007).

What Is Health, Really?

An increasing focus on individual responsibility has also been coupled with a movement to a broader view of what constitutes health. The traditional biomedical view of health had embedded within it a more limited view of the role of communication, primarily as a vehicle for transferring authoritative knowledge to compliant patients. Given health's capture by the biomedical professions, most definitions of health have tended to focus on dysfunctions in one's physiology and

negative aspects, biological issues that need to be overcome so we can return to normal functioning.

Here we will use a broader definition of health, focusing on more prosocial behaviors and promotion of well-being and vitality, or in the words of the World Health Organization, we view health as "central to a flourishing life" (Freimuth, Stein, & Kean, 1989, p. 509). More conventionally, *Webster's* fourth edition uses these four different senses: "1. physical and mental well-being; freedom from disease, pain, or defect; normalcy of physical and mental functions; soundness; 2. condition of body or mind (good or bad health); … 4. Soundness or vitality, as of society." These definitions reflect more contemporary views of health that include: the absence of disease; the restoring of balance, dynamic homeostasis; a return to optimal functioning; feeling good, vitality, and self-actualization.

For some individuals, their identity may be inextricably interwoven with their biomedical health (Parrott, 2009). They may even be punished (e.g., loss of a job because of continued smoking) because of biomedical health concerns (Parrott, 2009). But a broader view forces us to consider who makes a more important contribution: Stephen Hawking, who has been profoundly ill for decades, or the average halfback on a college football team? Which makes the more vital contribution to society?

Seldom, in the context of a biomedical approach, is it even mentioned that many people are striving to self-actualize themselves, to make an impact on the community, to be a volunteer, to be musicians, artists, creative people, or write books—all of which may be better indicators of the vitality of a society. Our focus here will be on issues that lead someone to achieve, to be restored to this level of vitality, or to maintain vitality in the presence of chronic or even life-threatening biomedical problems.

The goal of our medical system should be to reduce morbidity and to prevent premature deaths, not to needlessly prolong the suffering of people who have a very poor quality of life. Increasingly people feel empowered to decline medical treatment, in part because such "refuseniks" weigh the quality of their life versus the impact (economic and otherwise) of treatments on their loved ones; for example, as many as 7 percent of women over 65 who have breast cancer refuse treatment (Konigsberg, 2011). In doing so, they are often frustrated by the unresponsiveness of the medical system and hospitals and other institutions, who often do not respect their wishes.

Institutionally the medical system's focus has traditionally been episodic and individualistic, while public health's focus has been continuous, with more of a population-based wellness approach. Most of our advances in mortality reduction have come as a result of public health approaches (e.g., improved sanitation) with only marginal gains, in spite of their tremendous cost, from biomedical ones. Prevention activities offer a much more substantial return both in terms of well-being

and financial concerns (Mukherjee, 2010). For every dollar invested in prevention, five dollars are returned in savings within five years (Prevention Institute, 2012).

As we move away from biological models of health, communication has a more central role in developing, maintaining, and restoring system integration of the individual in social and psychological, as well as biological realms (Zook, 1994). We also move away from a focus on disease and its episodic nature, to a view of information seeking as not a limited discrete event but a continuous activity vital to our well-being.

Is Everyone Sick?

> The drive in disease prevention to reduce uncertainty about the state of health and illness has led to a "culture of chronic illness" (D. Brashers, 2001, p. 477).

Some people seem to think as little as possible about the state of their health, and the consequences of their behavior. For others (particularly the elderly), health is constantly on their minds—health becomes their life. Increasingly, however, there is a concern among some observers about the medicalization of everyday life, and one way to deal with this problem is to increase individual autonomy and control over their health decisions. Traditionally the population has been divided into the well, the acute, and the chronic (Ferguson, 2007). A focus on surveillance medicine presupposes an individual has, in effect, a sword of Damocles hanging over his head, leading to a sometimes ultimately unhealthy preoccupation with illness rather than more prosocial approaches to health. The advent of wider spread genetic testing may exacerbate this problem by revealing incidentalomes: abnormal genomic findings that result in aggressive treatment and therapeutic responses (Kohane, Masys, & Altman, 2006). Essentially, at times it appears that the medical profession is striving to ensure that everyone has at least some illness, in the advent of categorizations like prediabetes and prehypertensive. Nearly one-half of the U.S. population has at least one chronic disease, and 37 percent of people over 65 have three or more (Lawrence, 2002). But this has at least one benefit: people with chronic diseases are more likely to seek information than those with acute ones (Galarce et al., 2011).

One description of what society expects of the sick is contained in the work of Talcott Parsons in the early 1950s. Parsons was a structural functionalist, taking an instrumental view of human societies, with each person having roles to perform that were critical to the maintenance and functioning of our institutions. In this traditional view, individuals were given the gift of life and this gift must be repaid, largely by performing useful work. However, the sick were limited in the

extent to which they could fulfill this obligation, which can lead to guilt on their part and potential sanctions from society as a whole.

To prevent these problems, a system of sanctioned deviance developed that was monitored and controlled by the medical profession, as illness was a loss to society. This system had four characteristics: individuals were freed from carrying out normal social roles; they were not responsible for their plight; they must try to get well; and they should seek competent help, and cooperate in their medical care. All this implies a more passive role, constrained by medical professionals. Adopting the sick role allows one to focus on health issues, but it also implied asymmetrical power relationships because of the role that doctors played in monitoring their behavior in the interest of society as a whole.

However, there was also a cultural value placed on instrumental action and a belief that even sick people must do something (e.g., search for information). This provided a major motivation to seek help, especially in the absence of competent help or of answers that prevented individuals from making a contribution to society as a whole.

The last several decades have seen a shifting of normative expectations, with individuals adopting proactive approaches to health, going so far that individuals see their bodies as a project (e.g., Feriss, 2011). So we have information-rich consumers who rely on multiple sources of expertise and a diminishing role for doctors. Information seeking, then, becomes a key tool in overcoming the traditional passivity of the sick role in the favor of action: reducing guilt and imparting to individuals the sense that they are still serving society. They have the responsibility to seek out information to restore the self to the status of functional efficacy (Schilling, 2002).

Health Literacy

> Effective adherence requires accurate information for making informed decisions about health behavior changes. Several studies show, however, that Americans' knowledge of cancer risks, symptoms, and preventive actions is far from optimal (Lerman, Rimer, & Engstrom, 1989, p. 4956).

> Although knowledge is not a sufficient condition for appropriate care-seeking, it is certainly a necessary one (Loehrer et al., 1991, p. 1669).

An individual's level of health literacy determines the information base they start with when confronting a health problem; their literacy level determines their need for information and what should be sought. Health literacy also includes the skills that are essential for information seeking, such as how to navigate our increasingly complex health care system. Information-seeking skills persist even as one's knowledge changes (Wright et al., 2008), evoking the old saying it is better

to teach a person to fish than to give them fish. Our contemporary health-care system, with shared decision making and consumer-driven approaches to health, is predicated on a literate populace.

The public's lack of health knowledge about causes, prevention, detection, and treatment is a significant problem. Limited health literacy is associated with higher rates of hospitalizations, poorer health, and higher mortality (Berkman, Davis, & McCormack, 2010; Cameron, Wolf, & Baker, 2011). One-half of all deaths in the U.S. can be attributed to preventable behaviors and social factors (e.g., diet, smoking, and alcohol abuse) (Wright et al., 2008). Historically, communication campaigns have met with limited success in diffusing health information. The quality of health communication, in general, is related to emotional health, symptom resolution, and pain control (Thorne, 1999). Patients can remember negative communication episodes with providers vividly for decades (Thorne, 1999). Communication generally, of which information seeking is one manifestation, has an impact on the quality of care, as well as increasing its cost. Poor communication can lead to increasing anger and litigiousness of patients (Thorne, Bultz, & Baile, 2005). In part because of shame and stigma, those with low health literacy are reluctant to ask questions and reveal their ignorance, even to their physicians (Cameron et al., 2011). One means of ensuring that information gets into the hands of those who need it is an enhanced understanding of information seeking.

According to Shapiro (2010), the term "health literacy" first appeared in the scholarly literature in 1974 in an article about health education in K–12 schools (Simonds, 1974). Use of the phrase grew slowly until 1993, when measures of the concept first appeared. By the late 1990s, dozens of occurrences of the term were recorded in the Medline database each year, and by 2003 it was appearing yearly in hundreds of titles and abstracts in the medical literature—almost 600 occurrences in 2009 alone. An official definition did not appear until 1999, when the American Medical Association (1999) offered this one: "the constellation of skills, including the ability to perform basic reading and numerical tasks required to function in the health care environment." Characterizations of health literacy have continued to vary and evolve. The National Academy of Sciences (Nielsen-Bohlman, Panzer, & Kindig, 2004), for example, says that health literacy is "the degree to which individuals have the capacity to obtain, process, and understand basic health information and services needed to make appropriate health decisions." Other health organizations, such as the Medical Library Association and the World Health Organization, have their own variations on these words.

However such literacy is defined, it is clear that the lack of it contributes to the health burden in America. Health literacy affects adults in all racial and ethnic groups. Proportions of individuals whose health literacy is basic or below basic ranges from 28 percent for whites to 65 percent for Hispanics (U.S. Dept. of

Health & Human Services, 2009). Only 12 percent of U.S. adults have proficient health literacy, and this is particularly problematic among those older than 75, with only 1 percent of them being proficient (U.S. Dept. of Health & Human Services, 2010). The National Assessment of Adult Literacy (Kutner et al., 2003) estimates that only 12 percent of Americans have sufficient skills to understand and act upon health information. More than 300 studies indicate that health-related articles exceed the average reading ability of U.S. adults (Connor, 2009).

Numeracy, or quantitative literacy, is competency with numbers and measures. It is the ability to reason with numbers and to apply mathematics to solve quantitative problems. Numeracy is not merely essential in many jobs; it is a necessary condition for coping with modern life. Nevertheless, some studies indicate that half of the adult American population may be unsure how to calculate percentages and be unable to understand probability statements (Paulos, 1989) or even, for that matter, understand what a percentage means (Blumenthal, 2010).

Innumeracy (lack of quantitative literacy) contributes to many personal problems, including lack of job prospects, excessive consumer debt, gambling, skepticism about science, and poor assessment of risks to health and safety (Paulos, 1989). These latter two deficits, in particular, can lead people to ignore and/or radically underestimate the consequences of certain preventative actions. For example, one may refuse to believe that smoking is a causative factor in developing lung cancer or misunderstand the likelihood of contracting a disease, having an accident, or outcomes of treatment. Thus, quantitative literacy is key to the promotion of prevention measures.

Because many health issues are expressed in terms of statistical probability—e.g., the likelihood of contracting an illness or of a treatment being effective—innumeracy can be a stumbling block to realistic perceptions of risk. An appreciation of risk is fundamental to a number of health behavior models. For example, the "perceived threat of disease" and the "perceived benefits of preventative action" are important components in the Health Belief Model; if people have great difficulty in forming accurate perceptions of threats and benefits, then the model loses its predictive value.

Many risk factors are correlational, in which a certain behavior or genetic background is associated with an illness, yet often the causal linkage has not been determined. Patients may be tempted by the lack of certain causation to discount what their doctor says. But assuming that they are convinced of a risk, they still may fail to understand the probabilities behind the acquisition or treatment of a disease.

For example, one important doctor-patient interaction is that which focuses on selecting treatment options—choices in which patients are increasingly compelled to choose. Risk assessments, discussed in more detail in the context of medical decision aids in Chapter 8, are increasingly popular and a major tool used

to encourage prevention behaviors. One approach used by health professionals has been to describe probabilities in terms of measurable random events, such as a coin toss to visualize likelihoods. However, even this kind of concrete analogy can go awry. Schwartz, Woloshin, Black, & Welch (1997) report that one-third of 500 women in their sample thought that 1,000 coin tosses would result in the appearance of fewer than 300 heads. And Parrott (2011) reports a case in which physicians used the coin-toss analogy in describing randomized assignment to control groups in treatment trials. The rural women patients in this case misinterpreted the doctor's words as implying that they were gambling with their lives. This was not the message intended by the physician.

How a health outcome (or other information) is *framed* has important consequences for patient decision making (Thorne, Hislop, Kuo, & Armstrong, 2006). People are more likely to accept scenarios presented with positive framing (e.g., survival rates from a treatment) than negative ones (e.g., likelihood of death from the same treatment), according to Kahneman, Slovic and Tversky (1982), Rifkin and Bouwer (2007), and Schwartz et al. (1997).

It is especially important that baseline risk data be given that allows the patient to understand medical outcomes, e.g., how many women out of 1,000 are likely to die from breast cancer over a 10-year period (Schwartz et al., 1997). Without baseline information, patients are more likely to have inaccurate perceptions of probabilities—e.g., they can only imagine what a "33 percent reduction in risk" means, not truly understand the final probabilities (Malenka, Baron, Johansen, Wahrenberger, & Ross, 1993). However, expressions of relative risks are more likely to lead to perceptions of efficacy among patients, presumably due to the use of large percentages (e.g., 33 percent) rather than absolute numbers (e.g., 4 in 1,000).

Overall, most people tend to overestimate the effectiveness of medical procedures (Schwartz et al., 1997), just as they tend to underestimate the risks associated with them. In terms of absolute risk reduction (expressed in terms of death rates), most gains of medical interventions are relatively modest. A common medical measure, *Number Needed to Treat* (*NNT*), is the number of patients who need treatment to prevent one additional person from having a negative outcome. In the case of anti-cholesterol drugs, treating 100 patients may only prevent heart attacks among one or two patients; some would not have heart attacks in any event, and others would have them whether they took the drug or not. And the value of medical actions must be balanced against other possible impacts of treatments, for example, their financial costs, side effects, and related psychological costs to patients. This complex way of thinking about medical treatments runs counter to the typical "illusion of certainty" that people attribute to actions and outcomes in the world—i.e., they want to believe in the effectiveness of actions.

Types of Health/Stage Issues

Information seeking can be related to a variety of motivations: e.g., group membership, fun, self-actualization (Boot & Meijman, 2010), surveillance, connecting with others, stimulation, getting direction, education, socialization, and so on (Dervin, 1989). The ultimate form of seeking can be linked to the initial set of conditions that starts someone on their quest.

Naturally, health information seeking can enhance an individual's general knowledge of a particular subject, adding to the information base they already have and leading to learning (Shaw et al., 2008). It has been argued that one distinguishing feature of human beings is their curiosity. Sometimes individuals are simply fascinated with particular topics. So, people can seek information about a particular area even though it is not directly related to immediate planned actions.

Individuals can also gather information to make a decision. Obviously this type of information seeking is tied to a direct event and individuals can gather information about preventive measures, the nature of the illness, treatment, coping, and so on. Individuals may engage in residual information seeking related to decision making. That is, an individual has already made a decision (e.g., pursuing a particular treatment option) and needs to rationalize it to others, or to further confirm it. In more extreme forms, this leads to "cyberchondriacs," "cyber-seekers," "information hounds," and "hyper-information seekers" who become obsessed with gathering information, often double checking information provided by health providers (Morris, Tabak, & Olins, 1992).

People at times gather information to share with others, either as a topic of conversation or to help them in some way. For example, many of the calls to the Cancer Information Service (CIS) are on behalf of a family member or friend whom the caller is concerned about. In effect, the caller acts as a "health agent"— seeking information on the patient's behalf (Freimuth et al., 1989). Increasingly, information seeking is a shared activity conducted by citizen scientists, advocacy groups, and other manifestations of the wisdom of crowds. Patients often become more informed so that they can communicate more effectively with their caregivers (Morris et al., 1992), engaging in anticipatory information seeking related to decision making.

People may also engage in information seeking to counter-argue, to resist changes advocated by others. So, an obese person may seek information, which is all too readily available, concerning the lack of efficacy of most weight-reduction programs. In our often contentious and litigious health-care system, people may engage in information seeking for financial reasons, to ensure appropriate compensation or reimbursement.

Finally, in the most dire circumstances, people need hope and a spiritual dimension, if nothing else, to cope with health-related issues: "The classic example that cancer patients often mention is professionals who say to them 'there is noth-

ing more we can do.' The message those words convey extends beyond cruelty and thus is unconscionable in humane cancer care" (Thorne, 1999, p. 376).

Types of Health Information Seeking

Information relating to health can cover a number of different facets, each of which may be quite complicated in its own right. So, seeking different types of health information may be associated with different outcomes. Those who seek wellness as opposed to illness information are more likely to report positive health assessments and lower occurrence of health risk factors (Weaver et al., 2010). Different issues entail varying types of information seeking due to inherent differences between diseases and their staging. Over time, individuals form expectations for the sort of health-information content found in particular information carriers. While various channels have inherently varying capabilities, they also have unique historical patterns of development and resulting usage that may cause individuals to consult them for different purposes.

In one of the few research streams that addressed content issues within a specific disease domain, J. D. Johnson and Meischke (e.g., 1991, 1992a, 1994) focused on six major content types: general information regarding cancer; information related to specific types of cancers; prevention information; detection/diagnosis information; treatment information; and information related to how to deal with cancer across a variety of carriers. Similarly, Ankem (2006) identified five categories of cancer information needs: nature of disease; treatments; tests; prevention and restorative care; and family and other psychosocial concerns. The Johnson and Meischke studies found significant differences across channels, across content, and interactions between channels and content, thus suggesting that users generally prefer different channels for different types of content. Increasingly, individuals are also interested in information about the politics of cancer, science and cancer, rehabilitation, continuing care, palliative care, and alternative approaches.

General information covers a wide range of different types of problems and different issues related to its care, prevention, and treatment. Individuals are exposed incidentally to this type of information in a wide array of sources (which will be the focus of Chapter 4).

Detailed information on *specific types* of disease may be more difficult to come by in the mass media, except for common cancers like breast and lung. Sometimes, as in the case of famous people who have cancer (e.g., Michael Douglas), information can be very detailed. However, concern about specific types of cancer is usually triggered by more immediate events, such as a family history of cancer or a diagnosis of cancer of someone in one's immediate social network. The type of cancer also affects information seeking; it is typically lower for lung cancer patients, for whom there are few efficacious treatments (Eheman et al.,

2009). Information related to *prevention* is increasingly promoted by groups like the Army of Women. Organizations are also very active in disseminating this type of information.

When people are concerned with whether or not they have cancer and appropriate *treatments*, they are more likely to turn to authoritative channels for health information, but the advent of the Internet and resources like MedlinePlus® and various support groups have led to disintermediation and a broadening of people's conception of what and who is authoritative. Whether a problem is chronic or acute, requiring immediate treatment, also has impacts. Patients with emergency admission and those with uncommon diagnoses are typically less satisfied with information provided (Veenstra & Hofoss, 2003).

The results of the Johnson and Meischke research established significant differences in the perceived likelihood of individuals turning to specific channels, with more differences across channels than within them, for a range of contents. These studies suggest that individuals prefer to use channels that are more interpersonal, a general finding of information-seeking research (Case, 2012), and/or more authoritative. These results point to some instances where there were no clear preferences, suggesting individuals would be willing to receive cancer-related information from a variety of channels. Generally, the ratings of less authoritative channels were high enough for particular contents, except for treatment, that, as past exposure studies have demonstrated, people's preferences could easily be supplanted by ease of access. So, somewhat disturbingly, people who seek medically related information generally turn to family and friends first and tend to contact professionals only as a last resort. This is a theme we will return to often, because it is clear that access concerns override issues of quality and credibility of sources for most individuals for a wide range of information-seeking concerns (Case, 2012).

Why Is Health Information Seeking Important?

The aim should be to aid and foster a self-reliant, self-actualizing consumer who can make the most of decisions and play an equal role with the sellers in the marketplace. The key to such consumer emancipation is better information (Thorelli & Engledow, 1980, p. 9).

The central assumption underlying this book is that information seeking is a key facilitator for promoting, maintaining, and returning to health as broadly conceived. Cancer, for example, is often environmentally caused, and therefore could be subject to primary preventive measures. Further, earlier detection, diagnosis, and speedier treatment could save many lives. Public education and enhanced motivation could have a substantial role in improving health, an assumption incorporated

in the recommendations of key policymakers for ensuring that Healthy People 2020 has been reached (Harris et al., 2011). Providing information to patients can increase their psychological well-being, relieve anxiety, and can help them make more informed treatment decisions, but patients and family needs for information are often unmet (Adams, Boulton, & Watson, 2009; Galarce et al., 2011).

Information seeking can be defined simply as the purposive acquisition of information from selected information carriers. Not long ago, information related to cancer was the exclusive preserve of doctors and other health professionals. Today, not only is the diagnosis shared, but individuals have free access to a bewildering wealth of information. With this access has come an increasing shift of responsibility (some might say burden) to the individual to make decisions concerning his/her treatment and adjustment to disease.

It has become commonplace to suggest that in some instances, patients come to know more about their disease than the physicians who are treating them. While one would hope that doctors would seek answers to questions they have about patient care and treatment, in practice they may not seek the best available evidence for their questions. When they do decide to seek answers, they tend to consult highly digested, easily accessible sources (Ely, 2005). Recognition of these issues places even more importance on information seeking as a critical survival tool. Seeking (and scanning) are associated with knowledge acquisition, healthy lifestyle behaviors, screening, as well as discussing information with physicians, obtaining information useful in decision making, exercise, and fruit and vegetable consumption (Shim, Kelly, & Hornik, 2006). Information seeking is associated with better outcomes post-treatment, better emotional well-being, and increased satisfaction with medical treatment (Eheman et al., 2009).

However, there also is a darker side to these trends: institutions lose control, and medical care can become less efficient as individuals perform the traditional work of health professionals. This puts an increased burden on individuals who can quickly feel the impacts of information overload, in part because they lack critical information-seeking skills. Many Americans report negative experiences with the effort required, the frustration involved, and they have concerns about the quality of information gathered as a result of their information searches (Arora et al., 2007). As we discuss in Chapter 6, many people confronted with health problems engage in avoidance and denial, making a system dependent on proactivity problematic. For example, it has been found that use of cancer information resources is relatively low, regardless of one's personal history of cancer (Roach et al., 2009).

Information is an important first step in health behavior change (Freimuth et al., 1989). The consequences of information carrier exposure and seeking are many, including information gain, affective support, emotional adjustment, social adjustment (Zemore & Shepel, 1987), attitude change, knowledge change, behavior maintenance (Anderson, Meissner, & Portnoy, 1989), a feeling of greater con-

trol over events, reduction of uncertainty (Freimuth, 1987), and compliance with medical advice (Epstein & Street, 2007). Much health behavior (e.g., breast cancer screening) involves acting on the basis of personal and informed judgment (Atkin, 1973). The scope and nature of the information on which to base these judgments, the repertoire of alternative courses of action known to the searcher, and ultimately the action taken are affected by individuals' information-seeking behaviors.

Changes in public knowledge, attitudes, and behavior are critical to enhancing health. Active information seeking is also associated with favorable responses to a variety of other health practices (e.g., having regular physicals and regular exercise) (Rakowski et al., 1990). In short, aggressive responses, of which active information seeking by individuals is one, are most likely to lead to positive outcomes—prevention, early detection and treatment, and more efficacious treatment. Information seeking also leads to earlier prognosis, which at the very least allows the terminal patient and his/her family more time to adjust to difficult circumstances (Steen, 1993). The very decision to seek medical care is also largely based on individual initiative. It is well known that, for diseases like cancer, the earlier the detection, the greater the likelihood of reduced morbidity and mortality (Mukherjee, 2010).

Research suggests that different channels provide health-related information only to selected segments of the public. This in turn suggests that the public's seeking is a crucial component in the dissemination of health-related information; facilitating seeking would then improve the speed with which medical advances are disseminated. It has been argued that major advances in health are more likely to come from encouraging people to behave in healthier ways, rather than from advances in medical science and technology. This assertion highlights the importance of health promotion and communication.

Information seeking is generally considered to be one indicant of a person who is proactive about their health (Rakowski et al., 1990). Yet, communication theory and research have not caught up to these societal trends (Freimuth et al., 1989). Traditionally communication research has focused on the sender of communication messages and how the sender can persuade receivers, who are cast as target audiences (e.g., Rice & Atkin, 1989). In the future, we must turn to the question of information seeking and the constraints on it, to advance our understanding of health promotion in communities (Finnegan, 1994). Funding of the Health Information National Trends Survey (HINTS) by NCI is but one sign of growing federal interest in information-seeking trends as an important policy issue (Nelson et al., 2004). There also has been a substantial growth in health information-seeking articles submitted to leading journals (Thompson, 2006).

We know a lot about how formal organizations (e.g., the Veterans Administration, the American Cancer Society) conduct campaigns to change individual behaviors. Increasingly, however, individual action, embodied most clearly in in-

formation seeking, determines what messages individuals will be exposed to and how they will behave. As the information environment becomes increasingly decentralized and diffused, understanding individual needs, preferences, and seeking has become increasingly important.

Unfortunately it is often the case that the information needs of individuals are not met. In an interesting study reviewing systematically research in this area between 1998 and 2008, Eike Adams et al. (2009) identified 11 categories of information need. They found that diseases like breast and prostate cancer received significant attention, but for most other types of cancer, especially after the diagnosis and initial treatment stages, needs were often unmet. The implications of cancer for long-term care for partners, family members, and supportive care were often only poorly developed.

In our view, actors operate in information fields where they recurrently process resources and information. These fields operate much like a market, in which individuals make choices (often based on only incomplete information, often irrationally) that determine how they will act regarding their health. This contrasts directly with the view of information campaigns that tend to view the world as rational, known, and that concentrate on controlling individuals to seek values of efficiency and effectiveness (e.g., Rice & Atkin, 1989).

A focus on information seeking develops a true receiver's perspective and forces us to examine how an individual acts within an information field containing multiple information carriers. Some of these carriers may be actively trying to reach individuals, but many contain passive information awaiting retrieval. Campaigns may result in felt needs on the part of the individual, but the individual and his/her placement in a particular social context will determine how needs are acted upon. A true picture of the impact of communication on health needs to contain elements of both perspectives. Yet, because most of the work in this area tilts in the direction of understanding more formal campaigns, here the focus will be primarily on how individuals make sense of the information fields within which they act. This focus on receivers dovetails nicely with the renewed focus on the customer, client, and/or patient and the personalized medicine movement generally (Galarce et al., 2011). Historically, as Mukherjee (2010) points out, as cancer treatment became more sophisticated, it became increasingly personalized as to staging and type. This medical trend has been greatly accelerated by genomic developments with over 1,700 single genetic tests (e.g., www.genetests.org).

Client/Consumer Movement

> By now, consumers' freedom to choose, to be informed, to be heard, and to be safe seem to be accepted as classic rights. The right to choose assumes an open market and a true open market assumes informed consumers (Thorelli & Engledow, 1980, p. 10).

Increasingly the responsibility for health-related matters is passing to the individual, partly because of legal decisions that have entitled patients to full information (Falconer, 1980). Since the 1970s, patients have been more and more active participants in decisions affecting health care, with concomitant improvements in the attitude and mental state of patients, as part of the growth of health consumerism (Epstein & Street, 2007). The rise of the consumer movement can be traced to a speech by John F. Kennedy in 1962 in which he articulated four basic consumer rights: to be informed, to choice, to safety, and to be heard (redress) (Jacoby & Hoyer, 1987). It is also deeply ingrained in U.S. culture, with perceptions of Jeffersonian democracy deeply interrelated with an informed public (Galarce et al., 2011).

The consumer movement in health is in part actively encouraged by hospitals, insurance providers, and employing organizations who want to encourage health consumers to "shop" for the best product at the most affordable price (Hibbard & Weeks, 1987). It is commonplace for hospitals to provide patients with a statement of their rights. Among these rights typically, is the right to seek information, as in this example from a hospital guide: "4. You have the right to seek and receive all the information necessary for you to understand your medical situation" (Beth Israel, 1982). Facilitating and enhancing this consumer movement have been developments in information technologies, which make more specialized media sources available, permitting increased choice in information carriers, and increased connectivity with other interested parties.

Still, the consumer movement assumes individuals are increasingly sophisticated and can understand issues ranging from advanced cell biology to psychosocial adjustment to pain management. Individuals have free access to a world of health information. Over one million articles are published every year in the biomedical and technical literature. Many patients do not receive state-of-the-art treatments, partly because physicians cannot keep up with the information explosion—a growing concern within the National Institutes of Health (NIH). The overload of information on health professionals today forces decentralization of responsibilities, with increasing responsibility passing to individuals if they are going to receive up-to-date treatment.

In effect, patients must often do the work of doctors, who cannot keep abreast of information related to specific treatments, especially for more exotic diseases. Recognition of the limits of health professionals also requires individuals to be able to confirm and corroborate information by using multiple sources. Paradoxically, however, there may never be enough information to answer all of the questions posed by patients, since for very specific issues there is likely to be a smaller, more manageable amount of information (Sechrest, Backer, & Rogers, 1994). Some of the most important questions patients have may never be answerable: for example, how long will I live if I start this new, experimental course of treatment?

Individuals confronted with health problems often find that they must make judgments without even a grasp of basic terminology. This increasing responsibility for information seeking leads to a growing burden on individuals, who are expected to understand rapidly changing health and scientific information (Seibold, Meyers, & Willihnganz, 1984). It may be unfair to make the client responsible for every aspect of his/her treatment, especially in these highly uncertain times. In this new world, individuals must confront health problems very much as a scientist, constructing practical theories upon which they must act. This may establish a set of expectations that only the best educated can achieve. Will people make the right choices; do they know enough to weigh and decide between the often conflicting pieces of information they will receive? Human beings are far from optimal information seekers, and, while information is a multiplying resource, attention, by implication, is a zero-sum resource (Smithson, 1989). Attempting to keep track of prevention information alone could consume all one's spare time, raising serious questions about the nature of a life driven by such obsessions (Zook, 1994). This issue has taken on even more importance with the advent of genetic testing among the "presymptomatic ill" for such genes as BRCA-1, which plays a significant role in the development of breast cancer (Johnson, Case, Andrews, & Allard, 2005), and with the increasing prevalence of chronic diseases and co-morbidities.

Adding to this mix is the fact that for many people, the first time they will think about serious illnesses in a meaningful way is when they are initially diagnosed, so they may not possess the background information and training to make effective choices. For most individuals, information seeking related to health issues is a novel task fraught with many barriers. While they are dealing with an emotionally charged situation, they will be asked to weigh and evaluate often conflicting medical claims, placing a tremendous burden on them.

All this also raises the question: whose information is it, anyway? The social norms that cast doctors and public health officials as the brokers of medical information are yielding to an era in which individuals actively seek information (Johnson et al., 2005) and where a balance of power is sought in the patient-provider relationship (Epstein & Street, 2007). Information that to a client is necessary for coping with cancer, may be seen by doctors as an intrusion into their prerogatives. Exacerbating this problem is the fact that doctors and patients may not share similar outcome goals. Traditionally, doctors have viewed the ideal patient as one who came to them recognizing their authority and who was willing to comply totally (with enthusiasm) with recommended therapies (Zook, 1994). Still many, if not most, patients do not comply with treatment regimens (Epstein & Street, 2007).

Most doctors believe in treating cancers aggressively, even those with low cure rates; however, increasingly some more harmful aspects of chemotherapy and oth-

er treatments are weighed against the likelihood of success and the quality of life (Mukherjee, 2010). So while doctors typically engage in narrow problem-solving relating to disease, patients often view a disease as but one component of a complex social system of which they are a part. What good does it do to save me, if I will be but a shell of my former self and my family is bankrupted in the process?

Perhaps the most threatening aspect of enhanced information seeking for health professionals is their loss of control. Yet, no market can operate effectively if information is not freely available, if one group of professionals is granted a monopoly on information. Still, the more control that health professionals have, the less effective they may ultimately be, especially in terms of ensuring that clients act according to consensus views of treatment. While the hoarding and withholding of information often benefits the interests of individuals in privileged or specialist positions (Moore & Tumin, 1949), in many respects doctors have benefitted by this shift of responsibility, since their failures might be a result of major choices patients have made (e.g., whether to have surgery alone or in combination with chemotherapy). Thus, there is less of a feeling among clients that their doctor has betrayed them when things go wrong (Steen, 1993). Increasingly, the blame is likely to be placed on the individual for not only choosing the wrong treatment regimen (and not adhering to it) but also for not engaging in the primary prevention activities that would have allowed them to avoid health problems in the first place (Becker & Rosenstock, 1989).

Most discussions of information seeking tend to focus on the benefits of information seeking. Yet, information seeking can be viewed as having many negative consequences: people in authority lose control and the burden on individuals increases tremendously. Many doctors have legitimate concerns about self-diagnosis and patients possessing just enough information to be dangerous (Broadway & Christensen, 1993), and the general preferences of consumers may cause them to avoid unpopular, albeit effective, invasive procedures (Greer, 1994). As more and more of us become responsible for our own care, in part because of the rise of outpatient treatments, home care, and hospices, these issues will only take on greater importance. As we will see, the forces preserving ignorance may be far more compelling than those resulting in information seeking. Diseases such as cancer are seen as mutilating, inflicting pain, and eventually devouring its victim—it is widely feared. Even worse, its primary treatments, radiation, chemotherapy, and surgery, may be even more feared than the disease itself (Mukherjee, 2010).

Plan of This Book

As we have seen, health information seeking is of great pragmatic importance for both the individual and society. It is also more complex than it might at first appear. The individual needs to gather information on multiple contents from an

ever-increasing array of information carriers (e.g., channels, sources, messages). In doing this, people are faced with the real limits of their past knowledge base and their ability to process information. They also must wrestle with denial and fear of the answers that may be the result of their search. We will examine each of these issues in the chapters that follow. Chapter 2 develops a more complete picture of the nature of information and the information environment of individuals.

Part II of the book focuses on the nature of information seeking, developing a Comprehensive Model of Information Seeking (CMIS). Chapter 3 specifies the psychosocial issues that drive health information seeking. Chapter 4 focuses on the characteristics of particular information carriers and associated theoretical frameworks. Chapter 5 compares and contrasts various models of information-seeking behaviors. It will also discuss different styles of individual information seeking. Chapter 6 focuses on outcomes dealing with both the dark side (e.g., avoidance, ignorance, and denial) and bright sides (success stories) of information seeking.

In Part III we discuss strategies for seekers and for health professionals. Chapter 7 details strategies individuals can use in their information seeking. Chapter 8 discusses what health professionals can do to facilitate a seeker's search. Health professionals are typically active providers of information to often obstinate audiences. Looking at the world from a seeker's perspective requires a substantially different approach by health providers. In summary, Chapter 9 weaves all the themes of the book together in discussing the importance of information seeking for the development of theory and the emerging professional disciplines associated with information seeking.

Further Readings

Arora, N. K., Hesse, B. W., Rimer, B. K., Viswanath, K., Clayman, M. L., & Croyle, R. T. (2007). Frustrated and confused: The American public rates its cancer-related information-seeking experiences. *Journal of General Internal Medicine*, 22, 223–228.

The authors assessed the barriers faced by people searching for cancer information, based on data from more than 6,000 respondents to the National Cancer Institute's 2003 Health Information National Trends Survey. Nearly half (45 percent) of those in the sample had searched for cancer information, and of those almost half reported problems in their search. Among the complaints were the amount of effort required (48 percent), frustration with the search (41 percent), and concerns about the quality of the information located (58 percent). Those without a high school education or health insurance had the biggest problems. An underlying issue highlighted by this research is that seniors were less likely than other age groups to search for cancer information and yet are more likely to be

diagnosed with cancer. The study suggests that cancer information-seeking needs to be better facilitated if cancer prevention and control are to be optimized.

Berkman, N. D., Davis, T. C., & McCormack, L. (2010). Health literacy: What is it? *Journal of Health Communication, 15,* 9–19.

Berkman et al. review the history of the concept of health literacy, explaining the various ways it has been defined and measured. They point out that disagreements regarding definitions have hindered both research on, and attempts to increase, literacy.

Parrott, R. (2009). *Talking about health: Why communication matters.* New York: Wiley-Blackwell.

According to Roxanne Parrott, most people (and especially parents) want to talk about health—whether ill or not. Questions like "Am I normal?" or "Is my kid developing normally?" are common concerns. Many have experienced situations in which communication with physicians was problematic. Parrott explores personal concerns while discussing the more general topic of communicating about health. Written in the first person and filled with anecdotes as well as medical facts, it makes an engaging read.

U.S. Department of Health and Human Services (2011). *Healthy people 2020.* Washington, DC: US Department of Health and Human Services. Available at http: //www.healthypeople.gov/2020/default.aspx

The site provides the latest set of national health goals, listed under many headings. Each goal has specific objectives, and each of these is targeted for an improvement (often 10 percent above or below the 2010 indicator) by the year 2020. Among the new topics addressed are genomics, preparedness, and social determinants of health.

TWO

Information Fields and Carriers

Overview

... they judge that the diffusion of knowledge must necessarily be advantageous and the consequences of ignorance fatal (de Tocqueville, 1966).

Information seeking related to health encompasses a wide array of beliefs, attitudes, intentions, and behaviors. First, we start with basic orientations toward the world around us in terms of our beliefs concerning the benefits of any action. As emphasized by de Tocqueville's quotation concerning the early United States, information seeking takes on different roles in different cultural frameworks. Just as health care is culturally bound, health information seeking is also affected by cultural factors. In the U.S., where national values sanctify individual action to achieve benefits or to overcome threats (Hofstede, 1984), information seeking is naturally viewed more favorably than in cultures with more fatalistic orientations (Hofstede, Hofstede, &. Minkov, 2010). In our society, it is an individual's obligation, and at times a burden (Wallack, 1989), to seek one's own answers to questions, to make one's own judgments, and to then decide one's own course of action in response to challenges.

Once this basic information-seeking belief is established, an individual faces more particularistic concerns when confronted with specific needs. The intention to seek information has a relative salience within the individual's other intentions. For example, while an individual may vaguely know that he/she needs to possess

more information related to fiber in his/her diet, he/she may not be able to act on this concern because of more pressing concerns (e.g., a chronic disease like diabetes, family or work problems, and so on). In addition, an individual's intention to act may be further constrained by myriad other factors in his/her environment, including the availability of information sources.

Once an available source is selected, several other factors may determine its relative standing in the array of sources to which an individual may be exposed. I may have different attitudes about the efficacy of using certain elements of my environment as sources of information. So my choices for action are conditioned by my attitudes concerning the outcomes derived from a particular source that may result from prior usage. I may use some sources a great deal, while I sporadically use other sources for information, within the same limited content domain. So my beliefs, attitudes, and intentions set the framework within which action is possible.

The act of information seeking itself can take an amazing array of forms. I may be cued by a commercial to view a Katie Couric television special about colon cancer. This might lead to an additional act of information seeking and having a colonoscopy. This test might be positive, leading to more specific information seeking centered on securing answers to particular questions. How will my family cope if I have cancer? How will I deal with it? What is colon cancer? How is it treated? What are the side effects of treatment?

I may seek answers to these questions from a variety of channels, from a variety of sources within channels, and from a variety of messages contained within these sources. These information carriers may provide me partial answers to the above questions. These answers, in turn, may stimulate additional questions, the answers to which I may not be immediately able to get because of constraints that exist in my immediate information environment. For example, for financial reasons I may be limited to the extent to which I can directly consult experts as sources. I may not be aware that MedlinePlus can provide extensive information for an Internet search. I may be fortunate and have a neighbor who is an oncologist with whom I can informally discuss my concerns. One of my close relatives may have had colon cancer, so I can draw on their direct experience.

Thus from somewhat simple beginnings, an elaborate process of information seeking, acquisition, and further seeking springs. If the tests show that I have colon cancer, at least for a while, the information search, and the questions that guide it, may dominate all other concerns in my life. These processes may, in very real ways, become my life.

Information Seeking: Some Basic Distinctions

Naturally, before we define information seeking, we must discuss the more basic concept of information. As we have seen, the word information is ubiquitous;

it has even been used to define our society as a whole. As with many central concepts, several senses of the word are employed in the literature (Case, 2012). Unfortunately, several of these meanings are also mutually contradictory.

Perhaps the most appealed-to source for a definition of information comes from Shannon and Weaver's (1949) seminal work on telecommunication systems. Their central concern was how to send messages efficiently, with minimal distortion, over mediated communication channels. Yet, this work has always been troublesome because of its mechanistic, engineering transmission focus, which slights the meaning of messages (Gleick, 2011)—something fundamental to definitions of knowledge.

Shannon and Weaver (1949) developed an abstract definition of information based on the concept of entropy. Total entropy would represent complete randomness and lack of organization in messages. With greater entropy you also have higher levels of uncertainty, so that the more familiar a situation is, the less information it generates. In this sense something is information only if it represents something new, thus a measure of information is the "surprise value" of a message (Krippendorf, 1986). However, it is quite possible that only an experienced person can recognize the unfamiliar in the most seemingly familiar of messages (Rowley & Turner, 1978). This also leads to the expert's paradox: the greater one's expertise, the more likely he or she is to be successful in finding information, but the less likely that information is to be informative in this sense of information (Buckland, 1991). Since most people associate information with certainty, or knowledge, this definition can be somewhat counterintuitive (Case, 2012).

Much more globally, information is sometimes equated with any stimuli we register or recognize in the environment around us (Miller, 1969). In this view, information involves the recognition of patterns in the basic matter/energy flows around us, everything shown in Figure 2-1 (Case, 2012; Farace, Monge, & Russell, 1977; Hjorland, 2007). The other side of this view focuses on the nature of an individual's perceptual processes, arguing that they shape what we consider to be information, what we will perceive, and how we will perceive it (Miller, 1969). But there is also a sense, a very important one for health, that information is what you use to develop a higher level of comfort, perhaps even more of a feeling of familiarity with a situation. The more confident and sure you are about something, the less uncertain it is (Farace et al., 1977). Thus, information can also be viewed as the number (and perhaps kind) of messages needed to overcome uncertainty (Krippendorf, 1986). In this view, information is of value if it aids in overcoming uncertainty; the extent to which information does this also defines its relevancy (Rouse & Rouse, 1984).

Associated with this view is the concept of information load, a critical problem that most organizations and individuals must confront. Information load is a function of the amount and complexity of information. Amount would refer to

the number of pieces (or bits) of information, somewhat akin to the accumulation of data. Complexity relates to the number of choices or alternatives represented by a stimulus. In a situation where all choices are equally probable, entropy is at its maximum. This sense of information reflects the close association of information with decision-making processes, something we will return to in later chapters.

Figure 2-1: Distinguishing Key Terms.

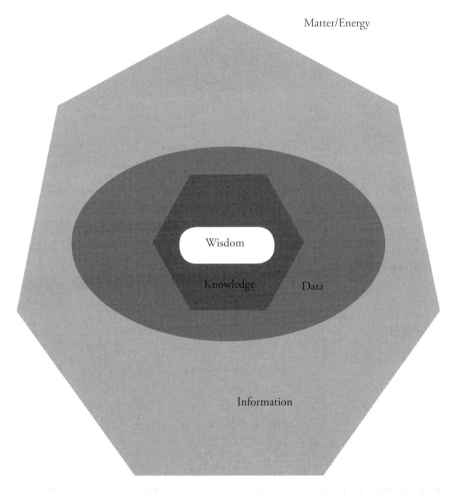

Adapted from *Managing Knowledge Networks*, by J. D. Johnson, 2009, Cambridge, UK: Cambridge University Press, p. 12. Copyright by Cambridge University Press.

The senses and properties (e.g., timeliness, depth, breadth, specificity, quality, accuracy, quantitative/qualitative, hard/soft [Dervin, 1989]) of information are many. In this work, we will use information in its most general sense—the dis-

cernment of patterns in the world around us. Data, in this framework, is a special cases of information. Data take on the characteristic of facts, more isolated, atomistic elements. They are often associated with information technologies because of the certainty of 0, 1 binary bits of information suitable for processing in a computer that can be recognized with some invariance as either one thing or another.

Knowledge runs the gamut from data, to information, to wisdom, with a variety of distinctions made between these terms in the literature (Frické, 2009). While there is a generally recognized ordering among these terms (see Figure 2-1), with wisdom having the least coverage of the other sets, they are often used interchangeably and in conflicting ways, resulting in some confusion (Boahene & Ditsa, 2003). The increasingly limited set associated with higher-order terms also can be associated with greater personal interpretation (and hence potentially more idiosyncratic meanings) as one moves from data, a special type of information, to wisdom, somewhat paralleling the distinction between tacit and explicit knowledge, and representing a progression of states (Holsapple, 2003). It has also been suggested that value and meaning increase as one limits the domain coverage, and not surprisingly so does the difficulty in developing informatic systems that capture the higher-order terms (Burton-Jones, 1999).

Information Fields and Pathways

One constraint on information seeking is the information field within which the individual is embedded. This field encompasses the carriers of information an individual is normally exposed to and the sources an individual would normally consult when confronted with a problem. For professionals, this information environment might be incredibly rich, including access to sophisticated databases, advanced satellite systems, and "search engines" for computerized information retrieval. The arrangement of an individual's information field limits the degree to which that individual can act on his/her predispositions. The information field an individual is in constrains the very possibility of selecting particular sources of information.

An individual's information field provides the context for their information seeking. Information fields contain resources, constraints, and carriers of information that influence the nature of an individual's information seeking (Archea, 1977; Hagarstrand, 1953). The concept of field has a long tradition in the social sciences, tracing back to the seminal work of Lewin (Scott, 2000) and various philosophical traditions (Schatzki, 2005) with recent variants like information horizons (Sonnenwald, Wildemuth, & Harmon, 2001), information grounds (Fisher, Durrance, & Hinton, 2004), small worlds (Fulton, 2005; Huotari & Chatman, 2001), and social positioning (Given, 2005). In some ways the totality of someone's information fields has analogs to the notion of social capital in that it describes the resources an individual has to draw upon when confronting

a problem. When individuals share the same information field, they also share a context, which provides the information grounds for further interaction (Fisher, Erdelez, & McKechnie, 2005). As a best-selling book on social networks puts it, "The more contexts two people share, the closer they are, and the more likely they are to be connected" (Watts, 2003, p. 116).

Information fields represent the typical arrangement of information stimuli to which an individual is daily exposed. Thus, individuals are embedded in a physical world that involves recurring contacts with an interpersonal network of neighbors and co-workers. This physical context serves to stabilize an individual's information fields and in large part determines the nature of information individuals are exposed to in their interpersonal communication networks. How individuals interact with their built environment can have profound impacts on their health (Saarloos, Kim, & Timmermans, 2009). They are also exposed to the same mediated communication channels (local newspapers, television news, etc.) on a regular basis.

Individuals can, if they so desire, arrange these elements of their information fields to maximize their surveillance of health information. They can regularly attend to television programming, and they can subscribe to magazines with high proportions of health-related content. In other words, individuals who are more concerned with their health are likely to mold their information fields to include a richer mixture of health information sources. How they shape this field over time determines not only their knowledge of general health issues but also their incidental exposure to information that may stimulate them to more purposive information seeking. Thus, in a sense, individuals are embedded in a field that acts on them, the more traditional view of health campaigns. However, individuals also make choices about the nature of their fields; the types of media they attend to, the friendships they form, and the neighborhoods they live in, which are often based on their information needs.

The nature of an individual's stable information field can shape his/her more active information seeking, since it provides a starting point for more active information searches. Naturally an information field can change to reflect changes in an individual's life, which at times are also directly related to changing information-seeking demands. When an individual becomes a patient, his/her interpersonal network changes to include other patients who are proximate during treatment. They also may be exposed to a greater array of mediated communication (e.g., pamphlets, videos, etc.) concerning the nature of their disease. As individuals become more focused in their information seeking, they change the nature of their information field to support the acquisition of information related to particular purposes. In this way individuals act strategically to achieve their ends and in doing so construct local, temporary communication structures and fields that mirror their interests.

In sum, then, individuals are embedded in information fields that determine their level of awareness and knowledge. The nature of these fields also determines the likelihood that they will be exposed to information that may trigger a desire to seek more information or to change their health behavior in some ways. The presence of weak ties (Granovetter, 1973) may expose them to information that prompts change, and this may trigger an expansion of the individual's information field. In addition, the mediated channels to which individuals are recurrently exposed may incidentally contain information related to a communication campaign that causes them to seek further information. Of course, the experience of symptoms or the presence of someone in their immediate social network who has a disease also may cause an individual to expand their information fields to obtain information that can answer their immediate concerns. The expansion of the individual's field is often determined by their knowledge of and beliefs concerning the efficacy of various information carriers, a topic we will return to when we discuss the Comprehensive Model of Information Seeking (CMIS).

Pathways describe the behaviors people engage in as they respond to these forces. Johnson and his colleagues (Johnson, Andrews, Case, Allard, & Johnson, 2006) have developed the concept of pathways, the route someone follows in the pursuit of answers to questions. Thus, someone who is unexpectedly confronted with a health problem—say after hiking, a man starts feeling various symptoms and has an unusual rash on his leg—may expand his field to include a casual acquaintance who is a nature lover, an infectious disease specialist, the Internet, hiking magazines and websites and so on. Once he has a diagnosis of ehrlichiosis, he does not go down more paths, but his fields may change. He may choose alternative means of regular exercise that don't expose him to ticks, and he may routinely check the CDC website for updates on this disease.

These different approaches imply different relationships between actors and their information environments and thus also encapsulate different views of the relationship between individual actions and contexts and the active role individuals can play in contextualizing. Fields could be seen as embedded in traditional, causal approaches to human action, while pathways reflect more modern notions of narrative and a search for typical patterns (Johnson et al., 2006). Pathways reveal individual practices, calling attention to the importance of the sequencing of actions (Savolainen, 2008); seeking information from the Internet and then going to a physician is distinct from going to a physician and then consulting the Internet. Recently, this has also been described as cross-source engagement, or one-step paths, reflecting the growing tendency for people to seek information from multiple sources, including those other than health professionals (Nagler et al., 2010).

Information Seeking

Information seeking can be defined simply as the purposive acquisition of information from selected information carriers. Traditional definitions of communication have often foundered on the notion of intentionality (Dance, 1970). Still, here it is assumed that information seeking is primarily intentional. This intentionality is related to the accomplishment of a particular goal that the individual has in mind. Since individuals determine the value of information acquired in relation to a particular goal, information seeking is inherently a receiver-oriented construct.

Since this activity is goal related, it also may be more rational than communication as a whole. An individual may formulate a plan of information seeking. Some individuals may engage in what could be termed meta-information seeking. That is, they seek information about information seeking. In part that is what this book is about: the choices individuals make in determining their information-seeking behavior. So an individual may consult sources about what sources they should consult. At times this occurs before the start of a search, but it also may occur in a parallel fashion. That is, I initially consult some carriers; I find that they don't have enough information, so I formulate a plan laying out a path for further searches. This process may continue until the individual becomes satiated, exhausted, or the time for that particular search expires.

Information Carriers

Information carriers are the primary repositories of information available to individuals within their information fields. The literature has focused on three primary classes of information carriers: channels, sources, and messages (See Figure 2-2). There are multiple channels (e.g., magazines, the Internet) from which health-related information can be acquired; within each of these channels there are a variety of sources, and each of these sources can contain a variety of messages. So while *The Economist* and *TV Guide* share many channel similarities (e.g., lack of immediate feedback between source and receiver), each of us would recognize critical differences between them as sources (e.g., credibility). Similar differences in characteristics might occur for different messages emanating from the same source. So I might trust my mother to give me advice on nutrition but not on different types of treatment for diabetes.

While each information carrier has its own unique properties, there are also some dimensions (e.g., perceived utility) that transcend the differing types of carrier with assessments of credibility also naturally following these classifications (Hu & Sundar, 2010). The relationship among these different carriers is somewhat akin to the relationship between compounds, molecules, and atoms in chemistry. Messages are the essential building blocks of which the other units

are composed; the irreducible component of carriers. Sources, somewhat akin to molecules, contain a relatively stable combination of messages. Channels, like compounds, are made up of more complex structures of sources that share similar attributes. By and large, communication researchers have focused their efforts within each of these classes of carriers, rather than trying to assess the things that are in common across them.

Figure 2-2: Information Carrier Matrix.

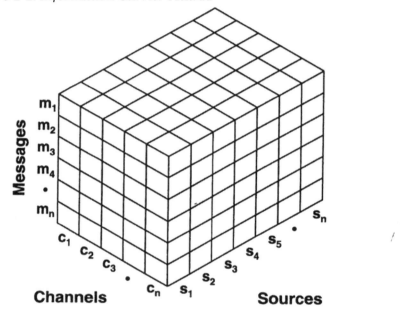

Adapted from *Cancer-Related Information Seeking*, by J. D. Johnson. Cresskill, NJ: Hampton Press, p. 27. Copyright 1997 by Hampton Press.

Channels have been variously defined: "an information transmission system" (Goldenson, 1984, p. 137) or "the means by which the message gets from the source to the receiver" (Rogers & Shoemaker, 1971, pp. 24). Channels are also often seen as constraints, as in the conduit (or pipeline) metaphor; thus a message has to stay within channels (Axley, 1984; Putnam & Boys, 2006; M. J. Reddy, 1979). As the preceding illustrates, and as Berlo (1960) has noted, channels are one of the more ephemeral communication concepts. Relying on the metaphor of a person on one shore trying to reach another on the opposite shore, Berlo distinguishes between three senses in which channels are used: "modes of encoding and decoding messages (boat docks), message-vehicles (boats), and vehicle-carriers (water)" (p. 64). Here we will stress mainly the sense of channels as message-vehicles, the contrivances by which messages are delivered to an individual. Thus "... a channel is a medium, a carrier of messages" (Berlo, 1960, p. 31).

Channels, because of their encompassing nature and because of the large volumes of research in this area, will be our primary focus throughout the rest of this book. Since channels are the largest aggregate of the different types of information carriers, they are usually the first branch of an individual's (and thus an agency's) decision tree about how information seeking should be done. Thus my first decision when confronted with symptoms of disease might be to ask my spouse, see a doctor, or go to the Internet.

Sources represent a particular node/location of information. "A *source* is an individual or an institution that originates a message" (Rogers & Shoemaker, 1971, p. 251) or "One that supplies information" (*American Heritage Dictionary of the English Language*, 1979). While interpersonal channels such as doctors may share many similar attributes, they also differ along dimensions such as personal dynamism, trustworthiness, and credibility that have been the classic concerns of persuasion research.

Messages consist of the words, symbols, or signals used to transmit a particular content emanating from a particular source within a particular channel. For example, Berlo (1960) distinguishes between a message's code, content, and treatment. Codes are defined as groups of symbols that can be structured in meaningful ways. Treatment refers to the decisions sources make in arranging both content and codes. To Berlo (1960, p. 169): "Messages are the expressions of ideas (content), expressed in a particular way (treatment), through the use of a code."

As Figure 2-2 reveals, individuals can pursue their information seeking within an information matrix formed by channels, sources, and messages. Over time, individuals may come to have habitual pathways for negotiating this matrix (Johnson et al., 2006). Pescosolido (1992), for example, identified "cascades" or strings, in the selection of sources of health information related to medical care decisions; these were associated with demographic factors and, most importantly, the social networks of people. Disturbingly, in several instances physicians weren't included in these strings. For example, I may start a search for prevention information with a decision to consult a mediated communication channel, but I also may decide that I want this channel to contain authoritative information as well as a personal touch. This unique hybrid of properties is represented by my local hospital's telephone hotline. After placing a call, I might decide that a particular operator is inexperienced, so I might then decide to call again or to call another telephone service operated by a nonprofit like the American Cancer Society. This new source I evaluate to be more credible, partially because of the nature of the messages that are being transmitted to me. While I can accept the information specialist's message concerning the need for a PSA test, I consider the linkage she is suggesting between fat in my diet and prostate cancer to be farfetched and discount it. In other words, I move within this matrix, making decisions about how I will go about pursuing the information I want related to particular topics, which

information I will accept and discard, and whether or not I need to continue my search within the matrix.

Summary

In sum, then, individuals are embedded in an information field that determines the context of their information seeking. The nature of this field determines their exposure to information that may trigger a desire to seek more information. For example, weak ties may expose an individual to information that suggests changes should be explored, triggering an expansion of the individual's information field, or the mediated channels one is exposed to may incidentally contain information that causes them to seek more information by activating various pathways. Since the primary focus of this book is on information-seeking behavior, the nature of an individual's search, the factors that underly it, the characteristics of information carriers, and fields and pathways that shape it will be explored in much more detail in the next several chapters.

Further Readings

Berlo, D. K. (1960). *The process of communication: An introduction to theory and practice*. New York: Holt, Rinehart & Winston.

A seminal text in communication theory, David Berlo's book promoted his influential model of the communicative process: Source-Message-Channel-Receiver (SMCR). This model described communication as a dyadic process, in which the message is a central feature, and factors such as attitudes, knowledge, and social systems play important roles. Berlo's focus on manipulation of messages to improve their understanding, and on the communication skills of the source and receiver, contributed to the growth in information campaigns in the last half of the 20th century.

Case, D. O. (2012). *Looking for information: A survey of research on information seeking, needs, and behavior* (3rd ed.). Bingley, UK: Emerald Group Publishing.

A review of more than 1,400 writings on the topic of information seeking, this text contains chapters on definitions of information, and on information needs, that are relevant to this book. Later sections of the book selectively review research on health-related information seeking, yet more from the perspective of health-care professionals than the patient side of the equation.

Gleick, J. (2011). *The information: A history, a theory, a flood*. New York: Pantheon.

Science journalist and biographer James Gleick provides a fascinating history of both the theories and technology surrounding information. While provid-

ing brief biographies of many famous figures in the development of computing, Gleick is at his best when explaining Claude Shannon's mathematical theory of communication—the so-called information theory, along with its precursors. According to Gleick, even genetics can be thought of as a mechanism for exchanging information. Well written and full of interesting anecdotes.

Johnson, J. D., Andrews, J. E., Case, D. O., Allard, S. L., & Johnson, N. E (2006). Fields and/or pathways: Contrasting and/or complementary views of information seeking. *Information Processing and Management, 42,* 569–582.

Information fields—an individual's array of resources, constraints, and carriers of information—form the starting point for information seeking. Yet once information seeking is triggered, the actions that follow are better described as a path that leads from one source to another. Based on the ideas of sociologist Bernice Pescosolido regarding social organization and interaction, the authors used a survey of a large sample (n = 882) of Kentucky residents to demonstrate how patients may construct paths (which may become habitual) through a variety (or not) of sources of medical advice (in this case about genetic testing). They often turn, for example, to friends and family, or to the Internet, before consulting a medical professional; about 40 percent of the respondents in this sample said they would first consult Internet resources, then a medical doctor, for information and advice.

PART TWO

Modeling Information Seeking

THREE

Socio-Psychological
Factors in Health

Overview

In this and the next two chapters we will discuss the major elements of a Comprehensive Model of Information Seeking (CMIS) (see Figure 3-1) comparing it to other theoretical approaches to this area. The CMIS seeks to explain the communication channel usage of information seekers. It has been empirically tested in cancer (Johnson, 1993b; Johnson & Meischke, 1993b) and organizational contexts (Johnson, Donohue, Atkin, & Johnson, 1995). It contains three primary classes of variables. The antecedents determine the underlying imperatives to seek information and are related to basic health factors that are the focus of this chapter. Information-carrier characteristics, the focus of Chapter 4, shape the nature of the specific intentions to seek information from particular carriers. Chapter 5 focuses on the outcomes of these classes of variables on information-seeking actions, which reflect the nature of the search itself. It also will compare the CMIS to other approaches to modeling information seeking.

The antecedents to information seeking in the CMIS are drawn from prior work in the health area, particularly models of health behavior. Needless to say, there has been extensive theoretical work in this area. Here we will focus on two models, the Health Belief Model (HBM) and the Transtheoretical Model (TM) illustrating some common themes, which have been incorporated in the CMIS, and some shortcomings of the literature, which the following chapters will address more fully.

Figure 3-1: Comprehensive Model of Information Seeking (CMIS)

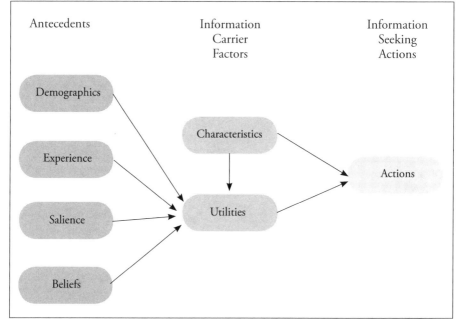

Adapted from "A Comprehensive Model of Information Seeking: Tests Focusing on a Technical Organization" by J. D. Johnson, W. A. Donohue, C. K. Atkin, & S. H. Johnson, 1995, *Science Communication, 16*, p. 276. Copyright 1995 by Sage.

Health Belief Model

Increasingly, illness and disease are being attributed, in part, to individuals' lifestyles and their ability (or willingness) to change certain health behaviors. This is reflected in a growing body of research on disease prevention that has focused on strategies for behavior change. One theoretical framework that has been used to explain and predict preventive health behaviors is the Health Belief Model (HBM), a social-psychological model based on value-expectancy theory. It argues that people generally pursue positive outcomes and avoid negative ones. Although this model incorporates many variables, scholars have typically tested only a few in any one investigation. The HBM has been the focus of intensive research, although it has primarily been examined in the context of preventive health behavior. Its major relationships have received support across a variety of studies, although the level of variance accounted for is relatively low (e.g., Calnan, 1984).

The variables contained in the antecedent factors portion of the CMIS are drawn heavily from the HBM, which, in turn, is drawn from the work of Lewin and other social psychologists (Kegeles, 1980; Mikhail, 1981). The HBM also shares certain similarities with uses and gratifications theory, a theory of media

usage we will discuss in the next chapter, which specifies the social environment, demographics, group affiliations, and personality characteristics as background factors.

Figure 3-2: The Health Belief Model

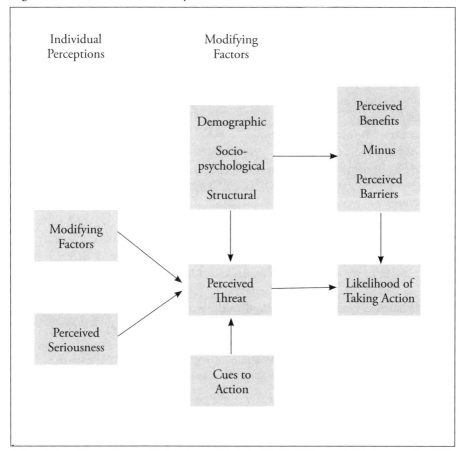

Adapted from "Compliance with Medical Advice," by M. H. Becker & I. M. Rosenstock, 1984. In A. Steptoe & A. Mathews (Eds.), *Health Care and Human Behavior*, p. 181. London: Academic Press. Copyright 1997 by Elsevier.

Figure 3-2 illustrates the HBM (Becker, Maiman, Kirsch, Haefner, & Drachman, 1977; Becker & Rosenstock, 1989; Cummings, Becker, & Maile, 1980; Rosenstock, 1974a), which includes seven major factors hypothesized to influence health behavior: background characteristics; knowledge/attitudes/beliefs; social/ group norms; barriers to action; cues to action; readiness/behavioral intentions; and outcome behaviors. The HBM suggests that individuals will take preventive health actions when they perceive themselves to be susceptible to a disease, when

the disease is perceived as a serious illness, and when the benefits to undertaking the recommended health behavior outweigh the barriers. Some stimulus (called a cue to action) is believed to be necessary to set the cognitive and behavioral processes in motion. These cues can be either internal, such as symptoms, or external, such as a public service announcement on television or an interaction with friends or relatives.

The HBM includes communication explicitly as one of many potential cues to action that can influence behavior by modifying knowledge, attitudes, beliefs, group norms, and readiness to engage in the target behavior. Other factors, such as demographic, socio-psychological, and structural variables, are believed to indirectly impact on the outcome variable by their influence on individuals' threat perceptions and perceptions of the benefits of preventive actions (Rosenstock, 1990).

The HBM is incomplete (Mikhail, 1981), even though its authors have added variables (such as locus of control and self-efficacy) over time (Rosenstock, Strecher, & Becker, 1988). The most notable addition, called health motivation (Becker et al., 1977), refers to the degree of general concern about health matters. Health motivation is now a third main component in the HBM and indicates the motivation to make health issues salient and/or relevant. Saliency of health matters is believed to directly impact a person's likelihood of taking some preventive health action (Rosenstock et al., 1988) and is incorporated as a major element of the CMIS. In most empirical investigations, the focus has been on the impact of the perceived threat and cost/benefit analysis on preventive health behaviors. Variables such as health motivation, (health) locus of control, self-efficacy, as well as cues to action, have received almost no attention in empirical tests of the HBM (Rosenstock, 1990).

The traditional HBM assigns a passive role to individuals (Leventhal, Safer, & Panagis, 1983). The CMIS, on the other hand, recognizes individuals as more active in seeking and processing information. Individuals are likely to engage in health behaviors for proactive/wellness reasons as well as for threat-related ones. In addition, empirical tests of the HBM, while suggesting that its major variables have an impact on these processes, also suggest that there are other factors, not currently specified in the model, which may have pronounced effects (Calnan, 1984; Rosenstock et al., 1988). In general, the thrust of the model is on individually based psychosocial factors, not on the broader social context, including the information environment, in which individuals are embedded. This social context plays a critical role in an individual's self-regulation (Leventhal et al., 1983). The HBM has been criticized for its lack of concern for temporal dynamics and its small effect sizes (Berry, 2007), and it has been argued to be less effective in predicting outcome variables than other models (Zimmerman & Vernberg, 1994).

The major weakness of the HBM for our purposes is its very limited treatment of communication variables and its lack of explicit treatment of informa-

tion seeking. Historically the model has slighted cues to action as a component (Janz & Becker, 1984), partially because the model has only been incompletely tested in any one empirical test (Becker & Rosenstock, 1984). The HBM does not identify the key dimensions of effective cues to action, nor has the HBM generated much research in this regard. Rosenstock (1974a) has conceded that cues to action have not been adequately examined, and a later review of research related to the model by Becker and Rosenstock (1984) suggested that this state of affairs has not changed very much. This review also implied that cues to action (and thus communication variables) are not a major variable in the HBM, nor a major concern of its formulators. Indeed, "Specifically what constitutes the cues to action and how they affect behavior are still in need of intensive study" (Mikhail, 1981, p. 71). But as we have seen, information-seeking behavior could represent an important interim step toward changing behavior.

The HBM also does not pay attention to characteristics of the source of the message and the manner in which a message is presented, although more recently it has been suggested that factors related to number and type of source should be incorporated in the model (Rosenstock et al., 1988). A more elaborated specification of the role played by communication, as detailed in the characteristics portion of the CMIS (discussed in the next chapter) and a more general approach to the underlying factors that lead to information seeking are both necessary. The results of one such study suggest that certain core principles of the HBM (such as threat perceptions and general health concern) may be very useful in predicting health information-seeking behavior if they are combined with communication theories that focus on factors that shape information acquisition (Meischke & Johnson, 1993).

Transtheoretical Model

The Transtheoretical Model (TM) of behavior change introduced by Prochaska and DiClemente (1983, 1985, 1986) was developed from a systematic review of the psychotherapeutic literature in the context of smoking cessation. This model focuses on intentional change on the part of the individual and therefore has direct implications for information-seeking actions (Prochaska, DiClemente, & Norcross, 1992). There is considerable evidence that this model can be applied to a wide range of health problems. Originally it suggested there were five basic processes of change: (1) consciousness raising, (2) catharsis, (3) commitment, (4) conditional stimuli, and (5) contingency management. These original processes have been modified and elaborated in subsequent research to as many as 13 separate processes of intentional change (DiClemente & Prochaska, 1985).

Difficulties in coping can result from three different problems with these processes (DiClemente & Prochaska, 1985). First, individual ignorance of them could result in a restricted range of responses. Presumably this is where informa-

tion seeking could make the most difference in an individual's coping response. Information seeking also is directly related to the consciousness-raising process where feedback and education are critical components. Second, an individual could be inept in implementing one of these processes. Third, an individual might prematurely implement the latter processes without going through all the necessary steps. When an individual experiences stress related to a perceived medical problem, two general coping options are available: the problem-solving or instrumental option involves a direct behavioral response, while the other option involves the self-regulation of emotional stress. Needless to say, given our focus on information seeking in this book, we emphasize the first option.

The TM suggests that readiness to engage in the target behavior falls along a continuum, beginning with precontemplation, contemplation, decision making, active change, and maintenance. Contemplators seriously consider taking action and are most concerned with consciousness raising. It can therefore be assumed that the highest levels of information seeking would be associated with this stage, in which individuals are gathering the information to be used in their decision making. Any information they gather also will interact with their individual beliefs of self-efficacy in determining the likelihood that they will take action. Information seeking at later stages is likely to be used to confirm and reinforce a decision that the individual has already made, to keep the individual from wavering and relapsing to his or her original behavior. Still, even relapsers, people who are smoking again, often gather information related to their next attempt to quit smoking, enhancing their perception of self-efficacy, which is critical to their decision to try again (DiClemente & Prochaska, 1985).

Health messages can be targeted to specific phases of readiness (e.g., messages targeting individuals who are at the precontemplation phase). This should enhance the prospects for change, given the assumption that additional, well-conceived targeting is usually beneficial. Indeed, the inclusion of the different phases of readiness implies that legitimate secondary outcome measures (e.g., increasing the percentage of a defined population that moves from precontemplation to contemplation) exist for campaigns other than "behavior change." The ability to measure and examine changes along the full spectrum of readiness is viewed as critical to a complete understanding of the overall impact of campaigns within defined populations and is one reason behind the TM's increasing popularity in recent decades.

Other Models

There are of course many other models of health behavior; for example, in the Theory of Reasoned Action (Fishbein & Ajzen, 1975) a person's commitment to engage in the target behavior is conceptualized as a "behavioral intention." These models have been systematically compared to each other, with often conflicting

findings (e.g., Hill, Gardner, & Rassaby, 1985). Our central concern with information seeking requires us to substantially modify/elaborate previous theoretical efforts in the health area, which tend to cover communication within a very static model and typically only in passing. Recognizing that information seeking related to disease is not invariant, and proceeds in an interactive process is dependent on the staging of the disease, and other factors (Johnson, 1997), we believe that the CMIS relates to more traditional models of health behavior in four primary ways (See Figure 3-3).

Figure 3-3: Relationships between Health Models and CMIS.

Adapted from *Cancer-Related Information Seeking*, by J. D. Johnson, 1997. Cresskill, NJ: Hampton Press, p. 40. Copyright 1997 by Hampton Press.

First, they can interact with each other. As we will see, many variables that cause health behaviors also determine information seeking. It is, therefore, possible for an individual to be simultaneously engaged in acquiring information that can lead to future action while he or she is already acting. For example, an individual who is engaged in dietary changes to prevent the onset of diabetes may also be starting to gather information that relates to possible treatment options.

Second, these processes can run parallel to each other. An individual might be gathering information, but not engaging in any other action, because of fears of the outcome of genetic testing. In this case, information seeking becomes a means of forestalling action. In addition, exposure to information unintentionally, such as exposure to a public service announcement during an entertainment program, can provide an important foundation for later more active searches (Lenz, 1984).

Third, information seeking can be fed into the HBM, or other models of health behavior, in its traditional role as a cue to action. Interestingly, the severity of a cue to action depends on an individual's level of readiness (Rosenstock, 1974a). Thus, a woman of mature age may seek a mammogram not because she feels susceptible to breast cancer or perceives screening mammography as particularly efficacious. Instead, she may seek a mammogram simply because it was recommended in a communication campaign, or because a significant other recommended the test as "something that should be done" (i.e., a normative prescription).

Fourth, information seeking can be cast as an outcome of the HBM. The consequences of information seeking can be affected by the nature of information-seeking search behavior, particularly in terms of the extensiveness of the search (Lenz, 1984). Indeed, information seeking may be the end of the process as well, since it may inform the individual that no further action is required at this time.

Antecedent Factors

Antecedents to information seeking largely focus on the imperatives that motivate someone to seek answers to questions. These factors determine an individual's natural predisposition to search for information from particular carriers. The CMIS focuses on four primary antecedents: demographics, personal experience, salience, and beliefs. Demographics and personal experience are background factors that often affect the choice of communication channels for information seeking. Rosenstock (1974a) has commented on the general superiority of models that specify linking mechanisms between background characteristics and health behaviors. These factors also help shape someone's information field, determining his or her exposure to cues to action. Salience and beliefs are personal relevance factors that largely determine the imperative to seek information.

Demographics

> In other words: If we know a person's age, income range, and general understanding of genetics, we are able to provide a fair prediction of where they will first turn for information about the genetic basis of cancer (Case, Johnson, Andrews, Allard, & Kelly, 2004, pp. 665–666).

While it has become commonplace to segment audiences of health-care messages and focus on particular groups in order to target messages, a topic we will return to in Chapter 8, there are several limitations to this approach. First, there do appear to be general principles applicable across groups that can guide any efforts to understand and to enhance information seeking. For example, as we will detail, most individuals prefer interpersonal and easily accessible sources of information. Nevertheless, often to institute specific programs, especially for high-priority underserved groups who suffer from health disparities, we must understand differences between individuals associated with the various groups they belong to.

Second, demographic factors have been included in many models of health behavior, and they do influence health-related information seeking as well as other prevention behaviors. Yet, in a diverse society such as ours, striving for particular knowledge of groups is increasingly problematic because of overlapping group membership. How do we come to know the information needs related to breast cancer of African Americans of Cuban descent who are lesbians, Christian Scientists, recent immigrants, of low socio-economic status, and illiterate? To which of these groups does the individual truly affiliate; which are we most interested in? In the end we are all individuals, with arguably unique personal experience and background factors, which may explain the often conflicting findings found in particular demographic research studies, and the move to tailoring of messages over the last decade or so.

Third, examination of demographic factors leads to the exploration of underlying factors, for which group membership can be stereotypically a surrogate. Demographically based explanations typically account for low proportions of the variance in information seeking (Lenz, 1984) and, relatedly, for decision-making preferences (Degner & Sloan, 1992), in part because they are imperfect reflections of these underlying processes (Niederdeppe, 2008). So it may be the case that culturally Hispanics are more likely to be fatalistic and to have lower educational levels than other groups, predispositions that have important effects on the likelihood one will seek information and be successful in their search, but not all Hispanics will have the same level of these factors. Information seeking can also be affected by disparity, digital divide issues that are closely linked to demographic factors.

In general, the classic profile of high information seekers is white, middle-aged women who are members of high socio-economic status (SES) groups and also highly educated (Galarce, Ramanadhan, & Vishwanath, 2011; Johnson, 1997). Women's interest in health, in part, is related to their societal roles, with women often seen as caregivers who are concerned not just with their health, but also the health of their children, spouses, and other relatives. Relatedly, self-diagnoses by younger and wealthier people are more likely to disintermediate, challenging the traditional authority of physicians as a result of the direct access to information

(Lowery & Anderson, 2002; Savolainen, 2008), so the highly educated are more likely to cite the Internet as their first source of information (Kelly, Sturm, Kim, Holland, & Ferketich, 2009).

RURAL. Rural people have reduced access to services and treatment facilities, transportation issues (Lustria et al., 2010; Shaw et al., 2008), more reliance on telemedicine and the web, and generally poorer information fields. Rural populations, such as those in Appalachia, are marked by higher poverty rates than the national averages, shortages of health professionals, and, unfortunately, higher cancer incidence and mortality. They also may suffer from a greater cancer burden because of familial and hereditary cancers, and they may not be aware of the association between genetic factors and cancer (Kelly, Andrews, Case, Allard, & Johnson, 2007). Rural breast cancer survivors also report a need for more education and support regardless of the staging of the disease (Wilson, Andersen, & Meischke, 2000).

GENDER

> The pressure to preserve a brave face and the linked pressure to avoid information about the illness was more common among men, who maintained hope through silence (Leydon et al., 2000, p. 911)

Generally men have been found to seek less information than women (Rutten, Arora, Bakos, Aziz, & Rowland, 2005). Indeed, they have been found to be blockers of the dissemination of genetic information within families (Koehly et al., 2009). Women often act in the role of caretakers (or gatekeepers) for their families who pass on information to others. They often treat their own health care as a low priority compared to other demands on their time and resources (Lustria et al., 2010). They also are responsible for 80 percent of the health-care decisions made in the U.S. (Luscombe, 2010). This may be why men have been found to be generally satisfied with the information they receive concerning prostate cancer, even though their partners often have unmet needs for information and are thus more likely to be active information seekers (Echlin & Rees, 2002). Interestingly, however, men describe their wives as coping well with their mate's prostate cancer, when they keep their concerns to themselves (Arrington, 2005).

Mothers also have been found to more effectively cope than fathers when confronted with childhood cancer (Goldbeck, 2001). Eheman et al. (2009) found that women breast cancer patients were one and a half times more likely to seek information than male cancer patients. Two studies of the general population by Kelly and Hornik (2009) and Rutten, Squiers, and Hesse (2006) also found women to be consistently higher seekers of information than were men. Given

the clear differences in preferences of women for information, better strategies for matching information provision to patient desires need to be a priority (Harrison, Galloway, Graydon, Palmer-Wickham, & van der Bij, 1999).

AGE. Research has suggested that older patients are generally more compliant and less likely to challenge physicians (Rutten et al., 2005), and to believe they do not have a right to medical information (Biesecker, 1988). Older people were also more likely to seek genetic-related information from medical professionals (Case, Johnson, Andrews, Allard, & Kelly, 2004). The overall pattern of the results in a series of programmatic studies conducted by Johnson and his colleagues, suggests that age is negatively related to channel selection, which could reflect the increased resignation and fatalism of older individuals toward cancer (Johnson, 1997). Older CIS clients were less likely to receive social support, want to share decision making with physicians, and to seek alternative sources of information (Czaja, Manfredi, & Price, 2003).

RACIAL AND ETHNIC DIFFERENCES. Racial and ethnic differences primarily reflect cultural norms that directly relate to a person's willingness to talk about and share information related to health. Contributing to health disparities, African Americans are more likely to seek information first from friends/family (Ndiaye, Krieger, Warren, & Hecht, 2011). African Americans seeking hereditary cancer information would be more likely to consult an African American oncologist or local pastor: however, when other factors, such as education, are controlled for, demographic differences often disappear (Kelly et al., 2009).

While over the last several decades our dominant cultural predisposition in the U.S. to share and discuss information about health issues has changed remarkably, partly for legal reasons, it was not that long ago that a diagnosis of cancer, for example, was suppressed and not revealed to the patient or to those around him or her (Lichter, 1987). In fact, it is probably the case that most cultures around the world still treat cancer as a social taboo, denying its very existence. When combined with the fatalism also present in many cultures, there may be very little information seeking related to cancer in many cultural contexts. Many cultures attribute illness to spiritual forces, which directly conflicts with the biomedical Western model (Wright et al., 2008). Asians and Africans tend to have a collective identity belief in indigenous health practices and emphasize spirituality, while Latin Americans emphasize family and gender-based roles (Dutta & Basu, 2011). So, for example, Pacific Island immigrants in New Zealand avoid cervical cancer screening because of cultural topic avoidance and modesty (they do not even have words for certain body parts), and religion (Sligo & Jameson, 2000). Similarly, African American women are likely to know less about their family history and

breast cancer because of the strong cultural taboo against talking about cancer (Lustria et al., 2010).

While Hispanic is commonly used as a label for Spanish-speaking groups, there are considerable differences within this category (e.g., Cubans, Mexican Americans, Puerto Ricans). Mexican Americans often have a cultural and religious bias against modern medicine (Wright et al., 2008), difficulties in language, norms against asking questions of (high-status) doctors, and reluctance to admit illness (stoic acceptance is preferred). Among Mexican Americans, the less educated and less affluent tend to have much lower levels of health-related information seeking; their almost exclusive source of health information is friends and relatives (Hsia, 1987).

EDUCATION. An individual's educational level, and associated professional status, probably has the most important consequences for information seeking and generally has the most consistent effect of any of the socio-demographic variables on the use of health services (Lichter, 1987), with more educated people more likely to use the Internet, for example (Case et al., 2004). More highly educated people are also more responsive to news of the celebrity cancer-related events, which may be partially attributable to their greater health knowledge and community involvement (Niederdeppe, 2008).

Education has three direct effects on an individual's information seeking capabilities. First, it provides a critical substantive base for deciding what information, if any, is needed. One of the primary impediments individuals encounter in their information seeking is their tendency to be effectively blocked, for educational or other reasons, from highly specialized information concerning treatment (Messerli, Garamendi, & Romano, 1980).

Second, it provides a set of criteria for evaluating the nature of information that can be acquired. Education is especially critical for the ability of individuals to interpret information, although the initial knowledge base of individuals may have the impact of dampening the relationship between it and information seeking in particular situations. Education is the single most important predictor of scientific literacy (Barinaga, 1994).

Third, a large part of modern technical education involves a familiarization of the individual with effective search strategies: what knowledge bases are most useful, what sources are the most authoritative, what is a sufficient answer, and so on. The higher one's level of education, the more likely it is that one will be knowledgeable about a wide array of channels and capable of using them.

SOCIO-ECONOMIC STATUS. In general, the poor have four primary problems: they know less about cancer (e.g., early warning signs); they are not as aware of prevention services; they know less about the health-care system, and they are

more likely to rely on folk medicine and alternative treatments (Freimuth, 1990). Americans living in poverty experience a higher incidence of and greater mortality from cancer than the non-poor, partly attributable to riskier lifestyles and lack of knowledge but mostly due to delays in seeking treatment (Loehrer et al., 1991). Socio-economic status (SES) is also positively related to preventive health behaviors (Nemcek, 1990).

In general, barriers to cancer care are associated with SES factors affecting access primarily attributable to the costs (e.g., time, distance, money) of health actions; factors that lead their caregivers to report they are having more problems (Given, Given, & Kozachik, 2001). Lower SES is also associated with many barriers to securing information and quality treatment, such as lack of insurance and transportation (Robert, 1999). In addition, SES affects cancer screening, nutritional and dietary patterns, immune status, and occupational exposure to carcinogens (Baquet & Ringen, 1986).

Social class, which unfortunately directly interacts with many other demographic factors we have discussed, has been shown to have a significant relationship with health communication behaviors. The higher one's social class generally, the greater his/her access to information and information seeking. The poor are less likely to perceive a need for information or to engage in intense searches for it, partly because they do not trust "establishment" positions and the poor's social network is likely to be isolated from the rest of society, further reducing their access to information (Freimuth, 1990). All of this has led to an increasing interest in health disparity issues at the National Institutes of Health.

INTERACTIONS. Combinations of demographic factors produce even more dramatic effects. So caregivers with lower levels of education report they are in poorer health (Given et al., 2001). In some instances, when other demographics are controlled for, differences between African American and white women disappear (Calle, Flanders, Thurn, & Martin, 1993). This suggests that such background factors as education and SES may be accounting for some findings associated with other demographic factors (Robert, 1999), which make an individual's existing information base even more crucial.

Personal Experience
One element that can trigger health-related information seeking is an individual's degree of personal experience with disease (Johnson & Meischke, 1994; Shaw et al., 2008). In general, it has been found that triggers are needed to cue health-related actions, even when people believe they are personally susceptible to severe health problems (Rosenstock, 1974a). Personal experience has been found to be the most important discriminating variable in channel selection across specific media channels (Johnson & Johnson, 1992); with the very act of mammogra-

phy screening triggering effects more uniformly across this sample, suggesting that women who have had a mammography may have acquired the information they needed to make a decision and no longer consulted these channels. Such experiences provide a knowledge base that people can draw from in intrapersonal knowledge seeking before starting an outward search. It has been found that those with disease experience are more likely to search the Internet for hereditary cancer information than are physicians (Kelly et al., 2009), and those with a family history of cancer are more likely to scan news coverage (Niederdeppe, Frosch, & Hornik, 2008).

In its original formulation, the CMIS emphasized the role of direct personal experience. Someone who has had such experience may have already had their questions answered and have less need for seeking sources beyond the intrapersonal. However, since that time it has become clear that other types of learning also can moderate the need for active information seeking and should be accordingly subsumed under this portion of the model. Thus, many of the models we will discuss in Chapter 5 take a broader view. Accordingly, as we have just seen, prior education can influence information seeking, especially its role in determining where one should start and where answers are most likely to be found. Sometimes we also learn from the experience of others in our social networks.

SOCIAL NETWORKS. If there is anyone in the respondent's social network who has had experience with cancer, this increases the social significance of cancer information (Atkin, 1973). Further, whether an individual has a social contact who has cancer has been shown to predict information seeking about cancer (Lenz, 1984). In fact, most calls to the CIS have been from friends/family of someone who has cancer; three out of every four families will experience cancer firsthand (Freimuth, Stein, & Kean, 1989), but their experiences will naturally differ by the type of cancer and its course (Lichter, 1987). Social networks affect access to information in three ways: exposure, legitimation, and opportunities (Veinot, 2009). Generally it is argued, given the influence of interpersonal communication on healthy choices, those with strong interpersonal networks are more likely to have a strong health orientation (Dutta-Bergman, 2005). We will examine more general impacts of social networks in the next chapter.

PERSONAL EXPERIENCE ALONG THE HEALTH CONTINUUM

> Hope and fear are intertwined, and patients oscillate between the desire for more information and the avoidance of new information. Hope might be accomplished and maintained through silence, periods of self-censorship, and not searching for information or searching by proxy, and these strategies enable patients to circumvent negative information about their illness, which poses a constant threat to hope (Leydon et al., 2000, pp. 912–913).

It is generally recognized that there is a progression of actions depending on one's proximity to disease, with key differences in information-seeking behaviors and approaches to problem solving at different stages of the process (Echlin & Rees, 2002; Rutten et al., 2005; Tian & Robinson, 2008), the cancer trajectory (Adams, Boulton, & Watson, 2009), or the cancer care continuum (Epstein & Street, 2007). Elsewhere it has been argued that there are four distinct information seeking stages based on an individual's personal experience with cancer: casual, purposive-placid, purposive-clustered, and directed (Johnson, 1988) following the distinctions made by Emery and Trist (1965). An individual's communication channel usage will differ at crucial stages of his/her personal experience with cancer, taking on a different pattern and form.

The *casual* stage is characterized by a general lack of concern, interest, or purposive information seeking. Reflecting this condition, an individual's search for health-related information is accidental and aimless. The individual will run across information in his/her more general information-seeking patterns. For example, in perusing magazines or newspapers, an individual will accidentally encounter information related to health matters. At times this information, as is true of presidential health problems, can be quite informative and complete (Atkin, 1979). Accidental information acquisition that can affect health behaviors of individuals does occur at this stage, providing a critical substantive base of information an individual can draw from at later stages. Since information seeking at this stage is casual, it is sporadic, with information campaigns, or factors associated with one's information field, determining how much health information an individual will process at any one time.

The central question for an individual at the *purposive-placid* stage is: What can I do to prevent disease or promote health? At this stage, an individual starts to initiate the more purposive, rational information-seeking characteristic of this and the later stages. However, there is no particular urgency, since information seeking relates to preventing disease in some distant future, rather than any one specific kind, immediately. This stage of health-related information seeking can be triggered by many factors, such as: generalized health consciousness; family history; media agenda setting through information campaigns; or advice of trusted health professionals.

At the purposive-placid stage, an individual's information processing becomes more rational and focused. It is not very motivated, suggesting individuals might not feel greatly disturbed if they find less information than they would want. This may change once the perceived *want* has been replaced by perceived *need*, activating a perception of gaps in one's knowledge. At this stage, individuals expand their information search to include more specialized sources, such as books focusing on health issues, health-care professionals, and individuals in their extended net-

works. Information seeking at the purposive stages becomes more of an interpersonal process, especially in terms of an individual's access to health professionals.

In the next stage, the *purposive-clustered* stage, an individual is directly confronted with the question: Do I have a specific health problem? The information seeking of the individual becomes much more focused on issues that will give him/her a direct answer to this question. It is here, for example, that it is likely a man will have a PSA test if he suspects he has prostate cancer. Cancer screening and diagnostic tests constitute a specialized form of information seeking. The purposive-clustered stage has many similarities to the previous stage, with information seeking focused on particular contents and specialized information carriers. At this stage, the central problem confronting an individual is whether he/she actually has a particular problem. This triggers a search for more specialized information carriers for very particular content related to symptoms, means of detection, and somewhat more incidentally to consequences (e.g., treatment and prognosis).

Information channels consulted at this stage include credible individuals in their extended social network, libraries, and health professionals. Usually a person will consult his/her spouse, a relative, or friend about his/her symptoms before consulting a health-professional, and this may at times result in treatment delays depending on the information pathways they follow (Johnson et al., 2006). The purposive-clustered stage is also triggered by more personalized factors, such as a recommendation of a doctor.

Finally, for the *directed* stage, which follows a diagnosis, the crucial question for the patient is: How can I cope? Patients must learn to adopt a new role, familiarize themselves with a new set of institutional rules, and face stigmatization and stereotypes associated with their diagnosis. A patient is confronted with an overwhelming array of negative outcomes: anxiety, depression, guilt, severe side effects from treatment, pain, disfigurement, loss of work role, powerlessness, dependency, dehumanization, alienation of loved ones, isolation, and eventual death (Falconer, 1980). Responses can range from acceptable treatment practices to denial to suicide. Patients are often engaged in a "never-ending process of making sense" that in itself may represent several stages (McCaughan & McKenna, 2007).

In this situation, a near majority of breast cancer patients were at a loss as to which questions to ask, and nearly one-quarter reported they were too emotionally upset to ask any (Messerli, Garamendi, & Romano, 1980). Women diagnosed with foetal abnormality show a similar pattern of forgetfulness (Lalor, Begley, & Galavan, 2008). The thought patterns of the sick are more volatile, often irrational, and emotional, reflecting rapid switching from denial to knowing to forgetting (Lichter, 1987). In their first medical encounters, there are so many things told to them, in such difficult circumstances, that they forget much of what they

are told. In one study, 20 percent forgot their prognosis and more than 50 percent forgot specific medical instructions. The more they are told, the more they will forget. Individuals with some sort of medical background tend to remember more, in part because physicians rely on jargon (Lichter, 1987). Given all this, it is important that messages be repeated and carefully spread out over a period of time (Falconer, 1980). This increases the importance of delivering information to cancer patients in more than one modality, communicating verbally, but also providing written information that one can refer back to.

The directed stage of information seeking begins after authoritative diagnosis of the illness and the start of a treatment plan. In fact, at this stage information seeking becomes so elaborated that it can itself be broken into several distinct steps: (1) symptom-experience; (2) assumption of the sick role; (3) medical care contact; (4) dependent-patient role; and finally (5) recovery or rehabilitation (Suchman, 1965). While this classification of steps cuts across the directed and purposive-clustered stages, it also suggests even further refinement of people's information seeking at the latter stages. To simplify matters, the directed stage will be treated as more of a unitary phenomenon here.

At this stage, information seeking is one of the primary functional coping strategies a cancer patient has at his/her disposal and his/her need for this information is often unmet (Epstein & Street, 2007). This lack of information may be more likely to lead to fear in patients who remain uninformed. At times, the patient's search for information can appear to be almost frantic, with a tendency to accept information from any available source, no matter how authoritative it might be (Falconer, 1980). Fortunately, because of the patients' rights movement, patients are more willing to ask questions of physicians and to discuss matters openly (Croog & Levine, 1989). Naturally at the directed stage, the content of the information search becomes much more focused, and the sources become much more specialized and authoritative. The content of the information search focuses on the nature of the disease, the comparative advantages of different treatment strategies, and on specific coping strategies.

Obviously, if an individual has previously had cancer, this factor has a major impact on his/her level of knowledge, beliefs about the disease, and its salience to him/her, even if it can relate negatively to search behaviors because of prior knowledge acquisition (Lenz, 1984). It can take a very long time for an individual to assume "normal" life after a cancer diagnosis, especially since s/he has learned that the early signs of cancer are often ones s/he can't detect. Cancer survivors are likely to construct their information fields in such a way that they are constantly monitoring their environment for advances in prevention, detection, and treatment related to their particular type of cancer. But it is also possible for people to cope for the long haul by engaging in various repressive mechanisms (Hinton, 1973). Changes in prognosis or a recurrence of cancer can cause an individual

to rethink his/her information fields and his/her information-seeking strategies (Lichter, 1987). Cancer survivors report greater consumption of cancer-related information, more trust in health professionals, and television but also evaluated their information-seeking experiences negatively. They were more likely to report they (or others on their behalf) had looked for cancer information (Roach et al., 2009).

Studies indicate that people are less likely to look for information as their proximity to cancer increases; this makes it even more important for interventions, such as enhancing health literacy, to occur at earlier stages. Paradoxically, people in the latter stages are less likely to look for information even though they are in a situation that calls for more information (Degner & Sloan, 1992; Johnson, Andrews, & Allard, 2001), something that calls for more research for understanding the dynamics involved (Eheman et al., 2009). The decline in intent levels is directly linked to perceptions of the disease, with only 10 percent of clients seeking genetic tests when there is no efficacious treatment and/or it is fatal, 50 percent seeking testing for breast cancer for which there is hope for both treatment and prevention, and 80 percent seeking treatment for diseases with effective treatments (Marteau & Croyle, 1998).

For terminal patients, there are unique information-seeking demands (Donat & Pettigrew, 2002). They are in a curious state, with a known unknown that has been described as "middle knowledge." They know they are going to die, but they don't know what dying is. For the terminally ill, more suffering is probably attributable to poor communication than any other single factor except pain, with most patients expressing relief at having at least some certainty (Lichter, 1987).

The dying patient also must accept and learn a new role: s/he is supposed to continue to want to remain alive, while accepting s/he is going to die; s/he must arrange for financial matters and the transition of others into new roles in the family system; s/he must limit their claims on the time of health professionals, so that s/he can attend to those who still have a hope of survival; and s/he must accept that s/he is not to be as active a participant in the network of social obligations around him/her (Lichter, 1987). Needless to say, this is a difficult role to accept, with resistance exhibited in illogical refusal to cooperate in treatment, denial, and attempts to remain autonomous (Falconer, 1980).

Salience

> ... perfect knowledge is itself impossible, and an inherently impossible basis of social action and social relations. Put conversely, ignorance is both inescapable and an intrinsic element in social organization generally ... (Moore & Tumin, 1949, p. 788).

... everybody is ignorant, only on different subjects (Will Rogers quoted in Smithson, 1989, p. 92).

The Personal Relevance Factors specified in the CMIS, salience and beliefs, provide a set of linking mechanisms, derived from past research, which act to transform a perceived gap in information into an active search. These variables are also related to the degree of perceived health threat an individual feels, a set of factors that have been included in a number of models of health behavior (Cummings et al., 1980). An individual's motivation to seek information and the specific targets of this search are affected by factors associated with the personal relevancy of the disease, such as salience and beliefs.

"[I]nformation is valued to the degree it is salient. Salience to an individual means the perceived applicability of information to a problem he or she faces..." (Evans & Clarke, 1983, p. 239). An individual might wonder: Is it important that I do something? Salience is directly related to the rate of information acquisition (Salmon, 1986). Uncertainty, sometimes equated with gaps related to the lack of experience, information, or knowledge (Molleman et al., 1984), is a problem for most cancer patients and their friends and family. As indicated above, the information to reduce this uncertainty may come from a variety of sources and may be about a variety of topics. However, Dervin and her colleagues (Dervin, Jacobson, & Nilan, 1982) have found that information seeking among blood donors was related to "gap-bridging": individuals asked questions that were directed at determining implications of events for themselves directly and/or related to their future activities. Perceptions of risk to one's health especially are likely to result in information-seeking action (Becker & Rosenstock, 1989).

Salience refers to the personal significance of health information to the individual. The relevance of information, the central concept in information science (Froehlich, 1994), is often intertwined with its salience. As Thayer (1988) has observed, we cannot be moved by the "truth" of information, we can only be moved by its relevance. Relevance and salience judgments are typically not absolute ones when individuals engage in information seeking, rather they are comparative ones (Wilson, 1977). Ultimately, relevance is based on a mental calculation of the relationship between an individual's need and any one piece of information (Schamber, 1994). Information seeking has also been directly related to the expected rewards associated with it, suggesting a clear link to motivational processes (Ruben, 1986). Psychological relevance has also been suggested to be a powerful variable when related to behavioral intentions concerning health (Hill et al., 1985).

Kegeles (1980) has suggested that the role of motivation in the HBM is essentially equivalent to the concept of salience. The issue of salience has always been somewhat controversial in the HBM. While the force of salience may be determined by the interaction of a number of variables, many of them reflected

in gap conceptions, our concern is with the outcomes of these processes that can be said to drive a certain level of information seeking. Thus, salience provides the underlying motive force to seek information.

General health consciousness also been found to play a role in people's information seeking (Dutta-Bergman, 2005), especially at earlier points in the cancer continuum. Weinstein (1979) has found that lifestyle indicators such as paying special attention to diet and not smoking were positively associated with information seeking about cancer. Various indicators of the value of illness threat reduction have been significantly related to breast cancer screening; so women who have expressed concern about having breast cancer have been found to be more likely to participate in screening programs than those who have not (Fink, Shapiro, & Royster, 1972).

Beliefs

Various factors can serve as impediments, or the classic barriers in health research, to channel selection. An individual's belief in the efficacy of various medical procedures can also affect health information seeking and preventive behavior (e.g., Becker & Rosenstock, 1989). In spite of often conflicting patterns of research findings (e.g., Calnan, 1984), it appears that an individual's beliefs about the nature of disease, its impact on him/her, and his/her level of control over it, play an important role in information seeking (Eheman et al., 2009) and people's more general pattern of actions related to health. For example, a belief that God determines our genetic makeup often shapes individual action (Parrott, 2011). For many individuals, it does not make much sense to learn more about things over which they have no control, so the powerless tend not to seek information (Katz, 1968) and neither do members of fatalistic cultures. In general, behaviors advocated by health professionals must be culturally acceptable (Rice & Atkin, 1989).

It has also been argued that information seeking is related to the extent to which individuals perceive they control the future or perceive that there are efficacious methods of prevention, treatment, and control (Rosenstock, 1974a). A belief that there is no procedure available for early detection of cancer is an example of response efficacy, suggesting there is not an appropriate response to a threat. Somewhat relatedly, an individual's perception of the extent to which he or she can shape or control events also will have an impact on his or her level of awareness. The very act of seeking information involves admitting one's ignorance. Some individuals just don't have the interpersonal skills necessary to form the informal network relationships necessary to acquire information (Wilson & Malik, 1995). Others have such low self-esteem they are afraid that any information they get will confirm their already low self-concept. As a result, individuals will only admit ignorance, a topic we will return to in Chapter 6, in certain limited situations.

High internal locus of control has been associated with more information seeking, resulting in more positive coping strategies (Sullivan & Reardon, 1985). It has been suggested that an individual's feeling of self-efficacy, whether she has the ability to perform the desired response, may be the operative factor, especially in its interaction with locus of control (Rosenstock et al., 1988). Indeed, belief in the efficacy of early detection of breast cancer was the strongest correlate of a woman's ability to perform breast self-examinations (Calnan, 1984) and it has also been associated with the use of health-related websites by middle-aged women (Yoo & Robbins, 2008). Self-efficacy has also been found to mediate the relationship between diet knowledge and behavior with people high in self-efficacy more likely to strongly link nutrition with appropriate behaviors (Rimal, 2000). Rimal's (2001) classification of perceived risk and self-efficacy into four groups—responsive, proactive, avoidance, and indifference—argues that the responsive group with high efficacy and high risk will be the most likely to seek information. Although some types of risk, such as dread risk, indicating overwhelming fear and emotional responses to environmental concerns, may block information seeking (Kahlor, 2010). The researcher most closely associated with the concept of self-efficacy is Bandura, who conducted extensive research in the health arena (Bandura, 1997); self-efficacy is now widely accepted as a major determinant of information seeking (Galarce et al., 2011).

However, there are also dangers in promoting perceptions of efficacy. For example, many women are overly confident in their ability to detect changes in their breasts, leading them to prefer breast self-exam to mammography screening, which is much more likely to detect cancers at an early stage. This misleading feeling of efficacy can potentially lead to delays in treatment (Johnson & Meischke, 1994). Many women do not obtain mammograms, because they don't believe they are necessary in the absence of symptoms (e.g., a lump) (Rimer, Kaper-Keintz, Kessler, Engstrom, & Rosan, 1989), apparently a somewhat common problem across diseases and cultures (Sligo & Jameson, 2000).

Summary

Individuals who are active information seekers, who act on the information they gather, are more likely to confront problems, engage in preventive behaviors, and to seek prompt treatment. If there is one truism to a variety of health concerns, it is that the chances of a cure are significantly greater with early detection. As we have seen, the antecedent factors contained in the Comprehensive Model of Information Seeking are drawn from several theoretical perspectives. In the CMIS, these background and direct relevance factors are expected to be associated with each other. It has been suggested, for example, that there is a logical connection between direct experience and salience in the CMIS (Napoli, 2001). The CMIS

assumes that the imperatives to seek information represented by the antecedents are shaped by various evaluations of communication channels, which we turn to in the next chapter, that determine the form of information-seeking behaviors.

Further Reading

Bandura, A. (1997). *Self-efficacy: The exercise of control.* New York: W.H. Freeman.

It would be difficult to identify a more commonly invoked concept in the health behavior change literature than self-efficacy. A milestone in the long and distinguished career of psychologist Albert Bandura was his 1977 article on self-efficacy as a concept central to any theory of behavioral change. In Bandura's gradually evolving social learning theory, self-beliefs play a key role—underlying the self-reflective and self-regulatory nature of human motivation. Decades of studies of health information campaign outcomes emphasize that lack of belief in one's ability to change can undermine any message.

Christakis, N. A.. & Fowler, J. H. (2009). *Connected: The surprising power of our social networks and how they shape our lives.* New York: Little, Brown & Company.

Why do spouses often die shortly after their partner passes away? A Harvard professor and expert on health-care policy, Nicholas Christakis teamed up with James Fowler, a political scientist, to explore how to better explain how social networks affect the quality of life for individuals. According to them, five rules guide the relationship between social networks and the individuals within them. These generalizations help explain how individuals influence one another, leading to both a better life (e.g., social support in hard times), but also negative outcomes (e.g., spread of bad habits like smoking and over-eating). Their book highlights implications for policymakers, such as ways that public-health interventions can be made more cost-effective.

Dutta-Bergman, M. J. (2005). Developing a profile of consumer intention to seek out additional information beyond a doctor: The role of communicative and motivation variables. *Health Communication, 17*(1), 1–16.

Communication professor Mohan Dutta-Bergman addresses a lack of research on the antecedents of health information seeking by developing the concept of "health consciousness." as a determinate of the motivation to search. This consciousness is akin to involvement with the topic of health, leading to a greater willingness to seek and process information about health. Dutta-Bergman's emphasis is on individual differences rather than audience segmentation. Using the DDB Needham Life Style surveys of over 3,000 panel members, he demonstrates that overall use of certain communication activities—especially interpersonal communication—leads to greater health consciousness and greater seeking of

health information. The article contains an interesting discussion of how television viewing might have a negative effect on health consciousness, although this effect was not supported by the findings.

Lichter, I. (1987). *Communication in cancer care.* New York: Churchill Livingstone.

Surgeon and hospice director Ivan Lichter may have changed the course of palliative care with this book, which is based on his experiences in working with cancer patients. Dr. Lichter was an advocate of keeping the patient informed about the state and nature of his or her illness, in contrast to earlier decades in which the patient was sometimes kept completely in the dark. His book urges doctors to understand the emotions attached to cancer and to promote the importance of family support for the patient. While Lichter has less to say about the role of other health professionals (e.g., nurses) and tends to focus on cases of advanced (and frequently fatal) cancers, it is still worth reading for his compassionate outlook.

Noar, S. M. (2005). A health educator's guide to theories of health behavior. *International Quarterly of Community Health Education, 24(*1), 75–92.

Seth Noar explains commonly used theories about individual health behaviors in this compact guide to selecting an appropriate theory for one's work with the public. The article describes widely used theories and how they might be applied in health interventions and education programs. The article contains a diagram of each major theory and two summary tables comparing components across the different models. The 45 references suggest further background reading. A useful starting place for health educators.

Rosenstock, I. M., Strecher, V. J., & Becker, M. (1988). Social learning theory and the Health Belief Model. *Health Education Quarterly, 15,* 175–183.

Rosenstock and colleagues tease apart the relationships between a variety of theories and concepts frequently used to influence and explain health-related behavior. Those explained in this succinct article include social learning theory, the Health Belief Model (HBM), self-efficacy, and locus of control. The authors offer a revised model, adding self-efficacy as a separate variable in the HBM. According to Rosenstock et al., an emphasis on enhancing efficacy is necessary when people are asked to modify complex behaviors such as substance abuse, smoking, exercise and diet.

FOUR

Information Carriers

A Focus on Channel Selection and Usage

Overview

The dynamics underlying the frameworks used to explain channel selection
and usage, detailed in this chapter, implicitly rest on the assumptions of uses
and gratifications theory, a classic mass-communication theory. The assumptions
of uses and gratifications theory are particularly important for a renewed focus
on receivers and information seeking. Although the focus in communication re-
search has generally been on the source of the message, more and more attention
has shifted to the receiver (Biocca, 1998; Contractor & Eisenberg, 1990). Indeed,
some have argued that the failure of many information systems can be traced to
designers ignoring the value of information to end users (Dervin, 1989) and oth-
ers have criticized research in health-care settings for not taking a user perspective
(Dervin, Harlock, Atwood, & Garzona, 1980).

Fundamentally, uses and gratifications theory suggests that individual receiv-
ers differentially select and use communication vehicles to gratify felt needs (Katz,
Blumler, & Gurevitch, 1974; Rubin, 2002; Ruggiero, 2000; Tan, 1985). First,
uses and gratifications theory assumes that media use is goal directed; that the
audience actively puts messages to use and this moderates their effects. Second,
it assumes receivers select differing media and content to fulfill felt needs. Third,
uses and gratifications theory assumes that individuals initiate media selection,
suggesting that people are active information seekers. Fourth, there are multiple
sources of needs satisfaction, and any one communication channel must com-

pete with other channels for satisfaction of individual needs (Tan, 1985) or, in more recent views, they seek complementarity in channels for their health needs (Dutta-Bergman, 2005). Fifth, "people are aware of communication alternatives and select channels based on the normative images those channels are perceived to possess" (Perse & Courtright, 1993, pp. 501).

Uses and gratifications suggests that people are active information seekers who are goal directed, selecting differing media and content to fulfill felt needs, thus initiating media selection (Katz, Gurevitch, & Haas, 1973; Rubin, 1986; Tan, 1985). Individuals will base their choices of channels in a way that will maximize their gratifications obtained, especially in relation to gratifications sought (Dobos, 1988). For health-related information seeking, people want answers to questions that may literally mean the difference between life and death. They desire both didactic and experiential (e.g., how others cope) information (Shaw et al., 2008). Perhaps the most telling theoretical weakness of the uses and gratifications approach is its failure to specify the initial motivating conditions for information seeking (Rubin, 1986; Tan, 1985), which the Comprehensive Model of Information Seeking (CMIS) accomplishes in specifying antecedent conditions related to health. One of the antecedents might be an orientation to healthy living itself (Dutta-Bergman, 2004; Jayanti & Burns, 1998).

Uses and gratifications theory, by suggesting that individuals will turn to specific media channels to fulfill specific cognitive or affective information needs, helps us to understand why individuals differentially expose themselves to channels and contents. It stresses the functions that media serve for users. In this chapter, we will focus first on the general characteristics of the major channels people turn to for health information seeking. Once a channel is selected, there will be differential levels of usage activity based on the operation of two major classes of variables specified in the CMIS, with media characteristics such as communication potential and editorial tone, and with utility determining the level of information-seeking actions.

Channels for Health Information Seeking

Since channels are the means by which people receive and transmit information, an understanding of them is critical in understanding the role of communication in health, and their characteristics are critical to understanding information seeking. How individuals select channels to accomplish particular purposes, and the impact of new information and communication technologies (ICTs) on the process, which we will review much more extensively in Chapter 8, has received considerable research attention in recent years.

General properties of channels can impact an individual's relative evaluations of them as disseminators of information. Individuals in the modern world are

confronted with a bewildering array of channels, from face-to-face communication to email to Twitter to RSS feeds. Traditionally communication research has distinguished between two basic types of channels: interpersonal, involving primarily face-to-face modalities (friends/family and doctors), and mediated channels (print and electronic mass media, including those available through the Internet).

Each of these channels possesses specific advantages and disadvantages. The mass media may be an excellent source for increasing the public's awareness of behaviors that help to prevent disease, but other sources that involve interpersonal contacts may be better at persuading people to adopt these behaviors (Rogers, 2003). Mass-mediated channels tend to provide information of a general nature with considerable efficiencies in reaching large audiences quickly with a message. Interpersonal channels are viewed as more effective in reducing uncertainty because they provide social support, enhance confidence in suggested outcomes, and are more tailored to individual needs and questions because of their immediacy of feedback and the situation specificity of their communication (Schramm, 1973). For these reasons, interpersonal channels are seen as more useful in presenting complex, serious information. In terms of health information seeking, many purposes and effects are at play, reinforcing the notion that mediated and interpersonal channels can have complementary impacts (Chaffee, 1979; Rogers, 2003). Thus, Salmon (1992) suggests that interpersonal communication can reinforce mass-media messages, mass communication can lessen the complexity and amount of what needs to be communicated interpersonally, and mass communication can legitimate interpersonal communication.

Mass Media

> Information-seeking is a crucial function because campaign messages that have the broadest reach can deliver only a superficial amount of informational and persuasive content—content that is seldom customized to the individual recipient (Salmon & Atkin, 2003, p. 459).

Although people generally prefer authoritative interpersonal sources, they get much of their general health information from the mass media (Barinaga, 1994; Rees & Bath, 2000a). (Somewhat disturbingly this is true for physicians as well [Niederdeppe, Frosch, & Hornik, 2008].) This has led to the movement to embed health messages in entertainment programming to reach people who are not health oriented (Dutta-Bergman, 2004). The media play an important role in increasing awareness of new health information (Simpkins & Brenner, 1984) and in raising the consciousness of the public of various issues through agenda setting (Worsley, 1989). For example, President Reagan's diagnosis of colon cancer was followed by an increase in calls to the CIS—a prime example of media agenda

setting (Arkin, Romano, Van Nevel, & McKenna, 1993). The callers differed from the usual profile of CIS users and were much more interested in prevention information (Freimuth, Stein, & Kean,1989). Subsequent investigations (e.g., Niederdeppe et al., 2008) have confirmed this link between news coverage of celebrity cancer and information seeking among the public.

The media encompass a wide array of separate channels, each with its unique properties, with at least suggestive evidence that individuals use major media differently because they find them differentially useful in providing health information (Wright, 1975). Television's greater intrusiveness compels exposure, while readers of newspapers and magazines can readily ignore messages they encounter (Atkin, 1981). Television is the primary source of current news for the public, followed by newspapers, then magazines (TVB, 2010). Print media such as newspapers and magazines are more appropriate for detailed, lengthy, and technical material; while brief, simple, timely ideas are more effectively communicated via broadcast channels (Atkin, 1981; Hanneman, 1973). Reflecting this, historically the accuracy and depth of public knowledge have been positively associated with the use of print media (Wade & Schramm, 1969), and credibility has also been positively associated with the use of print media (Hammond, 1987).

Besides the deliberate impacts achieved through campaigns, which we will discuss in more detail in Chapter 8, mass media, particularly entertainment programs, often achieve unintended "incidental" learning about health among their audiences (Robertson & Wortzel, 1977), which is often at odds with the messages public health agencies are trying to achieve (Signorielli, 1990). Often mass media and public institutions have conflicting priorities (e.g., entertaining the public vs. informing them) (Atkin & Arkin, 1990). For example, advertising often promotes the consumption of products (e.g., cigarettes and alcohol) that are deleterious to public health (Wallack, 1990), and they often present negative role models (Berry, 2007). Editors of magazines may engage in self-censorship as a result of advertising revenues, which historically has led to few stories about cigarette smoking and associated health risks (Kessler, 1989). Often public health messages have to contend with an overwhelming preponderance of messages focusing on unhealthy behaviors (Alcalay, 1983). Heavy television viewing may be a risk factor for poor health due to the behaviors often modeled (e.g., fast-food commercials could lead to poor nutrition) as well as being itself a sedentary activity (Boyne & Levy, 2011; Wallack, 1989).

Historically, doctors on television were presented in a more positive light than other professionals, being characterized as stable, rational, warm, fair, and so on. They are also portrayed as risk takers, prepared to engage in unconventional treatments, who will overcome many barriers (e.g., unreasonable administrators) to secure the best care for their patients. "The work of the television doctor is one of personal and almost mystical power over not only the physical but also the emotional

and social life of the patient" (Gerbner, Gross, Morgan, & Signorielli, 1981, p. 902). Given the experiences of patients with doctors detailed earlier, this televised portrayal leads to a high confidence level in physicians that is often disappointed, leading to frustration and conflict. Further, an unrealistic belief in the "magic of medicine" when coupled with the unhealthy lifestyle that television promotes dampens motivations to engage in preventive behaviors (Gerbner et al., 1981).

Somewhat similarly, cancer patients who turn to the media for televised portrayals of how people cope with cancer often see unrealistic portrayals, such as in the recent Showtime production of the *The Big C* in which the lead character, diagnosed with terminal melanoma, never really appeared to be sick in the first season. Patients often suffer in the social comparison process, since most dramatic depictions have more supportive families, fewer side effects of treatment, and a greater likelihood that the individual will survive against all odds. Medical procedures are often presented as more successful in the media than they really are (Wright, Sparks, & O'Hair, 2008). As a result, the more contact breast cancer patients have with the media, the worse they think they are coping with the disease (Aydin, Ball-Rokeach, & Reardon, 1991).

Historically content analyses of newspaper coverage have indicated that typical coverage is not related to priorities of cancer communicators and that it does little to dispel public misconceptions (Greenberg, Freimuth, & Bratic, 1979). Typically information related to incidence rates, prevention, and control of cancer is not as publicized as it could be a leading to potential misunderstandings (Calloway, Jorgenson, Saraiya, Tsui, 2006; Slater, Long, Bettinghaus, & Reineke 2011). Certain types of cancer (e.g., of the breast) tend to receive an inordinate amount of coverage, while other high-incidence cancers like melanoma are virtually ignored, at least in magazines (Clarke & Everest, 2006). The pattern of coverage in the media, in effect, acts to reinforce negative public attitudes about cancer and heighten fear; all this suggests the danger to individuals of relying on one source of information (Clarke & Everest, 2006). Three topics account for most of the coverage: famous people with cancer, specific potential causes of cancer, and recent treatment strategies. Media coverage of famous people, such as a First Lady (Stoddard, Zapka, Schoenfeld, & Costanza, 1990) or pop music star (Twine, Barthelmes, & Gateley, 2006) with breast cancer, may increase public awareness and effect beliefs and behavioral intentions related to cancer.

Specialized print sources such as brochures and pamphlets, which are often targeted to particular audiences and distributed by mail or in public settings (e.g., health fairs, health agencies), often play an important role in the dissemination of health information (Klonglan & Bohlen, 1976). They have the advantage of allowing patients to review and reference material in the future (Ankem, 2006). Pamphlets seem to have a small but positive effect on information seeking: Broadstock and Hill (1997) found that 4 percent of patients and families given one for

the Cancer Information Service (CIS) ended up calling that helpline; however, Sherr and Hedge (1990) found that the brief nature of leaflets for AIDS prevention led, in some cases, to misinformation and anxiety. Perhaps the best use of brief printed material may be to encourage patients to ask questions of health professionals. Telephone books and home reference books are also frequently used as sources of professional information, although their use has gradually been eroded by equivalent, yet more interactive, Internet sources.

Generally the media play a major role in stimulating individuals to seek information from other sources (Anderson, Meissner, & Portnoy, 1989). The media are less important than other sources for the socially integrated, but more important for the relatively socially isolated (Katz et al., 1973), an apparently growing segment of the public, who come to depend on the media for information, social comparisons, and modeling of coping processes (Aydin et al., 1991).

Interpersonal Communication in Social Networks

> ... there is often a lack of fit between the social and psychological needs of the individual in crises and the individual's social support network (Walker, MacBride, & Vachon, 1977, p. 40).

Because face-to-face communication can use all the senses, has immediate feedback, and is more spontaneous, it has become the standard against which other channels are evaluated (Durlak, 1987; Kiousis, 2002). Interpersonal communication has also been characterized by its intimacy and the awareness of the other's needs. People want emotional support and understanding from the people they consult; those that provide it are considered helpful regardless of the quality of the information they provide (Pettigrew, 2000). The lack of intimacy, that on the surface should be an ingredient in face-to-face encounters, in interactions with health professionals, has been a continuing focus of concern, especially in doctor-patient interactions.

The nature of an individual's interpersonal environment, or social fields (Perin, 1991), has important consequences for information seeking (Lenz, 1984) and for health practices (Mullen, Hersey, & Iverson, 1987). Its importance is increasing with rising consumerism, a focus on prevention, self/home care, and a greater focus on individual responsibility. There are four basic dynamics involved: lack of adequate social network ties worsens health, increasing demands for medical services; social networks shape beliefs and access to lay consultation; disruptions in social networks trigger help-seeking; and social networks moderate (or amplify) other stressors (Gore, 1989). Social networks have also been examined as the vectors along which epidemics, STDs, and other contagious diseases spread (Pescosolido & Levy, 2002) and clear linkages have been demonstrated empiri-

cally between social networks and health more generally (Clifton, Turkheimer, & Oltmanns, 2009; Cornwell, 2009).

An individual's effective network is constituted by friends, family members, and other close associates, while an extended network is composed of casual acquaintances and friends of friends, who, because they have different contacts than the focal individual can provide them with unique information. They also impart the normative expectations to individuals that are often linked to behavioral intentions and actions (Ajzen, 1987). Communication networks themselves can represent convergence of network members around symbolic meanings of support. These networks in effect constitute elaborate feedback processes through which individual behavior is regulated and maintained (Albrecht & Adelman, 1987b). This is particularly so in terms of communication, because of the natural tendency of people to communicate mostly with others like themselves—a pattern called "homophily" (Rogers, 2003).

So, for example, in Fishbein's theory of behavioral intentions, the social normative component often has been the best predictor of behavioral intentions, because it reflects the perceived expectations of significant others (Seibold & Roper, 1979). With this connection, Green and Roberts (1974) suggest that breast cancer screening is more effective when done in concert with social groups.

The Role of Intermediaries/Surrogates

Family members often act on behalf of their loved ones in seeking information (Arrington, 2005), becoming "proxy information agents" (Galarce, Ramanadhan, & Vishwanath, 2011), with over one-half of online inquiries conducted on behalf of someone else (Connor, 2009). Interestingly, while patients were more significantly satisfied with doctors and nurses, friends and family were more satisfied with the Internet (Pecchioni & Sparks, 2007). Parents are often gatekeepers of health information for children (Koehly et al., 2009). However, they are often ill prepared for this task, with limited technical skills and often needing coaching and information support themselves, since their own health is often impacted (Given, Given, & Kozachik, 2001). In addition, there are few documented, effective strategies to assist family members with advanced cancer (Given et al., 2001).

Lay intermediaries are very important sources for the public's information seeking (Abrahamson, Fisher, Turner, Durrance, & Turner, 2008). Somewhat ironically, intermediaries often do not take the same care and concern with themselves that they do with others. So, for example, Australian parents were more likely to protect their children from the sun than themselves (Buller, Callister, & Reichert, 1995). Caregivers often have overwhelming responsibilities: they provide physical assistance and emotional support; become the liaison between various parties; deal with financial and household issues; and monitor symptoms and report them to providers (Wright et al., 2008).

Social Networks and Social Support

Social networks are often viewed as the infrastructure of emotional support (Epstein & Street, 2007; Goldsmith & Albrecht, 2011; Haines, Beggs, & Hurlbert, 2002), and they affect the resilience that people have in the face of adversity (Harvard Mental Health Letter, 2006). They also have important impacts on changing people's health practices (Mullen et al., 1987). Social support is seen as being "... inextricably woven into communication behavior" (Albrecht & Adelman, 1987c, p. 14) and "... *supportive communication is that which facilitates adaptive uncertainty management*" (Ford, Babrow, & Stohl, 1996, p. 191, italics in original). Generally two crucial dimensions of support are isolated, *informational* and *emotional,* with informational associated with a feeling of mastery and control over one's environment (Freimuth, 1987), and emotional support crucial to feelings of personal coping, enhanced self-esteem, and needs for affiliation (Albrecht & Adelman, 1987b). Both kinds of support play a role in health.

Strong ties in one's social network also may be preferred because they are more likely to be stable, and because of the depth of the relationship individuals may be willing to delay immediate gratifications from the other, due to equity demands (Albrecht & Adelman, 1987b); strong ties may be more readily accessible and more willing to be of assistance (Granovetter, 1982; Haines et al., 2002). However, the bereaved's social network often distances itself from him or her (Wright et al., 2008). This is especially ironic since terminally ill patients often prefer strong to weak ties, as do the elderly (Wright, Rains, & Banac, 2010). Poor people also tend to rely more on strong ties because of their lack of other alternatives for dealing with problems (Wright et al., 2008).

However, interlocking personal networks lack openness (the degree to which a group exchanges information with the environment) and may simply facilitate the sharing of ignorance among individuals. "The degree of individual integration in personal communication networks is negatively related to the potential for information exchange" (Rogers & Kincaid, 1981, p. 243). The degree to which individuals expand their networks and are encouraged to do so by members of their effective network has important consequences for health-related information acquisition.

The strength of weak ties is perhaps the most well-known concept related to network analysis. It refers to our less-developed relationships that are more limited in space, place, time, and depth of emotional bonds. This concept has been intimately tied to the flow of information. Weak-ties notions are derived from the work of Granovetter (1973) on how people acquire information related to potential jobs. It turns out that the most useful information came from individuals in a person's extended networks, casual acquaintances and friends of friends. This information was the most useful precisely because it comes from our infrequent or weak contacts. Strong contacts are likely to be people with whom

there is a constant sharing of the same information; as a result, individuals within these groupings have come to have the same information base. Information from outside this base gives unique perspectives.

Weak ties provide critical informational support because they transcend the limitations of our strong ties, and because, as often happens in sickness, our strong ties can be disrupted or unavailable. Weak ties may be useful for discussing things you do not want to reveal to your close associates, providing a place for an individual to experiment, extending access to information, promoting social comparison, and fostering a sense of community (Adelman, Parks, & Albrecht, 1987).

A mobilized, supportive social network is critical to overcoming problems with denial and other fear-control processes. People may turn to their effective networks for support in part because health-care providers often have a difficult time handling the demands of patients (Evans & Clarke, 1983; Freimuth, 1987). Yet, individuals may be reluctant to seek support from their personal network because of difficulties in impression management (e.g., loss of face and self-esteem), identity management (e.g., self-concept), and concerns about equity (e.g., how can they reciprocate?) (Albrecht & Adelman, 1987b). So, drug users consult their peers for advice referrals to service and nonjudgmental council (Regen, Murphy, & Murphy, 2002), and patients turn to other patients because of the unique support they can provide (Wright & Miller, 2010).

Early studies in the area of social support tended to argue that the more integrated networks were, the better they were in terms of support (Albrecht, 1982). While highly integrated networks lead to positive social identity and the acquisition of tangible services from others with whom the individual has strong ties (Albrecht & Adelman, 1987b), it turns out that less-dense networks of relationships may be more supportive (Stokes, 1983), since they provide access to a wider range of information sources (Ray, 1987). The conclusion drawn now is that individuals in low-density, heterogeneous networks, partitioned into discrete subfunctions, fare better in terms of social support and are more likely to use health services (McKinlay, 1973). In particular, ties to others outside their immediate group, such as clergy, are much more likely to reduce stress (Albrecht, 1982). These dynamics may explain why more patients do not establish ties with each other (Suchman, 1965). More heterogeneous networks facilitate coping, role transition, and access to needed information. They also contribute to a greater sense of personal control on the part of individuals, since they are not dependent on any one group of individuals (Albrecht & Adelman, 1987a).

Family units heighten many of these effects because of their additional ties of kinship and genetic factors. Families have been described as information-processing units, which develop their unique "family paradigm" for viewing and acting in the world. They are also clearly rule-governed units that often specify

information-processing roles for their members (Reardon, 1990). Families can reinforce unhealthy behaviors (e.g., poor nutrition) and can contribute to relapse behaviors. Eighty percent of individuals who change their behaviors (e.g., weight-reduction programs) will return to their old behaviors when they return to the social context that created them (Gore, 1989).

Medical professionals generally prefer to deal with the patient directly, avoiding third-party intermediaries, especially family members (Ray & Miller, 1990). Partly as a result, family members often feel inadequately informed, for example, at the various stages of cancer of one of their members, which concomitantly increases their anxiety levels (Welch, 1980). Differential states of knowledge among family members can create real problems in communication among them. Such differences threaten the reliance of many individuals on family members for advice, given their limited experience and information (Wright & Miller, 2010). Cancer can have long-term effects on the family, especially among survivors. One study found that deaths from childhood cancers resulted in divorce in 70 percent of couples within two years (Lichter, 1987).

Interestingly, most cancer patients report high levels of support from their spouses and families (Gotcher & Edwards, 1990) although many wished they had someone to talk to openly about their problems (Sullivan & Reardon, 1985). Many cancer patients, especially males, find it difficult to deal with their increased dependency on family members (Lichter, 1987). Unfortunately for many cancer patients, one of their constant sources of anxiety is that members of their social network will withdraw from them or that they need to "protect" members of their family from their anxieties, especially about impending death (Gotcher & Edwards, 1990; Lichter, 1987). People also often feel socially isolated due to embarrassing aspects of disease and symptom treatment, such as in prostate cancer for incontinence. Further, some diseases carry a stigma and/or taboo (e.g., leprosy) (Wright et al., 2008) factors that contribute to individuals turning to others outside their immediate network for support (Wright & Miller, 2010). Often people are reluctant to approach their strong ties because of concerns over reciprocity failure and feeling they will over-benefit from the relationship (Wright & Miller, 2010).

This darker side of information seeking becomes particularly apparent in the relationship between friends and family and seeking genetic-related information; especially since negative ties often have more impact on health than positive ones do (Pescosolido & Levy, 2002). Genetic information affects not only the individual seeking it but his or her biological network. On the one hand, reactions to positive test results can cause feelings of extreme dismay or suicidal tendencies (Marteau & Croyle, 1998), and on the other, negative test results may have the unintended effect of people acting in unhealthy ways due to false reassurance or misinterpretation of results (Armstrong, Schwartz, & FitzGerald, 2002). Determining one's predisposition to certain diseases can cause strains in familial

relations, producing resentment by other family members (such as a daughter who learns she is predisposed to breast cancer) or leading to survivor guilt, where families ostracize a member who does not share the same genetic destiny (Marteau & Croyle, 1998).

Those who are able to maintain close ties in their interpersonal networks are more likely to cope effectively with cancer (C. F. Sullivan & Reardon, 1985). Unfortunately, often those confronted with severe health problems, especially those who are stigmatized, find that the size of their interpersonal networks shrink (Goldsmith & Albrecht, 2011). Individuals need the social support of their immediate social networks to deal effectively with the disease and in the maintenance of long-term health behaviors (Becker & Rosenstock, 1984) and to manage uncertainty (Goldsmith & Albrecht, 2011), but they also need authoritative professional guidance in the institution of proper treatment protocols.

Interpersonal Communication with Health Professionals

> It is not information as such which patients desire, but intensified support of their hopes, concern for their person, and confirmation of the validity of what they think they know (Cassileth, Volckmar, & Goodman, 1980, p. 496).

Effective communication requires a shared language, common goals and agreement upon basic roles and behaviors expected from each participant (Falconer, 1980, p. 35). Health professionals are often the source for resolving conflicting information and resulting ambiguity (Hanneman, 1973) and for relieving anxiety (Molleman et al., 1984). Research shows that authoritative sources, such as the family doctor and pharmacist, are generally regarded as the most reliable sources for everyday health matters (Worsley, 1989). Johnson and Meischke (1991) found that women over 40 preferred more authoritative, specialized sources such as physicians and health organizations for receiving cancer information. For most cancer contexts (e.g., detection, treatment, coping, etc.), doctors appeared to be preferred over health organizations, friends/family, and the media (Johnson & Meischke, 1991).

Elsewhere we have noted the low levels of compliance with medical regimens. Patient dissatisfaction with physicians may drive them to other channels, such as the Internet, and interestingly, they trust the information they find there more (Tustin, 2010). Patients often have considerably different outcome goals than doctors (Suchman, 1965), with doctors often ignoring explicit patient instructions about extraordinary medical treatments, and even when they are trained in communication skills, this training often does not reflect the needs of patients (Cooper & Mira, 1998). When doctors act contrary to their patients' perceived interests, patients naturally resist compliance (Falconer, 1980; Groopman, 2007). The two parties in this relationship often have vastly different views of the prob-

lems of patients. So, for example, students saw acne as a severe problem while doctors viewed it as mild or inconsequential (Berry, 2007).

There are six core functions in the patient-clinician communication relationship: fostering healing relationships, exchanging information, responding to emotions, managing uncertainty, making decisions, and enabling patient self-management (Epstein & Street, 2007). This relationship is obviously one of great pragmatic importance, especially with our attention turned to the funding of health-care systems. The difficulty of the task facing physicians, who are often operating under severe time constraints, of finding a definitive diagnosis with often scant information, should not be underestimated.

Unfortunately, many problems exist in physician-patient interactions. Pendleton (1983) in a review on doctor-patient communication, described some studies indicating patients often do not receive the information they desire during consultation. Patients engage in surprisingly little information seeking with physicians, particularly question asking (Cegala & Broz, 2003; Post, Cegala, & Miser, 2002). Lack of communication between doctor and patient has been found to contribute to decreased ability to recall information given by the caregiver, patient dissatisfaction, decreased adherence to prescribed regimens, and other forms of noncompliance (Epstein & Street, 2007; Lane, 1983). Physicians spend less than 10 percent of their time explaining things to their patients (Lichter, 1987). In one study, almost one-fourth of patients did not know the purpose of a drug they were taking (Lichter, 1987). Though patients often have unresolved questions, they appear to be reluctant to ask doctors about them (Biesecker & Biesecker, 1990), in part because of the status differences between them (Matthews, 1983) and some are concerned with impression management (Parrott, 2011). Patients only directly voice their concerns one-fourth of the time (Post et al., 2002). Patients also may initially be anxious, and they might not have the medical background needed to ask even the most rudimentary of questions (Falconer, 1980). Physicians then interpret this lack of question asking as a sign of apathy, which signals to them the patient does not want more information (Lichter, 1987). All of this has led to growing recognition, although there is still considerable resistance, that communication skills should be an essential part of the training of physicians (Wright et al., 2008).

There is consistent evidence that, in part because of their greater understanding and higher verbal skills, doctors communicate best with higher SES patients (Wertz, Sorenson, & Heeren, 1988). This suggests that, in spite of the steady stream of criticisms of doctors, there are really two sides to any relationship. Patients with a highly participative style were more likely to have better outcomes (Cegala, Street, & Clinch, 2007). However, many patients may not have sufficient health-related knowledge or communication skills to successfully negotiate this critical relationship (Phillips & Jones, 1991). There is some

evidence that training involving both patients and physicians can lead to more proactive information seeking and improve information exchange (Harrington, Norling, Witte, Taylor, & Andrews, 2007), and patients would often benefit from training in information-seeking skills related to their dealing with physicians (Cegela, 2006).

Doctors often operate under the assumption that patients automatically comply, so they don't follow up or seek feedback from patients concerning what they are doing (Lichter, 1987). Health-care providers overestimate the quantity, completeness, and effectiveness of their explanations (Thompson, Whaley, & Stone, 2011). Physicians are also under increasing financial and institutional pressure to shorten, not expand, the time they spend with any one patient. Sadly, it also may be the case that it is unrealistic to expect both high levels of medical competence and warm, empathic communication skills from a large proportion of physicians (Phillips & Jones, 1991).

Physicians often have problems communicating hereditary cancer information because of their lack of knowledge, discomfort with screening, lack of confidence, and they perceive that patients are just not interested (Kelly, Andrews, Case, Allard, & Johnson, 2007). Physicians often feel uncomfortable around cancer patients, in part because treatments are not efficacious (Mukherjee, 2010). Interestingly, only a slight majority of patients appear to want to discuss a bad prognosis even when they have metastatic cancer (Epstein & Street, 2007). Physicians have a number of defense mechanisms to protect themselves from the dying patient, who at times will represent to physicians their personal and professional failure: they can adopt an impersonal officious style; they can delegate treatment to others; they can hide behind technology, focusing on diagnostic machines rather than the patient; and so on (Lichter, 1987). Perhaps sensing this, it is not uncommon for patients to become more guarded with doctors as cancer advances, partially because they may have lost faith in them (Hinton, 1973). They also come to believe that doctors are not the ones they should bring emotional problems to (Johnson & Meischke, 1993a; Mitchell & Glicksman, 1977).

Compliance Gaining

Quite simply, compliance gaining represents attempts to get the other to do what you want. This is done for a variety of reasons, some of them altruistic. One interesting controversy within the compliance-gaining literature is the question of when one has the right to persuade (Littlejohn, 1992). This right is generally taken for granted in the context of physician-patient relationships.

Historically these relationships have been viewed from a deficit model with a focus on insufficient information as a result of lack of provision by clinicians (Epstein & Street, 2007). More recent approaches have focused on a process model where a clinician monitors the amount of information being provided to patients

and helps them interpret it so that they do not become overloaded and can truly participate in decision making. This focus on the process model directly relates to a paradox: "...the same communication behaviors may improve some outcomes, but worsen others" (Epstein & Street, 2007, p. 42). So, while providing information can act to relieve anxiety and uncertainty in one area, it also may act to heighten concerns in others. Thus, a definitive diagnosis of cancer can reduce uncertainty, but it raises a host of other concerns.

A persistent puzzle has been a large percentage of patients who don't comply with medical prescriptions or with other doctors' instructions, with estimates ranging from 50 to 30 percent, respectively, for these two aspects of medical care historically (Lane, 1983). More recently, a World Health Organization (2003) study found only 50 percent of patients with chronic diseases in developed countries were in concordance with treatment recommendations. For one specific class of drugs, statins, patients were at 50 percent adherence at six months, 30–40 percent within within one year (Bandolier, 2004). It has been estimated that noncompliant patients nearly double treatment time and the complications that they have, and that the cost of their care is four times that of compliant patients (Lane, 1983). Chronic disease patients often stop taking medicines within 30 days of their onset (Kreps, 2009).

It is generally recognized that the use of compliance-gaining strategies is important for doctor-patient relationships, since a major part of medical practice relates to persuading patients to engage in health-related activities. However, in spite of considerable research attention, a magic bullet still hasn't been found to achieve higher levels of adherence (Kreps, 2009). This is in part because compliance is almost exclusively defined in terms of the perspective of medical providers who often explicitly and implicitly blame patients for being uncooperative (Lane, 1983), although some have argued that patient-provider communication is the most important predictor of adherence (Wright et al., 2008) with patients who receive more adequate explanations more likely to comply (Thompson et al., 2011). It appears that noncompliance does not vary with the severity of illness, duration of disease, and so on. The one variable that does appear to affect compliance directly is the complexity of potential treatments (Lane, 1983). This directly relates with another positive contributor to compliance: that is, doctors providing education, often repeatedly, to their patients about important aspects of their illness and treatment (Brown, Stewart, & Ryan, 2003; Lane, 1983). While there is some evidence that longer visits are associated with more negative outcomes, education often takes considerable time, and in our cost-driven health-care system, this time often is not available (Brown et al., 2003). Perhaps even more troubling, 20–30 percent of the care that is given would not be recommended based on evidence (Schiavo, 2007).

In the absence of considerable progress on the physician side, and especially given our recent focus on patients as consumers, more and more attention has been devoted to issues of patient self-advocacy and the active role they can play in health-care decision-making (Epstein & Street, 2007; Wright, Frey, & Sopory, 2007). Patients who are more assertive in their information seeking are more likely to receive answers that allow them to make informed health-care decisions (Real & Street, 2009). However, even the most dedicated patient can quickly become overloaded with the amount of information available through the Internet and other sources (Epstein & Street, 2007). This is but one indication of the importance of contextual factors in this dyadic relationship, especially important is the time that doctors have with patients (Real & Street, 2009). Given the increasing complexity of the healthcare system, "... the tacit boundary previous researchers have drawn around the patient-provider relationships seems outdated" (Lammers & Barbour, 2009, p. 108).

NURSES. Traditionally, partly because they are predominately women, but also because of their proximity to patients, and the resulting direct provision of emotional and physical care, nurses have been seen as more effective communicators, who care more about the personal side of disease and the coping of the patient and his/her family. They also are thought of as the most trusted source among health professionals (Clayton & Ellington, 2011). Patients often view nurses as the most likely sources of information (Faulkner, 1985). At times, nurses can be embargoed against sharing information by institutional rules, and they often engage in the same strategies as doctors for avoiding patients (Lichter, 1987). For example, Wilkinson (1991) found that nurses often block patients from divulging their worries, and that this pattern varies by the nurse's religious beliefs and attitude towards death.

OTHERS. Once someone is diagnosed, a larger number of other health professionals—radiological technicians, physical therapists, pharmacists, volunteers, social workers, chaplains, genetic counselors, telephone information specialists, office staff, health educators, occupational therapists, psychologists, and so on—often come in more contact with the patient than do physicians. Their communication may be more understandable, if not more authoritative, since they may have more time, more interest, less jargon, and fewer differences in status with patients. Yet in almost half of the interviews with genetic counselors, one of the parties was not aware of the most important topic that the other participant wanted to discuss during the session (Wertz et al., 1988). Patients also may be reluctant to communicate openly with other health-care professionals, like psychologists, because they realize this information may be shared among members of the health-care team (Falconer, 1980).

Organizations

The specialized information needs of the public have traditionally been served by a variety of non-media institutions (e.g., agricultural extension services). Various institutions, which we will cover in detail in Chapter 8, have extensive communication programs. They are umbrella organizations, who give their seal of approval to messages they disseminate. In a very real sense, they have compelling advantages over other sources because of their perceived trustworthiness that adds weight to particular messages. They engage in wide-ranging programs of communication with the public, using different sources, message, and channels.

Libraries have also been traditional centers for information in their communities. They are the host for a variety of channels: books, magazines, newspapers, pamphlets, and electronic media of all sorts, including access to Internet websites, medical databases and health-oriented discussion groups; public Internet access is virtually universal now in U.S. libraries. The two types most relevant to this discussion are medical libraries found within hospital clinics and universities and city or county public libraries, some of which have specialized consumer health collections. There are about 16,700 public-library branches (ALA, 2011) and more than 4,000 additional hospital and academic health sciences libraries in the United States (National Network of Libraries, 2011). Regarding the former, a survey by Hollander (2000) found a wide variety of consumer health materials in about 40 percent of 105 academic health sciences libraries that responded. These included books and electronic resources (e.g., patient-oriented websites) as well as pamphlets. Chobot (2004) notes the involvement of many medical libraries in consortia and networks that provide not only consumer health websites but sometimes also question-answering services for medical problems.

Some studies suggest that public libraries are among the preferred sources of health information for the public, partly because of the human assistance they can receive there in finding and interpreting information (Chobot, 2004). According to a National Library of Medicine study, health-related questions are among the top-ten topics of interest in public libraries, accounting for between 6 percent and 20 percent of all inquiries (Wood, Lyon, & Schell, 2000). A large sample telephone survey (n = 882) of the general public (Case, Johnson, Andrews, Allard, & Kelly, 2004) found the public library to be among the top three choices for information on inherited cancer, roughly tied with physicians but lagging the Internet as a source.

Hospitals and HMOs are increasingly the providers of care, and generally patients are dissatisfied with communication within these institutions (Harlem, 1977), although in response to the client/consumer movement, most have substantially upgraded their communication programs, something we will return to in Chapter 8.

Hybrid Channels

There are a number of indications that programmatically the best channels for providing health information are those channels that constitute a hybrid of the positive properties of both mediated and interpersonal channels.

TELEPHONE INFORMATION AND REFERRAL SERVICES. Information and referral centers can take many forms, such as hotlines, switchboards, and units within organizations (e.g., nurses' medical help lines) where individuals can call to get answers to pressing concerns. They serve three primary functions: educating and assisting people in making wise choices in sources and topics for searches; making information acquisition less costly; and being adaptable to a range of users (Doctor, 1992). These services have been found to offer considerable help and assistance to callers (Marcus, Woodworth, & Strickland, 1993).

One example of a hybrid channel is the Cancer Information Service's (CIS) telephone service that has a widely available 800 number (1-800-4-CANCER). Telephone information and referral services like the CIS represent a unique blend of mediated and interpersonal channels, since they disseminate authoritative written information as well as verbal responses to personal queries (Freimuth et al., 1989). The hybrid nature of telephone services and referral services is important, since it can overcome some of the weaknesses of other channels. They have the additional advantage of homophily of source, a crucial factor in effective communication, since the calls are handled by individuals of closer status and background to potential callers than are physicians. It has been suggested that the CIS provides an important link between symptomatic people and health services, since a substantial proportion of callers follow up with more information seeking, passing on information to others, or consultations with health professionals (Manfredi, Czaja, Price, Buis, & Janiszewski, 1993). Generally, cancer telephone services have also been used effectively with media campaigns, combining the best features of interpersonal and mass communication (Arkin et al., 1993).

Telephone services as a channel offer the advantages of being free, available without appointment and forms, offering empathic understanding, allowing greater client control, anonymity for both parties, bridging of geographic barriers, immediate responses, and allowing the client to take greater risks in expressing feelings (Adelman et al., 1987), convenience, cost-effectiveness, and personalized attention (Johnson, 2005). All these factors result in respondents rating CIS as the highest quality source of cancer information with a high rate of user satisfaction in subsequent surveys (Johnson, 2005).

INTERACTIVE SOFTWARE FOR HEALTH INTERVENTIONS. Interactive health communication, implemented either on a desktop computer or in the form of a stand-up kiosk, allows integration of text, graphics, animation, sound, and video. Jones

(2009) notes that such systems can be implemented on a variety of equipment and in divergent ways: on either general purpose or dedicated computers, in open spaces or private booths, to be used standing or sitting, and intended for opportunistic use or integrated into clinic practice. Common features include use by the general public (rather than medical or information professionals), and the employment of a touch screen to collect user input rather than (or in addition to) a keyboard and mouse. A few kiosks include the capability for biometric measurement, e.g., of blood pressure. More recently, tablet computers have been used to collect information from patients in some settings (e.g., emergency rooms [see Benaroia, Elinson, & Zarnke, 2007]), and we can imagine that such mobile devices may also be used to provide information to patients in future applications.

Computers have been used for patient education in hospital and clinic settings since the mid-1980s. Since that time, interactive computer systems have developed for informing patients and the public about diabetes, asthma, hypertension, tuberculosis, nutrition, dental care, eye care, cancer treatment, urinary problems, respiratory problems, Alzheimer's, surgeries, smoking/alcohol/drug cessation, and a variety of other health conditions and lifestyle topics. They have been placed in public libraries, pharmacies, community centers and retail sites (e.g., supermarkets, McDonald's) as well as clinics and hospitals (Jones, 2009).

Typically commands for moving around among the various available information categories and appeals within the intervention can be simple and visual. Animation of breast self-examination, mammography, and other sequences can be used to enhance the communication intervention (e.g., Kreuter et al., 2006). The presentation can take advantage of visual design principles and human interface guidelines to maximize effectiveness. With minor modifications, the communication intervention created for such projects can be customized to meet local needs.

This type of hybrid channel, often represented in more advanced Internet sites and coupled with tailored communication, offers many potential advantages over existing ones. Face-to-face communication is often described as the ideal form of interactive communication, which other media seek to emulate but always fall short of. However, interactive health communication applications, by combining several communication technologies, increasingly permit interactive integration of text, graphics, motion, and sounds that rival and in some ways surpass face-to-face communication, both in terms of the accuracy of information presented and its potential impact.

Traditional mass media allow messages to be carefully designed to maximize their informativeness and persuasiveness. Text, graphics, and sound can be carefully integrated to carry messages over multiple channels. Television commercials are examples of media messages intended to elicit maximum impact. Adding computer-controlled interactivity to carefully designed media messages yields a range of specialized capabilities. Users of such systems can control the pace at

which they receive information. They can choose content of particular interest to them in the order of their choice. The program also can direct users to particular content based on needs assessed through online questionnaires. Content can be customized to a particular geographic area. Time-varying information can be easily updated without altering the body of the message. Use of the technology can be private so that users are not inhibited from seeking sensitive information. It also can be programmed to ensure that all users are exposed to key information.

Use of interactive health communication also has its problems: limited access to technical equipment, technologies are sometimes unstable and often incompatible, and technophobia and its impacts on users are not completely understood (Johnson & Heeter, 1989). Costs are also an issue. Jones (2009) finds that very few implementations have been cost-effective when compared with other channels; examining what he considers a successful project, Jones estimates that the Michigan Health Kiosk (Fintor, 1998), which lasted six years in 100 locations, probably cost about 50 cents per use—competitive with the cost of pamphlets yet presumably more effective. Jones (2009) and Nicholas, Huntington and Williams (2004) also note organizational and implementation problems with kiosks: misguided attempts to make them replicate the Internet or eliminate the Digital Divide, or to force them on health professionals for whom they may be a distraction.

The relationship between new information technologies and emotions is an interesting one. It has been argued that these technologies act to dampen emotions and thus produce higher quality decisions, and that the greater psychological distance of the mediated communication should make it easier to express negative emotions (Culnan & Markus, 1987). These factors may be especially important in a disease like breast cancer that stirs deep emotions.

We will say more about emerging new media for health interventions in Chapter 8.

The Web as an Omnibus Channel

It has been estimated that there are more than 130,000 health-related websites and lists currently online (DMOZ, 2011)—although it must be noted that many of these sites concern fringe areas like psychic abilities, miracle cures, and the health of animals. Nevertheless, the Internet and web are increasingly supplanting interpersonal and mass-media carriers as the preeminent sources of health information, with African Americans, for example, far more likely to consult them first (rather than physicians) for hereditary cancer information (K. M. Kelly et al., 2009). Some have even argued that study findings prior to the Internet should be disregarded because of its game-changing nature (Eheman et al., 2009). People are drawn to the Internet because of its convenience, anonymity, confidentiality, just-in-time decision-making support, and the diversity of information sources (Berry, 2007). Powell, Inglis, Ronnie, and Large (2011) found four motivations

for seeking health information online in their qualitative interviews: desires for reassurance, for second opinions, for greater understanding of existing information, and to circumvent perceived external barriers to traditional sources (such as a wish not to "bother" their doctor). Lee and Hawkins (2010) reinforce these themes by noting that sometimes information provided by health-care professionals is not always understood or absorbed when first conveyed, prompting follow-up searching on the web; and diagnoses or illnesses similarly require emotional processing and support, causing patients to connect with others online. Boot and Meijman's (2010) review speculates that a drive for self-actualization, and perhaps even a need for entertainment, come into play in online seeking of health information.

The Internet, much like a traditional library, is the host for a variety of channels and sources (Lewis, 2006). So people engage in discussion and support groups; they read information from authoritative government websites; they write and read blogs of experiences with illness, and they watch video on Medline describing various medical procedures. The Internet is also disorganized—or if you prefer, decentralized—and participatory, which contrasts sharply with mass-media sources that often have very centralized editorial control. Unfortunately, not everybody makes these distinctions, so it is often difficult to interpret research results.

The majority of Internet users report that they learned something from their Internet searches (Houston & Allison, 2002). Roughly 91 percent of Americans recognize the Internet as an "important" source of information (UCLA, 2003) with one-third of them using an online social network for dealing with health issues (Wright, Johnson, Bernard, & Averbeck, 2011). Health care is a good example of this expansion of important sources, since it includes not only a wide array of documents (ranging from popular to scientific) but is also the gateway to advice from a number of interpersonal sources (from laypersons to experts). Consequently, the seeking of health information is one of the most common uses of the Internet: by 2002, 60 percent of Americans were using the Internet and 66 percent of those had used it to find health information; estimates vary, but it appears that between 2 and 4 percent search for health information on a daily basis, while between 14 and 25 percent do so several times a month (Rice, 2006). Determining the source of online health information is often difficult, making credibility determinations problematic (Hu & Sundar, 2010). According to Doolittle and Spaulding (2005), over 70 percent of Internet users say that their treatment decisions are influenced by what they find on the Internet.

It is not merely information that attracts people to the web, it is also the opportunity to connect with others—what has been called the social web. Reporting on a sample of 3,001 Americans, Fox (2011) writes that 18 percent of Internet users have gone online to connect with users who have similar health concerns, and that that figure rises to 23 percent among those with chronic conditions. When

questioned about their most recent health problem, the same sample made it clear that health-care providers remain the most popular source of help (70 percent), then friends and family (54 percent), and finally other sufferers (20 percent). Interestingly, a small portion of the reported contact with health-care professionals, and much of that with friends and family, was also via the Internet. The main reasons given for turning to a medical professional were for an accurate diagnosis, information about drugs or alternate treatments, or recommendations for other doctors or medical facilities. In contrast, friends and family were sought out when what was needed was emotional support or a quick remedy for an everyday health issue.

The potential, and even success, of social media in the health context has been noted in a number of studies and reviews of online social support, e.g., Chung and Kim (2008), Doolittle and Spaulding (2005), Eysenbach (2003a), Eysenbach, Powell, Englesakis, Rizo, & Stern (2004), Lieberman and Goldstein (2005), Loader, Muncer et al. (2002), McCormack and Coulson (2009), Rains and Young (2009), Reeves (2000), Shaw, Hawkins, McTavish, Pingree, & Gustafson (2006), Wright (2002), and Wright and Bell (2003). Although social support groups may vary in success by composition of their membership, they have generally been found to increase emotional support, feelings of efficacy and general quality of life among those struggling with illness in themselves or close others—although Eysenbach et al. (2004) point out how limited is our knowledge of the effectiveness of "peer-to-peer" groups that do not involve medical experts. Online support offers particular advantages to those who are isolated by rural settings or physical disabilities and thus have less opportunity for face-to-face interactions. Perhaps the most advanced example in the genre is Patients Like Me.

Thus, consumers are increasingly looking to the Internet for answers to important health questions—to both documentary sources and advice from other laypersons and professionals in discussion forums. The Internet is ideally suited for the active information seeker. Since it requires more active involvement, it is more likely to be used by individuals who are health conscious (Dutta-Bergman, 2004). Since Internet usage is less "accidental," it is more likely to be in concordance with the user's existing perspectives (Kivits, 2009). Heavy users of the Internet are more likely to disintermediate, bypass, or downplay physician's authority or middleman status by going directly to a source (Lowery & Anderson, 2002). Unfortunately, doctors often don't pursue answers to questions that arise when treating patients, with estimates of up to two unanswered questions for every three patients they see (Hersh, 1998); given the pace and complexity of medical knowledge, this finding suggests that at times, clients may have more recent information than the doctors they visit. Physicians may in turn view heavy Internet users as cyberchondriacs who are overly obsessed with their health (Lewis, 2006).

While consumers generally are not suspicious of the information they find on health-related websites, independent subject-matter experts find high levels of problems with missing and/or inaccurate information (Berry, 2007; Seidman, 2006). This is not only a problem with the Internet as a carrier; unfortunately, doctors and other health professionals are also subject to this problem (Berry, 2007; Cline & Haynes, 2001), and physicians themselves have been found to vary widely in their assessments of the accuracy of health information found on the Internet (Craigie, Loader, Burrows, & Muncer, 2002).

Repeated concerns have been raised about the accuracy of information encountered over the Internet, just as similar concerns have been raised in the past about information from the mass media, friends, and family (Johnson, 1997). Very few sites provide truly comprehensive information, in part because they often have very specific missions (Bhavnani & Peck, 2010). Culver, Gerr, and Frumkin (1997), for example, found that 89 percent of the messages they monitored on an online health discussion bulletin board were authored by persons without medical training, that one-third of the advice was "unconventional," and that personal experience tended to be the source of the information provided; even the few medical professionals in the discussion group rarely cited published sources for their advice. Other concerns about the quality of health information on the Internet have been raised by Jadad and Gagliardi (1998), McClung, Murray, and Heitlinger (1998), Biermann, Golladay, and Baker (1999), Winker et al. (2000), Rice and Katz (2001), Craigie et al. (2002), and Doolittle and Spaulding (2005), among many others. There also have been concerns expressed about conflicting information, lack of integration, disparate websites, premature conclusions, and so on (Gustafson et al., 2008). At the same time, the *Health Forum Journal* (1995), Widman and Tong (1997), Lee and Hawkins (2010), Powell et al. (2011), and other commentators have pointed out the great potential for the Internet to be a positive source in helping patients, particularly those with chronic diseases and those who have to travel great distances to see providers (Bundorf, Wagner, Singer, & Baker, 2006).

Gone are the days when patients simply made the "obvious" (and indeed perhaps the only) choice of consulting with their doctor. Thus, the dominance of Internet sources represents a partial overturning of the famous "two-step flow hypothesis" that emerged from 20 years of research by Paul Lazersfeld and others (Case et al., 2004). The Internet has changed the nature of information seeking. It is often a first choice for finding out about a host of topics as well as a conduit for discussing those topics with other Internet users; to some degree the Internet substitutes for older media (Kaye & Johnson, 2003). As a result, the emergence of the Internet as an omnibus source may also have changed the nature of opinion leadership; both more authoritative (e.g., medical journals) and more interpersonal (e.g., cancer support groups) sources are readily available and accessible online.

The Internet, in its accessibility, anonymity, and potential interpersonal authoritativeness, may now act as a substitute for the classic two-step paradigm, supplanting the social and physical proximity dynamics of interpersonal networks.

Conclusions about Channels

Most individuals, especially the more educated, rely on more than one channel for information, except for very specialized topics (Hanneman, 1973). Flay (1987) has found that to induce behavioral change regarding health promotion, the media must repeat the message over a long period via multiple sources. Donohew, Helm, Cook, and Shatzer (1987) suggest that media should be used in a complementary fashion to achieve desired effects. Health campaigns have traditionally recognized the strategic necessity of reaching people through multiple carriers (Green & McAllister, 1984).

The channels reviewed here reveal the potential richness of information fields for health, but each channel examined also has weaknesses. For example, there has been much concern about the lack of emotional support by physicians. On the other hand, family members are often relied on for professional health-related advice that is beyond their legitimate areas of expertise. Naturally this can have grave consequences in potentially delaying authoritative treatment programs and interfering with them once they are in place (Johnson & Meischke, 1993a). Perhaps recognizing this, patients seek to meet different needs with different people; they have different expectations of various sources (Green & Roberts, 1974).

Since the primary focus of this book is on information-seeking behavior, the nature of an individual's search, the factors that underlie it, and the characteristics of information carriers and fields that shape it will be explored in much more detail in the next several sections of this chapter. Next, we will focus on competing perspectives of channel selection, and then we will see how the Comprehensive Model of Information Seeking (CMIS) explains the relative usage of a channel once it is selected.

Channel Selection

Perhaps the most basic decision that individuals can make in relationship to information seeking is in the channels they use to seek information within the information-carrier matrix. Lenz (1984) has referred to this as a choice among methods. This decision is different from, and usually should precede, the factors that determine how much a channel would be used once selected. Research attention over the last couple of decades has focused on the factors that lead to channel selection by senders of messages. Central to these approaches is the assumption that there is an optimal match between channels and tasks that will lead to more effective performance (Sitkin, Sutcliffe, & Barrios-Choplin, 1992;

Steinfeld, Jin, & Ku, 1987). Research in this area falls into two competing camps (Rice, 1993), one focusing on the characteristics of the channels themselves (Daft & Lengel, 1986) and the other focusing on the social context of communication (Fulk, Steinfield, Schmitz, & Power, 1987).

A major shortcoming of this research is that it focuses on senders, almost totally ignoring receivers (Sitkin et al., 1992), although it has been suggested that a mirror image of many issues from a sender's perspective could apply to receivers as well (Trevino, Daft, & Lengel, 1990). For example, a receiver shouldn't choose a "lean" channel (e.g., a brochure) to understand ambiguous information. Our focus is on the receiver of messages, individuals who are actively seeking information, so we will selectively review this literature, focusing on social information processing, characteristics, and health-based approaches.

Social Information Processing
All communication occurs within a social environment, with a minimum of agreement necessary on such basic properties of communication events as the symbol system and the channels used. Communication is an activity that implies shared behaviors (Fulk et al., 1987). It is impossible to communicate with someone by electronic mail if s/he refuses to use the medium (Markus, 1994). The key assumptions of a social information processing approach (Fulk, Schmitz, & Steinfield, 1990) closely follow the work of Salancik and Pfeffer (1977, 1978), which assumes that an individual's social environment affects media selection.

A key tenet of the social information processing perspective is that channel selection is rule driven (Ruchinskas, 1983). To coordinate their interdependent relationships properly, individuals negotiate complementary role behaviors. One way that this is done is by the generation of rule governing relationships. Similarly, media use is often a question of behaving appropriately, selecting the channel that is the best representation of our roles and the social norms surrounding them (Markus, 1994). Thus, many patients expect to be treated face-to-face by physicians, and when this does not occur, or a surrogate is used, they resist.

Characteristics of the Media
Researchers concerned with channel selection have classified both social presence arguments and media richness as two representatives of the characteristics school that assumes channels have invariant properties across situations (Steinfeld et al., 1987).

SOCIAL PRESENCE. Media differ in the extent to which they reveal the presence of other human interactants and can capture the emotional, feeling side of relationships (Daft & Lengel, 1986; Markus, 1994). It has generally been accepted that individuals will be most receptive to channels that reveal the presence of other

people (Sullivan, 1995). Across a wide range of settings, interpersonal communication has been considered the preferred channel for access to information and stimulating ideas (Mintzberg, 1976; Zuboff, 1988).

Social presence refers to the degree to which a channel approximates the personal characteristics of face-to-face interaction (Durlak, 1987) and enhances the psychological closeness of interactants (Sullivan, 1995). Early studies of the impact of teleconferencing technology were particularly concerned with issues like the absence of nonverbal components, the depersonalization of messages, and the presumed linearity of interactions (Acker & Calabrese, 1987). Social presence perspectives essentially argue for the superiority of face-to-face communication because of the richness of the communication cues available that may be filtered out by new communication technologies. They argue that mediated channels filter out nonverbal cues that make more salient the presence of other interactants (Walther, 1994). Yet, the reduction of cues could conversely focus attention on tasks, promote enhanced possibilities of conflict resolution, and lead to quicker solutions of problems (Fulk & Boyd, 1991). Others have suggested that professionals who want to conceal their true purposes also may want to avoid media rich in cues (Contractor & Eisenberg, 1990).

Increasingly, emerging technologies may be better than face-to-face communication because of their superior capabilities, particularly in terms of: memory, storage, retrieval, timeliness, participation/enhanced access to other sources, transforming, translating one medium to another (e.g., voice to data), overcoming temporal unavailability through asynchronous communications (e.g., telephone tag), more specialized content, and computer-searchable memory (Culnan & Markus, 1987; Huber, 1990; Markus, 1994; Perse & Courtright, 1993). Although at times, what appears at first to be efficient merely adds complexity to existing information fields. So, for example, increased email use often leads to a desire for more face-to-face communication (Contractor & Eisenberg, 1990). These trends make our knowledge of communication channels, especially new media, increasingly critical for understanding how people seek information. So, interestingly, in a comprehensive study across a number of organizations, other channels were often ranked more highly than face-to-face (Rice, 1993), findings that are increasingly repeated in studies focusing on email.

INFORMATION RICHNESS. Daft and his colleague's media richness theory (Daft & Lengel, 1986; Lengel & Daft, 1988) argues that the capacity of a channel to reduce uncomfortable psychological states associated with uncertainty is essential to channel selection. So, individuals will ultimately choose channels that match the level of uncertainty reduction they feel is required in any one information-processing task (Sitkin et al., 1992). If a problem is extremely complex, then face-

to-face discussions may be the only way to address it. If it is simple, then written instructions may be the appropriate choice.

Media richness theory argues that the information-processing requirements of individuals depend on equivocality and uncertainty. As uncertainty increases, more personal, "rich" forms of communication substitute for more impersonal modes. Communication media or channels differ in their inherent capacity to process rich information, assumed to be an objective characteristic of the media. "Information richness is defined as the ability of information to change understanding within a time interval" (Daft & Lengel, 1986, p. 560). Thus, media of low richness (e.g., impersonal written documents) are effective for processing well-understood messages and standardized data, while media of high richness (e.g., face-to-face meetings) are necessary to process information high in equivocality and uncertainty.

Dervin and her colleagues (Dervin, Jacobson, & Nilan, 1982) have found that information seeking in health settings was related to "gap-bridging": individuals asked questions that were directed at determining the implications of events for themselves directly and/or related to their future activities. Her research has a clear receiver or information-seeker orientation, articulating several classes of variables that need to be considered. The actor's situation could include the individual's formal roles and the relative access to information they have because of these roles. The actor's current need for drive reduction or gaps in their sense making and their related information purposes are also important. An actor's search for information would be guided by their strategies (a topic we will turn to later) and the underlying criteria for determining the type of information that will fill in the gaps in their current understanding.

There are a number of specific gap-filling situations that an individual might experience that imply different information-seeking processes (Dervin et al., 1982). In a decision situation, individuals have clear goals and are free to choose the information-seeking strategies for attaining them. In a barrier situation, individuals feel that they cannot attain their information goals because of factors like a policy of confidentiality. In worry situations, individuals do not know clearly what their goals are nor do they have a clear idea of what strategies to pursue. In an observing situation, individuals may be monitoring a situation but not actively engaged in a search for any particular type of information.

Conclusions about Channel Selection

While empirical research directly comparing these contrasting perspectives on channel selection is slight, the few studies that have been conducted have not been unequivocally supportive of any of the above positions (Fulk & Boyd, 1991; Markus, 1994; Rice, 1993; Rice & Aydin, 1991). Media-richness perspectives have often faced contradictory findings in empirical research, in part attributable

to the unexpected impacts of new media of communication (Fulk & Boyd, 1991). Steinfield et al. (1987), in reviewing the literature on social presence, found some moderate support in laboratory contexts, but in general found that social presence only accounts for a small proportion of the variance in media behavior. Theoretical work is still evolving in this area demonstrating a commendable capacity to incorporate new research findings and theoretical arguments (e.g., Trevino, Lengel, & Daft, 1987). Yet this literature fails to address one issue: once a channel is selected by a receiver, what factors will determine the level of usage associated with it? This is the precise issue that the CMIS is designed to address.

Channel Usage

While selection of particular channels has critical effects on the ultimate outcomes of a search, a basic tenet of communication research is that repetition reinforces and enables knowledge gain, attitude change, and behavior modification. It also affects such basic relational issues as trust, which develops in ongoing relationships (Johnson, 2009c). The Comprehensive Model of Information Seeking (CMIS—see Figure 3-1) seeks to explain usage. To review, it contains three primary classes of variables. The antecedents, discussed in Chapter 3, determine the underlying imperatives to seek information. Information-carrier characteristics shape the nature of the specific intentions to seek information from particular carriers and are the focus of this section. Information-seeking actions reflect the nature of the search itself and are the outcomes of the preceding classes, and will be discussed in more detail in Chapter 5.

Information Carrier Factors

While antecedents, such as salience, provide the initial motivating force for information seeking, the nature of the search itself is determined by the information-carrier factors. The information carrier factors discussed in this section are drawn from a model of Media Exposure and Appraisal (MEA) that has been tested on a variety of information carriers, including both sources and channels, and in a variety of cultural settings. Studies focusing on magazines were conducted in India (Johnson, 1983); in Nigeria (Johnson, 1984b); and in Germany (Johnson, 1984a). In addition, studies were conducted in the Philippines on films (Johnson, 1987) and on more generalized perceptions of television, radio, and print channels in Belize (Johnson & Oliveira, 1988).

Research on the MEA focused on three dimensions—editorial tone, communication potential, and utility—which have been clearly related to exposure and evaluation decisions across many communication channels. The first two dimensions, editorial tone and communication potential, primarily relate to message content characteristics; the third dimension, utility, represents a judgment of how

these attributes serve individual needs (Atkin, 1973). This research stream relates attributes of the medium to the functions they serve for the user, a focus shared by other programmatic media research (e.g., Burgoon & Burgoon, 1980; Burgoon & Burgoon, 1979). Following the MEA, the CMIS (Johnson, 1993b; Johnson, Donohue, Atkin, & Johnson, 1995; Johnson & Meischke, 1993b) posits determinative relationships between two information-carrier factors: characteristics and utility, and information-seeking actions.

CHARACTERISTICS. Editorial tone reflects an audience member's perception of the credibility and intentions of a carrier. If individuals perceive that information is disseminated for reasons other than the mere provision of information, this will weigh heavily in their evaluation of channels and in their usage decisions. So, for example, there is a tendency for the public to associate media messages with commercial motivations (Worsley, 1989), a factor that weighs heavily in the evaluation of websites. By extension, trust is also a component of editorial tone and has been linked to use and perceptions of utility of online information (Rains, 2007).

Another component of editorial tone is perceived accuracy, despite motives. Studies focusing on the media generally have found that television is perceived as the most credible media channel (Wallack, 1989). However, for health-related matters, television's level of trustworthiness is clearly below that of doctors, scientists, and the National Institutes of Health (Barinaga, 1994; Worsley, 1989). It has been suggested that there are seven criteria that affect judgments of the credibility of web information: source, content, format, presentation, currency, accuracy, and, interestingly, speed of loading (Wathen & Burkell, 2002). Perhaps troubling is the finding that a user's need for information is positively correlated with their credibility assessments (Wathen & Burkell, 2002).

General properties of channels can impact individuals' evaluations of them as disseminators of health information. A research stream conducted by Johnson and Meischke focused on this issue in three different studies. The first two studies focused on friends/family, doctors, organizational, and media channels with a general population sample (Johnson & Meischke, 1992a), and a sample of women who had had a mammography (Johnson & Meischke, 1993c). The other study focused on the media channels of television, newspapers, and magazines with a general population survey (Johnson & Meischke, 1993b).

The Johnson and Meischke (1992b) study that focused on the media found magazines and television were evaluated more highly for editorial tone than were newspapers. The relative low ranking of newspapers as a credible and accurate channel of cancer information might be partly caused by a concern with media bias in news reporting, as well as more specific concerns about confusing cancer information. Although content analyses of headlines of news stories about cancer have generally found these to be fairly accurate (Freimuth, 1984, as cited in

Siefert, Gerbner, & Fisher, 1989), health coverage in the news media has been criticized for attributing more certainty to new findings than is scientifically justified. They have also been criticized for portraying minor advantages as major breakthroughs and for exploiting the emotions of patients and the public (Atkin & Arkin, 1990). These perceptions could seriously affect people's faith in the credibility and accuracy of newspapers, since newspapers are used to a large extent to fulfill information needs, whereas television is primarily seen as an entertainment medium (Atkin, 1985).

The findings for editorial tone in the Johnson and Meischke research stream suggested that women evaluate professional sources more highly than friends/family and the media for cancer information. However, even friends/family received an average score of 6 on a 10-point scale for accuracy (Johnson & Meischke, 1993c). While the public can perceive differences in the reliability of various sources of information, they do not sharply distinguish between authoritative professional sources of information and alternative sources (Worsley, 1989). Interestingly, in this regard, expertise of a source makes a surprisingly small contribution to the persuasive impact of a message; it's much more important for a source to be seen as trustworthy (Atkin, 1992) and credible (Atkin, 1981).

Communication potential refers to an individual's perception of the manner in which information is presented. This dimension relates to issues of style and comprehension. For example, is a television program visually stimulating and well-paced? Visual attractiveness of magazines has also been related to exposure cross-nationally (Johnson & Tims, 1981). The specific targeting of most magazines makes it more feasible to write in a style that is understandable, as well as attractive, to a particular audience. Broadcast channels, such as television and radio, appear to be best suited for carrying stylistically entertaining messages that engage the tastes of the audience, assuring closer attention to the informational content (Atkin, 1981).

Respondents were somewhat satisfied with the understandability of cancer-related messages across a wide range of channels; however, one of the most interesting findings of the general population study was the relatively lower standing of doctors in the eyes of the public (Johnson & Meischke, 1992a). Respondents did not perceive doctors to be more understandable than the media in communicating cancer-related information. This is counterintuitive, since interpersonal channels generally tend to be more effective in communicating complex information due to the opportunity for giving and asking for feedback (Rogers, 2003). As we have seen, the current literature on doctor-patient communication also shows that many patients have a difficult time communicating with their physicians (Epstein & Street, 2007). This might be attributable to the somewhat low level of understanding of the public about cancer, which makes it more difficult for the layperson to clearly and understandably communicate about this topic

with professionals (Phillips & Jones, 1991). Doctors often fail in their attempts to communicate with patients because of their usage of incomprehensible jargon (Falconer, 1980; Lichter, 1987).

Low literacy is clearly a factor when the public encounters health information, whether written or spoken. The Institute of Medicine (Nielsen-Bohlman, Panzer, & Kindig, 2004) estimates that 90 million Americans (almost a third of the population) have difficulty understanding and using health information. They point to over 300 studies indicating that most health-related materials in print exceed the average reading ability of American adults (Connor, 2009). Such literacy problems are thought to have a direct and negative effect on the health of the U.S. population (Levy & Royne, 2009).

Even more surprising is the level of comprehension of individuals for the simplest of broadcast messages. A systematic program of research sponsored by advertising agencies has found that 97 percent of the public exhibited some degree of miscomprehension of messages, with a 30 percent misunderstanding of the core meaning of 60-second televised messages and 63 percent correct answers to magazine advertisements. The average accurate retention, measured by unaided recall, was 15 percent. In summarizing their results, Jacoby and Hoyer (1987, p. 50) suggested that "partial non-comprehension, however, is likely the most typical experience, particularly for communication with many meanings."

Consumers are not alone in their misunderstanding of information, although mistakes made by physicians and nurses are at a higher level of complexity than broadcast messages. An experimental study by Hersh, Crabtree et al. (2002) showed that students of medicine and nursing were only partially successful in applying the results of medical-database searches to clinical questions. Subjects did the best in interpreting the implications of medical literature for prognosis and worst in applying retrieved documents to questions of diagnosis and potential harm to the patient. The medical students did better than the nurses at online searching: however, both groups were able to improve their answers to medical questions through searching of online medical literature. An earlier analysis by Hersh (1998) of existing studies concluded that literature searchers exhibit poor recall of potentially relevant items, their results typically address only a small portion of physicians' actual needs in practice, and overall the extent of the benefits of information retrieval for medical doctors are unclear.

UTILITY. The preceding dimensions involve a direct evaluation by an individual of a particular channel. The final dimension, utility, relates the characteristics of a medium directly to the needs of an individual and shares much with the uses and gratifications perspectives discussed in the preceding sections. For example, is the information contained in the medium relevant, topical, and important for the individual's purposes? C. Atkin (1973) has argued that mass-media exposure

will result from a combination of such needs of the receiver and the attributes of a message. Research on the uses and gratifications of media use suggests that people use mass-media channels to satisfy affective (e.g., being entertained, escaping boredom) as well as cognitive needs (e.g., being informed, getting advice) (Atkin, 1985; Rubin, 1986).

There was a more general trend across channel characteristics to rate doctors and organizations more highly than friends/family, and the media for providing useful cancer-related information (Johnson & Meischke, 1992a, 1993c). These results also reveal a considerable potential irony: media are the source of most of the public's health information (Freimuth et al.,1989) in spite of the clear public preference reported here for information from doctors and organizational channels. This reiterates the apparent tendency for individuals to choose less-authoritative information sources because they are easily accessible (Case, 2012).

Summary

In communication research, the issue of channel selection and usage has probably received as much attention as any other single topic. Historically debate has centered on the competing advantages of interpersonal and mediated communication channels, in part because of institutional, academic differences in how these two separate areas of communication are studied. So, speech and communication departments focus on persuasion and interpersonal communication, and journalism and broadcasting departments focus on the media. While the literature is clear that there are differences in the perceptions and usage of differing communication channels, it is less clear whether these differences really make a difference for information seeking related to health.

The overriding concern of searchers for answers, especially at the latter stages, is the content of the search, not necessarily how information is delivered. So, it might be best to cast channels as playing complementary roles for individuals, with the primary criteria determining selection being easy access within one's information environment (Chaffee, 1979). In effect, people will accept answers to their questions from the first available source, often without much concern for the quality of the answers they get. The proliferation of channels makes this area of study even more volatile, for while it is clear that people have preferences, actual usage data suggest at best a weak linkage between preferences and behavior, the subject of Chapter 5.

Channels appear to be imminently substitutable. No one source, not even doctors, can be all things to all people. Instead, people seem to construct their information fields so that channels are segmented and specialized as to the functions they perform. So, they seek out friends and family for emotional support, and they seek professional knowledge from physicians (Johnson & Meischke,

1993a). They do this in part because their needs change rapidly, and they need to be able to discuss a range of possible selves with others. With fellow patients, they may show their fear of imminent death, while with family members they put on a brave front, preserving their traditional role as a strong authority figure, and they humor doctors by going along with pointless treatments to preserve the physician's goodwill. So, in many ways the usage and selection of any one particular communication channel are contingent on what role the other channels in an information field are performing. People confronted with disease construct a patchwork quilt of channels from the material at hand that serves to buffer them from an often cold world.

Further Readings

Atkin, C. (1973). Instrumental utilities and information seeking. In P. Clarke (Ed.), *New models in mass communication research* (pp. 205–242). Beverly Hills, CA: Sage.

Chuck Atkin's influential chapter reviewed key studies—particularly related to politics—with an eye towards explaining the effects of uncertainty on information needs, and the interaction of those needs with aspects of message content (e.g., completeness and discrimination). While leaving open the possibility that messages might be attended to for other reasons (e.g., entertainment purposes), Atkin made the case that most of the time our selection of information has to do with the usefulness of that information, particularly for decisions, actions, and maintaining cognitive or affective states (e.g., achieving understanding or forming an opinion). Atkin's review helped to close off what at that time had been an obsession with investigations of selective exposure, ignoring a systematic approach to information seeking.

Clarke, J. N., & Everest, M. (2006). Cancer in the mass print media: Fear, uncertainty and the medical model. *Social Science and Medicine, 62*(10), 2591–2600.

A content analysis of top circulation magazines in North America looks at the framing and content of stories on cancer. Among the conclusions: cancer is strongly associated with fear and frightening statistics about prevalence and mortality; many articles contradict themselves and other publications, especially in regard to the causes and possible prevention of cancer; metaphors of warfare and battle are often employed in describing cancer and its victims.

Daft, R. L., & Lengel, R. H. (1986). Organizational information requirements: Media richness and structural design. *Management Science, 32*, 554–571.

One of the most-cited publications in the management literature, Daft and Lengel stress the inability of many communication media to reproduce all the

information that might potentially be transmitted and the problem this raises for organizations. For example, written documents cannot easily convey emotion, while a phone call does not reproduce visual cues—thus, media form a hierarchy of lean to rich in terms of information potential. A common problem is not sheer lack of information but rather too much ambiguity. The implication is that more uncertain situations may dictate richer media. Yet organizations and managers are constrained by both structure and available resources (including communication technology). The authors suggest how organizations can provide means to reduce uncertainty and clarify varying interpretations of messages and tasks.

Epstein, R. M., & Street, R. L., Jr. (2007). *Patient-centered communication in cancer care: Promoting healing and reducing suffering.* (NIH Publication No. 07-6225). Bethesda, MD: National Institutes of Health.

Epstein and Street's report on communication with cancer patients aims to improve clinical practice as well as encouraging more research on the topic. They find that relatively little research has been conducted on ways to change clinical practice. Currently few clinicians are exposed to more than a brief course on communication skills; more effective training should be multimodal, carried out over longer periods of time, in group settings with skilled facilitators, and provide for feedback and practice. It is especially important that health professionals receive this training early in their careers. On the patient side of the equation, even simple strategies such as having patients write down any questions prior to appointments, encouraging their viewing of informational videos and use of personal health diaries, can substantially improve the communication between them and their health-care providers.

Fulk, J., Steinfield, C. W., Schmitz, J., & Power, J. G. (1987). A social information processing model of media use in organizations. *Communication Research,* *14,* 529–552.

Somewhat in contrast to the approach of Daft and Lengel, Janet Fulk and her colleagues suggest that more attention needs to be paid to the social environment in which tasks, and communication about them, exist. They contend that social processes mediate use of communication media and media-use behavior. Their model attempts to integrate rational choice models of media use, with social influences (e.g., the desire to maintain good relations with colleagues). The resulting model considers such variables as perceptions of media characteristics, past experience with media, and individual differences, in predicting choices of media for communication.

Johnson, J. D. (1983). A test of a model of magazine exposure and appraisal in India. *Communication Monographs,* 50, 148–157.

This study of exposure to and appraisal of two political magazines distributed by the U.S. Information Agency concluded that we need to know more about why people attend to certain information sources. Situational factors such as accessibility, available time, and competing media clearly play a role in exposure to printed publications—even more so since the emergence of the Internet. This research reported on of the initial tests of the MEA that became a major component of the CMIS.

Jones, R. (2009). The role of health kiosks in 2009: Literature and informant review. *International Journal of Environmental Research and Public Health*, 6, 1818–1855.

A professor of health and social work, Ray Jones reviews the role of kiosks in providing health information, based on a review of literature up to 2007, and interviews with hundreds of participants in kiosk projects in the U.K. and North America. Jones divides kiosks into those that are *opportunistic* (e.g., used voluntarily in public locations) versus kiosks that have been *integrated* into clinical practice (which patients are asked or required to use). The projects examined go back to the 1980s: however, the emphasis is on recent implementations. A very well-organized analysis, with many pictures of the kiosks in use.

Rogers, E. M. (2003). *Diffusion of Innovations* (5th ed.). New York: Free Press.

This classic book (the second-most-cited book in the social sciences, according to some sources) reflects over 40 years of scholarship by communication professor Everett Rogers. The first edition was published in 1962, and this final edition appeared less than a year before his death in 2004. In it, Rogers explains how new ideas, practices, and inventions may spread (or not). In his theory, individual choices to adopt anything new will depend on key variables like awareness, interest, and potential for trial. Adoption decisions are also strongly shaped by social phenomena such as norms, networks, gatekeepers, and opinion leaders. Diffusion theory has been used in tens of thousands of investigations over the last half-century in a wide variety of disciplines. Rogers' model is applicable to a variety of health issues in which both individual and collective choices are important, such as disease prevention and family planning.

Models of Information Seeking

Overview

A model is a lie that helps you see the truth (Howard Skinner as quoted in Mukherjee, 2010, p. 139)

In this chapter, we will examine a variety of information-seeking actions, or behaviors, that can result from the imperatives for information seeking discussed in Chapters 3 and 4. In doing this, we will also compare various approaches to modeling information seeking. We will primarily focus on activities, manifest behaviors, including depth, breadth, and persistence associated with a search; the formation of information fields; the stimulation of pathways; and different styles of searching that result from the underlying forces that drive information seeking. In Chapter 7, we will more specifically cover individual tactics for seeking (e.g., observation versus direct questioning).

Approaches to Action

Types of Actions

There are several types of information-seeking actions; for example, Lenz (1984) argues that search behavior can be characterized by its extent, or the number of activities carried out, which has two components: scope, the number of alternatives investigated; and depth, the number of dimensions of an alternative investigated.

She also identifies the method of the search, or channel, as another major dimension of the search. Applying this to the information-seeking matrix, an individual might choose the method of consulting a telephone information service, decide to have a narrow scope by only asking questions about smoking-cessation clinics but investigate every recommendation in detail, thus increasing the depth of the search. In his grounded theory of researchers and scholars, Ellis (1989) developed a model that included the following activities: starting, chaining, browsing, differentiating, monitoring, extracting, verifying, and ending. Newer approaches to modeling information seeking have more elaborate descriptions of actions; for example Wilson (2000) includes four types of search behaviors: passive attention, passive search, active search, and ongoing search.

Naturally, given judgments as to the effort that should be expended, people may impose their own time limit on a search, and it is also the case that sometimes the health problem they are confronting will impose its own limits on their actions (Lenz, 1984). An important corollary of this is dogged persistence until a high-quality answer is found as the idealized search behavior. This is also the realm of curiosity (and even of obsession); however, seldom do individuals engage in the effort that a fictional detective might pursue to solve a mystery. They often prefer that others do their work for them.

Actions in Communication Networks

> It entails the capacity of actors to make practical and normative judgments among possible trajectories of action, in response to the emerging demands, dilemmas, and ambiguities of presently evolving situations (Emirbayer & Mische, 1998, p. 967).

One specific conception of an information context is that of the information field within which the individual is embedded (Cool, 2001). An individual's information field provides the starting point for information seeking. It represents the typical arrangement of information stimuli to which an individual is regularly exposed (Johnson, 1996, 1997), the information resources they routinely, habitually use (Sonnenwald, Wildemuth, & Harmon, 2001). Individuals are embedded in a physical world that involves recurring contacts with an interpersonal network of friends and/or family. They are also regularly exposed to the same mediated communication channels (e.g., Twitter feeds, Facebook pages, radio, and so on).

As individuals become more focused in their information seeking, they change the nature of their information field to support the acquisition of information related to particular purposes (Kuhlthau, 1991). In this sense, individuals act strategically to achieve their ends and, in doing so, construct local communication structures in fields that mirror their interests (Williamson, 1998). Some of the most interesting early work in the area of social contexts for information be-

havior was done by Pescosolido (1992), who identified "cascades" or strings in the selection of interpersonal sources of health information. Disturbingly, physicians were not cited by respondents in two of the eight interpersonal source clusters in her 1992 study in spite of the focus on recent severe health episodes. This may be in part because of a lack of trust in traditional sources that causes individuals to seek alternatives, such as the web, for medical information (Rains, 2007). Three of the eight patterns revealed single source consultations (e.g., physicians alone), reflecting the disturbing lack of persistence of individuals in seeking help for their medical problems (Johnson, 1997).

The movement from field, which represents a stable equilibria of carriers, to pathways, may be generated by the forces specified in the Comprehensive Model of Information Seeking (CMIS). It is more dynamic and active, focusing on individual actions over time in response sequences. Contexts may change as a result of individual choice and a response to what an individual has uncovered, and thus it has parallels to foraging (Pirolli & Card, 1999) and berry-picking (Bates, 1989). The movement to pathways may result from dissatisfaction one is experiencing with sources within one's field, such as friends and family (Rains, 2007), who are often turned to first for health information (Wathen, 2006), or with one's physician (Tustin, 2010). The path one follows can also influence users' judgment of their ultimate source, especially for issues like branding and trust (Hargittai, Fullerton, Menchen-Trevino, & Thomas, 2010). Unlike a field, which is constructed to meet individual preferences, paths can uncover discordant sources of information, producing conflicts that must be resolved. Paths are contingent on what is found, and how one reacts to this information, and they may lead us to encounter unexpected (Erdelez, 2005) or serendipitous information (Bjorneborn, 2005). It would be expected that once someone's concerns have been addressed, one may return to a stable field that may reflect a different patterning of carriers such as one may develop in response to a chronic disease.

Network analysis represents a very systematic means of examining the overall configuration of relationships within any social system; as such it offers a very rich way of describing pathways that individuals might pursue in their social worlds. As we focus more and more on how people share information with each other and work together in teams seeking answers to questions, networks become a very concrete way of representing the communication patterns involved. The most common form of graphic portrayal of networks contains nodes that represent social units (e.g., people, groups) and relationships of various sorts between them. Because of its generality, network analysis has been used by almost every science to study specific problems (Watts, 2003), and it has broad applicability to health issues (Valente, 2011). So much attention has been paid to network analysis that a comprehensive review of all material related to it is beyond the scope of this

chapter, so we will focus on the fundamental question of how people come to find answers to their health concerns in their social networks.

Since information seeking related to cancer becomes more of an interpersonal process as a person's experience with cancer hits closer to home, the nature of an individual's networks has important consequences (Lenz, 1984). An individual's effective network is constituted by friends, family members, and other close associates; while an extended network is composed of casual acquaintances and friends of friends, who, because they have different contacts than the focal individual, can provide him/her with unique information.

Interlocking effective networks can lack openness (the degree to which a group exchanges information with the environment) and may facilitate the sharing of ignorance among individuals. As other scholars have noted, "The degree of individual integration in personal communication networks is negatively related to the potential for information exchange" (Rogers & Kincaid, 1981, p. 243). The extent to which an individual expands his/her network has important consequences for health information acquisition, and there has been an explosion of interest in the relationships between social networks and health in recent years (Christakis & Fowler, 2009).

The nature of an individual's interpersonal communication network has direct linkages to a number of health outcomes. A mobilized, supportive social network is critical because it can expand the range of information available to an individual. An individual needs the social support of his/her immediate social network to deal effectively with the disease and in the maintenance of long-term health behaviors (Becker & Rosenstock, 1984), but s/he also needs authoritative professional guidance and information in the institution of proper treatment protocols. This sort of guidance is typically only available in an extended network. Sadly, poor people tend to rely almost exclusively on strong ties in their effective networks because of their lack of other alternatives for dealing with problems (Granovetter, 1982); thus, they are not exposed to more authoritative health-related information.

One of the things that characterizes effective communication networks is knowing what the other knows and when to turn to them (Cross, Rice, & Parker, 2001). Despite doubts about the validity of self-reports of network linkages, some scholars believe that individuals have strong, albeit often crude, intuitions of surrounding social structures; they are aware of who is linked to whom in a stable network (Corman & Scott, 1994; Freeman, 1992); and, by implication, they have some awareness of where information resides. The literatures on opinion leadership, small-world dynamics, and transactive memory provide frameworks from which to understand information-seeking actions.

Both the traditional opinion leadership (Katz & Lazersfeld, 1955) and network role literature suggest that people seek out knowledgeable others in their

informal networks for answers to their questions (Johnson, 2009c). One key advantage to the use of opinion leaders is that they can sometimes serve as mentors to help in the developing of individual skills. So, not only do opinion leaders disseminate ideas, but they also, because of the interpersonal nature of their ties, provide additional pressure to conform as well. Opinion leaders not only serve a relay function, they also provide social support information to individuals and reinforce messages by their social influence, partly as a result of their positions in network structures. However, the literature is less clear on the question of how people come to know who these others are.

The classic small-world problem of where to go is couched in terms of an individual who needs to contact a distant other (e.g., someone who knows how to cope with substance abuse), previously unknown to them, through intermediaries. Small-world issues have received renewed attention with the advent of the Internet (Watts, 2003). The twist is that we are not seeking a particular target other but rather targeted information that another may possess. In this sort of "expertise" network, knowledge may substitute for formal authority in identifying targets yet may result in problems of access, managing attention, overload, and queuing (Krackhardt, 1994).

Watts (2003) has recently given more focused attention to how individuals strategically target particular intermediaries. He suggests individuals start with two broad strategies. One is to engage in a broadcast search in which you tell everyone you know, they in turn tell everyone they know until a target is reached or an answer is found. This approach is crude and has some obvious problems: one, it reveals your ignorance broadly; two, it implicates a large number of others, distracting them from their other tasks; three, it may produce large volumes of information that need to then be filtered by some criteria (e.g., credibility, relevance, and so on); and, fourth, it makes your problems visible to a wide range of others. The alternative, a directed search, may start by developing some criteria (e.g., I will only ask people I can trust with sensitive, confidential information) used to guide contact with others who may have answers to my questions. Retrieval criteria are important components of transactive memory approaches.

Knowing who knows what is a fundamental issue in communication networks; it answers the know-who question (Borgatti & Cross, 2003). Using computer search engines and networks as a metaphor can also lead us to interesting insights into this human systems problem. If people can be considered to be computers, then every social group can be viewed as a computer network with analogous problems and solutions (Wegner, 1995), developing means of retrieving and allocating information to collective tasks (Palazzolo, Serb, She, Su, & Contractor, 2006). But we are not focused here on the hardware and software available to search for expertise, classic knowledge management tools used in many organizations (e.g., SPIFI, directories, "yellow pages"). Perhaps the most serious limit

on these technologies is the recurring preference of individuals for interpersonal information sources who can digest and summarize vast quantities of information for individual seekers (Johnson, 1996). Some have argued, then, that the fundamental unit of transactive memory is task-expertise-person (TEP) units that answer the know-who question (Brandon & Hollingshead, 2004).

Transactive memory explains how people develop cognitive knowledge networks that help them identify the skills and expertise of others. Several interrelated processes are involved, including retrieval coordination, directory updating, and information allocation (Palazzolo, 2006; Palazzolo et al., 2006; Wegner, 1995). Retrieval coordination specifies procedures for finding information. Directory updating involves learning who knows what, while information allocation assigns memory items for group members. Once someone's expertise is known, they are more likely to become the objects of information searches (Borgatti & Cross, 2003), of action, in CMIS terms.

Styles of Information Seeking

Another potential approach to information-seeking actions is a focus on differences in information-seeking styles, or ways of relating to information-seeking tasks encompassing clusters containing several factors. It has often been assumed that most individuals would be active information seekers when confronted with severe health problems. But the literature makes it clear that many individuals go through processes of denial, at least temporarily. Cancer patients often become information avoiders for some period after their initial episodes with cancer. Some individuals are also relatively apathetic toward cancer, confronting more important problems in their particular situation (e.g., difficult financial circumstance, heart problems and other comorbidities, and so on). Manfredi, Czaja, Price, Buis, & Janiszewski (1993) identified a number of characteristics of nonseekers of cancer-related information: they are less likely to enlist the support of others, do not feel a need for information beyond that provided by their health-care providers, and are less stressed when first diagnosed. Any approach to information seeking must be able to confront general predispositional and specific domain differences in individual approaches to information seeking.

As we have seen, individuals have different profiles of media use and information field configurations related to health. They also have different approaches to acquiring information, often determined by their skill levels and health literacy, as we will see in Chapter 7. These factors might cluster together under more global encompassing definitions of styles of information seeking. It has been argued that patients can quite readily identify what style they fall into (Thorne, 1999). Several style classifications identify wide ranges of types that have been empirically demonstrated to impact various information-seeking actions (Eheman et al., 2009).

Consumer researchers have long recognized differences in individuals in information seeking related to products. Thorelli and Engledow (1980) found that a subset of consumers were *information seekers*, who had had higher education, higher SES, higher ownership of durable goods, higher skepticism about products, and who were sensitive to information, focused on product tests, likely to be opinion leaders, sympathetic toward government intervention on behalf of consumers, and favorable toward business (although they were critical of specific practices). Interestingly, information seekers often acted as "vigilantes," who policed the marketplace, becoming very knowledgeable, complaining vigorously, joining organizations, and pinpointing fraud and deception. In short, they acted very much like members of advocacy groups we will discuss in Chapter 7. Kiel and Layton (1981) have suggested that consumer information seeking is characterized by three styles: low search, selective search, and high search. Most individuals studied were selective searchers, with information seeking often a complex process for individuals, making discernment of one general pattern very unlikely.

One of the few examples of style approach applied to general information-seeking problems is Donohew, Helm, Cook, and Shatzer's (1978) description of four different types of seekers based on antecedent personality traits, information-seeking strategies, and mood-related outcomes. *Loners* rated themselves more highly on mood states like depression and aggression and were rated lower on prior knowledge and information received from others. *Formal seekers* had broad-based strategies and perceived information to be more available, while scoring lower on feelings of anxiety and deactivation. *Risky seekers* had more prior knowledge, higher feelings of egotism, narrowly focused strategies, and had lower ratings on information given to others. *Informal seekers* rated more highly on variety and information received and lower on perceived availability of information and feelings of pleasantness.

There also have been various descriptions of different styles of coping, of which information seeking may be a component. For example, Sullivan and Reardon (1985) studied the role of social support satisfaction and health locus of control in styles of coping of breast cancer patients. They identified several different coping approaches. *Denial* was characterized by active rejection of any information about diagnosis, restricted discussions, and few reports of emotional distress. *Fighting spirit* was characterized by highly optimistic attitudes, active search for information, desire to know as much as possible, and low levels of distress. *Stoic acceptance* was represented by awareness of diagnosis, failure to seek new information unless their condition changed, apparent indifference to cancer, and restrained responses to pain and distress. *Hopelessness/helplessness* was characterized by people who thought they were dying, preoccupation with the disease, emotional distress, and feeling there was nothing that could be done about it (including information seeking, presumably).

Morris, Tabak, and Olins (1992) engaged in a program of research related to prescription-drug information seeking by the elderly. They identified four different styles based on combinations of characteristics identified by a cluster analysis of variables derived from the Health Belief Model and an identification of traditional sources of health information. *Ambivalent learners* were not particularly healthy but were nevertheless receptive to information. *Uncertain patients* had not received much information from health professionals and perceived difficulties adhering to treatment regimens. *Risk avoiders* were the youngest and best educated and were in the early stages of treatment regimens. They were seeking information to gain control and were the most likely to rely on authoritative, professional sources of information. Finally, the *assertively self-reliant* were the least receptive to information, the least discriminating in their use of sources of information, and did not perceive themselves to have an information deficit.

Ferguson (1991) has suggested a typology of health-activated health-responsible consumers that is particularly pertinent. *Passive patients* generally approach problems with grim resignation. They feel that there's little they can do to improve their health. When confronted with a terminal disease, they are likely to give up without a fight. *Concerned consumers* sometimes ask questions and may occasionally seek a second opinion, but they almost always go along with what their doctor recommends. They are generally compliant with medical advice and receive average medical outcomes. *Health-active, health-responsive consumers* represent a growing minority of clients. They have intense self-directed involvement, are motivated and demanding, and generally have the best health outcomes. They would regard a diagnosis of cancer as a challenge and an invitation to examine their lives. They have driven many of the changes in the modern health-care system.

Another widely cited approach to styles is Miller's (1987) classification of people's coping styles with stress. *Monitors* seek information to help them cope, while *blunters* avoid information. While intuitively appealing to practitioners, various questions have been raised about the psychometric approach used to empirically assess this model (Baker & Pettigrew, 1999; Galarce, Ramanadhan, & Vishwanath, 2011; Rees & Bath, 2000b).

Several variables identified over the last few chapters are associated with predispositions that could cluster as styles individuals have for approaching various information-seeking problems. The antecedent variables, especially staging, and information-carrier characteristics, might relate to predictable "cascades" of information-seeking behavior related to particular problems. So, individuals with considerable experience with cancer, in high socio-economic classes, with rich information fields might engage in scooping strategies aimed at obtaining a new piece of information related to a particular treatment regimen. On the other hand, individuals who are somewhat unsophisticated in their channel usage, who do not believe information seeking would be helpful, and who have high

fear levels, may avoid information. Identification of different styles of informa-
tion seeking appears to have great potential for developing richer descriptions
of information-seeking behaviors and their relationships to underlying drivers of
information seeking.

Summary

In summary, given the foregoing, the CMIS suggests that the antecedent fac-
tors shape perceptions of the utilities of various actions. Characteristics such as
editorial tone (i.e., trust) and communication potential (i.e., being able to couch
answers in understandable ways) then shape both utilities and action in social
networks. One of the least articulated elements of the CMIS has been the nature
of actions. A focus on social networks reveals a host of interesting manifestations
of actions. It also raises issues of how much assistance one is likely to find in the
social networks in which one is embedded, and how to balance differing networks
representing separable concerns. Now that we have a much more elaborated un-
derstanding of actions, we can finalize our discussion of models of information
seeking.

Models

Models are a very popular means of representing complex processes by trying to
capture their essential elements and representing the relationships among them
(usually graphically), and they have been used extensively to describe general
information-seeking behavior (Wilson, 1999). They attempt to organize (and
simplify) a body of knowledge to pave the way for more developed theories and
limited empirical tests. Models force a developer to make explicit their underly-
ing approaches and assumptions, appealing to explanatory factors that may lead
to prediction of certain outcomes. Despite their heuristic advantages, models also
have weaknesses: they may oversimplify processes and they may lead people to
overgeneralize from them, without realizing the limitations of their tacit assump-
tions. For example, the powerful model Shannon and Weaver (1949) developed
for telecommunication systems has been used too loosely to describe other com-
munication processes.

 In this chapter, we will first review some alternative models of information
seeking (see Table 5-1), before returning to the CMIS and its empirical tests; us-
ing them to develop a critique of the model and to suggest future directions for
research. Theoretical models of information seeking must address four key issues.
First, models should provide a sound theoretical basis for predicting changes in
information-seeking behaviors, and by extension, provide guidance for the de-
sign of intervention strategies. Unfortunately, information-seeking research has a
number of descriptive, proscriptive models but few empirically tested ones (Baker

& Pettigrew, 1999). Second, models should provide guidance in designing effective strategies for enhancing information seeking, such as those developed in Chapters 7 and 8. Third, models should explicitly conceptualize information-seeking behavior, developing rich descriptions of it at all levels. Finally, models should answer the why question: they should explicitly address the underlying forces that impel particular types of information seeking and explain its intensity/persistence.

Table 5-1: Comparisons of Differing Health Information-Seeking Models

	HIAM	ECMISB	RISP	CMIS
Background				
Theories derived from	Betteman, Atkin, Lenz	HBM, Adherence Literature	Theory of Planned Behavior, Heuristic Systematic Model	HBM, uses and gratifications, MEA
Context	Cancer Information Service	Health	Environmental risks, health, international	Health, organizational
Empirical work	Derived from CIS call records	Derived from author's prior empirical work	Holistic and partial tests in differing contexts	Holistic and partial tests in differing contexts
Antecedents				
Demographics	Discussed but not formally included in model	Yes	Yes	Yes
Information Base	Evaluate current information	History, health literacy	Information insufficiency	Personal experience
Salience	Implied in stimulus	Not explicitly included	Affective responses to threats	Yes
Beliefs	Cost/benefit analysis	Not explicitly included	Informational subjective norms, Information gathering capacity	Yes
Carrier Factors				
Social context	Side discussion on poverty, knowledge gaps	Social networks	Informational subject norms	Social networks as carriers
Characteristics	Implied by methods	Active vs. passive	Relevant channel beliefs	Editorial tone, communication potential
Utility	Implied by methods	Not explicitly	Not explicitly	Uses and gratifications

Table 5-1: Comparisons of Differing Health Information-Seeking Models
continued

	HIAM	ECMISB	RISP	CMIS
Actions				
Intentions	No	No	Sometimes	No
Search Behaviors	Yes	Use in decision making	Not very explicitly, focus on cognitive processing	Scope, depth, method, persistence
Flow/cycles	Yes	More domain, implied in phases	Causal direction one-way	Specifies underlying driving forces
Pathways	Specifies one path	Traces hierarchy	Not explicitly	Not in model, but embedded in Information-Carrier Matrix
Fields	Implicitly	Yes	Not really	Expansion or contraction
Outcomes				
Quest satisfied	Yes	Yes	Implied	Beyond scope
Decision making	Sets stage for	Yes	Processing behavior	Beyond scope
Enhanced literacy	Store new information	Incorporated in 2010	Implied in information sufficiency	Beyond scope
Dark side	Mentioned specifically	Implied	Avoidance mentioned	Beyond scope
Health/daily living outcomes	Beyond scope	Yes	More effort, more stable outcomes	Beyond scope

NOTE: HIAM: Health Information Acquisition Model; ECMISB: Expanded Conceptual Model of Information Seeking Behaviors; RISP: Risk Information Seeking and Processing; CMIS: Comprehensive Model of Information Seeking

Flow Models

Most of the early models developed to describe information seeking were in essence flow charts that described the surface actions, in a sequential fashion, that individuals took in their quest for information. Representatives of this type of model would include Schamber's (1994) Information Retrieval Interaction Model; Ward and Hansen's (1993) Search Strategy Model; Saracevic, Kantor, Chamis, and Trivison's (1988) General Model of Information Seeking and Retrieving; Donohew, Tipton, and Haney's (1978) Model of Information Seeking, Avoiding and Processing; Krikelas's (1983) Model of Information Seeking Behavior; Kuhlthau's (1991) model of the Information Search Process (ISP); and Czaja,

R., Manfredi, C., and Price's (2003) Conceptual Model of Patient Information Seeking. Perhaps the most relevant of these models for our purposes is the Health Information Acquisition Model (HIAM) (see Figure 5-1) developed by Freimuth, Stein, and Kean (1989) to organize their book focusing on the operations of the Cancer Information Service (CIS) (see Table 5-1). While the model itself has never been explicitly tested, it is grounded in descriptive research focusing on the responses of callers to the CIS. The model rests on more classic information-processing models (e.g., C. Atkin, 1973; Lenz, 1984). The labels and conventions used in its graphical representation place it clearly in the flow-chart tradition, with a series of yes-no decisions and branches based on these decisions. The models almost exclusively focus, at least graphically, on surface-level action. The model also recognizes the need for feedback loops at various stages that may require users to go back and repeat particular sequences, a rather common problem in non-programmed information seeking, as the nature and scope of the problem (and perhaps even new stimuli) change as a search unfolds.

Figure 5-1: Health Information Acquisition Model.

Adapted from *Searching for Health Information: The Cancer Information Service Model* by V. S. Freimuth, J. A. Stein, & T. J. Kean, 1989, Philadelphia, PA: University of Pennsylvania Press, p. 8. Copyright 1989 by University of Pennsylvania Press.

The model starts with a stimulus, either internal or external, which requires a user to evaluate his/her current information. If it is adequate, there is no need to search further. If inadequate, then a user must set goals for an information search and determine if attainment of those goals is important. If they are, then an individual engages in search behaviors and evaluates the information obtained. If the information is adequate, then the individual makes a decision. If the information is inadequate, then a seeker might engage in another cycle of information seeking if s/he determines that the benefits outweigh potential costs. At times, however, even if the information is important, searches may "end prematurely because they seem to be yielding more frustration and confusion than insight" (Freimuth et al., 1989, p. 12).

This and other flow models have some compelling advantages. First, they provide pragmatic guidance to designers of information systems, which was, after all, often their original purpose. The HIAM, for example, was explicitly formulated to guide those interested in disseminating information to the public. Second, they also can help individuals construct a rational plan for a search.

The Health Information Acquisition Model shares some common problems with flow models. First, they assume that professional authoritative sources are the primary ones consulted. As a result, they don't have very full representation of the complexities of the information-carrier matrix. Second, especially with the current development of comorbidities, most individuals are engaged in multiple simultaneous searches for information with each one possibly stimulating others. Third, at times these searches inform each other, so the outcomes of one search may suggest that further information relating to various other alternatives does not need to be included in future searches. So, if I decide surgery is not an option for a certain condition, then when it comes to looking for information relating to coping with a disease, I need not be concerned with the aftereffects of surgery. Fourth, at times during the process of searching for information on one issue, serendipitously the need for information on another is uncovered, often through accidental exposure, resulting in a stimulus for further searches, a feedback loop not currently contained in the model. Most of the flow models (partly because of the absence of feedback loops) assume success and do not deal effectively with other outcomes (e.g., the frustration arising from contradictory recommendations noted in the HIAM). Fifth, as the foregoing suggests, sometimes information-seeking behavior is non-linear (Longo et al., 2010).

Unfortunately these linear stage, or phase, models almost always run into problems in the real world, where people do not engage in an orderly, sequential, mechanistic approach to problems. These models offer rational approaches to irrational phenomena, driven by only dimly understood underlying processes and as a result do not capture the "blooming confusion" of the real world. Sixth, at the outset of a search, sometimes the need is only vaguely defined and the ulti-

mate outcome goals are uncertain. Some might even suggest that determination of whether or not a search is worth it might come before setting of goals for it (or at the very least this might be a reciprocal, iterative process). Finally, and most importantly, these models just describe surface actions that are driven and shaped by variously underlying processes and that must surmount barriers not specified in the model (e.g., beliefs, efficacy). At the very start of the process, the stimulus may be not apprehended because of denial and avoidance processes we will return to in the next chapter. Further, sometimes individuals, through the actions of concerned intermediaries, are brought into the flow downstream from the initial starting point. As Weick (1969) observed long ago, sometimes rationality results from action; it does not precede it nor activate it.

Figure 5-2: Expanded Conceptual Model of Information Seeking Behaviors.

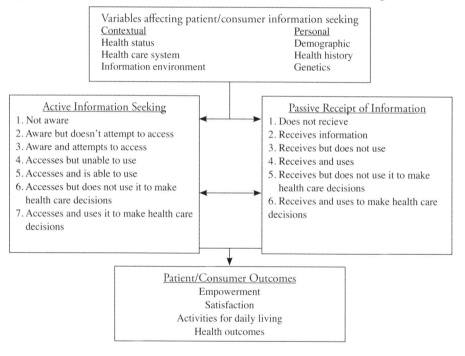

Adapted from "Understanding Health Information, Communication, and Information Seeking of Patients and Consumers: A Comprehensive and Integrated Model," by D. R. Longo, 2005, *Health Expectations*, 8, p. 192. Copyright 2005 by Blackwell.

Domain Models
Another popular approach is essentially to lay out major components of the processes without specifying relationships between them. This also is a way of ap-

proaching developing typologies or categories of different issues or processes that need to be considered in the information-seeking process. One example of this approach is Burt and Kinnucan's (1990) Information Model, specifying Internal Personal Actuality and Internal System (i.e., information technologies), Actuality, as bridged by representations of Cognitive Models (i.e., knowledge structures), Data Models (i.e., relational data bases), and Conceptual Models (i.e., user views).

Longo's (2005) Expanded Conceptual Model of Information Seeking Behaviors (ECMISB), while suggesting phases, somewhat akin to flow models, would seem to fall primarily in the domain realm (see Figure 5-2). It specifies two classes of variables influencing information behavior: contextual (e.g., health status, information field, networks), and personal (e.g., demographics, personal experience). It then specifies phases of information use, differentiating active and passive information seeking in the process. Finally, it explicitly details patient consumer outcomes such as empowerment, satisfaction, and activities of daily living. Its roots are in the HBM and in the traditional concerns of physician-patient interactions, especially adherence issues. Along with the CMIS, it has been recognized by the NCI as one of the few viable models of health information-seeking behavior (Longo et al., 2009).

Model of Risk Information Seeking and Processing

The Model of Risk Information Seeking and Processing (RISP) has been programmatically examined empirically (See Figure 5-3) (Griffin, Dunwoody, & Neuwirth, 1999; Kahlor, Dunwoody, Griffin, & Neuwirth, 2006). This model has been tested in international contexts, and newly proposed paths have been added to it as a result (ter Huurne, Griffin, & Gutteling, 2009). In some ways, it represents a more sophisticated version of flow models, with some appreciation for causal factors drawn from the Theory of Planned Behavior and other theoretical models that may influence decisions to seek or not to seek information. Perceived hazard characteristics are assumed to determine affective responses, which in turn, along with information subjective norms that reflect social and cultural factors, lead to a determination of information insufficiency, and also indirectly, information seeking behavior. Information insufficiency follows an assessment of current knowledge against a sufficiency threshold. This concept is similar to Dervin's gap notions. The higher the sufficiency threshold, following classic attitude change models, the more effortful and motivated the information seeking (Griffin et al., 1999). The relationship between information insufficiency and information-seeking behavior is then moderated by relevant channel beliefs, which are similar to the variables contained in the model of Media Exposure and Appraisal (MEA), and perceived information-gathering capacity, which relates to one's sense of self-efficacy. The model identifies individual characteristics, or demographic factors, as playing a role in these processes. Empirical tests of the model, similarly to the

CMIS findings, suggest that many of its variables have both direct and indirect effects on actions (ter Huurne et al., 2009). They also suggest that emotions play a very strong role when perceptions of risk are involved, reflecting the operations of variables at deeper levels, beyond rational apprehension. Their discussion of categories of seeking and processing is evocative of fields (routine heuristics) (Griffin et al., 1999). They go on to say that stable fields might be particularly important for lifestyle changes associated with improving health.

Figure 5-3 Risk Information Seeking and Processing Model (RISP).

Adapted from "Proposed Model of the Relationship of Risk Information Seeking and Processing to the Development of Preventive Behaviors" by R. J. Griffin, S. Dunwoody, & K. Neuwirth, 1999, *Environmental Research Section* A, 80, p. S232. Copyright by Elsevier.

Kahlor (2010) has recently found promising results for an augmented RISP model focusing on intent (Kahlor, 2007). Interestingly, the 2007 empirical tests demonstrated lower paths between levels and rational responses. The RISP model has been criticized for not focusing on the information that is retained, slighting the role of emotion, and only being tested with survey data (Turner, Skubisz, & Rimal, 2011). The augmented RISP includes variables from the Theory of Planned

Behavior, Health Belief Model, as well as explicit parallels with the Health Information Acquisition Model and the CMIS to which we will now turn. However, in doing so, Kahlor is moving beyond modeling, threatening its traditional parsimonious approach.

Tests of the CMIS

Communication research has focused on senders (e.g., professional medical sources) and how they can use persuasion and communication campaigns to influence individuals; comparatively little research has focused on the receiver as an active information seeker and processor. In addition, most models of health behaviors, such as the HBM, have traditionally slighted or downplayed the role of communication. On the other hand, models of channel and media usage neglect the powerful health-related motivations that often impinge on individual usage of particular information carriers. Given these critical shortcomings of different models that could be used to explain information seeking related to health, a synthesis is needed: a comprehensive approach to information seeking, such as that developed in the CMIS.

The Comprehensive Model of Information Seeking (see Figure 3-1) seeks to explain actions related to information seeking. It accounts for the stream of health information behavior, continuous action, and in the context of our approach to health, not any one particular episodic problem. To recapitulate, it contains three primary classes of variables. The antecedents, discussed in Chapter 3, reflect the underlying imperatives to seek information; they activate, however imperfectly, individuals to seek information and determine the intensity of their search. Information carrier characteristics, referred to in Chapter 4 when we discussed the model of Media Exposure Appraisal, shape the nature of the specific intentions to seek information from particular carriers and involve an assessment of their goodness of fit for particular purposes. Information seeking actions reflect the nature of the search itself; they are the outcomes of the preceding classes.

The CMIS has been empirically tested in health (Johnson, 1993b; Johnson & Meischke, 1993b) and organizational contexts (Johnson, Donohue, Atkin, & Johnson, 1995). Thus, it has been subjected to tests in differing conditions to assess its generalizability to a wider range of information settings (Baker & Pettigrew, 1999). Johnson (2003) has systematically compared these two contexts and their implications for the CMIS. The empirical tests rest on a foundation of rigorous scale development, unique in this area of research, and tests of the entire model. Like other encompassing models, portions of the CMIS have also been tested in subsequent empirical research (e.g., Han et al., 2010; Kelly, Andrews, Case, Allard, & Johnson, 2007; Rains, 2007, 2008).

The CMIS has been cited by the National Cancer Institute as one of three viable models of information-seeking behavior (Longo, 2005) and as one of six

models of health information-seeking behavior identified after a systematic litera-
ture review (Lambert & Loiselle, 2007). The CMIS has also been reviewed and
used in the information science,[1] communication, and health literatures.[2]

A major advantage of CMIS is that it is one of the few models discussed in
this chapter that has been empirically tested in differing contexts, in its totality.
Research on the CMIS suggests it provides the "bare bones" of a causal structure,
although the nature of the specific relationships contained in the model appear to
be context dependent. Tests of the CMIS in health situations suggested the model
worked best with authoritative channels, such as doctors, which are the object of
intense, goal-directed searches (Johnson, 1993b; Johnson & Meischke, 1993b)
and in organizational contexts for rational programmed tasks (Johnson et al.,
1995). In other words, when underlying factors have been crystallized by impor-
tant events or by experience with programmed tasks, the rational flow of processes
specified in the CMIS appears to come to the fore (Brooks, 2011). The findings
of these empirical tests point to a number of issues that need to be confronted in
future empirical work.

While context is an integral part of information seeking, the extent to which
the two can be systematically related is limited by the lack of literature consider-
ing both concepts in tandem (Johnson, 2003), although recently this situation has
improved markedly (Johnson, 2009c). Determining clear linkages to contextual
factors offers the potential of moving information-seeking research from the de-
scriptive level it has generally operated on a more theoretical level, a topic we will
return to in the concluding chapter. Thus, greater understanding of context isolates
crucial explanatory variables and could suggest theoretical propositions between
contextual and information-seeking variables generalizable across situations.

Most of the prior research on the CMIS has focused on cancer-related infor-
mation seeking by the general population (Johnson, 1993b; Johnson & Meischke,
1993b). Needless to say, for most individuals this is a nonrecurring problem,
which is novel and fraught with emotional complications, for which individuals
do not have established scripts to shape their actions. In many ways, this situation
is analogous to the nonprogrammed decision processes that led organizational
theorists to emphasize the irrationality and subjectivity of organizational deci-
sions (March, 1994). In addition, for cancer-related information seeking, at least
at the advanced stages, answers must be timely and authoritative.

Tests of the CMIS in the defined context of a technical organization sug-
gested critical differences in the more rational and programmed tasks faced by
engineers. The critical mediating factor of characteristics in the prior (i.e., health-
related) tests was not as crucial in this organizational context, in which individuals
gathered information wherever it might be available, whatever the characteristics
of the media. The most important variables were those related to an individual's
existing information base, those associated with an individual's need for recur-

rent, programmed information seeking, and those drawn from Johnson's model of MEA. The results also suggested that, in the organizations, individual differences in education and interpersonal interdependence play a more direct role; the general pattern of findings suggested a more sophisticated understanding of information seeking among technically trained respondents, resulting in more programmatic, scripted approaches that, while rational, are often outside of conscious awareness.

As in prior tests of the MEA, only a minimal relationship was found between appraisal/utility variables and exposure ones, reflecting imperfect translations between deeper and surface levels found in all the social sciences as well as in tests of RISP. The results of the CMIS test suggested there were few dramatic differences between channels, questioning the traditional fascination with channel selection in the discipline of communication (Rice, 1993; Sitkin, Sutcliffe, & Barrios-Choplin, 1992). This implies that differing media may be easily substitutable and that answers to questions are the central, overriding concern of respondents. This is especially true of the frantic search for answers that may characterize the search process immediately after a diagnosis of life-threatening disease, when "just-in-time" information is needed. In the organizational tests, antecedents had significant direct impacts on actions; while in the magazine test, which focused on a general population sample and a health-related context, antecedents had minimal effects on any of the other variables, suggesting that the mediating role of information-carrier factors may depend on specific contexts.[3]

J. D. Johnson and Meischke (1993b) found clear evidence for magazine exposure in which the antecedent factors discussed in Chapter 3 played a minimal role; the critical factors were the characteristics of the channel. Because of this, the impact of health-related factors may indeed be minimal since the factors that activate a need for information have not been triggered, echoing classic problems of accidental exposure to which we will return in Chapter 9. It is clear that in the early stages of cancer-related information seeking, the channels that we are recurrently exposed to in our environment have critical implications for our information acquisition. Thus, a disquieting finding of this research is that health-related factors contribute only minimally to the CMIS at the early stages of health information seeking, where routines and scripted approaches have not crystallized and general models of media exposure might serve a researcher just as well; this is a conclusion also reached by other researchers, as we will see in the concluding chapter.

In the initial study, the doctor channel represented in many ways the clearest support of the CMIS, with the strongest relationships between variables, especially health-related factors (Johnson, 1993a). Prior research results have also indicated that media receive relatively lower evaluations than other channels as sources of cancer-related information, even though they are the most frequently

used channel. More generally, the patterns of relationships for the paths between information-carrier factors and information-seeking actions suggest that there may be a qualitative difference between doctors and the other channels for these paths. Certainly there is much less likelihood of accidental exposure to doctors than there is to the other channels. In that sense there was less "noise" in the tests of this channel. The uses and the gratifications individuals seek from the doctor channels are also quite different from those sought from the other channels in terms of issues like typical content domains (treatment, diagnosis), compelling motivations, and the authoritativeness of answers.

It is possible that for individuals who are more directly confronted by cancer, their original information field and the reasons for it (e.g., entertainment, social support) have remained largely intact. However, special needs lead to the searching of additional channels, in this case doctors and other health professionals, for very limited domains of specialized, tacit knowledge. Searches for these specialized gaps would be much more goal directed, rational, subject to conscious awareness, and linear, than for those channels that represent an individual's typical information field. This is further reinforced by the increasingly limited array of authoritative channels that can answer specific information inquiries as a search continues. So, early on almost any channel might contain information somewhere concerning the benefits of mammography screening, but very few channels might be able to answer questions about the efficacy of a new experimental treatment and, as a result, the possible sources of information narrow considerably (Paisley, 1993).

The failure of some CMIS paths also reflects their linkage to general predispositions to communicate, rather than being linked to specific information-seeking problems. These factors are tied to another disappointing result of the tests, the low levels of variance explained in information seeking actions, although the variance explained fell within the ranges classically found in studies seeking to explain media usage (Palmgreen, 1984) and tests of other information-seeking models. There are two potential explanations for these findings. One is the traditional disparity found in social science research between beliefs, intentions, and behaviors, especially in health contexts (Ajzen, 1987). The disjuncture between these domains parallels the three major components of the CMIS: antecedents, information-carrier factors, and actions. J. D. Johnson (1982, 1984c, 1985) in a series of tests of a model of social interaction, long ago made the point that there is only an imperfect translation between these sorts of levels, which at times, in more modern views, may even operate at cross purposes to each other.

More recently, there has been a trend in the social sciences to recognize different types of consciousness or rationality, a subject to which we will return in the next and concluding chapters. Reflected in the antecedents are factors beyond the conscious awareness of most individuals; these are only partially apprehended by individuals with deep tacit understanding of issues, such as those experienced

in work situations, as a result of long practice, habitus, the 10,000-Hour Rule or, as in disease situations, when individuals are forced to confront more directly their underlying drives and needs (Brooks, 2011). So in these contexts, more latent (unconscious, tacit knowledge) forces can become more manifest (rational, subject to conscious awareness), shaping individual's evaluations of carriers and then actions.

Second is the largely accidental exposure of respondents to health information in the media, and for that matter other easily accessible channels, such as friends/family members, and the large number of other factors that might account for exposure, such as ritualized use of a channel and exposure driven by other concerns (e.g., entertainment) (A. M. Rubin, 1986). Interestingly, the patterns of results for number of sources consulted and the number of times a source was consulted, the primary operationalization of actions in the tests, indicated a different pattern across the various contexts. For friends/family and doctors, effects were greater for times media were consulted, and on numbers of sources consulted. De facto exposure is incidental to normal media use, whereas motivated selection is more likely to occur when someone is ready to change a health behavior (Flay, McFall, Burton, & Warnecke, 1990). For example, TV is the least specialized of the media, most commonly used for entertainment, as part of daily rituals, but also used for other functions such as surveillance of the environment (Katz, Gurevitch, & Haas,1973). TV exposure might have diluted the effect of the variables examined in the CMIS, which were posited to activate information seeking.

Seeking information from the media might be separated from health concerns, unless driven by a specific need (Reagan & Collins, 1987). Thus, at least for a general population sample not directly confronted by the disease, factors that account for media exposure generally may be better explanatory variables for exposure to health-related information than purely health-oriented variables, a point to which we will return to in the concluding chapter.

Summary

As we have seen in this chapter, various models have been developed to describe information seeking. Some have even suggested that information-seeking theories constitute a major stream of conceptual thought in health communication. Unfortunately, the level of theory and research related to this critical area has lagged behind the numerous persuasion theories that undergird health communication campaigns. In addition, significant theoretical research has focused on how information is processed on these issues (Buckland, 1991), rather than focusing on how it is acquired (Miller & Jablin, 1991). With a few notable exceptions (Atkin, 1973), most information-seeking models have been surface-level descriptive ones, almost treating the process of information seeking as equivalent to a black box.

In many ways, when we look at the literature on information seeking, forms of action have been surprisingly under-conceptualized. This is especially so when we compare the models we have examined in this chapter (see Table 5-1). In the RISP model, alone among the ones evaluated here, in spite of the well-established disconnect between them and behaviors, sometimes intentions serve as a surrogate for action. The ECMISB specifically delineates active and passive searches and ties actions directly to decision-making processes. The models perhaps differ most dramatically in their discussion of flow or cycles of behavior, with the HIAM clearly specifying a potentially iterative process in searching. Both the RISP and CMIS, which share much in common, identify a one-way causal direction specifying underlying generative mechanisms. Although especially with the contemporary focus on health, and the growing concern for chronic disease and comorbidities, searching has become a more continuous, rather than episodic process, always ongoing at some level, with answers often stimulating further searches, and may provide a rationale for not having explicit feedback loops in CMIS. The CMIS is over-simplified by design; a more detailed, surface-level model might include feedback loops from actions to antecedents, for example, and this has been a criticism of the CMIS (Lambert & Loiselle, 2007). The models do not specifically articulate a rich conceptualization of pathways, although the ECMISB traces a hierarchy, and Johnson elsewhere in his work offers a framework for examining them within his information-carrier matrix. Finally, the ECMISB, RISP, and CMIS explicitly incorporate broader notions of information fields, with Johnson and his colleagues arguing that its underlying process could account for its expansion or contraction. In the realm of action, other scholars have suggested that the match between information retrieved and information needed (Bates, 1989) and habituated information seeking (Wilson, 1977) should be examined in models.

The differences across these models may be partially attributable to their roots in different theoretical traditions. Only the ECMISB and CMIS explicitly claim a common root— the ubiquitous HBM. They also have differences in context, with the HIAM having a very narrow focus on the Cancer Information Service, although its authors suggest it could be extended to other programs. The other models focus on health more generally, but in the case of the RISP and CMIS, there also is a focus on other contexts, environmental risks and organizational respectively. Both the HIAM and the ECMISB have more of a grounded, inductive approach, being based on prior empirical work of their authors. The RISP and CMIS both have been tested empirically, holistically and partially, and as a result of those tests, more refined understanding of those models has developed: they are more open, in Littlejohn and Foss's (2011) terms.

In the case of antecedents, except for a person's information base, the HIAM, while often discussing them in connection with the model, does not specifically incorporate them in its graphical depiction. All of the models make reference to

demographic factors. They all also, in one way or another, include some specification of an individual's existing information base, although the HIAM and RISP both make more explicit references to deficits or drivers of future information seeking. Salience and beliefs are not explicitly included in the ECMISB, and salience is implied in the stimulus that starts the process for the HIAM. In some ways, as Table 5-1 suggests, comparing models is hampered by the interchangeable concepts that are being used to claim differences between models that are more apparent than real—as in other social science issues we are hampered by the modern-day Tower of Babel, this is particularly true for salience and belief factors in the RISP and CMIS. Neither the CMIS nor RISP provide operational guidance on specific behaviors that might be incorporated in programs designed to enhance information seeking, surface actions that are the focus of flow models. They instead focus on the underlying forces that drive individual persistence in acting to seek information. The CMIS has tried to answer the why question, focusing on underlying factors, which are theoretically derived and which might explain information-seeking behaviors. While the RISP and CMIS models explicitly do incorporate underlying factors, with RISP also specifically including emotions, most operate at a surface level and focus on rational actions.

The field of information behavior still struggles under the assumption that information behavior is highly rational (Case, 2012) and goal directed (Spink & Cole, 2006). Rationality may lie at the heart of some of the "dubious assumptions" embedded in the literature and articulated by Dervin (1976): there is relevant information for every need; it is always possible to make information available or accessible; and people make easy, conflict-free connections between external, "objective" information and their own internal reality. Rationality essentially reflects acceptable reasons, causes, and explanations and is often deeply rooted in our technologies. The rational implies thinking, weighing, reflection, while irrationality reflects intuitions, emotion, and subjectivity (Nahl & Bilal, 2007; Pharo & Jarvelin, 2006). However, there has been a move towards a more subjective view of human information behavior, especially in terms of relevance judgments of users (Case, 2002).

Case et al. (2005) have systematically articulated why the avoidance of information may be very rational in particular situations where people have low self-efficacy. Similarly, face-threatening information about job performance may not be sought out (Ashford, Blatt, & VandeWalle, 2003). It may be perfectly rational, then, to avoid information when there is nothing one can do with the answers one may obtain. Lack of information seeking when confronted with disease appears irrational because this is when information could be most beneficial and result in reduced morbidity and mortality. Yet studies indicate that people are less likely to look for information as their proximity to cancer increases (Schwartz, 2004). If the threat is extreme, or if any potential responses are not expected to be effective,

then an attractive alternative is to ignore the threat entirely, blunting out a stressful event (Baker, 2005)—which in turn promotes consistency (Case et al., 2005).

The ultimate goals of rationality may be to develop a sense of coherence, and a simple one at that, with satisficing the standard rather than maximizing (Bates, 2005; Pirolli & Card, 1999). Many have argued that most people do not want a wide range of options, in part because our cognitive limits for processing information have been exceeded (Schwartz, 2004). In a related way, people may pursue information not for new insights, but for validation, legitimation, and reformulation (Cross et al., 2001).

A deeper understanding of rationality is needed to confront some common findings in the information-seeking literature. We tend to assume people will expend a lot of energy to attack important problems and will also make sure of the quality of sources and of answers—but they clearly do not (Case, 2006, 2012; Johnson, 1996, 1997; Johnson et al., 2006). Accessibility of sources is often the key determinant of their use (Bates, 2005), even for heavily rational engineers (Case, 2006, 2012). Most theorists confront the world with a scientific model that implies exhaustive searching and testing to come to the correct conclusion. However, most seekers will stop searching when they discover the first somewhat plausible answer to their query. It may, indeed, be deeply rational to preserve ignorance, to experience its many benefits (Johnson, 1996).

While the CMIS offers some hope for a general theoretical framework, it has encountered somewhat contradictory, if understandable, empirical findings in tests in different contexts. While a seeming weakness, this is actually a major strength of the model, since these empirical assessments of it are leading to a greater understanding of the complexities of these phenomena. So the tests point to staging, prior experience, and programmed nature of tasks as major limiting conditions on specific paths within the model. Other research has suggested a range of theoretical variables that might usefully be incorporated in a future model including the value of information (Mason, 1987), and the nature of ignorance (Wilson, 1977).

For information-carrier factors, in different ways the models incorporate social context, with the RISP specifically making appeal to informational subject norms (See Table 5-1). For characteristics, the ECMISB explicitly makes the important distinction between active and passive, which we will return to the final chapter. The RISP model refers to relevant channel beliefs, while the CMIS, which incorporates the MEA, is a little more specific, with references to editorial tone and communication potential. Alone among the models, the CMIS, following its grounding in uses and gratifications theory, explicitly incorporates utility assessments of information carriers.

In formulating the CMIS, Johnson and his colleagues chose explicitly not to focus on outcomes beyond actions (see Table 5-1). As we will see in the next

chapter, potential outcomes of information seeking are legion and not exclusively positive, something that the models all mention at some level. Interestingly, there is almost a presumption that the quest for information will be ultimately satisfied or that it can be satisfied—the information is out there—we just have to find it. The other models also assume that improved decision making and enhanced literacy will be outcomes of the information-seeking process. The ECMISB and the RISP, in particular, assume that the more effort one engages in, the more stable will be the health outcomes.

Notes

1 With some of the articles based on it among the most frequently cited in a variety of information science journals (Andrews, Johnson, Case, Allard, & Kelley, 2005; J. D. Johnson, Andrews, & Allard, 2001).

2 For a partial listing, the reader can consult these sources: W. A. Afifi et al., 2006; W. A. Afifi & Weiner, 2004; T. D. Afifi & Afifi, 2009; W. A. Afifi, 2009b; Babrow, 2001; Case, 2002, 2007; Czaja et al., 2003; Griffin et al., 1999; Lambert & Loiselle, 2007; Napoli, 2001; Rains, 2008; Rice, McCreadie, & Chang, 2001; Savolainen, 2008; T. D. Wilson, 1997.

3 This general finding may be partially attributable to the nature of channel differences examined in the organizational test, which focused on issues of authority and the official nature of the channel, rather than more classic communicative attributes of the channel, which had been the focus of prior research work. Reflecting this, the path between characteristics and actions was not supported, suggesting contingent channel differences that need to be explored in future research, perhaps incorporating some perspectives on channel usage (e.g., social information processing) discussed in Chapter 4.

Further Readings

Freimuth, V. S., Stein, J. A., & Kean, T. J. (1989). *Searching for health information: The Cancer Information Service model.* Philadelphia, PA: University of Pennsylvania Press.

The strength of this early review of research on health information seeking lies in its thorough analysis of data from over one million calls to the Cancer Information Service and of follow-up surveys of more than 7,000 callers. Based on this, the authors advance a model of health information acquisition that is noted for its consideration of cognition in response to an information need, e.g., as when a patient thinks about the benefits versus costs of seeking.

Johnson, J. D., & Meischke, H. (1993). A comprehensive model of cancer-related information seeking applied to magazines. *Human Communication Research, 19,* 343–367.

This article brought together Johnson's earlier work on a model of media exposure and appraisal, with uses and gratifications research findings, and the Health Belief Model. The resulting Comprehensive Model is applied to informa-

tion seeking about breast cancer. The media examined in this case are magazines, which were thought to be a good vehicle for reaching women at risk and alerting them to prevention and screening possibilities as well as potential treatment options. The difficulties associated with measuring health beliefs receive particular attention.

Kahlor, L. (2010). PRISM: A Planned Risk Information Seeking Model. *Health Communication, 25*(4), 345–356.

LeeAnn Kahlor's PRISM model melds Ajzen's (1991) Theory of Planned Behavior with the Risk Information Seeking and Processing Model of Griffin, Dunwoody and Neuwirth (1999). Elements are also taken from several other health-related theories and models, including the CMIS and the Extended Parallel Processing Model (Witte, 1992). In a test of PRISM with 804 online respondents, the model accounted for 59 percent of the variance in information-seeking intent. An open question is the degree to which the model would hold up when tested with specific health risks rather than the general risks assessed in this test.

Lambert, S.D. & Loiselle, C.G. (2007). Health information-seeking behavior. *Qualitative Health Research, 17*, 1006–1019.

A thoughtful analysis of literature on the concept of health information-seeking behavior (HISB). Reviewing 100 articles and five books, Lambert and Loiselle note variance and lack of specificity across these writings regarding definitions of the concept. They see HISB as employed in three distinct contexts: coping with health threats, participating in medical decision making, and in behavior change/prevention. Among the problems they see in some literature: a tendency to oversimplify the process and components of seeking; an assumption of active seeking, ignoring the potential for passive receipt of information; lack of attention to different outcomes (e.g., receipt of information but not use of it; or rejection of information from one source but acceptance of it from another); and confusion about antecedents (e.g., what personal and situational variables give rise to information needs, and the extent to which those needs might be ignored). As a remedy, they advocate the careful study of the interaction among personal and contextual factors related to information seeking.

Lenz, E. R. (1984). Information seeking: A component of client decisions and health behavior. *Advances in Nursing Science, 6* (3), 59–72.

Given the increasing emphasis on patient participation in healthcare, this synthesis was prescient in its conclusions. Based on a review of three decades of relevant literature in both health-care and consumer behavior, Elizabeth Lenz devised a model of the information search process composed of six steps: stimulus, goal, decision to seek, search behavior, information acquisition, and evaluation

of adequacy of the latter. Lenz saw the client as an active seeker and sketched out ways that such seeking might be investigated.

Longo, D. R. (2005). Understanding health information, communication, and information seeking of patients and consumers: A comprehensive and integrated model. *Health Expectations, 8,* 189–194.

This essay by *Health Expectations* editorial board member Daniel Longo underscores the need for a conceptual model of health information seeking and use and the role of passive receipt of information within that process. As the studies by his colleagues and other researchers indicate, many consumers still receive health information through traditional mass-media sources like newspapers, magazines, radio, and television. But whether the public actively seeks or passively receives such information, there are still many barriers before they put the information to use in making personal health-care decisions. The conceptual model developed by Longo and his colleagues describes the multiple stages of seeking/receipt of information and identifies the many contextual and personal variables that influence those phases. Longo's essay is a possible corrective for those who overestimate the degree of active health information seeking (especially through the Internet).

Outcomes of Information Seeking

Overview

In this chapter, we consider the results of the processes we have described in the preceding three chapters. There have been many different ways to conceptualize the beneficial outcomes (e.g., as uncertainty reduction versus "making sense") and the pitfalls that may arise (e.g., wrong conclusions, or limited access to sources of information). The optimistic assumption that people usually pursue and find the information they need—however flawed that process may be—is what we call "the bright side." In contrast, under the heading of "the dark side" (e.g., several problems and negative outcomes), we pay particular attention to issues of ignorance and avoidance of information.

The Bright Side

> The aim should be to aid and foster a self-reliant, self-actualizing consumer who can make the most of decisions and play an equal role with sellers in the marketplace. The key to such consumer emancipation is better information (Thorelli & Engledow, 1980, p. 9).

It would be natural to assume that when a person looks for information, they usually find it—or at least part of what they were seeking—and then go on to apply that information to whatever task or curiosity prompted the search. It could

well be that this scenario is indeed the most common one. Yet, we know that many attempts to expand knowledge are frustrated and incomplete or hardly get underway before they are abandoned. We will deal with most of those negative scenarios a little later in this chapter. Our intention in this section is to describe the handbook, rational view of the information-seeking process as discussed in various theories of decisionmaking and sense making.

Sense Making

Sense making is often said to be the process by which we find meaning in our experience. The characterization that what people do with information is to "make sense of it" has its origins in the work of various phenomenological sociologists, particularly Alfred Schutz, Aaron Cicourel, and Harold Garfinkel. The roots of this way of thinking about thinking and learning are also found in the writings of various psychologists, including Jean Piaget and Jerome Bruner. While its origins stress individual understanding, some scholars of organizational behavior, such as Karl Weick and Gary Klein, have applied sense making in a collective sense. Thus, sense making is a framework that has been applied widely across many fields of inquiry.

Within the academic discipline of communication, the person most associated with the sense-making tradition is Brenda Dervin of Ohio State University. Dervin's work has been closely tied to research on information seeking through a wide variety of collaborations with scholars in health communication and information studies. A key concept in her thinking is that of a "gap"—the discontinuities or problematic situations that constantly arise in our lives; these gaps need to be bridged, and some of them can filled by information. At other times, gaps may require physical resources, emotional support, or some other form of non-informational "help" in order to be satisfied. Dervin and her colleagues (1980, 1989; Dervin, Jacobson, & Nilan,1982) have found that information seeking is related to "gap-bridging": individuals ask questions that are directed at determining the implications of events for themselves directly and/or related to their future activities. In this way, Dervin places sense making at a higher level of both importance and abstraction than the notion of information seeking. Dervin (1983, p. 170) describes the human situation as one in which "The individual, in her time and place, needs to make sense. . . . She needs to inform herself constantly. Her head is filled with questions." Indeed, an attempt to make sense of a situation typically starts with burning questions, whether asked of others or of oneself. The actor's current need for drive reduction, or gaps, and his/her related information purposes are critical triggers, then, to the process of information seeking and are shaped by the more concrete antecedents within the CMIS. As Kuhlthau (1991) has suggested, gap-bridging moves beyond just uncertainty reduction and often encompasses considerable anxiety evoked in the individual when facing unknowns. More contemporary approaches have moved beyond simple "gaps" to the man-

agement of uncertainty, recognizing that there are many reasons for seeking (or not seeking) information, such as reassurance (Johnson, 2009a).

Perceptions of various gaps in knowledge (usually known unknowns) triggers an information-seeking process, represented by the CMIS; the outcomes of that process, the information gathered, are then interpreted by sense-making processes (e.g., Savolainen, 1993; Thomas, Clark, & Gioia, 1993). The answers obtained are then compared to the original problem represented by the gap. If the gap remains (or if a new one has been created by the search), then the process continues, until time has expired (or exhaustion sets in, and people do not exhibit much *persistence* in their information-seeking actions [Johnson, 2009a]). Thus, information seeking is a dynamic process, with an individual's level of knowledge, reflected in their health literacy (as discussed in Chapter 1), changing as it develops (Kuhlthau, 1991).

Sense making shares with other approaches to information seeking the recognition that something is missing; e.g., that one's knowledge or emotional state does not match some preferred state or criterion level—as found in the work of Atkin (1973), Taylor (1968), and Miller, Galanter and Pribram (1960), among many others. Psychology and computer science have contributed related notions such as "schema" or "frames" (e.g., Minsky, 1974) and "mental models" (e.g., Johnson-Laird, 1983). That is, that we maintain knowledge structures with "slots" for the different features of common items and situations in the world; we know when information is missing from a given context and may unconsciously replace it with generic or default information or instead try to remember or to discover more accurate information.

Recently Klein (2009) has argued that making sense of decisions involves fitting data into a frame, or mental model, while simultaneously searching for a model that suits the data. When the data and frame do not seem to fit well, either the frame or the data may be rejected. So this back-and-forth search for a proper fit does not start with or privilege either the information (i.e., its relevance or accuracy) or one's world view but stands ready to reconsider either one.

Decision Making in Theory and in Practice.
"Much information seeking research is intertwined with decision making," wrote Donohew and Tipton (1973, p. 251) nearly 40 years ago. Indeed, over many decades, behavioral scientists in psychology and management have conducted studies of decision making and problem solving (e.g., March, 1994) in which both search and communication play key roles. The theories of decision making that have resulted from these investigations are still hotly debated. Of particular concern are the roles of uncertainty and cognitive bias in the process (Goldstein & Hogarth, 1997; Zey, 1992). Informed choice is the cornerstone of health consumerism and shared decision making and would rationally seem to increase

the drive for information seeking (Czaja, Manfredi, & Price, 2003). However, in many cases, especially those involving mental-health problems, patients are coerced into seeking care, with detrimental impacts on their information seeking (Pescosolido, Gardner, & Lubell, 1998). Even when they can freely choose, consumers typically don't compare alternatives, even when information is made available to them (Hibbard, 2003), nor do they act in accordance with the information they acquire (Ochoa et al., 2010). To many, the ultimate outcome of the health information-seeking process is better decision making (Lenz, 1984). But what constitutes an acceptable answer that will end a search, or alternatively, what tells us to give up a search—does it end with a whimper or a bang?

DECISION MAKING IN THEORY. The "Behavioral Decision School" of organizational theory has originated some important concepts for studying human communication. For example, many communication theorists have argued that the primary function of communication is the reduction of uncertainty (Berger & Calabrese, 1975; Farace, Monge, & Russell, 1977; Farace, Taylor, & Stewart, 1978)—although other scholars argue that this is not always so (e.g., Babrow, 1992; Bradac, 2001; Brashers, Goldsmith, & Hsieh, 2002). Uncertainty is generally seen as equivalent to lacking the appropriate information (MacCrimmon & Taylor, 1976) and is virtually a synonym for describing the gaps that often trigger information seeking (Dervin, 1980). Some research for example, has cast doubt on the fundamental linkage between uncertainty and information seeking, with researchers suggesting that in some situations, ignorance truly is bliss (Kellerman & Reynolds, 1990).

Uncertainty is often defined as a function of the number of alternative patterns identified in a set and the probability of each alternative (Farace et al., 1977). Information can remove uncertainty by helping to define relative probabilities, but it also can increase uncertainty when it leads us to recognize additional alternatives or to change the assessment of probabilities. Unfortunately the more uncertain the information, the more subject it is to favorable distortions (Downs, 1967), and, when information is vitally required, there is a tendency to treat it as more reliable than it is (Adams, 1980).

Thus, the key element of decision making is the selection from alternatives. If there are no true alternatives, then the decision is already made. But if there are many alternatives, all equally beneficial or problematic, then we have no basis for making distinctions and are left with a highly uncertain decision, since we do not have any basis for choosing the best alternative. So the number of alternatives, from two to infinity, has much to do with the complexity of decision making and of the information seeking in support of it. Not only do we have to gather information on each alternative relating to the various criteria that differentiate them, but we also have to gather information on how they interact and compare.

For example, often in choosing treatment options, we have to evaluate not only their medical efficacy, but how others might react to their side effects. So I may not be too disturbed if I lose what little remaining hair I might have, but I might be disturbed by my wife's reaction to this event.

One consideration is how much experience I have had in making this type of decision. Factors like experience can dictate how rational the information search might be (Johnson et al., 1995; Johnson & Meischke, 1993b). Similarly, if I have settled into a routine for making a decision, the premises of the decision and the information used to support it will be well known to me. Programmed decisions are routine, repetitive decisions for which a specific process has been developed, often computerized and quantitative (MacCrimmon & Taylor, 1976; Simon, 1960) and are the basis for the clinical decision programs we will discuss in detail in Chapter 8. Programmed decisions are often highly formalized, with set rules to follow and penalties associated with the breaking of the rules. So, for example, an insurance company might establish a strict protocol for patients presenting a particular problem to a physician. Increasingly there are concerns that while this sort of formalization can be efficient, it may ultimately be ineffective.

Decisions are non-programmed to the extent they are novel, unstructured, and important; to these, only very general models of decision making can be applied (Cyert, Simon, & Trow, 1956; Simon, 1960). For most individuals, initial decisions about various medical treatments are analogous to non-programmed decisions. (Part of the problem in physician-patient interactions stems from the disjuncture between what is a programmed decision for the physician is a non-programmed one for the patient and his/her family.) In their classic case study of the adoption of an information-processing technology, Cyert et al. (1956) point out how tortuous and cumbersome non-programmed decisions can be. In effect, the organization has to decide how to decide. Thus the decision-making process involves at least two major decisions, the first of which can contain many surprises. Perhaps you discover that a major issue needs to be considered that you hadn't included at first. So, the final decision must be postponed while the missing factor is assessed. When you gather information on the neglected issue, you discover that it interacts in unexpected ways with things you already thought you knew, which then forces you to rethink some already settled aspects of the decision. For some highly complex, novel, important decisions, a decision maker could literally go round and round for months, if not years, before s/he can reach the final stages of making a decision. One answer leads to another, instantiating pathways that are very complicated at best, if they do not lead us back to where we began. This is a luxury that decision makers do not always have, given the urgency of some health decisions, adding additional stress to the individual.

Relatedly, since information seeking operates in the support of making a decision, you may need to decide how to gather information. So, some individuals

argue that decision makers have two basic classes of decisions: one set on the substance of the matter and another on how to search for information (Johnson, 2009c). As we have seen, the role of information seeking, and more generally, communication, comes primarily in supporting the decision-making process by determining alternatives and gathering information related to them. The primary issue here is that a complete range of alternatives be selected and that the pertinent information related to each of them is gathered. Communication processes also play a critical role in how the alternatives are discussed and eventually how decisions are implemented.

While the selection of an exhaustive list of alternatives seems a straightforward process, any casual review of case studies of decision making suggests that often we seize on a limited range of alternatives, partly because of time pressures and then tend to gather information to support these early choices. Individual decision makers also exhibit a tendency to choose the first viable alternative. To a certain extent, we are all prisoners of our pasts and of our ideologies. Some have argued that the first stage of decision making really rests on the frame, or knowledge base, which an individual has developed because of his/her preexisting information fields and positioning within communication structures (Carley, 1986; Klein, 2009), which can severely limit the range of alternatives considered.

Where an individual fits within a communication structure has critical implications for the decision-making process (Connolly, 1977), influencing the volume of information and the diversity of information sources (Johnson, 1993a). So in effect we are doubly vexed: the support structures we rely on for determining alternatives may have already formed the choices we are likely to identify. Thus, the strength-of-weak-ties perspective (Granovetter, 1982) can be applied to decision-making approaches, especially for non-programmed decisions; we need to expand the range of communication sources to which we attend if we are to optimize our decision making. In the medical context, Jerome Groopman (2007) has pointed out the problems that can result when a physician narrows the range of his inquiry by avoiding open-ended questions while examining patients. A doctor quoted by Groopman (2007, p. 18) notes ". . . close-ended questions are the most efficient. But if you are unsure of the diagnosis, then a close-ended question serves you ill."

Once the major alternatives have been identified, then information needs to be gathered on the crucial dimensions of each of them and their consequences (Cyert et al., 1956). In many ways, this area, though it has been understudied when compared to the psychological processes associated with decision making (O'Reilly, Chatham, & Anderson, 1987; Saunders & Jones, 1990), represents some of the most intriguing findings related to decision-making research. Particularly so for the repeated finding, across several contexts, that people will knowingly use lower quality but more accessible information sources (Hardy, 1982).

While information seeking is critical to decision making and the associated process of uncertainty reduction, it is a subservient process, done to support these larger objectives. Thus, information-seeking research in these areas is often an afterthought, subsidiary to larger themes, although some have suggested processes related to attention and search are the most relevant to how decisions are made (March, 1994). A closer examination of this area can provide critical insights into both the underlying motivations to seek information and the outcomes of the information-seeking process.

Every day we see the consequences of poorly made decisions. Unfortunately, with increasing decision complexity, people become more conservative and apply more subjective criteria that are increasingly removed from reality (Van de Ven, 1986). Especially under conditions of threat, organizations, like some patients, may restrict their information seeking and fail to react to changing environmental conditions (Staw, Sandelands, & Dutton, 1981). Organizations in these circumstances may rely on existing behaviors, narrow their information fields, and reduce the number of information channels consulted.

The gathering of information often provides ritualistic assurance that the appropriate norms are being followed (Feldman & March, 1981). Ritualistic, repetitive information gathering is commonplace; individuals in interpersonal situations go over the same ground with individuals they like (Kellerman & Reynolds, 1990). In group contexts, members are more likely to share information they have already discussed, than to contribute new information (Stasser, Taylor, & Hanna, 1989). It appears that much repetitive information seeking is really aimed at increasing the confidence of decision makers in a choice they have already made (March, 1994). Information seeking often becomes a ritual that supports the appearance of rational decision making (Staw et al., 1981).

The problem is often not in deciding to seek information but on deciding when to stop. Having too much information can be as problematic as having too little when comparing various health-care alternatives (Hibbard, 2003). Adept decision makers know intuitively when they have gathered enough information for any particular purpose. They "satisfice" (MacCrimmon & Taylor, 1976), choosing an alternative that is simply "good enough" rather than optimal. They develop a sense as to when they have spent enough energy searching for information about any problem that confronts them (March, 1994). They also learn to approximate, to judge when they can make a high-enough-quality decision for any particular event (Farace et al., 1977). Decision makers search for an appropriate solution, not *the* optimal solution (Hickson, 1987). They have developed an appreciation for what their limits are, e.g., that they can mentally weigh only so much information at any given time.

Over the last three decades, studies have repeatedly demonstrated that decision making is often an irrational process. In fact, the link between decision

making and the processing of information is often much weaker than we would like to believe (Feldman & March, 1981). Decision makers often ask for more information (it is after all a part of the decision-making ritual) even when they have sufficient information on hand to make a decision (Klein, 2009). They know that very seldom will they be criticized for gathering additional information, but they might be blamed for failing to gather a critical piece of information (Feldman & March, 1981). Especially later in the decision-making process, sources are sought solely because they may say that the seeker can terminate their information seeking (Saunders & Jones, 1990).

An interesting paradox in this literature pertains to the relationship between information load and decision making. Decision makers often seek more information than needed, even when it induces overload (O'Reilly & Pondy, 1979). While this overload of information decreases decision quality, it increases the decision makers' confidence (McKinnon & Bruns Jr., 1992; O'Reilly et al., 1987), satisfaction (O'Reilly, 1980), and consumer comfort (S. Ward, 1987). Studies of firefighters, horse-racing handicappers, and weather forecasters show that these experts have increased levels of confidence when they are given more data yet typically exhibit worse results (Mauboussin, 2007). The problem is not the sheer amount of data per se but rather the difficulty in focusing on only the most relevant information. How does an individual determine that they should rely on experts, that there is an established body of knowledge? In effect, information becomes very addicting for some individuals; they have a constant desire for more, even when it has harmful effects, which may have some parallels to the cyberchondriac phenomenon discussed earlier.

DECISION MAKING IN PRACTICE: MEDICAL PROFESSIONALS. Increasingly, healthcare systems promote the gathering and sharing of information, a point to which we will return when we discuss health information technology. There is a constant dilemma for these systems, the imperative, in part stemming from efficiency needs, to limit the availability of information and the recognition that structural designs are flawed and circumstances change, requiring individuals to seek information normally unavailable to them. Still, the design of the formal structures and the rewards associated with them (e.g., promotion) often are arranged specifically to discourage the sharing of information (e.g., decreasing time spent per patient in HMOs) (Powell, 1990). Partly because of these constraints, physicians pursue only about 30 percent of the questions that arise during their practice (Dawes & Sampson, 2003).

Not only are there structural limits on the amount and kinds of information that any individual is likely to be exposed to, but there are also real limits to the amount of information that individuals can process given their psychological limits (Guetzkow, 1965). How they resolve these conflicting imperatives is a critical

question for modern health-care systems and leads directly to increasing tensions between patients and health-care providers.

The ignorance resulting from compartmentalization has the benefit of maintaining security (Moore & Tumin, 1949), and the ignorance of certain participants is essential to the maintenance of system equilibrium (Smithson, 1989). In fact, planned ignorance is essential to organizational efficiency achieved through specialization. By definition, a specialist focuses on a limited domain of knowledge; the broader the domain, the less sophisticated the specialist. One way to increase the efficiency of communication is to minimize the need for it by such strategies as coordination by plan, where specialized units concentrate on fulfilling formally assigned tasks that fit into the larger whole (March & Simon, 1958). The classic antidote to a monopoly on information is competition, often accomplished by establishing more than one channel for reporting the same information (Downs, 1967). Yet, health information is increasingly available to anyone who wants it, directly contradicting the underlying premises of medical specialization. The growth of the consumer movement in health can reduce the power imbalance between health professionals and patients.

Still, implementation of knowledge and innovations requires high formalization, centralization, and low complexity in systems. In some ways, the traditionally hierarchical specialist system works very well when answers are known and treatments are efficacious; it does not work very well for diseases like lung cancer where there are not effective treatments. This is also a major barrier to the creation of information systems, since inexperienced users have to negotiate a conflicting welter of claims and counterclaims, at the same time they realize that if they make a bad choice, they will personally bear a significant penalty (Brittain, 1985).

There is always an element of uncertainty in medical decision making; however, overt discussion of this uncertainty seldom occurs in physician-patient interaction, in part because of physicians' reluctance to share their uncertainty with patients (Politi & Street, 2011). Characteristics of physicians as decision makers also impact their relationships with patients. The typical physician believes in what he or she is doing, prefers action to inaction (especially surgeons, with most physicians assuming there is an illness until it is demonstrated otherwise), is pragmatic, and is highly subjective, relying on his or her experience and intuition. Relatedly, the typical physician is likely to play off uncertainty and chance when things go wrong—e.g., it works for most of my patients, you were just unlucky (Diamond, Pollock, & Work, 1994). In co-orientation frameworks, such predispositions can directly conflict with the preferences of active information seekers to seek rational knowledge and to wait to take action until they acquire it.

DECISION MAKING IN PRACTICE: PATIENTS. The Internet, as well as the traditional mass media, have made a wealth of medical information available to the ordinary

person, at a time when more power is being given to consumers to make health-care decisions. These circumstances create a tension between medical professionals and the patient, for which there is no easy cure.

Cancer is perhaps the most extreme example of this new world of medical information and decision making. Since a substantial proportion of cancer patients will eventually die of the disease and treatment is often painful, it is natural that fear and frustration drive many individuals to explore alternative, unorthodox treatments (Lichter, 1987). A survey conducted by the American Cancer Society (1992) found that 9 percent of cancer patients used scientifically unproven cancer treatments, most along with conventional therapies. Interestingly, more highly educated patients had the highest usage, perhaps because of the greater range of their information seeking. The well-to-do and the educated also have the time and financial resources to pursue unproven treatments, particularly when they weigh them against an overall cure rate of 50 percent for medically sanctioned ones (Reardon, 1989).

Perhaps the desperation of patients is related to the increased responsibility for treatment decisions that has been thrust upon them. And they not only have to participate in the decision but share the responsibility for how it turns out. As Barry Schwartz (2004) describes in another context, such a circumstance can easily lead to post-decision regret: patients must live forever after with the consequences of their choice, as it has become as much their responsibility as their physician's. This is a far cry from the days when doctors made all the decisions for us.

Strong cultures can severely restrict the content and informants available to individuals in their information searches; but interestingly, because of the increased sophistication of shared understandings, they can enhance the effectiveness of information seeking. They also can improve efficiency by clearly delineating roles, relationships, and contexts within which individuals seek information. Broadly speaking then, culture enriches our understanding of any information we gather, while it restricts the range of answers we can seek, most obviously by specifying rules governing the search process (March, 1994).

All cultures develop rules that limit the sharing of information. This is especially true for illnesses like cancer. Natural language is well suited for ambiguity and deception, and often concerns for politeness lead us to equivocate, dissemble, and to tell others "white lies." We also may be limited in polite discourse in the extent to which we can self-disclose personal information—a prime example of "information management." Conversely, others may be limited in the questions they feel they can ask us and the strategies they can pursue in seeking information. The line between natural curiosity and nosiness may be narrow. In fact, the Latin root for nice (*nescio*) means "to be ignorant," which also may explain why at a societal level good news tends to be more frequently, quickly, fully, and spontaneously communicated (Smithson, 1989).

It has been assumed for too long that overcoming ignorance is simply a matter of improving communication systems and processes. It is not that people do not gather information or learn things, but often they gather the wrong information for the wrong reasons from the wrong sources. Thus, many doctors will discount external information sources because of the not-invented-here syndrome. Individual consumers as they gain experience also have a tendency to discount external sources of information (S. Ward, 1987).

The specialist might argue that you should be ignorant of his actions, otherwise you are suggesting that you do not trust him (Smithson, 1989). Often, as in co-orientation frameworks (Farace et al., 1977), ignorance is a way of avoiding conflict (see "information management," below). I can tacitly assume that others agree with me, when real knowledge of his/her position would lead to disputes (Smithson, 1989).

In public communication campaigns, Hyman and Sheatsley (1947) found some members of the public to be Chronic Know Nothings who appeared to have something in their psychological makeup that made them impossible to reach. An important cognitive factor is the often irrational search processes that individuals may engage in (Huber & Daft, 1987). It is in these areas especially that ignoring is not necessarily the same thing as ignorance.

Smithson (1989) has identified three normative roles underlying ignorance. First is the "Certainty Maximizer" who tries to attain as much control and predictability as possible by learning and responding appropriately to the environment. As we have seen, this is also a very popular approach to uncertainty reduction in interpersonal communication. Second is the approach, popular among doctors, of treating uncertainty probabilistically when confronted with the unknown, ignoring ignorance where it cannot be overcome or absorbed, and selecting alternatives that maximize utility in the long run. Finally, the "Knowledge Seeker" thesis argues that individuals strive to gain full information and understanding, ignoring nothing that is relevant. When we discuss information and ignorance, the image that is often fixed in our minds is that of the scientist valiantly struggling with some known unknown (Reardon, 1989) or a fictional detective trying to solve a particularly perplexing puzzle. Beyond obsessions, curiosity, and creativity, lies a host of motivations not to seek information. While most contemporary theories of communication rest on a knowledge-seeker framework, there is growing evidence that most individuals are only dimly aware of the choices they are making (Donohew, Nair, & Finn, 1984).

DECISION MAKING AND IGNORANCE. In sum, ignorance is only one of many problems an individual has to confront. At times it is better to rely on easily obtained information than to spend the effort necessary to seek complete information. In short, the costs of overcoming ignorance at times outweigh the gains. (And it does

not take much to create barriers to information seeking.) Relatedly, the absolute amount of information sought by consumers, even for costly products, is relatively low (Ward, 1987). For some topics, it is even possible to be sated, to have acquired enough information. Thus, there may be as many, if not more, reasons for *not* seeking as for seeking information.

Beyond these factors, a more serious issue is that critical information related to a decision may be unavailable. Most importantly, we never know if the future may hold untold events that will alter even the most carefully laid plans. How do I decide to go ahead and make a decision even though I am missing some information? First, I need to decide how useful and available the information really is. If the missing information is easily available and is critical to what I will do, I may decide to wait until I have spent the extra time and energy needed to gather it. If it remains elusive and is only of tangential relevance, I may decide to press ahead and make a decision, realizing that at least I will have learned that this alternative does not work. The best decision makers have an intuitive feel for when they have reached the optimal balance of these factors; they have reached a subjective level of confidence of when they know enough to make the best decision they can make in their current circumstances.

So, now we return to the issue of whether a perceived gap in information will result in the initiation of a search for information, leading to sense-making that is reified in decisions.

Uncertainty Management

In their discussion of uncertainty in illness, Babrow, Kasch, and Ford (1998) note that the illness experience often increases stress. They described several different senses of uncertainty extant in the literature: mental confusion, ambiguity, equivocality, equally probable alternatives, and unpredictability. They also traced major sources of uncertainty: qualities of information (e.g., clarity, accuracy, completeness, and so on), probability beliefs, the structure of information (e.g., order, integration). Babrow et al. concluded that uncertainty reduction was not the exclusive motive of patients. Sometimes patients with a higher tolerance for ambiguity may be more tolerant of "watchful waiting" approaches to concerns like prostate cancer. At other times, people forestall seeking definitive diagnoses because of their potentially devastating impacts.

Earlier we discussed the central role of "uncertainty reduction" in the section on theories of decision making. Berger (2011) makes a critical distinction, that his uncertainty-reduction theory was meant for initial encounters such as those with strangers, while uncertainty management represents living for the long term with chronic disease and associated comorbidities. The focus on uncertainty management in part grew out of recognition that diseases like AIDS or HIV presented often unresolvable problems for those afflicted (Brashers et al., 2000). It is also the

case that those with serious illnesses, nearing the end of life, are confronted with multiple often overlapping uncertainties (Hines, 2001).

That humans constantly strive to reduce uncertainty seems sensible; however, there are many examples in which it does not hold true. As Sorrentino and Roney (2000) point out, the literature on uncertainty reduction tends to emphasize either the psychological *benefits* (particularly long term) of having new information (e.g., for assessing one's self or planning future behavior), or instead the *costs* of information (e.g., being forced to acknowledge threats or personal failings). While the benefits of learning something new have been emphasized in the uncertainty-reduction literature, other research stressed the psychological costs of acquiring information: cognitive dissonance (e.g., Festinger, 1957), open versus closed minds (Rokeach, 1960), selective exposure (e.g., Hyman & Sheatsley, 1947), and protection motivation theory (Maddux & Rogers, 1983) all consider psychologically costly information. Not many theories considered both costs and benefits.

Both the drive to reduce uncertainty, along with the potential for avoiding information, are featured in "uncertainty management" and "problematic integration" theories. A key assumption of this line of thinking, largely based on observations of human conversation, is that people do not always strive to reduce uncertainty; there may indeed be times when it makes more sense to avoid knowing something or even to deliberately increase uncertainty for psychologically or socially strategic reasons. As Bradac (2001, p. 464) states, "individuals may use uncertainty as a tool," particularly in sheltering the self and/or others from negative information.

While in everyday life we frequently withhold or "soften" our utterances to lessen friction with others (e.g., avoiding criticism and the hurt feelings that may result from unrestrained expression), the most important examples have to do with health-care situations. So it is that a physician might describe a more optimistic outcome than warranted if s/he is concerned that a patient will "give up hope" if they hear the unvarnished truth (Ford, Babrow, & Stohl, 1996). On the other side of the dyad, the patient may avoid listening or understanding in order to maintain uncertainty: not knowing may be more comfortable than knowing one has potentially fatal cancer (D. E. Brashers, Goldsmith, & Hsieh, 2002). The patient may even deliberately increase uncertainty by seeking out contradictory information (e.g., reading about alternative diagnoses and treatments or "miracle cures"). As Thompson and O'Hair (2008, p. 341) explain in a study of uncertainty management among cancer survivors:

> We react to uncertainty based on the meaning it has for us, appraising the situation as either danger or opportunity This process then leads to choices, which manage our uncertainty, choosing to seek or avoid information.

When the choice is to seek information, whether to decide what to do or simply to cope with emotional distress, the sources are many and varied (Wright & Frey, 2008). What source to search, whom to talk to, and what topics to avoid, are all decisions consciously made in the quest to manage uncertainty (Brashers et al., 2000; O'Hair et al., 2003). Kramer (2004) has described six basic management strategies in organizational contexts that also have relevance to health information seeking more generally. First, someone can, of course, seek information to reduce uncertainty. Second, a denial strategy results in someone treating information as irrelevant. Third is to treat uncertainty as a tolerable problem. Fourth is to assimilate uncertainty into a preexisting category; so, for example, uncertainty about bladder cancer becomes part of a more generalized uncertainty about cancer generally. Fifth is acceptance, where an individual comes to believe that uncertainty about some issues, particularly spiritual matters as an example, may never be resolved. Finally, the sixth strategy is imagined information seeking where someone might pose hypothetical questions. So, employees of Apple might ask "What would Steve Jobs do?" when confronted with problems. Uncertainty management and information seeking are so closely intertwined (Bradac, 2001) that the CMIS has even been classified in an encyclopedia entry as an uncertainty management theory (Afifi, 2009a).

The Dark Side

> Certainly the disadvantaged are not as likely as the rest of society to change the undesirable conditions of their lives, or to see information as an instrument of their salvation (Freimuth, 1990, p. 177).

Ideally, advances in medical research, in medical practice and in the dissemination of information about research and practice would automatically result in improved health outcomes. Sadly, that is not the case. Especially where the flow of information is concerned, failures to access, understand, and use information continue to be common. These problems originate not only with patients but also with doctors; they affect not only the least-educated members of the public, but also some of the best educated—including health-care professionals. In this section, we consider barriers to access, acceptance, understanding, and application of health information.

Erroneous Conclusions

It has been almost a half-century since the National Library of Medicine first made health literature available through computerized searching via a system called MEDLARS. Since that time, computerized retrieval of medical documents has grown increasingly more sophisticated. Along with general improvements in

computing equipment and transmission speeds, particular advances in medical information retrieval have included better indexing of documents, availability of the full text of articles, and easier-to-use search interfaces, to name just a few improvements. Yet, despite considerable investment in development of such utilities and in training of medical professionals to use them, they have made only a modest contribution to medical practice. Dr. William Hersh (2005, p. 147) in a commentary on his 25 years of involvement with medical information retrieval, concludes that clinicians ". . . do not always find the best information, nor do they answer their questions reliably" using such systems, and that "we cannot automatically assume that information resources. . .will automatically improve things" (p. 148). At least two studies (Hersh et al., 2002; Westbrook, Gosling, & Coiera, 2005) suggest that information retrieval systems answer clinician questions correctly only about half of the time. Perhaps worse is the possibility that misunderstood information from online databases makes physicians more confident in their flawed knowledge (Westbrook et al., 2005).

To some degree, the failings of formal information systems may affect patients as well as medical professionals. Ferguson (2007, p. 24), in a report advocating the use of Internet-based communities of patients to provide advice and support, contrasts such efforts with a "top-down" project by physicians that provided targeted, electronic information to chronic patients. The patients showed gains in knowledge and social support, but they had no increase in self-efficacy, health-related behaviors and, disturbingly, had worse outcomes then those who were left alone. Yet Ferguson (2007) also notes the lack of evidence that patients will be harmed by using and sharing Internet health information among themselves, arguing that concerns about patient error pale in comparison to the hundreds of thousands of errors committed by medical professionals each year, estimated in various studies.

Finally, health information campaigns can also be misunderstood, especially if they try to impart too much advice. Systematic comparisons of differing messages do not clearly indicate that more sophisticated, expensive, and complicated campaign approaches result in better outcomes (Dijkstra, Buijtels, & VanRaaij, 2005; Lichtenstein & Glasgow, 1992). Studies of safety campaigns in organizations suggest that better outcomes might be achieved by keeping messages simple; too many specific details, safety rules, and safety procedures can actually result in diminished performance (Real, 2008).

Unequal Access

There are a cluster of issues that pertain to information seeking, and the research agendas associated with it, which have implications for policy. In some respect they all concern aspects of social equity as it applies to access to information. In this section we discuss access, its associated problems, and the implications for

system design. We will then discuss three ways that these access issues have been framed: as a digital divide, as knowledge gaps, and as information poverty.

Access problems. The word "access" can embrace several different meanings. Typically when we use that word, we are concerned with the physical world: Can a person actually reach something with their body? However, issues of intellectual access are more challenging, particularly where information resources are involved. Eysenbach (2005), for example, points out that physical access to an electronic information resource is only the first of four levels. One may have access to a computer and the Internet, but can one find the information? This second level (findability) raises issues of indexing, metadata, and terminology. For every scientific term, there may be multiple common words that are relevant yet not preferred. Will the searcher know the necessary terms? Hyperlinks may be ambiguous, failing to make clear the relationship between one chunk of information and another (Eysenbach, 2003b). And once one finds the information, can one understand it? The third level (readability and comprehendability) concerns the language in which the information is embedded versus the knowledge of the seeker. As Sawhney (2000, p. 162) points out, "Information only has value when a recipient has. . .the capacity to process it." Medical terminology, in particular, can be opaque to the layperson and easily misunderstood. Finally, the fourth level, usability, is about whether the information can be applied to a useful end. Particularly where health issues are concerned, information must be put into context; it must be explained and related to one's personal situation and history. All too often this deeper knowledge is lacking in electronic records.

The digital divide. What some call the "inverse information law" says that access is often the most difficult for those who need information the most (Boot & Meijman, 2010). This problem is of particular concern when we consider unequal access to computers and telecommunications, and even more so with literacy issues related to their use. The term "Digital Divide" refers to the gaps, or more recently disparities, among individuals and collectivities, at different socioeconomic levels or geographic locations, with regard to their opportunities to access information technologies and to their use of those to accomplish tasks (Johnson, 2011). What exactly constitutes the "gap" has been a shifting target, as the technologies and their applications have matured and diffused. Historically the attention to the "divide" began with a focus on the technology itself, first in differences among groups as regards computer ownership or access; later the focus shifted to access speeds, e.g., the degree to which households and institutions (e.g., schools) were connected to high-speed telecommunications networks. This evolution paralleled the early-20th-century debate over "universal service" that led to open access across carriers and decades of cross-subsidies of local telephone

lines—under the theory that promoting telephone access also fostered larger social benefits (Sawhney, 2000).

Over time, more and more attention has been paid to issues of *intellectual* access rather than physical access to the equipment itself (Lievrouw & Farb, 2003). With computers becoming cheaper and more ubiquitous, with both wired and wireless networks proliferating (in some cases with free access), there is a great recognition that people need more than computers and telecommunications lines; rather they need to know how to use the equipment to accomplish tasks (e.g., find information, apply for a job, ask a question, or make a medical appointment). Simultaneously there has been a gradual de-emphasis on differences among demographic groups, as these even out (although there are still substantial differences in use by age cohorts and urban-versus-rural locations) and an increasing concern with literacy and skill levels, and the types of information usage limited by these factors (Lentz, 2000).

As the debate continues over how to characterize the Digital Divide and what to do about it, the implications for health care have grown more obvious. In the latest reframing of the Digital Divide as "digitally inclusive communities," health care is one of six "targeted principles" intended to guide public policy, in a plan that emphasizes the need for both high-capacity networks and technology training for users (IMLS, 2011). Access to the Internet will clearly be a key component in both providing medical services and encouraging better health. As former U.S. Surgeon General Koop (1995, p. 760) puts it:

> ... cutting-edge technology, especially in communication and information transfer, will enable the greatest advances yet in public health. Real health care reform will come only from demand reduction, as individuals learn to take charge of their health. Communication technology can work wonders for us in this vital endeavor....encouraging personal wellness and prevention and leading to better informed decisions about health care.

KNOWLEDGE GAPS AND INFORMATION POVERTY

> In the final analysis, it will be the human touch of the system—not the technology—that will determine whether it is successful or not (Office of Rural Health Policy, 1994, p. 13).

The concepts of an "information gap" and the "information poor" have been advanced in recent years as important policy issues, generally in terms of their broad societal ramifications (Chen & Hernon, 1982; Dervin, 1980; Lievrouw & Farb, 2003; Siefert, Gerbner, & Fisher, 1989). This is coupled with an increasing interest in our federal agencies in health disparities. In general, it has been argued that there is a growing difference in access to information between different segments of our society and that increasingly this gap also reflects other demographic clas

sifications, such as socio-economic status. Perhaps even more importantly, "informational have-nots" in many respects represent the average U.S. citizen, not a small minority of the population (Dervin, 1989; Doctor, 1992) and these individuals risk becoming members of a permanent underclass. Even more troubling, the principles of consumer-driven health care are rooted in the privileged position of higher SES groups that can indeed "shop" for health care, something that increasingly is out of reach for a growing number of Americans (Tomes, 2010).

New technologies and new media create an increasingly fragmented and privatized information environment, as opposed to the mass, public-access technologies represented by television and radio (Siefert et al., 1989). In response to these trends, governmental agencies are adopting policies to promote information equity among various segments of our society (Lievrouw & Farb, 2003), but some question whether access to information resources can ever truly be universal in spite of the best intentions of our policymakers (Fortner, 1995).

These inequities in part stem from the unwillingness of potential users to avail themselves of information resources. At a societal level, our existing information infrastructure tends to be fully used only by a minority of the population (Dervin, 1980; Dervin & Nilan, 1986). Library patrons, for example, tend to be those with higher levels of education, SES, community involvement, social networks, and other information sources (Zweizig & Dervin, 1977). Clearly, if not a knowledge gap, a utilization gap exists, in the use of CIS by demographic groups that would typically be classified among the information poor. Another major impediment in information seeking for some groups is a lack of necessary information-processing skills, some as fundamental as a lack of literacy and lack of knowledge of the primary language in which most health matters are expressed. The information fields in which the poor are embedded typically involve one-way communication from mass-entertainment-oriented media, such as television (Freimuth, Stein, & Kean, 1989). Added to this mix of impediments is the possibility of mistrust and deliberate rejection of what are seen as "establishment" positions (Freimuth et al., 1989).

Unfortunately this information gap is also directly related to such critical cancer-related factors as the early detection of the disease and the pursuit of efficacious treatment once the disease is diagnosed. The information gap also directly corresponds to the individuals who are least likely to have access to health care for economic reasons; so that these individuals are doubly disadvantaged. In addition, members of these groups are also often at higher risk for many health problems (Freimuth et al., 1989).

Beyond use lies the issue of need, regarding which studies of the general populace find users have few information needs, at least ones they can't satisfy informally (e.g., Beal, 1979). All this raises the policy question of how much support should be given to an information infrastructure that receives little general use.

The knowledge-gap hypothesis (Tichenor, Donohue, & Olien, 1970) argues that gaps will increase over time, since more highly educated individuals assimilate new information faster from mass media than more poorly educated ones; they also have more relevant social contacts who are likely to discuss issues with them. In one form, this hypothesis suggests that these gaps are perpetual; and that ironically, agency efforts to disseminate information only increase the gaps existing in society, since the educated will assimilate the information more quickly and completely (Viswanath, Kahn, Finnegan, Hertog, & Potter, 1993). In addition, technology and software access is likely to be greater for privileged groups within our society.

While the knowledge gap has generally been supported in static studies, its exact dynamics over time are still subject to some debate (Freimuth, 1990; Viswanath et al., 1993). Gaps are smaller for topics that are of local interest, that differentially interest certain groups (e.g., the performance capabilities of a BMW X5 vs. a GMC Acadia), and when they are couched in non-textbook terms (Freimuth, 1990).

Several underlying dynamics have been suggested for the existence and persistence of gaps. The deficit or individual-blame bias suggests that "information haves" possess: superior communication skills (e.g., reading, listening), a framework for understanding new information, and a greater range of social contacts. The difference position notes that many barriers exist to knowledge acquisition among groups in our society, including: literacy (non-native language speakers); "information ghettos," where there is primarily a one-way flow of information; exclusive within group communication that further reinforces ignorance; and the cultures of disadvantaged groups often are fatalistic. While the set of conditions described in the deficit position are fairly intractable, and often lead to blaming the victim, the second set focus on key information-seeking differences between groups that might be overcome more easily (e.g., messages could address fatalism, as well as the substantive issue at hand) (Freimuth, 1990).

It has been argued that the use of mass media can act to reduce gaps relating to issues that are of interest to normally disadvantaged groups (Freimuth, 1990; Freimuth et al., 1989), and, further, at some point the haves become satiated and the poor can catch up (Dervin, 1980). Another way of stating this is to suggest that there are ceiling effects for some knowledge. So, simpler messages (e.g., wear your seatbelt) and finite knowledge of an event or fact (e.g., Betty Ford has breast cancer) are likely to reduce gaps among audience members (Freimuth, 1990).

It has also been suggested that motivation can make the critical difference, overcoming problems represented by lack of education and social position. These issues were examined in a study by Viswanath et al., (1993) examining education, motivation, group membership, information functionality, and knowledge gain overtime in a community-based training program on diet, nutrition, and

cancerrisk. Community members volunteered for a home-based course (a prime indicant of motivation, the others being perceived risk and efficacy), while the public was incidentally exposed to information in the mass media and grocery stores. The study found a complex interaction among these variables, and that motivation alone could not overcome lack of education. For knowledge about dietary fat, a gap persisted over a one-year period among subgroups with differing levels of education within the home-based course group; the gap was less than that among the general population, and the motivated-but-less-educated subgroup surpassed the level of knowledge of the less-motivated groups of the general population. In the dietary fiber study, among the motivated group, the gap widened slightly between the more- and less-educated, although for the general population group it decreased slightly. This might be due to a higher interest in dietary fiber, and the greater flow of knowledge related to it in the mass media, which resulted in a higher general level of knowledge among all groups regarding this issue. In sum, this study found that while motivation increased knowledge levels, it did not overcome initial differences between groups in level of education.

Inevitably, differential access to information produces differential participation rates in our society (Lievrouw & Farb, 2003). Our mass media create information fields that are *informing*. They are geared to selecting information that is then consumed by their audiences. Increasingly, information technologies offer the possibility of *involving* audience members through their interactive capabilities and enhanced possibilities for information seeking (Lievrouw & Carley, 1991). The differential access to information sources has direct implications for the involvement of individuals in democratic processes (Braman, 1994; Doctor, 1992; Palmquist, 1992; Siefert et al., 1989).

It has been suggested that policymakers should strive to create information equity among different segments of our society as well as more globally (Siefert et al., 1989). One underlying reason for creating equity is that the wider the range of ideas available to individuals, the more likely it is that a plurality will gravitate toward the correct one.

Disconcertingly, it is also possible that people will become so overloaded with information they will "escape" by turning to any source that offers simple solutions to increasingly complex problems. The dark side of the quest for uncertainty reduction is that once an answer is arrived at, a decision made, blockage from future information seeking may occur (Smithson, 1989). As we have seen, disastrous consequences often arise from situations where group ideas become accepted as truth, discouraging even the possibility of seeking discordant information.

One step in reducing information gaps is greater knowledge of the factors affecting information seeking (Ramanadhan & Viswanath, 2006). As we have seen, information seeking clearly differs by amount of education. So it is important not only to provide access to the information superhighway, people also must receive

the training necessary to use it (Doctor, 1992). Rather than stressing simple access to ideas, it may be better to stress access to playful intellectual tools that allow individuals to make sense of an overwhelming information environment (Entman & Wildman, 1992).

Even if there is not a knowledge gap, there is a utilization gap. This utilization gap arises, in part, because some individuals consciously decide to decline membership in the information society. Some people have reached a saturation point; they cannot spend any more time communicating (Fortner, 1995). Some groups, such as labor unions, historically have mistrusted the application of new technologies (Palmquist, 1992) and deliberately rejected "establishment" positions. Others decide, for aesthetic or lifestyle reasons, not to adopt new information technologies. So instead of surfing the Internet, they prefer more civil discourse with their friends (Fortner, 1995). Others prefer old and familiar information sources.

We have always had among us Luddites who reject new technologies because they are socially and economically disadvantaged by them. We also have many individuals, who we typically don't like to talk about, who really don't want to know things, who are more interested in "vegging out" and being entertained (Fortner, 1995). While over and over again on a societal level we emphasize the need for individuals who will constantly grow and develop into perpetual learners, it must be acknowledged that some individuals would prefer a comfortable world where they do not need to change nor expend the necessary effort to become full-fledged participants in the information society. Even more disturbing is the process of information alienation arising from the frustrations of a failed search, where people come to believe that the information they seek will never be available to them (Dervin, 1980).

Some more cynical observers of information seeking in the professions suggest that perhaps the most powerful motivation for doctors to keep up to date is the ever-present threat of a malpractice suit (Paisley, 1993). Most other professions do not have similarly compelling external motivations to keep current; they do not have sanctions for "remediable ignorance," for actions that duplicate or overlook existing knowledge (Paisley, 1980). These professions can in effect conspire to say it is pointless to try to keep up.

Most of the people who write about, think about, and implement information technologies are information junkies who have very little understanding of (or tolerance for) information laggards. Some exhibit pathologies on the other extreme and become so concerned with acquiring information that it becomes an end in itself, rather than serving any particular purpose. These individuals, who are often information professionals, tend to overburden information systems, providing users with too much information and too many options, since they fail to distinguish between what people "need to know," as opposed to what it would be "nice to know," if one had unlimited time (Paisley, 1993).

Even more disturbing than the information gap is the *understanding gap* that is developing between individuals who have access to a rich array of diverse information sources and the resources necessary to synthesize information (Viswanath, Finnegan, Hannan, & Luepker, 1991). "[B]ad ideas spread more rapidly among the ignorant than among the informed, and good ideas spread more rapidly among the informed than the ignorant"(March, 1994, p. 246). Our elites, both institutions and individuals, are developing a considerably different view of the world than other members of our society, in part, because of their differential levels of information-seeking capacities and skills. Even among elites, constant self-selection of differing information sources is producing different views of the world. The information revolution is contributing to the accelerating fragmentation of our culture (Fortner, 1995).

This has led to considerable concern that individuals and organizations with resources and access will perpetuate (or even widen) gaps in information to preserve or enhance their power and economic advantages (Doctor, 1992; Lievrouw, 1994; Lievrouw & Farb, 2003). These issues, of course, are critical to any true reform of the health-care system, a process that is ongoing because of market pressures in the absence of government action (Koop, 1995). Increasing information levels among the public, especially of prevention information, offer the greatest possibilities of both improving health and reducing costs (U.S. Department of Health & Human Services, 1990; Koop, 1995), although some have suggested such information is widely available and has yet to have a significant impact on cancer mortality (Proctor, 1995). It has been estimated that 70 percent of premature deaths could be postponed by a focus on disease prevention and health promotion; this is especially true for factors related to tobacco, diet and activity patterns, and alcohol that are implicated in one-third of deaths in the U.S. (Koop, 1995; Lerman, Rimer, & Engstrom, 1989; Leutwyler, 1995). It has also been estimated that company wellness programs that encourage prevention-oriented programs cut company medical bills an average of 20 percent (Leutwyler, 1995).

Yet an increased focus on secondary prevention, involving screening and early detection, is not without substantial costs. Just among Medicare patients alone, colon screening adds an estimated $2 billion to annual costs (Steen, 1993). Disconcertingly, given recent moves to back away from aggressive screening programs, the costs of many screening programs may exceed the costs of therapy if the cancer were undetected at an early stage. In addition, some recommendations, such as breast self-examination, continue long after the evidence related to them has proved equivocal.

Many have suggested that we need to change our focus to more modern conceptions of health, which include wellness and primary prevention, rather than our traditional narrow preoccupation with the treatment of specific medical disorders (Freimuth, Edgar, & Fitzpatrick, 1993; Koop, 1995). A key element of

the change to broader conceptions of information is increased access to a national information infrastructure (Clark, 1992), which we return to in Chapter 8. There is broad public support for providing additional information related to health, especially in the media (Research!America, 1995).

Ignorance

> Those most in need of information were found to be the least likely to seek it (Weinstein, 1978, p. 32).

> ... recent work in psychology suggests that most people are not in touch with reality but rather function day to day on the basis of fundamental illusions which guide their action and their interpretations of information and events (Reardon & Buck, 1989, p. 22).

Ignorance and information seeking are inextricably intertwined concepts (Johnson, 2009a). Ignorance, as used here, refers to a state where an individual is not aware of information related to health. Ignorance exists when knowledge resides somewhere in the social system of which an individual is a part, yet the focal individual just does not have it. Ignorance by itself is not a sufficient condition for information seeking; classically it is argued that a perceived need for the information, such as heightened saliency due to a family history, is a necessary condition for information seeking to occur. Ignorance is thus different from ignoring, which often happens when an individual consciously knows that a problem exists, but chooses not to confront it, a not uncommon situation in the health field. A significant proportion of the U.S. population has been classified as nonseekers of information, with nearly one-third of people with cancer reporting they do not look for information concerning it (Ramanadhan & Viswanath, 2006). This profile directly impacts the move to shared decision making and increased responsibility of individuals for their own health care.

Kerwin (1993) has developed a useful classification scheme for mapping ignorance in terms of various levels of personal and societal awareness and/or knowledge (see Table 6-1). We make a fundamental distinction between the things that are accepted as knowledge, though they might be socially constructed and subject to future paradigm shifts (Berger & Luckmann, 1967; Kuhn, 1970), and things that are unknown. Typically, the number of unknown things is much larger than known things, but we have a tendency to focus on objects rather than their grounds (Stocking & Holstein, 1993), so we focus on what is known rather than what is unknown. While rare, it is possible for the individual to know things (e.g., an unproven treatment) his/her social system as a whole does not yet accept; however, we will treat this as an exceptional case.

*Table 6-1: Mapping Ignorance**

Personal Knowledge	Social System Knowledge	
	Known Things	*Unknown Things*
Known	Awareness	Known Unknowns
Unknown	Ignorance	Unknown Unknowns
Error	Error	False Truths
Proscribed Knowledge	Denial	Taboos

* Derived from "None Too Solid: Medical Ignorance," by A. Kerwin, 1993, *Knowledge: Creation, Diffusion, Utilization*, 15, pp. 166–185. Copyright by Sage.

Usually an individual will know much less than any social system of which they are a part. Some observers are concerned with the ignorance explosion, the growing gap between what an individual knows and what is knowable. Key to this state of affairs are literacy skills: about 100 million Americans (35 percent) suffer from marginal literacy (Stavri, 2001), and perhaps 85 percent are technologically illiterate (Lukasiewicz, 1994). While we are steadily increasing our knowledge of specific subareas, we are also raising the dilemma of decreasing the possibility of any one person knowing enough about each of the parts to integrate the whole (Thayer, 1988); this is especially true in an area as complex as health. According to the AMA's Ad Hoc Committee on Health Literacy (http://nnlm.gov/outreach/consumer/hlthlit.html), low health literacy has been linked with higher rates of cancer, diabetes, hypertension and asthma.

Of the things an individual knows, some will be in conscious *awareness* and others are tacit knowledge, things we do not know we know. Much of what we do in our social worlds, how we react to each other's nonverbal expressions, for example, is tacit knowledge, beneath our level of conscious thought. Intuition often falls in this classification, and it is often extremely important for how physicians make decisions based on their long experience. Similarly patients often "feel" that something is wrong, but they may not know what.

Next we have things we know we don't know, the *known unknowns*. They have also been termed conscious ignorance or meta-ignorance (Smithson, 1993). Interestingly, these things often are also socially constructed (Stocking & Holstein, 1993), and the pursuit of answers to them is the subject of intense scientific competition. Claims of knowledge gaps are used to support research programs and proposals, so scientists have vested interests in arguing for compelling known unknowns (Stocking & Holstein, 1993). Unfortunately for cancer patients, there

are too many known unknowns: treatments, etiologies, and preventions, related to cancer (Steen, 1993). However, these known unknowns do not necessarily stand in the way of more effective prevention; indeed, lack of knowledge does not necessarily stand in the way of better screening (Fletcher et al., 1993). So while we may not know efficacious treatments for lung cancer, we do know that smoking cessation would prevent a large percentage of cases (Proctor, 1995). Known unknowns, when considered irrelevant, are not perceived to need further inquiry or information seeking (Smithson, 1993). But when considered important, these things are most often the object of intense information searches.

Perhaps more problematic are the things we do not know we do not know: the *unknown unknowns*. These are the things that are most likely to result in surprises and environmental jolts. So, if we are in the iron-lung business, and it turns out it is easy to develop a vaccine for polio, this unknown unknown may just be lying in wait to demolish our comfortable world. Similarly, basic scientific discoveries introduce new possibilities ranging from atomic bombs to antibiotics.

Errors reflect mistaken beliefs, or things we think we know, but do not. As we have seen, misconceptions, or incorrect views of knowledge, are widespread concerning health and have direct implications for delaying treatments or seeking erroneous ones. Misconceptions are most likely to be corrected through interactions with others, especially weak ties. This is an additional benefit of widespread communication; we are more likely to come into contact with others who can correct our mistaken assumptions. If we only interact with the same others about the same topics, we are most likely to share and reinforce our mistaken assumptions.

False truths are things that are unknown to both ourselves and to others with whom we interact, but we think we know. As Will Rogers has observed "the trouble isn't what people don't know; it's what they don't know that isn't so"(quoted in Boulding, 1966, p. 1). False truths often form the conventional wisdom that is the basis for ongoing interactions; still, they are at times erroneous views of the world, which some fundamental questioning might overturn. But we do not question them precisely because they are accepted as truths.

Denial, things that are too painful to know so we do not, is a maladaptive means of adjusting to difficult circumstances and represents a major barrier to information seeking. Some form of denial, for at least a short period, can be expected among patients when cancer is diagnosed, especially if the prognosis is a gloomy one. The real problem arises when denial results in delays or failure to secure appropriate treatment (Lichter, 1987). Psychological processes of denial lead to premature cessation of information seeking for cancer patients generally (Cassileth, Volckmar, & Goodman, 1980; Evans & Clarke, 1983; Messerli, Garamendi, & Romano, 1980). For example, one study reported up to 20 percent of women who had a mastectomy avoided *any* cancer-related information in their first year after treatment (Freimuth et al., 1989). Delays in seeking treatment are

very common (Hinton, 1973) and can stretch into several months (Freimuth et al., 1989). Interestingly, in a six-month follow-up study of symptomatic callers to the CIS, one-third of callers had not been to a physician, did not know what illness they had, or had not yet received test results (Altman, 1985). It is not uncommon for individuals to avoid information that would force them to make a decision to overcome some problem; this is especially true for cancer-related information, HIV (Brashers et al., 2000), and genetic testing (Johnson, Case, Andrews, & Allard, 2005). It is also common in decision-making situations for individuals to avoid information that conflicts with chosen courses of action (Donohew, Helm, Cook, & Shatzer, 1987).

All of these mechanisms may invoke fear, which has been long thought to be a spur to action. While fear of cancer (in particular) may have declined somewhat over the last couple of decades, it has historically been by far the most dreaded disease for Americans (Erskine, 1966; Mukherjee, 2010; Sontag, 1978; Sontag, 1988). Cancer has almost been treated as a taboo subject, and it is common to blame cancer victims for their disease (Toch, Allen, & Lazer, 1961), restricting communication about it. Further widespread public beliefs such as "There is not much a person can do to prevent cancer," "It seems like everything causes cancer," and "The treatment is worse than the disease" retard information seeking as well as other strategies for dealing with cancer (Freimuth et al., 1989).

Like cancer, the increasing epidemic of obesity and rising anti-smoking sentiments are involving similar sensitivities, frames of responsibility, and barriers to communication (Kim & Willis, 2007). Those unaffected may say "Just eat less" and "Simply stop smoking," while the target audience may rationalize "My weight is genetic" and "I can't stop, I'm addicted." A significant portion of the public not directly affected by smoking or obesity nevertheless feels that these behaviors by others raise their own health insurance rates. The result is a poor basis for an information campaign or even for an empathetic conversation (Adler & Stewart, 2009). These sorts of barriers and misconceptions may also result in a failure to adopt preventive health measures, delay of medical treatment, or use of non-medically sanctioned treatments when cancer is diagnosed.

There has been a considerable confusion in the literature on the level of arousal necessary to get individuals to act appropriately (Green & Roberts, 1974), with high levels of fear, especially when coupled with low self-efficacy, leading to negative consequences. In these situations, the individual focuses on fear control responses, such as psychological processes like denial, anger, guilt, or even more direct action. Generally, it has been accepted that moderate levels of arousal are best for achieving health-related behavioral outcomes (L. Donohew et al., 1987; Hinton, 1973; Rimer, Davis, Engstrom, Myers, & Rosan, 1988). Too much fear may arouse feelings of hopelessness—a perception that one cannot cope with the health threat (Leventhal, Safer, M. A., & Panagis, 1983).

Fear also can play a major role in impeding health information seeking (Atkin, 1979; Lee, Hwang, Hawkins, & Pingree, 2008; Leventhal et al., 1983). Traditional HBM models have done "a poor job in accounting for the consequences of emotional arousal" (Leventhal et al., 1983, p. 5). The level of reaction to treatment for cancer is particularly troublesome: surgery is often mutilating; after four chemotherapy sessions patients are often suicidal, and there are widespread side effects from radiation. Mastectomies historically have been particularly devastating to women, with one-fourth seriously contemplating suicide and three-fourths reporting increased use of tranquilizers and alcohol (Gotcher & Edwards, 1990).

Fear, through processes of denial, can reduce the level of health-related information seeking. While generally fear reduction and effective coping have been associated with the amount of communication about one's illness (Gotcher & Edwards, 1990), in some cases information carriers may be avoided because they increase uncertainty and by that stimulate fear (Donohew et al., 1987; Swinehart, 1968). Fear may be so debilitating that it renders a person incapable of thinking rationally about a problem (Rosenstock, 1974b). For some, a continued state of anxiety may be preferable to the possibility of having the validity of their fears confirmed (McIntosh, 1974). Information seeking is one of the best means of reducing uncertainty and anxiety (Lichter, 1987), since, in general, heightened levels of efficacy may be the best means of coping with heightened fear (Witte, 1994). Ignorance may be a much more important factor than fear in securing timely treatment (Green & Roberts, 1974). Ignorance can often be reassuring resulting in a comfortable inertial state, whereas knowledge might lead to arousal to take action (Smithson, 1989).

Adult learners have become highly skilled at protecting themselves from the pain and threat posed by learning situations (Senge, 1990), and often information seekers who are conducting an unfamiliar search process, even one as simple as going to the library, experience considerable anxiety and frustration because of the unfamiliarity of the situation (Kuhlthau, 1991; Taylor, 1968). This only adds to the difficulties of information seeking related to health, since most individuals are not familiar with the sorts of information sources and resources needed to secure authoritative health information.

Individuals often turn to information carriers to relieve anxiety (Freimuth, 1987). Yet, inadequate communication between the patient and his/her caregivers increases uncertainty and consequent anxiety (Epstein & Street, 2007). Acquiring more information and enhancing awareness can increase a person's uncertainty and, relatedly, his/her stress levels. More generally, it has been argued that information seeking may not resolve ambiguity; it may create more, as it forces us to confront an often mysterious and unknowable universe (Babrow, 1992). These factors may lead some to abandon any search for information, turning their care

over to a physician who will handle everything for them once they have adopted the "sick role" (Lichter, 1987; Phillips & Jones, 1991). In a very real sense, this is form of denial, ceding responsibility for one's life to another. Interestingly, while the majority of patients (59 percent) wanted physicians to make decisions on their behalf, 64 percent of the public thought when faced with cancer, they would want to select their treatment (Degner & Sloan, 1992). While not uncommon (Morris, Tabak, & Olins, 1992), this passive approach by patients leads to less satisfaction and less fear management (Gotcher & Edwards, 1990) and ultimately shorter lives.

On the other hand, information seeking also can be a form of avoidance since it could be a substitute for more direct action in confronting problems (Swinehart, 1968). Ignorance can be used as a justification for inaction (Smithson, 1989), resulting in the rationalization, "I cannot do anything until I know more about the problem." Ignorance is often used as a justification for maintaining the status quo (Smithson, 1993).

Perhaps even more troublesome for social systems are *taboos*, or things that societies agree should not be known by their members because they threaten their underlying premises. Most traditional cultures throughout history have been truth preservers rather than truth pursuers, with information seeking permitted in only very limited, often highly personal domains (Thayer, 1988). Forbidden knowledge (e.g., religious domains, shamans) is an area for which there are still significant penalties for individuals who engage in information seeking. Much of our social life is designed to protect us from harsh realities, with various politeness norms, for example, guarding us against feedback harmful to our self-concepts (Reardon, 1989).

Narrowly, the real domain of *ignorance* is the things that are known at a social-system level that we don't know. For example, we may know we don't know enough about treatment options for diabetes. If this is a salient issue, we develop a search plan to address this shortcoming. We benefit greatly, however, in knowing the general parameters we need to search for. At a societal level, there are compelling reasons to promote ignorance through specialization, to narrow the range of consciously known knowns for individuals, thus reducing information overloads (Smithson, 1989) and allowing certain individuals to pursue more in-depth knowledge of particular areas. However, differential levels of ignorance among different segments of society also lead to critical knowledge gaps associated with health disparities.

The growing interest in information seeking can be coupled with a renewed interest in ignorance (Kerwin, 1993; LaFollette, 1993; Ravetz, 1993; Smithson, 1989, 1993; Stocking & Holstein, 1993). Given the pragmatic importance of this issue, it is somewhat surprising that it has received so little research attention (Smithson, 1989). The traditional health literature has tended to focus on the

many dysfunctional consequences of ignorance, often related to misconceptions individuals hold about cancer. First, ignorance is likely to result in considerable inefficiencies through such impacts as misunderstandings, the duplication of effort, working at cross-purposes, and so on. Second, ignorance can lead to disastrous outcomes for individuals in delaying treatment. Third, ignorance can result in a lack of integration of the individual into health-care systems, contributing to a feeling of individual anomie and hopelessness in the face of disease. Fourth, ignorance may be associated with low levels of compliance and involvement in treatment options. Certainly ignorance is pervasive on many health issues (Phillips & Jones, 1991). This lack of awareness has often had significant negative impacts on the implementation of health innovations like mammography, at least initially.

The results of ignorance are well documented, and health professionals have engaged in various efforts to ameliorate it; but ignorance persists. Conventional approaches to this problem have focused on a variety of factors that lead to ignorance. For example, some have stressed the random nature of ignorance, or the presence of noise, as a contributing factor. Others have emphasized the role of human cognitive processes (e.g., selective perception) (e.g., Kurke, Weick, & Ravlin, 1989) and psychological processes such as denial (Smithson, 1989). Still others have emphasized failures in communication as the cause for this situation.

Conventionally, given Western attitudes toward knowledge and progress, ignorance is viewed as something that needs to be overcome, in part, by increased attention to information seeking (Smithson, 1989). This belief structure is so ingrained that it is difficult for social science to come to grips with ignorance as an area of inquiry (LaFollette, 1993; Ravetz, 1993; Smithson, 1989, 1993), although interestingly uncertainty has been legitimated as an area of study (Smithson, 1993). Yet, in traditional health systems sometimes ignorance is planned for, and overcoming it may detract from efficiency and specialization goals, presenting health-care professionals with a substantial dilemma. So before considering factors that lead to information seeking, we must consider the factors that serve to sustain high levels of ignorance, to contemplate the benefits of ignorance. To understand a problem, you have to understand the forces that cause it to persist. Often problems associated with ignorance stem from the many positive benefits of remaining ignorant.

Our central argument suggests that ignorance persists because it is useful on several levels, if not a necessity, for societies and their members (Moore & Tumin, 1949; Smithson, 1989, 1993). The question for many individuals and health-care professionals is whether the benefits of facilitating information seeking, and resulting complications, are worth the very real risk of any strategies that might be used to overcome ignorance.

Avoidance

As far back as William James's (1890) writings on will and attention, and certainly in Sigmund Freud's (1923) theories about psychological defenses (repression, suppression, and denial), psychologists have noted our ability to ignore uncomfortable thoughts or disagreeable information. Information seeking is often avoided when it signifies discord, a recognition that something is wrong and order is disturbed, and, perhaps even more importantly, answers will force us out of habitus. An early characterization of this "avoidance" was that of an intentional *selection* of certain stimuli rather than others. Hyman and Sheatsley's concept (1947) of "selective exposure" is often cited as a reason why attempts to use the mass media to change health-related behaviors sometimes fail. They observed that humans tend to seek information that is congruent with their prior knowledge, beliefs, and opinions and to avoid exposure to information that conflicts with those internal states. The hypothesized need for "consistency" (in thought, and perhaps in emotion as well) also contributed to the growing research on "cognitive dissonance" (e.g., Festinger, 1957).

Research on "fear appeals" emphasized another possibility: purposeful *rejection* of information. Janis and Feshback (1953) found that extreme attempts to frighten people into practicing good dental hygiene—by showing them pictures of mouth cancer and deformed teeth—were not very effective. They hypothesized that such strong arousals led those exposed to "ignore" the threat, whereas milder portrayals were better at leading them to confront the underlying problem. Information about possible threats creates tensions in the minds of audience members, who must in turn find some way to resolve the tension. If the threat is extreme, or if any potential responses are not expected to be effective, then an attractive alternative is to ignore the threat entirely—which in turn promotes consistency. A key consideration, then, was the mechanism by which we *evaluate* messages (Sears & Freedman, 1967).

One unsettled issue regarding avoidance was the degree to which it was triggered by the situation that a person faced, as opposed to being a kind of trait that a person possessed permanently. Milton Rokeach (1960) saw it as a tendency to have either an "open" or a "closed" mind. Those with an open mind were more likely to approach new information than to avoid it (Sorrentino & Roney, 2000). Avoidance was also cast as a trait in 1980s typologies of coping behaviors. Information-seeking styles were characterized as either "monitoring" or "blunting," with the latter type avoiding negative information (Miller, 1987). Individuals who are monitors allegedly scan the environment for threats, whereas blunters tend to avoid threatening information or distract themselves from it. As many as one-third of patients choose to distract themselves when faced with threats they see as uncontrollable (Miller, 1979); for example, one-third of respondents to the 2003 HINTS survey who had a history of cancer reported not seeking informa-

tion related to cancer beyond that provided by their physician (Ramanadhan & Viswanath, 2006). Further, approximately one-quarter of cancer survivors do not attempt to obtain any cancer information and remain surprisingly unaware of such accessible information sources as the CIS (Roach et al., 2009). Some patients may avoid information that will undermine their faith in their physicians and their hope of ultimate cure and survival of cancer (Czaja et al., 2003). Avoidance can also be seen as a means of protecting others, particularly family members (Caughlin, Mikucki-Enyart, Middleton, Stone, & Brown, 2011), and avoiding information is often an intentional attempt to disregard it (Galarce, Ramanadhan, & Vishwanath, 2011).A recent content analysis of messages from Internet-based cancer news suggests that nearly two-thirds may have characteristics that induce uncertainty (Hurley, Kosenko, & Brashers, 2011).

Researchers of fear appeals (e.g., Dillard, 1994; Witte, 1992) have teased out distinctions in the way that people evaluate information directed at them in mass-media campaigns. Our attempts to control danger operate in parallel with the way we manage our fears and anxiety; we may protect ourselves from danger by accepting suggestions for avoiding.

The extent to which individuals believe they can shape or control events can impact their very awareness of potential problems. For many of us, it does not make sense to learn more about things over which we have no control—so the powerless tend not to seek information (Katz, 1968). Case, Andrews, Johnson, and Allard (2005) have articulated systematically why the avoidance of information may be rational in situations where people have low self-efficacy or face threatening health information. Similarly, seeking versus avoiding feedback about job performance has been found to vary widely among employees (Ashford, Blatt, & VandeWalle, 2003). People who are officially referred to Employee Assistance Programs often have limited abilities to cope with their problems (Poverny & Dodd, 2000). They don't feel able to correctly interpret and react to any new information with which they are presented. Use of the web and formal on-site and off-site sources often require some sense of self-efficacy. An individual's belief in the efficacy of assistance programs also plays a role.

It may be perfectly rational then to avoid information when there is nothing one can do with the answers one may obtain. If the threat is extreme, or if any potential responses are not expected to be effective, then an attractive alternative is to ignore the threat entirely—which in turn promotes cognitive consistency (Case et al., 2005). In their quest to avoid disquieting information, individuals may seek to avoid situations and carriers where there is even a possibility that they may be exposed to discordant information, since accidental exposure can threaten effective uncertainty management (Brashers et al., 2000). So people will avoid going to a physician when they think they may have a serious illness (Hines, 2001). In an interesting twist to these findings, it has been found that high-efficacy, high-risk

groups have more anxiety, which leads to higher motivations to seek, but lower ability to retain information (Turner, Rimal, Morrison, & Kim, 2006). People may also avoid information because the stress of a diagnosis, or the disease itself, limits their cognitive capacity for processing information (Brashers et al., 2000).

Summary

In this chapter, we have linked the concepts of ignorance and information seeking. Information seeking can only be fully understood when compared to the costs and benefits of ignorance. Typically research and thought have dwelled on the benefits of overcoming ignorance, which in the area of cancer-related information seeking are certainly overwhelming. Individuals who are active information seekers, who act on the information they gather, are more likely to confront problems, engage in preventive behaviors, and to seek prompt treatment. If there is one truism to cancer, it is that the chance of a cure is significantly greater with early detection. Still, there are several benefits to ignorance. For medical specialists, it increases their control over patients and the efficiency with which they can treat them. Individuals have the comfort of denying the existence of problems that they would have to work to overcome or that, as is often the case with severe health problems, are insoluble. They also experience lower levels of information load and information-processing costs.

Further Reading

Babrow, A. S., Kasch, C. R., & Ford, L. A. (1998). The many meanings of uncertainty in illness: Toward a systematic accounting. *Health Communication*, *10*(1), 1–23.

Austin Babrow and his colleagues tease apart different meanings of "uncertainty" in the context of health, reviewing literature and models from several disciplines. They point out that many health situations lack certainty (particularly coping with illness), that uncertainty is not a simple concept, and that it is not always negative in its effects. The authors offer a framework for thinking about lack of certainty and ways to study the concept.

Brashers, D. E., Goldsmith, D. J., & Hsieh, E. (2002). Information seeking and avoiding in health contexts. *Human Communication Research*, *28*, 258–272.

Dale Brashers and his colleagues apply an information-management perspective to the issue of information avoidance. In this context, "management" refers to those activities (e.g., seeking, providing, evaluating, interpreting, avoiding) that people apply to information. Managing information happens while pursuing other goals, e.g., maintaining relationships with others (spouse, doctor) and main-

taining one's own identity and well-being. Thus, it is a collaborative activity, and one that may proceed differently in different cultures and situations. The authors give a variety of examples of potential dilemmas in communication between doctor and patient and patient and family, concluding that information management is an important component in the process of coping with both an illness itself and the uncertainty that it gives rise to.

Case, D., Andrews, J. E., Johnson, J. D., & Allard, S. L. (2005). Avoiding versus seeking: The relationship of information seeking to avoidance, blunting, coping, dissonance, and related concepts. *Journal of the Medical Libraries Association*, *93*(3), 353–362.

Our intention in this article was to provide a historical review of how theorists and empirical researchers have treated the tendency to avoid discomforting information. We note that the early communication literature tended to focus on information selected rather than ignored and on cognitive consistency or dissonance. Similarly, early discussions assumed a drive to reduce uncertainty in virtually all situations. More recent theories, e.g., of uncertainty management, treat our motives for knowing (and telling) in a more sophisticated way. We look at research on information seeking about cancer, and about genetic testing, as prime areas in which to examine the ways that humans evaluate information.

Dervin, B. (1980). Communication gaps and inequities: Moving toward a reconceptualization. In B. Dervin & M. J. Voight (Eds.), *Progress in communication sciences* (pp. 74–112). Norwood, NJ: Ablex.

An early essay by communication professor Brenda Dervin regarding the proliferation of terms referring to some kind of inequity or gap among demographic groups. Phrases such as knowledge gap, information gap, communication gap, information inequity, information poor, and information poverty have all been used to suggest problems that needed to be addressed. Perhaps the most written about has been the "knowledge-gap hypothesis," embracing the idea that a variety of developments—whether information campaigns or new technologies—might enable the information rich to get richer (because they are connected and know how to take advantage of new knowledge or sources), while in comparison the information poor get poorer. Over a decade later, the notion of a "digital divide" joined these earlier concepts.

Groopman, J. (2007). *How doctors think*. New York: Houghton Mifflin.

Dr. Jerome Groopman, Harvard professor of medicine and researcher of AIDS and cancer, is perhaps best known for his essays in the *The New Yorker*. This book examines, through a series of fascinating case studies and reflection, how medical doctors understand patients and their illnesses, synthesize medical histo-

ries, and make diagnoses. Of special interest are the biases and cognitive errors to which medical professionals may fall prey.

Smithson, M. (1993).Ignorance and science: Dilemmas, perspectives, and prospects. *Knowledge: Creation, diffusion, utilization, 15*, 133–156.

According to Michael Smithson, there is much more to uncertainty than simple probability. He believes that science is shifting slowly away from a preoccupation with advancing knowledge and toward a more nuanced view regarding what is knowable and predictable—i.e., an acceptance of ignorance in its many guises (irrelevance, error, distortion, incompleteness, etc.). Smithson's analysis ties together various concepts, including forms of evaluation and representation (e.g., entropy, fuzzy sets). He concludes that our manner of dealing with ignorance has profound implications for science, technology, and society as a whole.

PART THREE

Strategies

Strategies for Seekers
(and Non-Seekers)

Yet it seems that information-seeking must be one of our most fundamental methods for coping with our environment. The strategies we learn to use in gathering information may turn out to be far more important in the long run than specific pieces of knowledge we may pick up in our formal education and then soon forget as we go about wrestling with our day-to-day problems (L. Donohew, Tipton, & Haney, 1978, p. 31).

... brains have difficulty processing all the relevant information—there is too much, it may not fit with expectations and previous patterns, and some of it may simply be too threatening to accept (Mintzberg, 1975, p. 17).

Instead, there is something about the uninformed which makes them harder to reach, no matter what the level or the nature of information (Hyman & Sheatsley, 1947, p. 414).

Overview

Individuals are faced with three fundamental information-seeking problems: (1) they have more choices; (2) they have more sources of information regarding these choices; and (3) more and more information is targeted at influencing their behavior (Marchionini, 1992). The previous chapters have been devoted to understanding information seeking; in this and the following chapter we turn to strategies that might be employed by seekers and by health professionals to facilitate and enhance information seeking. Before we turn to that task, a summary of some common findings in the information-seeking literature is in order, since

they can serve as useful benchmarks for evaluating the comprehensiveness and efficacy of any strategies we recommend.

Accessibility

People seek out information that is the most accessible. Accessibility may be the most critical issue in designing information systems. Eysenbach (2005) has suggested there are four levels of accessibility: Level 1, Physical; Level 2, Findability; Level 3: Readability, comprehendability; and Level 4: Usability. What is most surprising is how little it takes for a source to be deemed inaccessible. Similarly, somewhat disconcertingly, accessibility overrides such issues as the credibility and authoritativeness of a source. So individuals will knowingly seek out inferior information from a more accessible source.

In many ways, the findings related to the importance of access are some of the most compelling in the social science literature. What is fascinating, if not downright amazing, is the consistent set of findings suggesting that the threshold point where a source is considered inaccessible is very low. For example, T. J. Allen (1977) describes information access in research and development laboratories as determined by gradually diminishing communication up to 50 feet away from an interactant, with communication beyond that characterized by a dramatic drop off. So an engineer who is seeking an answer to a technical problem (e.g., what is the best material to use for constructing a safe bridge?) is usually unwilling to walk more than 50 feet away from his/her desk to get this information.

Even more disturbing is that access also may be the single most important criterion in evaluation by users of an information system (Rice & Shook, 1990). So accessibility outweighs quality in determining usage of information from a particular source (Johnson, 2009c). For health policymakers, the timeliness of information and the problem it is to be applied to also often outweigh quality considerations (Boroch & Boe, 1994). Interestingly, when consumers choose a physician, quality and competence are seldom considerations (Phillips & Jones, 1991). Somewhat relatedly, the accuracy of the knowledge provided was unrelated to the satisfaction of low-SES cancer patients with physicians (Loehrer et al., 1991). If our engineer is walking to the optimal source of information 45 feet away and happens to run into another, albeit less reliable, source of information in a 20-foot radius, then his or her search is likely to stop there.

In fact, it is a common finding that individuals will knowingly rely on inferior information sources for answers to their problems, because it would take too much effort to get authoritative information (Pinelli, 1991) even when it is easily available online (Sundar, Rice, Kim, & Sciamanna, 2011). Students often limit their searches to the first page of links, which increases the chances of acquiring inaccurate information (Kortum, 2008). Less than 20 percent of the general populace followed up on referrals by information specialists to professionals or

institutions for answers to their questions. Yet a study directly comparing quality and accessibility found that highly important but uncertain information needs might result in a preference for quality over accessibility (Lu & Yuan, 2011). Beyond accessibility, the relevance of the information also is more important than its quality (Menon & Varadarajan, 1992), and respondents are not very concerned with how up to date the information is (Chen & Hernon, 1982).

Even when individuals need information, they often do not actively, comprehensively search for it; rather they will wait until they accidentally stumble across the information, often in interpersonal encounters (Scott, 1991). "Many respondents reported that they made use of an information provider only as an afterthought in relation to another need" (Chen & Hernon, 1982, p. 57). These top-of-mind searches are more likely to result in the use of nonprofessional sources (Morris, Grossman, Barkdoll, Gordon, & Chun, 1987). Often people will only pose their pending questions when they exhaust other ways of spending their time, like a woman with a troubling lump who says nothing until she runs out of topics for conversation with the doctor she has just met at a party. But even more disconcerting is that she is as likely to accept an answer to this question if we substitute a nurse's aide or car mechanic for the physician.

Level of Skill

Having access to information means very little if an individual does not have the proper information-seeking skills and training to retrieve it (Doctor, 1992). A recent HHS report found that only 12 percent of the American populace are proficient in information literacy (U.S. Department of Health & Human Services, 2010). Seekers are often unaware of sources and how to use them (Doctor, 1992; Varlejs, 1986). Searchers often flounder in the beginning, lacking clear criteria, and so values of information and sources change as the search moves forward (Chang & Rice, 1993). In their early stages, searches can be characterized by the gathering of bits and pieces that an individual can fit into a coherent whole (Bates, 1989). This implies that one viable strategy for professionals might be to conduct information campaigns and training programs that increase individuals' awareness of sources, how to use them and for what they are appropriate. Interestingly, the more experience people have with a channel, the more accessible they also perceive it to be (Gerstberger & Allen, 1968).

Psychological Limits

There appear to be several psychological factors that make it very difficult to reach certain groups of individuals. These psychological processes are directly related to the often irrational search processes that individuals engage in (Huber & Daft, 1987). It is in these areas especially that ignoring is not necessarily the same thing as ignorance.

There are cognitive limits on the amount of information individuals can process, especially in short-term memory. Miller's classic observation that we can only viably keep seven discrete items in mind at any one time establishes an absolute barrier to information processing (Mintzberg, 1975). Beyond this limit, the presence of additional information, especially in overload conditions, lowers even this limited capacity. While it has become a truism that knowing how to search for information should be a major focus of our educational systems, rather than imparting perishable knowledge, the limits on short-term memory suggest a sound and deep knowledge base is critical to decision making (Lord & Maher, 1990; Mintzberg, 1975). Especially for responses to heart attacks and strokes, information should be "front-loaded" as there is not time enough to conduct an external search.

There is evidence that individual information processing can be substantially enhanced by holding positions that demand higher levels of processing (Zajonc & Wolfe, 1966) and by long experience in professional roles. Somewhat akin to chess masters who can instantly react to complex patterns based on experience, professionals develop an intuitive feel for how to react to complex information patterns (Simon, 1987). One key advantage of doctors as a source is in the level of intuition and reasoning ability they have developed as result of their training and long experience (J. D. Miller, 1994), which has deepened their tacit understandings of medical issues.

Beyond the limits of memory, humans have a limited ability to process and interpret information. Decision making is fraught with incomplete data gathering, shortcuts, errors, and biases (Reardon, 1989). Decision makers group stimuli into existing broad category schemes, which leads them not to search for additional information (Ozanne, Brucks, & Grewal, 1992). This reinforces a confirmation bias, ignoring or discounting disconfirming evidence. They often ignore their existing base of information (the base-rate fallacy) and will focus on compelling new information. For example, chronically ill patients may be subject to fads associated with new treatments. They also engage in the sample-size fallacy, generalizing from very limited experience. So if a new treatment has met with success with one member of a support group, others may assume that it will meet with similar success with all patients. At best, humans are limited in their capacity to seek, to process, and to correctly interpret information (Smithson, 1989). Even more importantly, they often are not aware of their limitations, grossly overstating their accuracy in information-processing tasks (Diamond, Pollock, & Work, 1994).

Inertia

People follow habitual patterns in their information seeking (Chen & Hernon, 1982; Varlejs, 1986). They fall into a pattern of information seeking on particular topics. Previously acquired information facilitates efforts to acquire additional information (Chaffee & McCleod, 1973), which suggests that the critical first step

in facilitating seeking is encouraging that it become a habit. Unfortunately, most people have bad information-seeking habits and there is considerable inertia that must be overcome in changing their existing behaviors. For example, regardless of the type of information needed, the first source individuals tend to consult is a friend or family member (Beal, 1979).

Direct experience has somewhat of an insidious side effect, since once someone is familiar with a source, they tend to continue to use it. Individuals are reluctant to move from the old tried-and-true sources, partly because they hold off evaluating a source until they have some experience using it (Culnan, 1983). Interestingly, almost two-thirds of respondents to a survey said they would return to an information source even when they had characterized it in the least helpful category (Chen & Hernon, 1982).

The problem of inertia is exacerbated by the number of competing sources of information available on any one subject. Most individuals find, partly because of time pressures, that they cannot engage in a comprehensive search for information. If there are ten sources of information available and they are familiar with two of them, and they trust these two based on prior experience, they may see little benefit to consulting any of the remaining eight. Most often, "the search for alternatives terminates when a satisfactory solution has been discovered even though the field of possibilities has not been exhausted" (Cyert, Simon, & Trow, 1956, p. 246); in part, because each additional piece of information makes it more difficult to determine what might be relevant to a particular problem (O'Reilly & Pondy, 1979). Individuals also fall into competency traps; they do not learn new, often superior techniques, because they are performing well with the old ones (March, 1994).

Interpersonal Communication

Face-to-face, interpersonal communication is the preferred mode of communication for information seeking. As we have seen, face-to-face communication offers many compelling advantages, including flexibility, feedback and subsequent message modification, greater relevance, a greater variety of rewards (Brittain, 1970), and timeliness (Katzer & Fletcher, 1992). It also is specific, vivid, and concrete, which generally is the kind of information decision makers prefer (March, 1994). Such interactivity is especially critical to online health information; individuals still want a human touch and often health impacts are dependent on it (Sundar et al., 2011). Partly because of these advantages, face-to-face communication is more likely to be persuasive, especially when the source is a health professional (Lichter, 1987). Yet face-to-face communication also has its liabilities, especially in terms of completeness and the lack of archiving of information.

Some have argued that the heavily interpersonal nature of work-related communication places a real upper bound on the use of information technologies

(McGee & Prusak, 1993), with users especially resistant to technologies that they see as barriers to interpersonal contact (Paisley, 1993). Individuals would prefer to turn to another individual whom they know and trust for information, so they are more likely to seek sources of information they know. For example, Booth and Babchuk (1972) reported that the more interpersonal resources an individual has, the more likely he or she is to seek information. Therefore, the quality of an individual's interpersonal networks had important implications for information seeking. People want to consult others who have digested and evaluated an array of written information (Johnson, 2009c). In many ways, information seeking is very similar to the traditional findings of opinion leadership; in our interpersonal networks we know who has expertise in particular areas, and they are likely to be the first objects of information seeking when we have a problem in their domain.

Individual Preferences

Different types of persons use different sources of information (Varlejs, 1986). Usually the more experienced, educated, and knowledgeable the individual, the wider the array of information sources consulted and the greater his or her access to professionals and organizations (Doctor, 1992). Beyond such broad generalizations, those in particular disciplines tend to accept as "standard practice" certain search patterns. Gould and Pearce (1991) have detailed the differences in a wide range of natural sciences in what are considered to be authoritative sources of information likely to be consulted by researchers. The particular "profile" of any one individual seeker may reflect the unique informal norms and socialization practices of a particular profession (Boroch & Boe, 1994). (What is "truth" for a social worker may be considerably different from what is "truth" for a doctor.)

Of course, additional sources of information add confidence in a course of action if they corroborate each other. But if the sources do not provide consistent answers, a not-unlikely circumstance, then a person has complicated his or her decision making. In fact, more communication can result in greater ambiguity and uncertainty, not improved decision making (Rice & Shook, 1990). While inconsistent information may often be a spur for additional information seeking to find a "tie-breaking" source, there is no guarantee that this additional source of information will not present yet another major alternative. So it becomes easier to understand why there might be real benefits, at least in terms of the amount of effort expended, to consulting only a limited range of familiar sources.

Costs

"All men by nature desire to know": these familiar opening words of Aristotle's *Metaphysics* (which, over the centuries, teachers of the young have repeatedly

had reason to question) continue to state the underlying rationale of university education (Pelikan, 1992, p. 32).

All of the foregoing findings are related to the "costs" of information seeking compared to the value or benefit of the information sought, particularly in relation to decision making (March, 1994). The costs of information acquisition are many: psychological, temporal, and material. Most seekers appear to assume it is better to rely on easily obtained information (they have an answer after all) no matter how dubious, than to spend the effort necessary to get complete information. The costs in terms of extra time and effort for a complete information search, which also may result in delaying opportunities, complicating decision making and increasing information overload, are real. There are also additional psychological costs, such as the loss of self-esteem and frustration that result from an unsuccessful search (Hudson & Danish, 1980), which may lead individuals to reject the use of frustrating sources of information (Horowitz, Jackson, & Bleich, 1983).

These costs have been articulated in various "laws" of information-seeking behavior. The principle of "least effort" has been evoked to articulate why channels are chosen first that require less effort (Broadbent & Koenig, 1988; Doctor, 1992; Hardy, 1982; Hudson & Danish, 1980; Krikelas, 1983; Saunders & Jones, 1990). Mooers' Law suggests an information source or system will tend not to be used whenever it is more painful and troublesome to have the information than it is not to have it (Culnan, 1983). Beyond these generalizations lies the assumption that people desire to know. In needs studies undertaken for public libraries, from 10 to 20 percent of respondents reported that they have *no* question or problem for which they needed answers.

In sum, ignorance is only one of many problems an individual has to confront. At times it is better to rely on easily obtained information than to spend the effort necessary to seek complete information. In short, the costs of overcoming ignorance at times outweigh the gains. (And what is astounding is how low the costs are that establish absolute barriers to information seeking.) It is even possible, at least for particular topics, to be sated, to have acquired enough information. Thus, there may be as many, if not more, reasons for not seeking as for seeking information.

In this and the following chapter, we develop general approaches targeted at seekers and health professionals for facilitating and encouraging information seeking. If for no other reason than that individuals are driven to make sense of their environment, it would be to health professionals' benefit to at least be aware of the sources their clients are likely to consult for this purpose. In turn, the information they actively seek is more likely to have an impact on their attitudes and behaviors than information that has been handed to them.

A Prosocial Approach to Information Seeking

Many of our major life problems are associated with lack of knowledge, skills, or ability to assess risks (Hudson & Danish, 1980). Information and the skills to acquire it are critical to surmounting these problems. It must be recognized that information acquisition is an important skill that should be central to our educational efforts to produce life-long learning as well as the training for particular professions. One strategy health professionals can pursue is to increase salience of these issues through better training programs that address optimal search behaviors (e.g., appropriate keyword selection) and acquaint individuals with unfamiliar sources of information, such as the search engines we will discuss in the next chapter. In general, health professionals do not give their clients sufficient guidance on what the optimal sources of information are. Acquainting individuals with sources that are relevant (Saracevic, 1975) and useful for their immediate purposes is the critical first step to developing better information-seeking habits.

The scholarly literature tends to focus on how we can provide information rather than what motivates people to seek answers to questions they pose for themselves. We do not know much about what motivates an individual to seek information, especially in terms of more prosocial seeking associated with personal growth and creativity, curiosity, or sharing information with others (Burke & Bolf, 1986). One consistent argument found in the literature is that people with high growth needs are more likely to consult a wide range of information sources (Varlejs, 1986). The rise of consumerism has also led to change in emphasis from a "curative" to a more preventive approach to health care. In general, positive health motivations need more attention. It also has been proposed that it may be better in campaigns to suggest individuals have a responsibility (e.g., to their family) to engage in cancer screening (Green & Roberts, 1974). This approach is much more consonant with traditional American beliefs that individuals are responsible for their health and should reformulate their lifestyles accordingly (Maddox & Glass, 1989). McGuire (1994) has found that generally the public is more influenced by health messages that stress health benefits, rather than the more traditional approach that stresses sickness and dangers to be avoided.

A state that information system designers may wish to encourage is one where individuals feel that they are in the "groove," that they are jamming with the information environment around them (Eisenberg, 1990). People want to maximize their cognitive load as well as their enjoyment (Marchionini, 1992); they do not like tasks or information systems that add to their frustration. They prefer systems that are intrinsically gratifying, that have an intuitive game-like feel (Paisley, 1993).

For example, searchers dislike "two-step" information systems that cite sources that then must be further consulted to locate the needed information. The

concept of flow, which captures playfulness and exploratory experience, has been said to encourage people to use new and unfamiliar information technologies. Flow theory, associated with the work of Mihaly Csikszentmihalyi, suggests that involvement in a flow state is self-motivating because it is pleasurable and encourages repetition (Trevino & Webster, 1992).

A flow state exists when individuals feel in control of the technology (e.g., feedback, selecting from options), that their attention is focused, that their curiosity is aroused, and they find the activity they are engaged is intrinsically interesting. The best computer software, often associated with the gaming systems we will discuss in the next chapter, captures the conditions of a flow state.

Meta-Seeking (Teaching the Public How to Seek)

Increasingly, the responsibility for health-related matters is passing to the individual, partly because of legal decisions that have entitled patients to full information. Consumerism and empowerment, however, require a high level of health literacy on the part of consumers, and an understanding of challenges and implications of this by developers, researchers, and health-care providers. Since the 1970s, patients have been more and more active participants in decisions affecting their health care (Johnson, 1997). The overload of information on health professionals today forces decentralization of responsibilities, with increasing responsibilities passing to individuals if they are going to receive up-to-date treatment, identify clinical studies that they are eligible for, and utilize the variety of consumer health tools now available. In effect, patients must often do the traditional work of doctors, who cannot possibly keep up with the breadth and depth of information related to specific research advances and studies and requisite eligibility criteria for their patients. Often health professionals think they know more than they really do (Surowiecki, 2004).

E-patients

The notion of the "expert patient" is one that has gained increased attention, particularly for rare diseases, given the amount and variety of information available on the Internet, and concern by some health professionals that patients may disintermediate existing power structures. Most compelling, however, has been how these groups are driving research. There are a number of examples, such as the Army of Women, of groups that have been highly successful at generating funds for clinical studies, enhancing participation in trials (particularly challenging in rare diseases), and garnering support for more trials.

The role of patients as research participants has been evolving for over a generation. Patients are central to clinical research, and there are a number of challenges and issues stemming from the health consumerism movement that stands

to impact the conduct and ultimate success of clinical research. These groups, while often promoting participation in clinical trials, can also undermine them by pressing for premature release of findings and undercutting controls and randomization that are essential to the scientific enterprise.

Recognition of the limits of health professionals also requires individuals to be able to confirm and corroborate information by using multiple sources in various formats—in other words, to develop effective health information literacy skills. Their efforts now can be more easily pooled because of advances in health information technology and social networking (and related) information tools to produce informed consumers who share information with each other and whose collective knowledge may even exceed that of some health professionals, especially in terms of issues related to everyday life with a disease. These patient collectives result in knowledge transfer, greater voice, concerted action, and health 2.0 collaboratives. They are somewhat similar to the citizen scientists movement in the hard sciences where large numbers of participants do observation, measurement, and computation facilitated by the Internet and modern computing. However, participation in these sites is often asymmetrical: while up to 41 percent offer consulting peers online, fewer than 6 percent actively contribute (Fox & Jones, 2009). Accelerating the trends in health consumerism are a host of technology and decision-support-related advances, including enhanced access to authoritative web-based information resources, personal decision aids, and social networking capabilities.

Social Networking

Social networking services use technology and software to facilitate the forming of interpersonal relationships. Thus, Facebook claims to be "a social utility that connects you with the people around you" (www.facebook.com; bold in original). Typically, they define a universe of users through directories. They also can define the types of relationships users would like to have with others. Users are often seen to be members of particular communities, and in some applications, social networking sites facilitate the development of Communities of Practice (CoPs) around particular interests and activities, such as Yahoo! groups.

The content features of these websites, especially in terms of facilitating the flow of complex information in various forms (e.g., graphic, visual, and so on), potentially can greatly facilitate the flow of information. One way this is accomplished is through social tagging by various users on the Delicious website, for example, which then becomes a way of sharing communally identified websites. Technologies associated with the sites enhance a number of differing possibilities for interacting: babble, chat, blasts, blogging, discussion boards, email, loops, pokes, requests, reviews, shouts, tagging, Track Back Ping, and so on. These features have been associated with the development of Web 2.0, which encourages

the development of collective intelligence through the democratic participation of users (Boulos & Wheeler, 2007). An example for a professional community is Sermo, an increasingly popular online community for physicians to share information. It allows all participating doctors to rate postings that are often made in response to information queries. Postings are then archived for easy reference.

Promoting Awareness of Optimal Search Behaviors

While use of the Internet is increasingly prevalent, with health often the second or third most popular use (Fox & Jones, 2009), users still have significant problems conducting quality searches. This is exacerbated by the ever-growing number of potential sites that could be consulted when one has a health problem. In some ways the Internet is like the Wild West: unregulated, with unknown dangers lurking beyond the next hill. So the user is often confronted with issues of whom to trust, with unknown commercial motivations and other hidden agendas associated with wild claims commonly found in an unsophisticated search of websites. Most searchers want just-in-time information to answer pressing problems and are often impressed with surface characteristics and style issues, specified in the CMIS, in evaluating websites (Eysenbach, 2005).

People typically don't systematically evaluate the quality of information they get on the web (Crespo, 2004). They tend to be unimpressed with, or unaware of, scientific standards of quality that underlie peer-reviewed, evidence-based websites like Medline, which is comprehensive and constantly updated. More than likely, they don't check when a site was last updated, the "read about us" page, the contact information, or the HON code offering a "Good Housekeeping seal of approval" (Crespo, 2004).

Personal Information Management

The Comprehensive Model of Information Seeking suggests that personal experience is a major factor in determining levels of information seeking. This also implies that information seeking would be facilitated by timely retrieval of information relating to one's personal history. This constitutes a form of intrapersonal communication with your own history, personal experience offering the possibility of "Refinding" and "Reuse" of information. It also can be associated with a relatively neglected problem of forgetting and discarding no longer useful information. This directly relates to developing adequate records of one's health. Traditionally, individuals have relied on physicians, hospitals, and other institutions to keep such records for them. But increasingly, partly because of events like Hurricane Katrina, where paper records held by institutions were lost, and the movement of Americans from place to place, it has become apparent that developing more systematic personal information management in this area might benefit individuals.

The movement to personal health records (PHR) dovetails with an increasing interest in developing electronic health records (EHR) and associated health information exchanges (HIE) on the part of the federal government in the U.S. These systems store health information and data, manage test results, keep track of order entry management, handle various administrative processes like scheduling appointments, systematize insurance records, provide decision support, promote collaboration among health-care providers, and have the potential for becoming large-scale research projects. However, these efforts have been stymied by resistance on the part of physicians in local practices and considerable expense, with less than 30 percent penetration in the U.S. This has led to a variety of ambitious initiatives on the part of the federal government, including the 2009 Health Information Technology for Clinical and Economic Health Act (HITECH), which mandates a substantial investment on the part of the federal government in stimulus money (Blumenthal, 2010).

Because health-care institutions have been slow to adopt standardized electronic records, a number of consumer-oriented technology solutions have been developed. Such systems are unconcerned with the portability and compatibility issues that plague HIE. Commercial systems come in several different forms. Some are provided by insurance companies and are intended to be more limited, containing information gleaned from billing information. Others come from larger health-care system and patient portals within these systems, such as those developed by Kaiser Permanente and the Veterans Administration.

Perhaps most interesting are those associated with personally controlled health records, for which firms like Microsoft are developing specific systems. Various concerns about the use of such systems have been expressed, especially since they are often related to various commercial applications. They do offer considerable advantages to consumers, including their use as decision aids, tracking, managing chronic disease, dashboards, keeping track of doctor's notes/orders, reducing repeated tests, and checking for mistakes (Marchibroda, 2009; Tang, Ash, Bates, Overhage, & Sands, 2006). However, they are not without their problems, including commercial motivations, privacy issues (since they are not subject to HIPAA), complexity, inclusion of clinically irrelevant data from questionable sources, user errors, and difficulties in uploading and downloading from physicians and institutions (Blumenthal, 2010).

Tactics for Seekers

An information-seeking topic that has received considerable attention in organizational research over the last decade has been that related to individual performance (Ashford & Tsui, 1991), especially during organizational entry or job changing (e.g., Brett, Feldman, & Weingart, 1990; Comer, 1991; Morrison, 1993a, 1993b; Morrison & Bies, 1991). Of particular interest have been the tac-

tics that individuals use to uncover information about task, cultural, and other expectations an organization might have (Miller & Jablin, 1991). This literature is highly relevant to health information seeking, especially for newly diagnosed patients, who are in a very real sense entering institutional environments for care in which they will be socialized into the "sick role" they will assume.

A newcomer in an organization is often confronted with a vast array of information that s/he must make sense of to determine appropriate behaviors. Healthcare providers may lay out a set of expectations, which are then reinforced by various written descriptions of treatment protocols. Information seeking often complements formal organizational socialization efforts, filling in the gaps and interpreting seeming discrepancies in the information provided. Active information seeking is often necessary because organizations, like hospitals and HMOs, withhold information inadvertently or purposively.

The vast array of information newcomers are exposed to, and the gaps in the information they are provided, often results in high levels of uncertainty. With such uncomfortable feelings, newcomers are driven to seek information that would reduce the uncertainty they experience. But here they may be doubly vexed if they are inexperienced information seekers who don't know what strategies are appropriate or useful. Counterbalancing the uncertainty newcomers are experiencing are the social costs of seeking information and a desire to manage the impression they give others.

Costs, as we have seen, are real and numerous and may impede information-seeking behaviors. Individuals may be afraid of going to the well once too often and being cut off from information from a particular source. They may assume that someone will think they are dumb for asking a particular question. One constant source of frustration for librarians is the unwillingness of clients to ask for assistance, even though this means that the client will follow very ineffective search strategies (Taylor, 1968). These factors may prompt individuals to pursue less-direct means of acquiring information.

As we have seen, information seeking for newcomers may involve much more uncertainty and urgency. It also may be more thoughtful, as newcomers consciously weigh the efficacies of various strategies they might employ. While we will focus on strategies that have been identified for newcomers in this section, we also will try to develop a comprehensive list of strategies that are more generally used by individuals. As always, we are most concerned with how individuals gather information for their purposes.

The most obvious strategy, and seemingly the most efficient, is to ask *overt questions* on the topic of interest. If I am a new patient, I may ask if I am expected to take my medicine every morning. Asking overt questions may be expected and encouraged early in someone's treatment. This strategy is more likely to be used when individuals feel comfortable with a situation; when they want a direct, im-

mediate, and authoritative reply. Individuals may feel uncomfortable asking direct questions if they believe others will see this as constant pestering, or if the question reveals more about themselves than they want others to know (e.g., as "Am I dying?" reveals fear). Use of questioning also involves a choice for the target of the question, which in itself may be a difficult choice (e.g., Do I bother the doctor or ask the nurse's aide?). Similarly, there is also the risk that a question (e.g., "How well am I doing?") will result in a negative answer that both the client and health professional would like to avoid. Direct questions are very useful for correcting knowledge deficits and ensuring common grounds for interaction (White, 2000).

Indirect questions are often employed in cases where someone is uncomfortable. They usually take the form of a simple declarative sentence or observation that is meant to solicit information, often disguised within an apparently casual conversation. Blau (1955) observed workers establishing occasions for information seeking by hanging out with others; merely being present at informal events. So at lunch, I might say to a fellow patient: "You know, the doctor was really nice when I talked to her. She encouraged me to come and see her whenever I had a question." Another patient, if this observation is inaccurate, might then tell me: "She means well, but she is really busy, and might not like it if you interrupt her too often."

Yet another strategy is to use a *third party* as an intermediary to gather information. Thus, rather than asking your doctor, who serves as a primary source, you might ask his/her nurse as a secondary source of information. This strategy would be used most often when a primary source is unavailable or the seeker feels uncomfortable approaching him/her directly. The downside to this strategy is that the secondary source must be trustworthy and a true surrogate for the primary one.

Another, more dangerous, strategy that individuals might engage in is *testing limits*. If an individual really wants to find out how his/her doctor will react to failure to take medicine, s/he might try progressively fewer dosages. Obviously this strategy is potentially confrontational, and the patient runs the risk of the doctor generalizing from the specific behavior to more global assessments (e.g., this patient is untrustworthy, so why should I waste my time on him/her). Still, individuals might use this as a last resort, especially when the issue is of paramount personal importance to them.

A less-direct strategy is that of *observing*. Patients can watch the actual behaviors of their doctors with other patients and weigh them against their words. Patients can learn how to handle critical situations from observing an experienced patient. Thus, an individual can inconspicuously imitate another's behavior through processes of social learning, self-monitoring, and comparison (Bandura, 1997). There are limits, however, to what a new patient can directly observe, espe-

cially concerning the thought processes or physiologic reactions that may underlie particular actions.

Beyond the strategies identified in the newcomers literature, general strategies identified in the information science literature might also apply: skimming, berrypicking (Bates, 1989), chaining, monitoring key sources for developments (Ellis, 1989). Probably, the most interesting of these is browsing because of its random, nonrational surface appearance.

Browsing essentially involves scanning the contents of a resource base. It is often used as a strategy early in a search process or when someone is scanning his/her environment (O'Conner, 1993). A key element of browsing is preparedness to be surprised and to follow up (Chang & Rice, 1993). Thus, in researching this book, I looked at book titles surrounding those identified by more formal, rational computerized searches. In doing this, I often found works that were more interesting to me than the immediate objects of my search. Traditionally, inadequate browsing capacity has been a major shortcoming of most computerized search software (Chang & Rice, 1993). Browsing in social contexts often takes the form of informal networking. Casual conversations (e.g., gossip) in a group may take on elements of browsing, with more intensive follow-ups on topics that interest an individual. Browsing is facilitated by accessibility, flexibility, and interactivity (Chang & Rice, 1993).

Another problem that patients confront is how to get information from often recalcitrant organizations. J. David Johnson (2009b) explores organizational information seeking in much more detail; here we focus on strategies that can be used to acquire information in traditional organizational structures. Individuals must recognize they can listen and learn from almost anyone in their new settings. While walking around, they might pause to "shoot the breeze" with others. This conversation will do very little good in an information-seeking sense if the patient spends all the time talking. A patient must be prepared to ask neutral questions and listen with care to responses. Thus, browsing is also a specific example of a more general strategy of going directly to the source of information rather than letting information be filtered by various intermediaries.

It helps patients to have key informants for particular domains of information. Traditionally, these individuals have been described as gatekeepers because of their role in filtering information, often in a condensed understandable fashion. No one can regularly go to the direct source of information; there is not sufficient time. Patients can apply Ronald Burt's (1992) strategies for structural holes, developing a wide range of nonredundant sources strategically located to give them the widest possible view of their treatment. In doing this, patients also should develop sources of information external to their organization (e.g., mass media) who can give them an idea of how their treatment regimen is functioning. At the same time, people are developing a breadth of ties; they need to insure that they

have sufficient redundant ties to give them alternative sources of information on critical issues (Burt, 1992).

In sum, while many tactics have been identified, we know less about what factors will trigger the use of any one tactic. We also do not know answers to such fundamental questions as how many tactics individuals are aware of and actually use in their behavioral repertoire. We also know very little about the sequencing of tactics and how individuals might use them in combination for particular effects. We do know that newcomers use a variety of channels and obtain information on a range of contents.

Information Brokers

As much of this book details, health-related information seeking can often be a great challenge to individuals. They have to overcome their tendency to deny the possibility of bad news and the distasteful problems associated with some diseases. They also have to be willing to believe that their individual actions can make a difference, that by seeking information they gain some control and mastery over their problems. They also have to overcome the limits of their education and prior experience. They have to possess skills as information seekers, a knowledge of databases, familiarity with the Internet, an ability to weigh conflicting sources of information and make judgments about their credibility. In short, any one of the factors on this long linked chain could severely impede, if not halt, the information-seeking process.

Recognizing this, individuals increasingly rely on intermediaries to conduct their searches for them. We do not mean organizations like the National Library of Medicine and other useful repositories of information for individuals, which we will discuss in the next chapter. Rather, we will focus on a growing trend for individuals to find representatives to seek information for them.

Cancer Information Service

> We need every weapon against cancer, and information can be a powerful, life-saving tool.... A call is made, a question is answered. NCI reaches out through the CIS, and the CIS is the voice of the NCI (Broder, 1993, p. vii).

> ...one phone call, one conversation, can save a life. This is the true essence of the service and the most rewarding aspect of the program (Morra, Van Nevel, Nealon, Mazan, & Thomsen, 1993, p. 7).

The U.S. Department of Health & Human Services (HHS) maintains several websites and phone services, and serves as a portal to Medline and other health databases. The HHS Information Resources Directory (www.hhs.gov/about/

referlst.html) provides referrals to web- and phone-based services, arranged alphabetically by topic (from "Abuse" to "Youth"); some of these sources are also duplicated in Spanish. Their Healthfinder website (www.healthfinder.gov) offers a simplified interface for locating information on 1,600 topics, and for finding health-care providers, as well as offering news and personalized health tips. More than a dozen HHS components (i.e., agencies, services, centers, offices, administrations) provide additional information services directly to the public. For example, the National Institutes of Health (NIH) give online courses in topics such as genetics, provide a portal for finding clinical trials, and offer text-based messaging services for smoking cessation (e.g., SmokefreeTXT is a service aimed at teens), among other programs. The Centers for Disease Control & Prevention, the Food and Drug Administration, the Indian Health Service, the Administration on Aging, and several others provide health information of various sorts, although they all point to similar websites and organizations.

Perhaps the most successful HHS utility is the Cancer Information Service (CIS), available to anyone who calls 1-800-4-CANCER. CIS was implemented in 1975 by the National Cancer Institute to disseminate accurate, up-to-date information about cancer to the American public, primarily by telephone (Morra et al., 1993). The impetus underlying the creation of the CIS was the assumption that all cancer patients should receive the best care. To accomplish that end, it was felt that free and easy access to credible information was critical (Morra et al., 1993).

The telephone information specialists within the CIS, who in many ways serve as information brokers, have a unique cluster of skills: though the CIS is not a help/counseling "hotline," callers are often very anxious; information specialists must be able to communicate highly technical information clearly to callers who come from all demographic groups and who differ considerably in their levels of knowledge; and they must have access to the most current cancer information. Over time, the CIS has become a community-based laboratory for state-of-the-science communication research that has supported more research related to information seeking than any other source. The most important example of this tradition is the Cancer Information Service Research Consortium (CISRC), a series of program project grants funded by the NCI. The first of these has been extensively described by J. David Johnson (2005).

Opinion Leadership

Increasing, the use of secondary information disseminators, or brokers, is really a variant on classic notions of opinion leadership (Katz, 1957; Katz & Lazersfeld, 1955; Rogers, 1983) and gatekeepers (Metoyer-Duran, 1993). Opinion leadership suggests ideas flow from the media to opinion leaders to those *less-active* segments of the population (Katz, 1957). Opinion leaders not only serve a re-

lay function, they also provide social support information for individuals (Katz, 1957), reinforce messages by their social influence over them (Katz & Lazersfeld, 1955), and validate the authoritativeness of the information (Paisley, 1994). So not only do opinion leaders serve to disseminate ideas, but they also, because of the interpersonal nature of their ties, provide additional pressure to conform as well (Katz, 1957). However, these highly intelligent seekers also may create unexpected problems for agencies, since they may create different paths and approaches to dealing with treating a disease or motivating clinical research studies.

How one person influences another is often determined by their structural positioning within groups (Katz & Lazersfeld, 1955). One finding of research into the relationship between interpersonal and mass-media channels is that individuals tend "to select media materials which will in some way be immediately useful for group living" (Riley & Riley, 1951, p. 456). Some have gone as far as to suggest that group membership can be predicted based on an individual's information-seeking preferences (Kasperson, 1978). Several studies have also demonstrated that one reason individuals seek out information is so they later can talk about it in their peer groups. It has been argued that campaigns should be conducted in such a way as to stimulate appropriate interpersonal communication (Flay & Burton, 1990), and that individuals could use their interpersonal channels to recruit others to join in (Rice & Atkin, 1989).

Prior approaches to health communication have emphasized non-seekers of information, the most obstinate audience members. In doing this, they have not supported those individuals who are the most active information seekers, perhaps on the basis or belief that these individuals can take care of themselves. Still, a major opportunity in health promotion may have been missed in not guiding and shaping the most active and concerned of audience members. These audience members can be (and probably are) opinion leaders in the old sense who are very influential on the very audience members that agencies most want to reach. These highly intelligent seekers also may create unexpected problems for agencies since they may create different paths and approaches to dealing with and treating cancer, such as Norman Cousins (1979), who wrote compellingly about his methods of coping with cancer.

Another trend in this area is the recognition of human gatekeepers, community-based individuals who can provide information to at-risk individuals (Metoyer-Duran, 1993) and refer them to more authoritative sources for treatments (Johnson & Meischke, 1993a, 1993c). Recognizing the powers of peer opinion leaders, many health institutions are establishing patient advocacy programs, where cancer survivors, for example, can serve to guide new patients through their treatment.

Though intermediaries play an important role despite more consumer health information on the Internet; increasing health literacy by encouraging autonomous information seekers also should be a goal of our health-care system. While

it is well known that individuals often consult a variety of others before presenting themselves in clinical settings (Johnson, 1997), outside of HMO and organization contexts, there have been few systematic attempts to shape the nature of these prior consultations. If these prior information searches happen in a relatively uncontrolled, random, parallel manner, expectations (e.g., treatment options, diagnosis, drug regimens) may be established that will be unfulfilled in the clinical encounter.

The emergence of the Internet as an omnibus source of information has apparently changed the nature of opinion leadership; both more authoritative (e.g., medical journals and literature) and more interpersonal (e.g., support or advocacy groups) sources are readily available and accessible online (Case, Johnson, Andrews, Allard, & Kelly, 2004). The risk here, however, is that individuals can quickly become overloaded or confused in an undirected environment. In essence, while the goal may be to reduce uncertainty or help bridge a knowledge gap, the effect can be increased uncertainty and, ultimately, decreased sense of efficacy for future searches. A focus on promoting health information literacy, then, would mean helping people gain the skills to access, judge the credibility of, and effectively utilize a wide range of health information.

Self-Help Groups

Increasingly more formal groups are serving as opinion leaders and information seekers for individuals. A big advantage of patient-centered support groups is speed, since waiting for scientific certainty can be lethal (Ferguson, 2007). They also can provide critical information on the personal side of disease: How will my spouse react? Am I in danger of losing my job? And so on. In addition, these groups also can prepare someone psychologically for a more active and directed search for information, once his/her immediate personal reactions are dealt with. Increasingly, more formal groups, acting as crowd-sourced medicine, are serving as opinion leaders and information seekers for, or supporting the everyday health information needs of individuals. Self-help groups are estimated to be in the hundreds of thousands across a wide variety of diseases with members numbering in the millions. In addition, these groups also can prepare someone psychologically for a more active or directed search for information, once his/her immediate personal reactions are dealt with. Driving this movement has been the notion that self-help groups have the potential to affect outcomes by supporting patients' general well-being and sense of personal empowerment (Barak, Boniel-Nissim, & Suler, 2008). Individuals sometimes prefer these groups to face-to-face interactions because they can keep an emotional distance and they feel that members of them are more likely to understand their unique experiences (Colineau & Paris, 2010). Some face-to-face groups have been particularly helpful to people who

face a variety of substance-abuse problems, especially the traditional approach of Alcoholics Anonymous (www.aa.org).

The Internet has increased the impact of these groups, the functionality and tools available to individuals, and with the additional twist that they are often supported by formal institutions or private companies. Perhaps the most prominent recent example of a robust and multifaceted online support system is Patients Like Me (PLM) (www.patientslikeme.com). PLM uses patient-reported outcomes, symptoms, and various treatment data to help individuals find and communicate with others with similar health issues (Frost & Massagli, 2009). As noted by a few of its developers, the essential question asked by patients participating in one of the several disease communities is: "Given my current situation, what is the best outcome I can expect to achieve and how do I get there?" (Brownstein, Brownstein, Williams, Wicks, & Heywood, 2009).

Another prominent and long-lasting self-help intervention is the Comprehensive Health Enhancement Support System (CHESS), which has focused on a variety of diseases with educational and group components, closed membership, fixed duration, and decision support (Gustafson et al., 2008). Computer-mediated support groups (CMSG) interventions such as CHESS have been shown, in a recent meta-analysis, to increase social support, decrease depression, increase quality of life and self-efficacy with their effects moderated by group size, the type of communication channel, and the duration of the intervention (Rains & Young, 2009).

Advocacy Groups

The emergence of advocacy groups over at least the last half century comes from people with the same disease or afflictions who need to share their efforts in facing similar challenges, exchanging knowledge that is recognized as different from that of health professionals, and speaking with a more unified voice to impact policy and related matters (e.g., Mukherjee, 2010). Advocacy groups have interests beyond serving and supporting the needs of their individual members; they may seek to change societal reactions to their members or ensure that sufficient resources are devoted to the needs of their groups (Weijer, 1995). At times these groups will have agendas that do not necessarily coincide with an individual's need for information. While the entrepreneurial broker is an individual's agent, advocacy groups need members to advance their group's agendas. For example, they often are especially interested in ensuring that the latest information on treatment is made available to patients, sometimes pressing for the release of information on experimental treatments before it would traditionally be available. They may expose their members to risky experimental treatments prematurely, but they would argue that these individual costs are often for the greater good of their

members and that the patrician attitude of cancer researchers has shrouded scandal in secrecy and led to an orientation toward treatment instead of prevention.

Advocacy groups are particularly active when there are not clear treatment options or when treatments are perceived to be ineffective (Weijer, 1995). At times individual and group interests coincide, and at other times they don't—something to remember when we turn to the next chapter that focuses on the role that health professionals can play in facilitating information seeking. Advocacy groups have been very successful in increasing research funds for specific diseases such as breast cancer. They actively seek more money for research that leads to information for databases, for enhanced access to and availability of information, and so on. In short, they lobby for an information infrastructure.

Increasingly, employers and insurance companies are also serving as advocacy groups with somewhat different interests. For a long time, corporations have been very concerned about escalating medical costs. It is in their interest to drive down costs as much as possible, at times to the detriment of their employees. New screening techniques (e.g., mammography, PSAs) have met with resistance by insurance companies. These institutions also have been leading advocates of the patient as consumer, in part to encourage second opinions and reduce unnecessary or ineffective treatments (Pfeiffer, 1989).

The issue of work-life balance has received increasing attention across a range of disciplines (e.g., Cheney & Ashcraft, 2007; Kossek & Lambert, 2006). Employee assistance programs (EAP) are often driven by an ideology of increasing worker efficiency and improving health as instrumental to generating productive employees (Dutta & de Souza, 2008). The scope of the national problems in areas traditionally encompassed by EAP services is troubling. It is estimated that 10 percent of employees are impaired sufficiently to need behavioral health intervention (Poverny & Dodd, 2000) and that $6 billion is lost in American businesses due to decreased productivity stemming from personal relationship difficulties (Turvey & Olson, 2006). As a result, there has been a national movement to enhance and enlarge a broad range of services for employees, including depression, stress, relationships, marital problems, compulsive gambling, career issues, financial and legal concerns, lactation centers, child and elder care, health and wellness, violence, and so on.

Traditionally EAPs focused on substance and alcohol abuse. An estimated 22.6 million Americans over the age of 12 are users of illicit drugs, and about 131 million use alcohol. About 8.5% of employed adults are heavy drinkers, and 29.7 percent are binge drinkers (SAMHSA, 2011). These patterns of substance abuse result in losses in workplace productivity estimated to cost in the tens of billions of dollars.

The still-lingering stigma associated with substance abuse is a barrier to developing effective programs (Dietz, Cook, & Hersch, 2005). While substance-abuse

prevention programs may result in higher health-care costs initially, prevention efforts lower health-care costs in the long term (Dietz et al., 2005).

Generally, people find employee benefit communication confusing and complicated (Picherit-Duthler & Freitag, 2004). Finding help in organizations is a complex phenomenon, and there are many barriers that seekers must overcome. Ignorance of employee benefits, which has a direct bearing on the employee's personal life, is widespread (Mitchell, 1988), often in spite of government-mandated procedures for informing employees. Lack of trust and concerns over confidentiality may result in workers seeking informal or external sources of information for dealing with their problems. They want to avoid being labeled or categorized in a way that is hard to remove (Geist-Martin, Horsley, & Farrell, 2003).

In general, the literature has focused on providing information to organizational members through formal channels rather than what motivates them to seek answers to questions they pose for themselves. A cornerstone of any strategy to facilitate information seeking is the removal of various access barriers. Firms have to support the sharing and using of information. Employees should be able to serve themselves from a common pool of available information through telecommunication and database systems. In creating such systems, management must be willing to let workers' inquiries go where they will while ensuring confidentiality.

The web is best used as part of an overall strategy for reaching an audience of employees, some of whom may prefer its relative confidentiality and self-paced, self-controlled depth of search. Corporate intranets can filter information that their employees are exposed to, but some might be leery of how confidential they really are. One consistent argument found in the literature is that people with high growth needs are more likely to consult a wide range of information sources. Organizations should nurture these individuals by providing them with the autonomy to pursue their searches and the ready availability of resources that meet their needs by such means as comprehensive websites. While there has been an increasing move to web-based resources, many employees find them difficult to understand and access (Freitag & Picherit-Duthler, 2004).

Human agents, opinion leaders and/or brokers, can overcome the incompleteness of organizational design. HR managers are seeking to find the appropriate balance between cost and effectiveness for delivering benefits communication with a clear preference for face-to-face communication (Freitag & Picherit-Duthler, 2004). They address the following problems: conversion of tacit to explicit knowledge; addressing individual cynicism and resistance to change; disruptions of work relationships; internal political and cultural barriers; and broader extraorganizational trends. Unfortunately, perhaps because of this long list of problems, these are difficult roles to fill, and in the natural course of events these linkages may decay quite rapidly. Indeed, the costs of seeking information within the organization may be so troublesome that people prefer to seek information outside

of the organization itself, rather than to ask overt questions (Johnson, 2009b). A sense of being safe to ask dumb questions is important in seeking information (Cross & Sproull, 2004). While opinion leaders, managers, and external sources may be sought out because they will maintain confidentiality, they all may feel larger imperatives to act if they feel the individual poses a threat to themselves or to others. Since EAP issues also are often associated with some stigmas, they can become all-too-tempting grist for the gossip mills of the organization. Because of these threats to confidentiality, individuals may feel very restricted in seeking help for certain problems, and protection of their privacy concerns becomes critical to the operation of formal EAP programs.

It is easy to avoid most of the messages directed at employees. People just do not look up information on the web, for example. What is difficult to avoid, but perhaps not to discount, is a formal referral to an EAP service. Similarly, intrusive workplace campaigns can sometimes reach the difficult employee. However, the current bent to proactive campaigns often ignores the powerful sources supporting ignorance, and the perhaps blissful lack of awareness of some employees that they may need help.

Wisdom of Crowds

Collaboration among patients means enhanced knowledge sharing, and the citizen researcher can leverage collaborative research via the wisdom of crowds to quickly correct erroneous information (Sarasohn-Kahn, 2008) and to supplement the wisdom of experts with that of laypersons (Hu & Sundar, 2010). Participation online is often asymmetrical, with up to 41 percent having consulted peers online, but less than 6 percent actively contributing (Fox & Jones, 2009). In spite of often-voiced concerns of health professionals, a surprisingly small percentage of Internet users report harm, although surprisingly large percentages report no help (up to 50 percent) (Fox & Jones, 2009).

As noted earlier, Patients Like Me (PLM) is currently a robust and prominent harbinger of what is to come. The site furthers the notion of the "patient researcher." In fact, there is some evidence that PLM is positively impacting outcomes (Wicks et al., 2010). Yet unlike social groups of the past, sites such as PLM are much more dynamic. For example, thousands of patients' data are aggregated so individuals can compare their own diagnoses, treatments, symptoms, and so on with many others to help choose a more personal path toward a better outcome. This path is lined with social and emotional support, quantified/visualized self-tracking, and opportunities for other treatments or research participation.

Stigmatized patients (e.g., HIV) use the Internet and relationships with their peers for legitimation and for "tag-team" searches that form longer collaborative strings (Veinot, 2009). In online support groups, weak ties might benefit participants (or have potentially negative consequences) given the disinhibition effect

often referred to in online communication, where people are known to say or do things they wouldn't normally do within closer networks (Barak et al., 2008). As in other weak-tie contexts, disinhibition can foster a sense of closeness, empathy, and kindness and a certain level of bonding that may break the inertia of the fields in which an individual has habitually been embedded and introduce them to new individuals or third parties whose diversity is more likely to result in self-correcting behaviors (Surowiecki, 2004).

Summary

Nevertheless, for many people these "high-tech" approaches alone are unlikely to work. Groups with lower literacy, those whose first language is not English, those less familiar with the complexities of health care, and those with serious health care problems will likely need to receive information in person from a known and trusted source (Shaller et al., 2003, p. 99).

This chapter started with a recapitulation of several recurring findings in the information-seeking literature that must be addressed by any individual or professional strategies. Many traditional barriers to information seeking can be addressed. Training programs and support structures can be designed to overcome an individual's lack of skills and awareness of information sources; they also can increase the salience of information seeking as an important life skill. Perhaps, most importantly, new technologies, which will be explored in detail in the next chapter, offer the possibility of overcoming and/or substituting for the traditional problems of accessibility, inertia, and the limitations of humans as information processors. But as Paisley (1993) details, knowledge dissemination research has gone through similar cycles of excitement of promising new technologies that have fallen by the wayside. Perhaps the most serious limit on new technologies is the recurring preference of individuals for interpersonal information sources that can digest and summarize vast quantities of information for individual seekers.

Further Reading

Dutta, M., & de Souza, R. (2008). The past, present, and future of health development campaigns: Reflexivity and the critical-cultural approach. *Health Communication, 23*, 326–339.

Communication professors Dutta and de Souza argue that health-promotion campaigns in developing nations could benefit from a reflexive and critical questioning of the assumptions that guide most health campaigns. In particular they wish to shift attention from "blaming the victims" to one in which structural

factors that promote ill health—e.g., rapid industrialization and urbanization, development of polluting industries, promotion of tobacco imports from the U.S.—are the focus of awareness and regulation. Dutta and de Souza provide several examples of health campaigns (HIV/AIDS prevention, healthy eating, microcredit/poverty reduction) more in tune with local knowledge and needs.

Frost, J., & Massagli, M. (2009). PatientsLikeMe: The case for a data-centered patient community and how ALS patients use the community to inform treatment decisions and manage pulmonary health. *Chronic Respiratory Disease*, *6*(4), 225–229.

Jeana Frost and Michael Massagli describe an online community for patients diagnosed with amyotrophic lateral sclerosis (ALS) on the website PatientsLikeMe. On the site, patients share information on their symptoms, treatments, and outcomes. Information from participants is depicted graphically, both on the individual and community level. Patients can then discuss these data within a forum, post comments on individual profiles, and send private messages to one another. Frost and Massagli's qualitative analysis of a sample of 123 comments reveals patient enthusiasm for this kind of sharing and support. They suggest that such ways of facilitating "health conversations" are likely to help patients manage a variety of diseases.

Johnson, J. D. (1997). *Cancer-related information seeking*. Cresskill, NJ: Hampton Press.

The precursor to this book, focusing on an explanation of the Comprehensive Model of Information Seeking. In this edition, cancer information is the main target of interest to consumers. Still valuable as a guide to the earlier literature on the topic.

Miller, V. D., & Jablin, F. M. (1991). Information seeking during organizational entry: Influences, tactics, and a model of the process. *Academy of Management Review*, *16*, 92–120.

Newcomers to organizations face the need to learn quickly and to tolerate high levels of uncertainty. They rarely feel that they are being given enough information. In order to better instill feelings of competence and acceptance in newcomers, we must understand how they seek information. Miller and Jablin's resulting model suggests that new employees use various tactics, some of which are covert or disguised, to find information while they learn roles and the expectations. The authors suggest that more attention needs to be paid to how information is acquired, not simply how it is processed into decisions and actions.

EIGHT

Strategies for Health Professionals

Efficiency requires members of the audience to be treated amorphously and to bend to the institution. Effectiveness requires that individuals be helped on their own terms (Dervin, 1980, p. 85).

Overview

Health professionals face a daunting task in today's rapidly expanding, ever-changing information environment. Individuals must come to intelligent judgments based on a welter of facts, forecasts, gossip, and intuition that make up their information environment. While this book has focused on closing the knowledge gap between lay information seekers and health professionals, there are also evident gaps among the various medical specialties. Perhaps most importantly, however, health professionals are not only responsible for themselves, but they also must nurture and enhance the information capabilities of their clients.

In this chapter, we will describe the traditional approach of health professionals to providing information to the public, then we will turn to what they can do to facilitate the public's information seeking. Traditionally, health professionals have thought of these processes in terms of a one-way, top-down flow of communication. They have relied on the mass media to reach large numbers of people efficiently in their campaigns (e.g., childhood obesity). These authoritative dicta and the lack of interactivity in the communication channels chosen were meant as much to discourage, or to preempt, information seeking as to stimulate it. Many

approaches and assumptions of traditional media research were often implicit in this approach.

Somewhat akin to mass media's historical bullet theory, the public was thought to be a relatively passive, defenseless audience. Public communication campaigns represent "purposive attempts to inform, persuade, or motivate behavior changes in a relatively well-defined and large audience, generally for noncommercial benefits to the individuals and/or society, typically within a given time period, by means of organized communication activities involving the mass media and often complemented by interpersonal support" (Rice & Atkin, 1989, p. 7). Unfortunately, health communication as a field, especially in its health and social marketing manifestations, has become closely identified with this relatively narrow, often ineffective, view of communication.

Underlying the campaign approach is the idea that communication in effect could be "shot" into an audience, like a bullet or inoculation (Schramm, 1972). This view of communication was embedded in the more general stimulus-response notions popular in psychological research during this period (Rogers & Storey, 1987). Most campaigns must grapple with the fact that they do not really reach intended audiences, and therefore they do not succeed among a large number of their audience members. Traditional health communicators have learned that these classic approaches are not very effective unless the needs of the audience and their reaction to messages are considered (Freimuth, Stein, & Kean, 1989). Thus, it soon became apparent that, while there were some notable successes, audiences could be remarkably resistant to campaigns, especially when they did not correspond to the views of their immediate social network. While there may be some commonalities across information fields, individuals' information environments are becoming so fragmented, driven by individual contextualizing, that assessing media effects (or campaign ones) is increasingly difficult (Johnson, Andrews, Case, Allard, & Johnson, 2006). There is a commonplace recognition now that mass media alone are unlikely to have the desired impacts; they must be supplemented with interpersonal communication within social networks (Noar, 2006), with growing importance attached to social media. Indeed, campaigns tend to reach those who are already interested and typically bypass those who are most in need of their messages (Lichter, 1987).

There developed a tendency among advocates of communication campaigns to cast "the audience as 'bad guys' who are hard to reach, obstinate, and recalcitrant" (Dervin, 1989, p. 73). The term "obstinate audience" was coined by Bauer in his classic research article detailing the active role audience members play in the processing of communication messages (Bauer, 1972). In natural situations, Bauer contends the audience selects what it will attend to. These selections often depend on interests, and the interests of audience members are reflected in their level of knowledge and the strength of their convictions. While exposure is the

first step to persuasion (McGuire, 1989), the audience members most likely to attend to messages related to health professionals' interests are those already committed to them. Dervin (1989), in this connection, has suggested that the most appropriate strategy might be to change the institutions delivering the message rather than to expect the audience to change deeply seated behavior patterns. In effect, campaigns reach the already converted. While this might have a beneficial effect of further reinforcing beliefs, the audience members who are most in need of being reached are precisely those members who are least likely to attend to health professionals' messages (Alcalay, 1983).

Stimulators

> ... it is doubtful that health education programs could be successful *without* the participants' readiness to learn, and their personal initiative to follow through on such interactions (Rakowski et al., 1990, p. 380).

Campaigns often fail because their recommended beneficial effects are not apparent, and they do not identify market segments within the total audience who require different communication approaches in line with their specific needs. The bottom line is that interested people may acquire, on their own, most of the information available on any subject (Hyman & Sheatsley, 1947; Real, 2008). Prepackaged campaigns fail to realize some people are active information seekers, nor do they answer the very specific questions active seekers have (Freimuth et al., 1989). This suggests that finer-grain discriminations of the audience may be necessary to ensure effective communication. However, campaigns that encourage information seeking may overcome some of the limits of superficial content targeted to a broader audience (Silk, Atkin, & Salmon, 2011).

As we have seen, perhaps the best strategy is to achieve a "match" between the information carriers with whom health professionals choose to disseminate information and the information-seeking styles of individuals. Thus, the question becomes the much more sophisticated one of placing the most appropriate content in the most appropriate channel, where it is most likely to be used by a predetermined audience.

Health professionals' efforts also suffer from unrealistic expectations (Atkin, 1979). Most advertising campaigns would be happy with a level of change in their audience of 3 percent to 5 percent a year (Robertson & Wortzel, 1977). Typical of the expectations of health communicators, Cole and Wagner (1990) expressed disappointment that only 37 percent of the colorectal screening kits they distributed during a screening program were returned for testing. Compared to most commercial campaigns, this is an astonishing level of success. McGuire (1989) has also pointed out the very low probabilities of success of communication cam-

paigns given the long string of steps that must be fulfilled (get the audience's attention, prompt them to think about it, persuade them to change behavior, etc.), each of which only has moderate probability of success. It has been estimated that the average health communication campaign changes the behavior of only 8 percent of the population (Noar, 2006), or stated in another way, meta-analysis shows the mean of correlations for media campaign effects to be .09 (Snyder & Hamilton, 2002).

Contemporary views of health communication are more likely to stress a dialogic view of interaction, with both parties initiating and attending to messages in turn. Historically, campaign developers have only sought the input of audience members to figure out the best way of changing their minds (Dutta & de Souza, 2008). Dialogic views also incorporate a much more specific role for information seeking, which in traditional views was almost totally ignored, at least on the public's level. A major focus of some public communication campaigns is also to encourage people to seek other channels for information, achieving both variety in delivery systems and repetition of messages (Salmon & Atkin, 2003). Health professionals' most important role in these more modern perspectives is as stimulus or cue to action, defining the agenda of the most important issues that an audience needs to face. Hopefully, establishing this agenda will result in proactive information-seeking behaviors by the public. Thus, a critical role of health professionals is that of managing attention.

Thus, one role of health professionals in this new environment involves facilitating the flow of information and ensuring that there is support for the nation's information infrastructure. Many health organizations have realized that promoting information technologies advances strategic advantages, especially in enhancing quality, maintaining market share, and developing innovations. Indeed, it has become commonplace for almost all hospitals and managed-care providers to have active information programs for their clients and for organizations to provide the extensive wellness and employee assistance programs that we described in the previous chapter.

Facilitating Information Seeking

When health campaigns motivate individuals to seek information on their own, effects of the campaign on changing individuals' behavior typically outlast the duration of the campaign itself (Turner, Rimal, Morrison, & Kim, 2006, p. 131).

In conclusion, successful government information librarians will be those who actively use technology to create a connection between users and the government information available to them. She will meet the user on the user's terms and she will prioritize her activities in favor of the user's workflow. Rather than

wait for users to come to her, she will broadcast news about government infor-
mation (West, 2008, p. 64)

Obviously a key role for health professionals lies in making it easier for the public to
seek and find health information and in encouraging them to do so. This represents
a significant shift in the priorities of health professionals as well as a major change in
the way consumers are viewed. An important aspect of this effort involves teaching
the public about the characteristics of information sources and channels.

Educating the Public on the Capabilities of Information Carriers
Information seekers are often frustrated in their attempts to seek information
(Arora et al., 2007), especially from doctors. A major focus of health communica-
tion in recent years has been on patient-doctor communication. The amount of
information physicians give to patients is correlated with patient satisfaction with
health care and with compliance (Epstein & Street, 2007). Patient dissatisfaction
with physician communication stems in part from feeling inadequately informed
during consultations. Partly this is due to a perceived lack of attention and empa-
thy (Tustin, 2010). Faith in physicians is negatively related to information seeking
from other sources (Hibbard & Weeks, 1987), suggesting that once patients have
a basis for judgment, they are less satisfied with doctors.

However, exclusive reliance on one source of information may be problem-
atic, since lack of communication between doctor and patient has been found
to relate to decreased ability to recall information given by the caregiver, patient
dissatisfaction, decreased adherence to prescribed regimens, and other forms of
noncompliance (Epstein & Street, 2007). People are more likely to follow behav-
ioral recommendations when their understanding is more complete (Freimuth et
al., 1989).

This suggests that a precursor to a better patient-doctor dialogue would be to
increase the public's knowledge base and to provide alternative information sources
besides doctors. Indeed, one objective of health-related campaigns should be to
sensitize individuals to other sources of communication and to increase their in-
formation-seeking capabilities. Flay and his colleagues (Flay, 1987; Flay, DiTecco,
& Schlegel, 1980) have found that to induce behavioral change regarding health
promotion, the media must repeat the message over a long period via multiple
sources. This is a classic finding in consumer research as well; the more information
channels an individual has access to, the higher the probability of purchase (Fisk,
1959). People who are highly exposed to one medium tend to be highly exposed to
others (Berelson & Steiner, 1964). Thus, one way of achieving impacts in the long
term may be to encourage exposure to a channel individuals are predisposed to in
the hopes that this will snowball into exposure to other channels.

The chances of success of classic campaigns are enhanced by using complementary mixes of mediated and interpersonal channels (Rice & Atkin, 1989). Information-seeking behavior, such as calls to the Cancer Information Service (CIS), has also been found to increase when individuals are exposed to cancer-related information from more than one channel. In turn, people are more likely to pay attention to and be influenced by mediated communication (e.g., brochures) they receive after a telephone call to CIS because they requested them and because of the "interpersonal" relationship with the information specialist on the phone (Freimuth et al., 1989). Donohew, Helm, Cook, and Shatzer (1987) suggested that media should be used in a complementary fashion to achieve desired effects. Thus, some have suggested that an "information prescription" should be provided by physicians to direct their patients to Internet sources that can provide them with more detailed information (Coberly et al., 2010). A number of health campaigns have also recognized the strategic necessity of reaching people through multiple carriers (Green & McAllister, 1984).

This is a key, and often missing, element of health education: educating the public about the characteristics and capabilities of various information carriers. Such campaigns are currently in vogue for many health-related telephone services. Efforts like these are part of a growing emphasis on informed consumer choice as a basis for provision of health care. This approach encourages competition among health providers and a decentralization of services. Such a strategy requires removal of various access barriers to information and the creation of incentives for a more active consumer role in health care (National Center for Health Services Research and Health Care Technology Assessment, 1988). If this plan is to work, the public must have access to up-to-date, technical information from a variety of sources. Motivated patients are likely to acquire information on their own, relevant to their health concerns (Real, 2008). The more scarce a piece of information is, the more one must work on their own to obtain it, typically the more valued and persuasive it tends to be (Cialdini, 2001). Designers of media campaigns may fail to realize that some people are active information seekers, and their messages do not address the specific questions active seekers have (Freimuth et al., 1989). Together these findings suggest that finer-grain discriminations of the audience may be necessary to ensure effective communication, much as in emerging approaches to personalized medicine.

Creating Rich Information Fields

Another possible approach to increasing awareness of health among the public is to increase the richness of their information fields; for example, providing Internet access or a laptop to those who don't have such resources. This strategy can potentially broaden awareness of health beyond one's immediate concerns, since it

removes barriers to the acquisition of information. Scanning relevant information on the web also increases the knowledge base of individuals that makes it possible for them to communicate more effectively with health professionals and to make more informed decisions about the appropriate solutions when a problem develops.

Health professionals must make it easier for people to use information technologies, since many individuals will resist change, especially changes related to information technology (Hoffman, 1994). Unfortunately, physicians have also resisted change. Because of the doctor's role as the key decision maker in hospitals, the benefits of advances in information technology have been slower to come in the health arena than in more commercial sectors of our society, lagging from seven to ten years behind other industries (Johnson, 2009d). Doctors find information technology threatening on several levels: it removes their exclusive control over information; it increases the possibility that their behavior will be monitored (e.g., through assessment of medical records of their patients); and many physicians are loath to admit ignorance in any area, a key problem when they need to learn new technologies (Schuman, 1988). Countervailing pressures to drive down costs from insurers and government agencies are overcoming the traditional resistance of health professionals to information technologies (Johnson, 2009d; Shortliffe, 2005). The National Institutes of Health see significant synergies between health IT and health communication, touting IT's capacity to improve provider-patient interactions, improve self-maintenance of chronic diseases, enhance health promotion, enable more productive interactions among differing health professionals, and facilitate efficient information seeking (Harris et al., 2011).

Creating richer information fields through such practices as "self-serving" by retrieving information from databases, for example, should make for a more informed consumer, who is likely to consume less time of health professionals' "being brought up to speed" on the basics of his/her disease and its treatment. Two general strategies for developing rich information fields will be reviewed in this section. The first is to increase the physical access to information in one's immediate environment. Beyond one's immediate physical environment, electronic access to information becomes critical.

Physical Environment

While health professionals cannot usually affect the situation of individuals who are in the early stages of looking for health-related information, at the point when patients seek diagnosis and subsequent treatment, health professionals should mind the physical environment of health institutions serving those clients. Locations in which information is accessed provide the opportunity and occasion for interactions with health-care professionals. Both social density (the number of

interactants within a bounded space) and proximity act to determine the access of individuals to information.

Minimizing physical barriers increases ambient information that can be easily observed or overheard by physically proximate parties. Individuals may be stimulated, by having physical access to information, to seek additional information. Many physicians are taking advantage of these factors by creating information-rich environments in their waiting rooms. Instead of stale popular magazines, various health-related brochures are available, as well as videotapes and monitors, and even in some cases, access to Internet connections, which can provide detailed information on a patient's particular concerns.

Access is also affected by the relative mobility of individuals. Increasing mobility can be a direct result of transport technologies, but the necessity for this mobility can stem from individual needs. Therefore spatial factors affect channels selected for information seeking in determinant ways, and channels, particularly electronic ones, can be viewed as the communicative surrogate of mobility.

Health Information Technology

> The challenge, then, is not to make more information available but to create and disseminate information that consumers can *use* in their decision making (Moorman, 1994, p. 49).

In spite of rosy predictions, the impacts of information technologies on health communication have been a matter of some controversy in recent years. Many have suggested that improvement in Health Information Technology (HIT) is the major strategy that could be employed to reduce our uniquely expensive health-care system and bloated administrative costs (e.g., Whitten, Cook, & Cornacchione, 2011). While computerization of information should make it possible to deliver the right information, at the right time, to the right place, accomplishing this has proven to be much more difficult than it would appear to be on the surface. While optimists wait for the next generation of computer software and hardware, realists are increasingly looking at institutions, especially their cultures and structures, as the major impediment to improved information usage. Much of the impetus for change comes in the promise of reduced costs and greater efficiencies (Wright et al., 2008); however, seldom do new technologies result in lower expenditures (Bodenheimer, 2005b), although they may produce enhanced capabilities.

In the following sections, however, we will look at the information-seeking possibilities created by new technologies in three areas. In essence, an information architecture does three things with data: storing, transporting, and transforming (Cash, Eccles, Nohria, & Nolan, 1994). While we will discuss these components

separately, increasingly it is their blending and integration that creates exciting new opportunities for information seeking. In the health arena, these benefits and possibilities are captured under the heading of "health informatics." Consumer health informatics is perhaps the fastest growing area of this specialty.

Data Storage

Traditionally, data storage has meant physical storage of information in filing systems, but with the volume of information related to health, paper-based systems are increasingly unwieldy (Johnson, 2009c). Modern conceptions of storage have broadened this function considerably to include verification and quality control of information entering a storage system. Security systems for the stored information, which directly relate to information seeking, are also increasingly important. For example, who should have access to personal information? In team-based medicine, several health-care professionals may need quick access to at least some of a patient's medical history; however, this raises issues of potential privacy violations. Security issues also involve means to ensure that no one can tamper with or change information residing in a database. The typical precautions used to preclude illegal access to patient records—e.g., passwords, automatic logout after so many minutes—slow down the speed and refocus the attention of health-care workers in urgent situations.

Information pollution has become an increasing concern of even the popular press because of the wealth of information stored on Internet resources and the difficulty in determining the reliability of that information. There is also reason to be concerned about the commercial motivations of many providers of information. One unresolved question is who is liable for erroneous information on a database: its provider, the author of a message, or the person providing the information? Doctors are reluctant to lodge too much authority in these systems because they are ultimately responsible for any advice they give patients, even if they are merely relaying information (Schuman, 1988). However, since most malpractice suits are based on a standard of reasonable care, as more physicians use information technologies, it also may be the case that not using them could be a basis for a malpractice claim (Diamond, Pollock, & Work, 1994).

Historically, doctors have mistrusted medical information systems because they may not capture the subtlety and nuance that only their long experience and training can bring to a situation (Schuman, 1988). They also do not provide much assistance to health professionals in areas where there is low consensus knowledge (Brittain, 1985).

On the other side are consumer activists, former cancer patients and family members who demand that all information should be made available, regardless of source, especially for conditions for which there is not effective treatment. Users should be the only ones who determine the utility of information, these advo-

cates believe; however, peer review often serves to preserve the status quo. It may even be the case that knowledgeable laypeople have more knowledge than general practitioners and even oncologists, in some areas.

To their credit, the authoritativeness of the information provided has always been a paramount concern for government databases. In part to deal with some of these problems, the National Library of Medicine's Medline systems cross-reference corrections to articles (Tilley, 1990). The National Cancer Institute (NCI) has also been paying systematic attention to these issues for at least a couple of decades (Hubbard, Martin, & Thurn, 1995). Physician Data Query (PDQ) is NCI's comprehensive cancer database (www.cancer.gov/cancertopics/pdq). It has summaries of a wide range of cancer topics, a registry of both open and closed clinical trials, a dictionary of more than 6,800 cancer terms as well as data on more than 2,300 agents used in cancer-related treatments.

PDQ was originally designed to address the knowledge gap between primary care physicians and specialists. For example, in a 1989 survey of primary care practitioners, two-thirds felt that the volume of the medical literature was unmanageable, and 78 percent reported that they had difficulty screening out irrelevant information from it (Hubbard et al., 1995). According to Kreps, Hibbard, and DeVita (1988, p. 362) "this knowledge gap is responsible for the prolonged use of outmoded forms of cancer treatment resulting in unnecessarily high rates of cancer morbidity and mortality." PDQ seeks to provide a current peer-reviewed synthesis of the state-of-the-art clinical information related to cancer. A critical issue facing all databases is how (and even whether) old, irrelevant information is culled from any storage system; in databases outside of medicine, outdated information is seldom removed. It may not be apparent to users of public databases, like many of those available on the Internet, that the information they provide is outdated. In contrast, the cancer information file of PDQ is reviewed monthly by six editorial boards of cancer experts in different areas (e.g., adult treatment, screening and prevention, complementary and alternative medicine). These boards have clear guidelines on levels of evidence for information to be considered for the database. These procedures clearly set PDQ apart from other databases in terms of the timeliness and authoritativeness of information it contains.

Increasingly salient is the related issue of the meaningfulness of the keywords and software assumptions that categorized the original information. This area of concern is being addressed, in part, by the National Library of Medicine's (NLM) Unified Medical Language System (UMLS) initiative to try to establish some standards for online information resources (MacDougall & Brittain, 1994), and controlled vocabularies have been a major issues for informaticians, especially in the creation of HIE, as well as for insurance companies for billing purposes.

It is hard to participate as an informed consumer if you don't know the language. There have been a variety of efforts designed to address these issues, such

as involving patients more in the creation of materials (e.g., Smith & Stavri, 2005); moving to plain language similar to prior moves by banks and insurance companies, and even handbooks for deciphering Medspeak have been prepared by the Medical Library Association for specific diseases. But all this is harder than it looks: synonyms are numerous, require context to interpret, and terms overlap in meaning; polyhierarchies representing multiple domains in which a word may be used; there also have been historical shifts in terminology (e.g., "dropsy" used to be a common word for edema). Ideally, terminologies or vocabularies should capture what is known about the patient; support information retrieval; minimize loss in storage, retrieval, and transfer; and support aggregation, reuse of data, and inferencing (Cimino, 2006).

Databases

Databases may be thought of as those repositories of information that are the key elements of a profession's memory, providing a means for storing, organizing, and retrieving information. Electronic storage makes it possible to link multiple databases, provide a common core of information, and create increasingly sophisticated searches. As we will see in the next section, usually they must be combined with sophisticated electronic access, such as via the Internet, to achieve their full potential for information seeking.

Databases, when coupled with powerful search engines and the linking capabilities of modern relational databases, also encourage ever-more complex questions. For example, data-mining programs are an application of artificial intelligence that may automatically scan for ways in which data may be linked

DATA MINING

which is sometimes called knowledge discovery, is the intelligent analysis of data so as to make strategic decisions. Data from multiple sources—typically from large relational databases—may be brought together and analyzed for associations and patterns. The technique was pioneered by intelligence analysts in governments and in business and has the potential to improve both the efficiency and effectiveness of operations.

Businesses may use data mining in order to facilitate product sales and the supply chains that feed retail stores. A classic example can be found in large retail chains (e.g., WalMart) that analyze store and produce point-of-sale data in real time to find relationships among variables such as price, product placement, and advertising, to make decisions about when and how to market their products. These data can be melded with other location-based data (e.g., neighborhood demographics) and with external data about competitors and the general economy. On a higher level, such data can inform decisions about product lines, store placement, and corporate strategy.

Data mining is used in many noncommercial applications as well. Intelligence analysts in government may analyze transportation (e.g., airline passengers) and communication (e.g., content analyses of emails originating overseas) to look for evidence of potential terrorist activity. The scientific uses of data mining are many. In medical research, data-mining software has been used to look for patterns in human DNA sequences in order to study risk of disease, in analyses of clinical trial data, and in the surveillance of adverse drug reactions among patients.

Privacy has been a troubling issue in data mining. Some U.S. government anti-terrorist efforts, such as the Total Information Awareness (TIA) program, have been discontinued due to concerns about violation of constitutional rights. HIPAA provides some privacy protections via requirements that data be anonymized when aggregated. However, there remain concerns that even anonymized patient data might lead to the identification of individuals when melded with other data sources.

and portray these associations in statistical and visual representations; it would be very difficult for even the most diligent human researcher to match inferential powers of such expert systems. On the immediate horizon are associative databases with data-mining programs that can automatically search for information on increasingly remote or tenuous relationships to provide answers we never expected (or at least would have been unable to uncover). For example, a data-mining program might discover a dietary factor that predisposes the Hmong to stomach cancer when they immigrate to the U.S.; or discover an unnoticed connection between migraine and magnesium deficiency (Swanson, Smalheiser, & Torvik, 2006).

Data Transport

Data transport is the acquisition and exchange of information. The previously mundane world of data transmission is increasingly the stuff of lead stories on the evening news, such as applications by Google or Apple that provide easier access to information.

TELECOMMUNICATIONS. The applications of telemedicine range from two radiologists in different states consulting over the same image of a patient, to distance learning for physicians and other health professionals, to automatically tracking possible problems with the various prescriptions written for any one patient. The purported benefits of telemedicine are many: increased access to information, increased consistency in medical decision making, matching diagnostic and management options to patient needs, increased quality of care, more interpretable outcomes, increased efficiency, increased efficacy, decreased costs, and a more uniform structure for health care (Blumenthal & Glaser, 2007). This is especially true for rural populations, who have received special emphasis from federal policymakers in relation to telemedicine.

There are many barriers to the use of telemedicine, however, including legal restrictions on the flow of information across states (e.g., a physician licensed in one state consulting electronically in another), tariff regulations that make linkages very expensive, insurers' willingness to pay for consultations, malpractice problems (are the images of sufficient quality to make judgments?), and patient acceptance (Office of Rural Health Policy, 1994).

Networks such as the Internet usually combine enhanced telecommunication capabilities with software that allows linkage and exchange of information among users and sources (including databases). One reason for the excitement behind the Internet is its easy access (both in terms of costs and lack of other barriers) and the increasing user-friendliness of search software and associated applications. Telecommunication systems such as fiber-optic cables and satellite systems pro-

vide the hardware that links individuals and provides enhanced access to systems, largely through the availability of various handheld devices. Telecommunication systems maintain communication channels (e.g., email) through which information is accessed and reported. They can specifically enhance the information seeking of patients by creating new channels for sending and receiving information, helping them in filtering information, reducing their dependence on others, leveraging their time to concentrate on the most important tasks, and enhancing their ability for dealing with complexity.

Electronic bulletin boards and discussion lists create communication spaces characterized by potential similarities among messages and communicators. This enhances participation and access by allowing all individuals who share a similar interest to use the same electronic space to communicate. Increasingly, cancer support groups are meeting in cyberspace, becoming one of the most common health applications of the Internet (Rains & Young, 2009). Even older technologies like telephone-linked care make use of automation and digitized response to treat chronic diseases in an economical manner (Mooney, Beck, Freidman, & Farzanfar, 2002).

For information seeking, the critical issues revolve around the carrying capacity of a particular system and the ease, range, and timeliness of access. Fiber-optic systems are vastly superior to traditional metal-wire systems because of their carrying capacities. Without this increase in carrying capacity, the current movement toward telemedicine, especially such applications as distant surgery, would be impractical. Some cancers, such as melanoma or prostate, are more easily and quickly evaluated when the rich visual imagery and interactivity of computerized telemedicine systems are brought into play (Krupinski, 2009; Sneiderman, Hood, & Patterson, 1994).

SERVICES PROVIDED BY THE NATIONAL INSTITUTES OF HEALTH. Combining databases and telecommunications with software creates telematics that allows for the possibility of increasingly sophisticated searches for information and analysis/interpretation of it once it is compiled. The NIH, primarily through the NLM and the NCI, have devoted considerable resources and thought to building a national information infrastructure in the U.S., playing a significant role in increasing the access of the public to authoritative information (Lindberg & Humphreys, 2008). This has been done partially to respond to the concerns of advocacy groups for more rapid dissemination of knowledge, particularly related to AIDS and breast cancer.

Early on these government efforts focused on telephone hotlines such as the CIS (Johnson, 2005); more recently the government has focused on providing information through access to authoritative databases such as the NLM's Medline, which first became free to the public in 1997 (Miller, Tyler, & Backus, 2004). Many NLM sites now have the capability to develop user profiles that keep them

abreast of self-defined areas of interest as relevant material is added to a database by using RSS feeds. The federal government is thus promoting a rich infrastructure from which individuals can draw information, enhancing their access to richer information fields (Johnson, 2009c). There are currently around 200 health-related government databases and public health information network sites.

NATIONAL LIBRARY OF MEDICINE. The National Library of Medicine, founded in 1836, is the largest research library in the world focusing on a single professional field (NLM, 2012), It has clearly demonstrated leadership in the development of various health informatics over nearly three decades under Dr. Donald Lindberg. While the NLM is primarily in existence to service the needs of health professionals, its databases, such as Medline, provide the critical national information infrastructure for enhancing patient care (Lindberg, Siegel, Rapp, Wallingford, & Wilson, 1993; E. H. Wood, 1994).

MedlinePlus has become a key resource for consumers interested in authoritative health information. This is particularly important since only one-quarter of health information seekers check on the quality of the resources they use. NLM has devoted considerable resources to ensuring the quality of information it provides on MedlinePlus (Miller et al., 2004), updating the site daily (http: //www.nlm.nih. gov/medlineplus/aboutmedlineplus.html). It contains directories, encyclopedias, dictionaries, tutorials, and links to clinical trials. MedlinePlus gets very high ratings from patients for its ease of use, informativeness, and its ability to aid in making better health decisions; however, only 43 percent of patients who searched health information have used MedlinePlus (Smalligan, Campbell, & Ismail, 2008).

NATIONAL CANCER INSTITUTE. The NCI has a broad array of programs focused on communication and information, including the CIS and PDQ, whose operations we have previously described. The CIS, described in the last chapter, has been the traditional leader in conducting research on services relating to information seeking and has been used as a laboratory for communication research (Johnson, 2005). NCI also has been funding systematic programs of research associated with several Centers of Excellence for Cancer Communications Research.

It also supports the only large-scale national survey conducted on a regular basis related to health communication that focuses on information seeking. Starting in 2003, the Health Information National Trends Survey (HINTS) has collected baseline data concerning trends in health information seeking (http: // hints.cancer.gov/dataset.aspx) that has proven useful for setting policy. A number of the articles cited in this book relating to cancer information seeking are drawn from this particular resource. This survey is one part of the overall recognition on the part of NCI of the critical role that communication can play in reducing morbidity and mortality (Rutten, Squiers, & Hesse, 2006).

Data Transformation

The integration of data storage and transport with sophisticated software offers unique opportunities for software solutions that transcend the limits of individual information processing. Such applications are especially helpful for novices, yet they are also a boon for experienced professionals who need to make decisions under pressure.

Data dashboards. Automobile dashboards have been analogized in computing applications, some of which have found their way into health care. Rather than providing feedback about devices (e.g., a car's components and movement), health-focused dashboards monitor either the status of patients or the performance of health providers such as hospitals. Data dashboards are often coupled to electronic health records (EHR) and personal health records (PHR). They also have been instrumental in wellness applications and tracking chronic disease management (e.g., blood-sugar levels in diabetic patients).

Discussions of human-computer interface development can be somewhat fadish, as has recently been shown in publications about Web 2.0 and visualization. Nevertheless, the social web is relevant as dashboards become the focus of collaboration efforts, since their indicators can serve as a cue for multiple users to take action. For example, a dashboard associated with a HIE might report an increase in the number of deadly viral diseases in a particular region. A visual alert on health professionals' dashboards (e.g., on their personal web page) might signal the need to take a variety of public health measures. As a result, direct coordinating communication, and

DATA DASHBOARDS

To use a familiar example, a car's dashboard contains a number of instruments that help the driver to monitor the vehicle and its environment, through an array of sensors. Some of the visual displays signal that appropriate action needs to be taken quickly (e.g., a significant decline in oil pressure, or a rise in coolant temperature), others give feedback on current performance (e.g., miles per hour or miles traveled), while still others provide longer-term information (e.g., maintenance is required, oil life is diminishing). More modern vehicle dashboards also have inferential capabilities (e.g., projected range, miles per gallon, traffic avoidance) to provide more detail on particular areas of concern to drivers. To be useful, a careful balance must be struck between providing too much information, which may distract the driver from the task at hand, and too little. Careful thought must be given to what indicators are really critical to system performance.

Data dashboards, sometimes called digital dashboards or performance dashboards, facilitate surveillance of a complex system in order to help make decisions and/or take actions. Their purpose is to convey key pieces of information at a glance and draw attention to the most important or most urgent information using color, spatial location, differing fonts, and graphic displays. They are typically implemented on a desktop computer or a mobile device, such as a cell phone or tablet computer. Dashboards typically display quantitative data; however, they might also include qualitative information, displayed as graphics and text. They are typically updated in real-time, and allow for user interaction with the data and the way it is depicted.

Dashboards are used in a wide variety of settings. The Obama administration has devised a number of them to inform the public about such matters as U.S. government spending. Some local school districts use them to inform the local community how they are doing in regards to annual targets for student achievement.

In health-care settings, dashboards are commonly used by hospitals to monitor performance and improve the quality of care. The dashboard may track aggregate clinical activities such as rates of mortality, catheter infection, C-sections, or stage of cancer at diagnosis. They are also used to monitor key events and processes such as number of adverse drug reactions, code response times, or percentage of transfusions with adverse reactions. Many systems that support electronic health records include a dashboard function to monitor the status of individual patients.

attendant delays and breakdowns, would be minimized, since a number of actors would focus on their element of the problem according to a pre-existing plan.

Increasingly users of health-care dashboards can customize their displays, drawing on a diverse array of information sources in creating "mash-ups." Essentially mash-ups are software tools that allow users to easily customize the information they choose to attend to by creating unique information fields drawing on sources ranging from conventional corporate intranets, to public information from the world wide web, to unique proprietary databases. These mash-ups can be shared with others and used in different formats for smart phones, so they are not limited to desktop applications.

Visualization, which is inherent in the dashboard metaphor, is more broadly used to understand the vast amounts of digital data currently available and is increasingly important to the National Science Foundation, which has a special funding initiative related to Foundations of Data and Visual Analytics as well as a number of other governmental and commercial firms. Especially critical to these initiatives is their possibility of generating insights that can lead to meaningful actions.

New approaches to visualization constantly emerge, suggesting a number of compelling needs and continuing problems. The fundamental problems increasingly relate to the development of databases and the quality of information that is put into them. These are often enormous undertakings, with especially grave problems for combining information based on different formats and vocabularies, whose benefits are often opaque to the people whose goodwill is needed to ensure good information is submitted (Kalman, Monge, Fulk, & Heino, 2002).

Reflections on Information Technology in Medicine

The preceding discussion suggests the increasing importance of information as a strategic asset that should be systematically incorporated in the planning of health professionals. Health professionals also need to lobby federal and state governments to maintain critical information infrastructures, such as publically available health databases.

These trends also suggest a need to reintroduce simplicity, partially by establishing more direct communication linkages with the primary source of information (Keen, 1990) and to think carefully about what information should be excluded from an individual's information processing. While more and more information can be produced and provided more efficiently, there is a concomitant increase in the costs of consuming (e.g., interpreting, analyzing) this information (More, 1990). To effectively coordinate dissemination, health information systems must be compatible and follow standards for information processing—a problem that has plagued the exchange of health information. Coordination costs increase with distributed work and more extensive lines of communication (Keen, 1990), so problems of information asymmetries (e.g., quality) may prevent the creation of

totally open health information infrastructures. For example, in hospital settings, CEOs typically receive twice as much decision-making information as their board, and three times as much as their medical staff (Thomas, Clark, & Gioia, 1993). This suggests there are considerably different knowledge bases and interpretive frameworks for individuals in different information-processing roles. In addition, the nature of information processed among functional specialties also differs, with production-based information more certain and quantifiable than the typical mix of marketing and sales information, for example. This specialization, which can be augmented and enhanced by information technology, makes it much harder for differing groups to communicate across their boundaries (Johnson, 2009c).

Until recently, most information-processing activities targeted *automating* tasks; increasingly computers are being used to augment human capabilities by *informating* tasks; the wave of the future may lie in restructuring tasks so that tasks are *transformed* (Cash et al., 1994). For example, the next wave of computers may exceed human capacities to simulate complex models, including many more variables than humans are capable of considering, to create scenarios of varying plausibility for the consideration of human decision makers.

Increasingly, seeking and interpretation will be delegated to intelligent software (Maes, 1995). These systems will not, however, be able to make the value decisions (e.g., is the physical and psychological cost of chemotherapy worth the potential benefits?) and ethical decisions often associated with treatment. It has become a truism that computer-based information and decision systems excel at programmed tasks; they do not perform well, and may even be dangerous, for tasks that are ambiguous and/or that need creativity and judgment (Keen & Morton, 1978).

Providing Quality Information to Those Who Need It

> Health professionals have long accepted the responsibility for identifying and responding to consumer needs. The predominant practice, however, has been defining needs in terms of how the health professional felt people should behave rather than the actual utilities sought by the consumer or the motivations that influence human behavior (Cooper, 1979, p. 8).

> It does little good to scare people, insult people, etc., except under certain extreme conditions. Changed health patterns must be shown to be in line with the audiences' self-perceived needs (Robertson & Wortzel, 1977, p. 527).

As we have seen, perhaps the best strategy is to achieve a "match" between those information carriers chosen by health professionals to disseminate information, and the desired outcomes (Dijkstra, Buijtels, & VanRaaij, 2005). Thus, the subtle question is how to place the most appropriate content in the most appropriate channel, where it is most likely to be used by a predetermined audience. Finer-grained

discriminations among the audience may be necessary if health professionals are to achieve their information dissemination goals. Perhaps the clearest controversy related to matching is the classic concern regarding the lack of emotional support by physicians. Yet, there is evidence that patients themselves do not consider physicians an appropriate source for emotional support, instead they are more likely to turn to family and friends for this sort of help. Patients have different expectations of various sources (Green & Roberts, 1974). What they want from physicians is authoritative, relevant, specialized information (Phillips & Jones, 1991).

Web 2.0

Web 1.0, or the read-only Web, operated much as a traditional library and promoted more efficient searches and reading passively from material (Strecher, 2008). Web 2.0, or Health 2.0, allows for more interactivity; users have the ability to create information and post it, sharing it through graphics, text, and video in a variety of social-media applications (Sarasohn-Kahn, 2008). On the horizon is the so-called Web 3.0—a semantic web facilitating the seamless sharing of information.

Increasingly, patients are forming interesting collectives, as we saw in the last chapter, invoking the wisdom of crowds. They often can be self-correcting when errors become evident in support groups and other social media (Sarasohn-Kahn, 2008). These collaboratives promote greater knowledge transfer, concerted action, and greater voice when approaching policymakers for funding, regulation, and other objectives.

While the Internet remains the primary source of Health 2.0 applications for most individuals, some have suggested that a better label would be "interactive health communication"—encompassing personal digital assistants, mobile phones, computer-tailored print materials, interactive voice response, computer-driven kiosks, DVDs, etc. (Strecher, 2008). Four types of interactivity are particularly relevant: user navigation, collaborative filters, human-to-human interaction, and expert systems (Strecher, 2008). User navigation then approaches the analogy of searching for information in a library. Collaborative filtering involves sophisticated software written for identifying user behavior and linking them to other individuals who have similar preferences. A similar application is found on Amazon.com, where recommendations are given to you based on the purchases of others who have chosen items similar to ones you have selected in the past. Human-to-human interaction mediated by the web can take the form of the information brokers covered in the last chapter, or services like the LiveHelp instant messaging service, available at NCI's website cancer.gov, combining the best features of the Internet with the CIS's traditional telephone service. Interestingly, a different mix of content is requested through the service, with much more of a focus on prevention-related information (Sullivan & Rutten, 2009).

In expert systems, rules derived from knowledge workers and/or experts (e.g., engineers, systems designers, health professionals) are incorporated into computerized information systems, something that is much more difficult to achieve in practice than it appears (Kukafka, 2005; Noar, Banac, & Harris, 2007). Thus "[e]xpert systems are computer programs that couple a collection of knowledge with a procedure that can reason using that knowledge" (Feigenbaum, McCordick, & Nii, 1988, p. 6). Expert systems resemble the process of tailoring interventions (Lustria, Cortese, Noar, & Glueckauf, 2009). They embody many of characteristics of artificial intelligence. They can result in more thorough and consistent decision making. In the health arena, expert systems have been developed primarily for diagnosis. They have also been used successfully on a wide array of additional tasks including processing medical claims, selecting the appropriate chemical formulation for a particular application, and health assessments. However, questions remain about the legal liabilities attached to computer judgments; in the event of a misdiagnosis, who is liable: the user of the software, its programmers, or the medical experts who were consulted to develop its knowledge base? (Fioriglio, 2010).

The Internet has spawned many flexible information search and retrieval services that determine its substantial benefit. Expert search engines, such as those found in tailoring applications, try to accommodate different learning and search styles of different users adopting their approach to specific individuals. Messages might be screened, sorted, and prioritized based on several categories: the urgency in which a response is needed, cognitive domains (e.g., keywords), social dimensions (e.g., more attention given to friends, those higher in the hierarchy), future communication events (e.g., the agenda for an upcoming meeting), and so forth.

Expert systems, and their associated tools of simulation and modeling, in effect can overcome the limits of individual cognition and bounded rationality by providing humans with answers without concerning them with an enormous range of variables and potential scenarios/options that these systems automatically consider (Gurbaxani & Whang, 1991). These computer programs increasingly rely on graphic images of data, assuming that for interpretation of information a picture is literally worth a thousand words. In some ways, they are similar to shared decision-making programs that allow patients to explore on their own information related to their problems, which is then used to facilitate joint decisions with their physicians about treatment options (R. A. Miller, 1994).

Targeting versus Tailoring

Traditional approaches to health campaigns have targeting messages to particular audience segments. Audience segmentation breaks down the mass audience into groups that are as homogeneous within, and as different from each other group as possible (Solomon, 1989). This type of health marketing approach essentially seeks to understand the consumer so well that health care sells itself by the mere

provision of information (Fox & Kotler, 1980). Demographic characteristics have typically formed the basis for targeting, but we have repeatedly seen the limitation of this approach.

Agencies need to recognize the fundamentally different nature of audience segments and develop different strategies to reach them. In segmenting audiences, agencies need to focus on the importance of different groups (e.g., who most needs to change?) and their receptivity (e.g., who is most likely to be influenced?) (Atkin, 1992). For example, women and more highly educated individuals are the most likely to pass on information to others (Meyers & Seibold, 1985) and thus to act as secondary information disseminators. So, agencies need to think carefully about how their target audience negotiates the information carrier matrix in their quest for answers.

In contrast to targeting that focuses on groups of individuals who share similar characteristics, tailoring focuses on individuals who have unique clusters of attributes and situations. There is evidence across a number of domains that tailoring is superior to nontailoring of messages for campaigns (Rimal & Adkins, 2003), but the effects sizes are relatively small (Noar et al., 2007). In part this is based on the classic public health formulation that impact equals efficacy times reach, with tailoring argued to have both high efficacy and high reach (Noar et al., 2007). In broad form, tailoring involves the use of computer algorithms to match personalized health information to messages designed to impact behaviors. In a systematic review of over 500 studies, Lustria and her colleagues (Lustria et al., 2009) found substantial variation in the number of features and formats of computer-tailored health interventions focusing on behaviors such as binge drinking, nutrition and diet, and smoking. Some programs were relatively brief and simple, while others involve complex theory-based tailoring with a variety of assessment tools, leading to the development of self-regulatory skills of various mechanisms for providing feedback (Lustria et al., 2009). Tailored information is more likely to be read, remembered, perceived more positively, and seen as personally relevant (Lustria et al., 2009).

Tailoring approaches focus on the unique attributes of individuals and mimics some of the classic characteristics of interpersonal channels (Kukafka, 2005; Noar, Pierce, & Black, 2010). These systems use *personalization* through the use of specific information gathered during assessment (e.g., name, persons your age, and so forth); *feedback* involving expert systems recommendation for the individual; and *adaptation* involving the development of content packages tailored specifically to the person's information needs (Lustria et al., 2009). Message tailoring goes hand in hand with audience segmentation and has seen considerable advances over the last couple of decades, especially with the advent of new media and technologies that facilitate its application. Thus, at the same time there has been a tremendous

growth in consumer tools for acquiring information, there has been a concomitant increase in health-care marketing and advertising tools (Tomes, 2010).

Tailoring interventions have used a variety of approaches to content based on information needs, stages of change, risk factors, and health behaviors (Lustria et al., 2009). Tailoring applications can allow risk information to be incorporated into individual preferences, highlighting perceived versus actual risks, numeracy, need for cognition, and locus of control. The power of computing lies in its ability to "branch" depending on patient responses (Slack, 1997), forming ever-more specific responses to specific concerns. Recent approaches to tailoring systems have included dynamic components that take into consideration what people have learned and what stage they are in in the treatment of disease (Walther, Pingree, Hawkins, & Buller, 2005).

In the not-too-distant future, it is possible that these factors will be linked directly to an individual's genetic makeup to fulfill the promise of personalized medicine. These applications have demonstrated greater influence than classic one-size-fits-all mass-media approaches. In part this is accomplished by the greater relevance of messages delivered to target audiences (Strecher, 2008).

Yet segmenting/tailoring by information-seeking attributes seldom appears to occur in practice (Lustria et al., 2009). Recently, more global characterizations of clusters of consumer characteristics have captured the imagination of marketers. Perhaps the most useful approach for health professionals then would be to develop different strategies for different styles of information seeking. Segmentation analysis along these lines would allow agencies to select target audiences in a readiness stage, those most likely to respond to any promotion (Freimuth et al., 1989).

Active information seekers may need nothing more than access to an authoritative database. Active seekers tend to be highly educated, skilled, aggressive, and persistent. They can be very effective partners in promoting health among others, as well as promoting access to information resources. In effect, these individuals are classic opinion leaders, who have a multiplying effect in the social systems of which they are a member. They also serve as agents of change through their discovery of and popularization of alternative approaches to health (Lefebvre & Flora, 1988). Their quest for information is chronicled in popular movies (e.g., *Lorenzo's Oil*) and television programs. There is a growing popular literature of biographies of these individuals' personal struggles with health (e.g., Cousins, 1979).

Health professionals can ease the difficulty of the search of active information seekers, but the best of the seekers will find the answers they seek despite the obstacles presented to them. However, health professionals need to ensure that the information individuals find, regardless of the individual's seeking style, is of high quality. This may be their most important role in the new age of information, ensuring that individuals have access to authoritative information.

Health Games

Health advocates have been attracted to computer games as an intervention vehicle because of the potential such games offer for both engagement and for tailoring of responses. An increasingly sophisticated array of gaming software, consoles, smart phones, and high-definition displays give players a vivid and compelling experience via which both knowledge and attitudes can be shaped. Through careful application of theory, design methodologies, and field testing, computer games can be used to increase health-related knowledge and skills and to motivate changes in behaviors.

According to Debra Lieberman (2012), games have three essential components: rules, a goal, and feedback regarding progress towards the goal. Games may be played by one person or many people; online multiplayer games may involve thousands of players. They may use ordinary computers, dedicated devices, televisions and/or mobile phones. Games can also incorporate physical sensors that monitor players' activities and current health status.

Various types of motivations can inspire use of games. In addition to the competitive desire to "win" when playing against the computer or a human opponent, games can offer other types of motivators, such as opportunities to solve puzzles, be creative, develop skills, or simply be distracted and entertained. Because certain topics and activities are of more interest to particular age groups or genders, games can be an effective way of targeting populations at risk for certain conditions, e.g., children and nutrition, teens and smoking, or older women and osteoporosis.

Thousands of health-related games now exist, and their design and use have inspired a series of Games for Health conferences in North America and Europe. Among the many topics and conditions these games address are alcohol and drug abuse, asthma, attention deficit disorder, autism, cancer education, cancer treatment adherence, cystic fibrosis, diabetes, dietary intake of fruits and vegetables, emergency medical care, epidemics, exercise, heart disease, HIV/AIDS, mental health, physical therapy, smoking prevention and cessation, stress management, stroke, and weight loss. In some controlled studies, games have been shown to increase a variety of positive factors, including learning about diseases and treatments, adherence to treatment, diet, self-confidence, discussion with others, and social support. On the downside, for some players, games may decrease interaction with other people or contribute to repetitive motion injuries.

Summary

Most individuals need considerable assistance in seeking information. They probably would best be served by the brokers and information specialists whom we discussed in Chapter 7. They also can gradually be brought up to speed to become self-sufficient information seekers by training in how to search for medical infor-

mation. One consistent finding of the information-seeking literature is active use of one channel often leads to information seeking in others. The primary assistance these individuals need is to get started down the road.

Increasing the availability of and enhancing access to health information thus are strategies that are particularly appropriate for individuals who do not possess the knowledge of sources and who are only casually motivated to seek. Currently a variety of institutions are following these strategies. Such strategies are essential to the premise of creating information equity in the public that might serve to reduce critical gaps in their knowledge and awareness. Increased familiarity with information carriers increases perceptions of accessibility, but this does little good if the information is not perceived as useful. Unfortunately, most individuals have no clear idea of how to weigh the merits of various perspectives on medical or scientific information, thus a critical new role of health professionals as credentialers is emerging. In effect, agencies could provide the equivalent of the "Good Housekeeping Seal of Approval" to information sources, such as the HON (Health on the Net) seal, providing an easy way for the public to assess the credibility of competing information sources.

Those in denial, those who refuse to seek information (or to act on it), may need to be the objects of classic communication campaign efforts, mobilizing their interpersonal networks in the process. But it must be recognized that such individuals are the classic obstinate, hard-to-reach audience. However, developing campaigns for the hard to reach may have useful spill-over effects in reaching audiences who are more ready to change, as indicated by findings of gains from using mass communication alone (Sherer & Juanillo, 1992). If the issue is pressing enough, then more authoritarian policy changes may need to be sought, such as enforcement through legal controls (e.g., distribution of cigarettes to minors) or engineering and design changes (e.g., airbags). Public health agencies would much prefer to change people through information campaigns, which are perceived to be inherently more democratic, preserving individual choice, cheaper, and are much less likely to backfire on them through public controversy. They also preserve the illusion of helping everyone: the information is out there; it's up to individuals to choose to acquire it (Salmon, 1992).

Because of the unwillingness of some individuals to acquire information, and even a tendency to engage in denial, it is important that health professionals make information easily available to target audiences. For example, in recent years an active movement has arisen to place more authoritative health information in entertainment programming on television by soliciting the cooperation of producers, directors, and writers. The development of media programming rich in health content is particularly useful in reaching underserved populations because of their traditional reliance on the media as a source of health information. While far from a perfect solution, partly because of the different needs of an entertainment chan-

nel versus an information channel (Sharf & Freimuth, 1993), it may provide at least partial information that could lead to a desire for more.

This may be one of the best strategies for increasing awareness of prevention issues, since the same powerful triggers that lead to acquisition of treatment and dealing with health information are not present for prevention. This approach also can increase the knowledge base of individuals that may make it possible for them to communicate more effectively with health professionals immediately after the disease is diagnosed and to make informed decisions about the appropriate course of treatment for them or for a family member.

Health-care professionals need to look to the mix of information in the current information environment, ensuring that they are providing the missing pieces of the puzzle, providing countervailing arguments when necessary, and emphasizing the importance of issues not addressed by others (Fox & Kotler, 1980). One interesting example lies in the area of mammography screening. It may be the case that commercial vendors of mammography equipment and film have done as much to increase awareness of the need for screening as the considerable efforts of public agencies. The efforts spent promoting mammography—which needless to say is an important public health issue—might have been better spent promoting vaccinations, or other health problems where there is not a comparable commercial interest.

Agencies can partner with private, commercial interests to provide an interesting synergy of resources and credibility. Most governmental agencies are barred from effective use of television because of the high cost of paid advertising.

As we have seen, perhaps the best strategy for health professionals is to achieve a "match" between the information carriers that agencies choose to disseminate health information and the information-seeking profiles of individuals at critical stages in their health information seeking. Thus, the question is how to place the most appropriate content, in the most appropriate channel, where it is likely to be used by a predetermined audience. In essence, this constitutes a type of segmentation approach to social or health marketing, with much more precise targeting of audiences based on their information-seeking styles.

Further Reading

Boahene, M., & Ditsa, G. (2003). Conceptual confusions in knowledge management and knowledge management systems: Clarifications for better KMS development. In E. Coakes (Ed.), *Knowledge management: Current issues and challenges* (pp. 12–24). London, U.K.: IRM Press.

While some contend that knowledge management (KM) is just another computing fad that will eventually fade, its persistence for more than two decades suggests otherwise. This chapter by two Australians discusses KM as an emerging

discipline and explains the basic concepts underlying it. Of special importance to our book is Boahene and Ditsa's discussion of the conceptual differences among data, information, and knowledge.

Johnson, J. D. (2005). *Innovation and knowledge management: The Cancer Information Service Research Consortium.* Cheltenham, U.K.: Edward Elgar.

Johnson's book considers a four-year period in the history of the Cancer Information Service (CIS) as a vehicle for highlighting the creative use of consortia, knowledge management, and innovation. During these years, CIS made successful use of consortia of health practitioners and health researchers to investigate innovative intervention strategies. This case study suggests ways that other organizations might leverage technology, information, and human resources to accomplish more, and better, outcomes.

Lustria, M. L. A., Cortese, J., Noar, S. M., & Glueckauf, R. L. (2009). Computer-tailored health interventions delivered over the web: Review and analysis of key components. *Patient Education and Counseling, 74,* 156–173. doi: 10.1016/j.pec.2008.08.023

Mia Lustria and her colleagues analyzed 30 studies in which computer-tailored behavioral interventions were delivered over the Internet. Targeted behaviors included the promotion of exercise and good diet and smoking cessation, among other efforts. Among the interventions they found a wide variety of features, approaches, and levels of complexity. The content of the programs tended to be customized on the basis of either health behaviors (the most common), stages of change, risk factors, or information needs. They conclude that research-based guidelines are needed for tailoring across different health behaviors, foci, and client populations before we will be fully able to assess the effectiveness of such approaches.

Noar, S. M., Banac, C. N., & Harris, M. S. (2007). Does tailoring matter? Meta-analytic review of tailored print health behavior change interventions. *Psychological Bulletin, 133*(4), 673–693.

Seth Noar and his colleagues conducted a thorough meta-analysis of 57 studies meeting certain inclusion criteria. Included among the studies examined were a mix of designs (comparisons of messages, and messages compared to no-treatment control group), target behaviors (e.g., smoking cessation, cancer screening, diet improvement), and theories employed, among other variations. Their overall conclusion is that tailoring does make a difference. Among the 40 "true tests" of tailoring, in which a tailored message was compared to another message, the mean effect sizes indicate that tailored messages well outperformed comparison messages in affecting health behavior change.

Rakowski, W., Assaf, A. R., Lefebvre, R. C., Lasater, T. M., Niknian, M., & Carleton, R. A. (1990). Information-seeking about health in a community sample of adults: Correlates and associations with other health-related practices. *Health Education Quarterly, 17*, 379–393.

One of the earlier studies to conclude that information seeking about health needed to be further studied as a "process" variable. This telephone survey of 281 adults resulted in two indices, Information-Positive and Information-Negative, shown to be correlated with other health practices, such as self-exams and use of seatbelts and dental floss. Interestingly, the only demographic variable to predict greater health-related information seeking was being female. The authors made a prescient comment (in those pre-web days) when they noted that "as our information-oriented society continues to develop, the benchmarks for defining an active information seeker may need to be redefined periodically" (p. 391).

Salmon, C. T., & Atkin, C. (2003). Using media campaigns for health promotion. In T. L. Thompson, A. M. Dorsey, K. I. Miller, & R. Parrott (Eds.), *Handbook of health communication* (pp. 449–472). Mahwah, N.J: Lawrence Erlbaum Associates.

Noted communication scholars Charles Salmon and Charles Atkin review the history, theories, and current state of the art regarding media campaigns. They do an excellent job of explaining what has worked the best in changing knowledge levels, attitudes, and behaviors in regard to health. Of particular interest is their discussion of the portrayal of incentives (positive and negative) for certain kinds of behaviors.

Shortliffe, E. H. (2005). Strategic action in health information technology: Why the obvious has taken so long. *Health Affairs, 24*(5), 1222–1233. doi: 10.1377/hltaff.24.5.1222

Edward Shortliffe, a pioneer in the application of computing to medicine, reviews the history of investment in medical information processing, beginning with hospital applications in the 1960s. Shortliffe traces the federal role in developing projects and resources, then focuses on what he sees as barriers to effective use of information technologies. Among the roadblocks are busy clinicians with other priorities; fear of threats to privacy; poor understanding of capabilities and costs; and the fragmentation of the health-care system in the U.S., which leads to local investments with few standards or economies of scale. Despite this, Shortliffe believes that the empowerment of consumers and the passage of HIPAA and other developments in health-care policy will lead to an era of increased adoption of IT in medicine.

| NINE

Summing Up

Information Seeking in the Information Age

Overview

In this chapter, we bring together our central themes and we point to the future. A compelling feature of research on information seeking is that it stands at the intersection of so many important theoretical and policy issues. It raises concerns that have captured the attention of U.S. political leaders ranging from Hillary Clinton to Newt Gingrich to Barack Obama. As a pragmatic issue, it is the subject of cover story after cover story in the popular press. Reflecting its growing importance, there is an increasing professionalization of the field with a growing concern for ethical standards and a concomitant focus on developing its own unique methodological tool kit with which researchers can explore problems. It also raises compelling theoretical questions in many areas that have received inadequate attention in the social sciences generally, to which we now turn.

Future Directions of Information-Seeking Research

Information seeking is a process that has become critical to a number of social science fields, each with its own tradition of inquiry and placement within the context of a larger discipline. So, the field's initial focus on uncertainty reduction, in part, grew out of a concern of interpersonal scholars with how people deal with strangers in their initial encounters with them. The first author's concern with cancer-related information seeking focused on the episodic nature of information

seeking driven by a desire to return to a healthy state. His personal history with cancer resulted in a focus on direct experience in the original formulation of the CMIS. In this book, we have broadened this conception to reflect an individual's existing knowledge base and the associated issues of purging, refinding, reusing, and forgetting. These issues also have direct implications for perceptions of gaps and the need to actively seek information from outside sources. Traditionally, however, there has been a disconnect between problems researchers focus on and concerns of patients related to cancer communication (Thorne, 1999).

Information-seeking research is often driven by the concerns of larger disciplines and/or its application to particular problems. As we have come to be aware of developments across these disciplines, however, we also have been tempted to overburden our models by including every variable, rather than, as in the traditional approach to modeling, only including the most important ones. There are other larger questions that information-seeking research needs to focus on in the coming years, which we highlight in the sections that follow.

Developing a Receiver Orientation

> Without considering audience attributes there is a greater likelihood that receivers will ignore the message, misunderstand the content, reject applicability to self, challenge claims with counter-arguments, or derogate the source.... (Atkin, 1981, p. 47).

Because of its traditional administrative science bent, research and theory have been dominated by a source perspective in information behavior. Particularly in areas relating to health, the concern has been in delivering messages from agencies to receivers. By and large, except for some cognitive difficulties individuals might have in processing messages, the nature and motives of consumers, or receivers, have been downplayed or ignored (Lammers, 2011). If receivers have been examined, it usually is in the context of how we can better get our messages across to them, with many echoes of this approach in agencies' concerns with health literacy issues. We focus on the imperfections in receivers, particularly their cognitive limits. We also focus on the question of what the public "really wants" so that we can construct more effective persuasive communication campaigns (Barnett, Danowski, & Richards, 1993; Dervin, 1980).

As we have seen, one historical reason for problems in campaigns has been a failure to consider a complete range of the motivations that impel individual actors. This has in turn led to perceptions of an obstinate and irrational audience that is blamed for thwarting well-meaning and beneficial campaigns (Dervin, 1980). (People just don't understand what's good for them!). Focusing on the sender often leads health professionals astray, because the assumption is just because a message is uttered, it is attended to. As the classic selective perception

and selective attention literatures suggest (Katz, 1968), a fundamental property of communication relationships is that a receiver must attend to a communication message for any communication to occur. A more receiver-oriented approach suggests people will only seek and process information when they deem it useful and relevant (Kahlor, Dunwoody, Griffin, & Neuwirth, 2006). How a message is perceived really determines the nature of a communication event, and receivers are ultimately the arbiters of the value of any piece of information (Hall, 1981; Rowley & Turner, 1978). It is the audience that ultimately interprets any message (Morley, 1993) and, more basically, determines whether any communication will occur (Katz, Blumler, & Gurevitch, 1974).

An approach that has information seeking as its focus inherently tries to picture the world of the actor and the self-interests that motivate him/her to particular behaviors (Dervin, 1980). Yet individuals are not totally free of constraints governing their actions. They depend on others for information and for services and the general societal framework in which they are embedded restricts the range of questions and alternatives that can be pursued. How is individual agency limited and shaped by the larger information fields and carriers that compose an individual's information environment? This question, then, lies at the heart of any future research efforts related to information seeking.

This is perhaps the most poorly understood area of human information behavior (HIB). Why do people seek information from some carriers and not others? Why do people seek information on some topics and not others? Why do they recurrently structure their communication to attend to certain messages, from particular communication channels, from specific sources? The antecedents to communication events and the structure of an individual's daily communication contain many answers to these questions, but with the exception of some works cited in this book, the larger field of HIB has ignored these issues fundamental to any theory of information seeking.

Individual Action in Social Context

One persistent theoretical problem in the social sciences is accounting for individual action in a social context (Johnson, 2003). Thus, the relationship between context and information seeking is a problem increasingly viewed as a central issue in information behavior research (Allen, Karansios, & Slavova, 2011; Cool, 2001; Dervin, 1997, 2003; Johnson, 2003; Kari & Hartel, 2007; Kelly, 2006; Pettigrew, Fidel, & Bruce, 2001; Solomon, 2002; Sonnenwald, Wildemuth, & Harmon, 2001; Talja, Keso, & Pietilainen, 1999). While context is central to all explanations of social science (Hewes & Planalp, 1987), it has been examined most often in micro, discourse-related processes (Bateson, 1972; Goffman, 1974). Generally, the persistent theoretical problem of accounting for individual action in a social context is seldom explicitly addressed, and we are unaware of the dif-

ferent senses of context in use (Dervin, 1997). Especially lacking is the identification of "active" ingredients of the environment that trigger changes in information seeking (Kindermann & Valsiner, 1995a; Rice, 1993; Thorngate, 1995). In general, in conceptualizing our world, we have a tendency to focus on objects rather than their grounds (Stocking & Holstein, 1993), focusing on messages or individuals, for example, rather than the contexts within which they are embedded (Kindermann & Valsiner, 1995a, 1995b). We concentrate on the processes that interest us, rather than on the diffuse social contexts that frame, embed, and surround them.

In general, there may be some mutual shaping of determinism and particularism, but some hard realities exist at both extremes. For example, initially there may be both deterministic and particularistic descriptions of a communication process that do not overlap (e.g., a patient's denial of the presence of cancer). However, over time we may come to understand there are some invariances in the process through multi-contextual inquiry (e.g., studying it across age groups and cultures in different care settings). Thus, we discover that all patients initially pass through a stage of denial. However, as our understanding matures through empirical confrontation, we uncover key active ingredients that lead to more precision in our understanding of the duration and recurrence of denial. So, older patients, in hospice environments, with supportive loved ones may be much more likely (there is still some particularism) to come to acceptance much earlier.

Different approaches to context, such as fields and pathways, imply different relationships between actors and their information environments and thus also encapsulate different views of the relationship between individual actions and contexts and the active role individuals can play in contextualizing. Fields could be seen as embedded in classic causal approaches to human action, while pathways reflect more modern notions of narrative and a search for typical patterns (Johnson, Andrews, Case, Allard, & Johnson, 2006). Similarly these conceptions in some ways represent the distinction between "objectified" and "interpretive" approaches to context (Talja et al., 1999).

While the larger framework of societal structures, norms, and values provides parameters for social action, it does not completely determine them. Information seeking is one of many actions individuals can engage in. Increasingly important theoretically is a focus on a cluster of similar behaviors, a multiple behavior approach, and their persistence and maintenance (Noar, Banac, & Harris, 2007). Information seeking is governed by available information fields and carriers, norms related to appropriate information-seeking behaviors, and individual beliefs concerning the efficacy of information seeking. Thus, it provides a focus for efforts to develop a more general theory of individual action.

Action is also an inherently dynamic view of human behavior that moves us further from traditional theoretical focus on a static world. As we have seen, in-

formation seeking is a dynamic process, with an often predictable sequencing of sources consulted, but with each additional step often determined by the answers received from preceding ones (Pescosolido, 1992; Savolainen, 1993).

Building Bridges

> … it is an unruly literature: publications on information needs, uses, and seek-ing sprawl across many academic disciplines, using dozens of overlapping con-cepts with varying definitions that, at times, conflict with one another. The find-ings of many thousands of studies are difficult to compare, much less synthesize (Case, 2002, p. xv).

Ruben (1992) has argued there will be an increasing convergence of commu-nication and information sciences research largely because of the "market pull" of societal trends. Information-seeking research is a critical focus of inquiry in a variety of disciplines: health communication, decision-making research, eco-nomics in relation to the operation of markets, sociology, information sciences, library and information sciences, computer science, cybernetics, systems engi-neering, consumer behavior, and so on. While information seeking is critical to many divergent bodies of knowledge, a coherent approach to the phenomenon has yet to emerge. The field needs a transdisciplinary approach, but it has typi-cally been interdisciplinary, with needless duplications, a lack of building on the foundational work of others, and proliferations of basic nomenclature (Parrott & Kreuter, 2011).

By and large, social science is organized by its major levels, psychology, so-ciology, and so on, in part because of the taken-for-granted assumption that so-cial phenomena vary greatly across them (Infante, Rancer, & Womack, 1993; Paisley, 1984). This specialization by level hinders the development of theory for processes like information seeking that cut across various levels, diminishing the potential impact of research.

Increasingly, academic research has found itself divided by context domains. So a person does psychological research, management, mass media, and so forth. This is particularly true of examinations of health communication where the schism between interpersonal (doctor-patient interactions) and mass (commu-nication campaigns, audiences) has hindered the development of research and theory (Freimuth, Edgar, & Fitzpatrick, 1993; Reardon, 1989). This increasing specialization hinders the development of research in areas like information seek-ing that cut across various contextual domains. Similarly there is a disconnect between research and system developers, like the one in information science be-tween the "soft" sciences of HIB and the "hard" science approach to information systems. Information technology is often developed without evidence in mind, but technology is moving so fast, it's often difficult for researchers to keep up

(Strecher, 2008). The pattern of results of research streams such as Pescosolido's (1992) emphasizes the importance of using several channels, especially authoritative interpersonal ones, to obtain health-related information. Focusing on information seeking provides a promise of integrating increasingly fragmented domains across the social sciences.

Studying information seeking across contexts is more likely to lead to generalizable theories of information seeking (Kahlor, 2010). McGuire (1983) long ago argued that studying processes across multiple contexts was essential to advancing our understanding of them. He also argued that it was even more important to study phenomena in widely different contexts, especially ones where our hypotheses were unlikely to work. In conventional inquiry, the tendency is to ignore discomforting elements (e.g., the importance of physical attraction in interpersonal relationships) by focusing on the elements of a context that conveniently fit our explanations.

Certainly, the picture that would emerge from examining information seeking solely in one context would be a distorted one. While both cancer and organizational contexts, for example, have similar broad macro trends (e.g., the growth of information technologies) and deep-seated cultural values (e.g., the advancement of knowledge) affecting them, and both require us to focus on receivers, there are also fundamental differences. The loci of constraints, whether individual or structural, are different. The impact of legal (e.g., malpractice) versus economic forces is markedly different on sources of information (e.g., doctors and management). Health information seeking, at least in its early stages, when focused on a specific, acute problem, may be somewhat frenetic, volatile, and unpredictable. On the other hand, organizational information seeking, at least for programmed decisions, may be more measured, bounded, rational, and habitual (Johnson, 2003).

So, examining information seeking across a wide array of everyday life contexts broadens our understanding of it (Savolainen, 1995). It also serves to suggest the active ingredients (e.g., programmed decisions) that may serve as the essential foundations of more sophisticated contingency explanations as well as increasing our appreciation of the impact of broader societal trends. In doing this, the things that do not change from context to context highlight what might be the invariant, the core, the essential being of information seeking.

Focus on Collaborative Behaviors Rather Than Individual Attributes

> The attributes or attitudes of actors contribute little or nothing in explaining actions. What matters is the structural location of actors (Nohria & Eccles, 1992, p. x).

Traditionally health communication has focused on psychological phenomena involved in the processing of persuasive information rather than on behaviors

representing the search for information (Smithson, 1989). But the structural ap-
proaches examined here offer compelling advantages over more psychological ones
(Dervin, 1980), suggesting a different level of analysis for information-seeking re-
search. While the primary focus of the literature has been on individuals, increas-
ingly information seeking is seen as a joint or collective activity (Hertzum, 2008),
especially with a focus on interprofessional teams in health-care settings (Reddy &
Spence, 2008). When collaboratives need new information, information seeking
is often performed by subgroups of actors who need to develop common under-
standings to share information, and in this sense the focus of information seeking
is on developing a coherent view of the information gathered (Hertzum, 2008).
The feeling of mastery, arising from active information acquisition, also may raise
interesting questions of when the seeker becomes the sought after. Often patients
find themselves bombarded with information from well-meaning friends and rel-
atives. At what point does a new patient gather, synthesize, and interpret enough
information that they can mentor patients newer than themselves?

 If for no other reason than the fact that health communication occurs in so-
cial collectivities, we must look beyond individual attributes, as the current inter-
est in social networks and health suggests. So there is an increasing emphasis on
intermediaries, citizen action, and the wisdom of crowds. Individuals often make
sense of health issues with their families through dialogue (Pecchioni & Keeley,
2011). As we have seen, the constraints imposed by the collective often determine
individual actions, especially information-seeking ones. But the answers individu-
als acquire and disseminate can in turn shape the collective. A focus on collective
activities, such as information seeking, a major driver of emergent network prop-
erties, offers many advantages for developing HIB.

Rationality and Objectivity

> Historically, we have perhaps placed too much faith in the model of the rational,
> information seeking, and probabilistic practitioner, expecting the mere availabil-
> ity of new information to lead to changes in his or her clinical policies (Lomas
> & Haynes, 1988, p. 90).

Recent years have seen an explosion of interest in HIB in part attributable to
the rapid development of the Internet and associated information technologies.
Concomitantly there has been substantial growth in theoretic frames, research,
and substantive models. However, these approaches have often been fragmentary,
dependent on the goals of disparate disciplines that are interested in differing
aspects of information behavior. They often have been rooted in the most rational
of contexts, libraries, where individuals come with a defined problem, or informa-
tion technology systems, that have their own inherent logic. Attempts to extend
this work to everyday life contexts often run into disquieting findings related to

the benefits of ignorance and the seeming irrationality of HIB. A broader view of our social world leads us to richer policy implications for our work.

The field of information behavior still struggles under the assumption that information behavior is highly rational (Case, 2012) and goal directed (Spink & Cole, 2006). Similarly, the limited focus on biomedical health promotes a narrow view of health. When placed in a broader context, the seemingly irrational (e.g., refusing treatment) may be perfectly rational (e.g., concerns about family's financial well-being in the absence of health insurance). Rationality may lie at the heart of some of the "dubious assumptions" embedded in the literature articulated by Dervin (1976): there is relevant information for every need, it is always possible to make information available or accessible; and people make easy, conflict-free connections between external, "objective" information and their own internal reality. Rationality essentially reflects acceptable reasons, causes, and explanations and is often deeply rooted in our technologies. The rational implies thinking, weighing, reflection; while irrationality reflects intuitions, emotion, and subjectivity (Nahl & Bilal, 2007; Pharo & Jarvelin, 2006). It may be the case that confronting disease also brings our latent, unconscious approach to developing information fields more to the level of manifest conscious awareness and as a result more subject to rational considerations (Brooks, 2011). However, there has been a move towards a more subjective view of HIB, especially in terms of relevance judgments of users (Case, 2012).

A deeper understanding of rationality is needed to confront some common findings in the information-seeking literature. We tend to assume people will expend a lot of energy to attack important problems and will also make sure of the quality of sources and of answers—but they clearly do not (Case, 2012; Johnson, 1996, 1997; Johnson et al., 2006). Accessibility of sources is often a key determinant of their use (Bates, 2005), even for highly rational engineers (Case, 2012) or consultants (Su & Contractor, 2011). Most theorists confront the world with a scientific model that implies exhaustive searching and testing to come to the correct conclusion. However, most seekers will stop searching when they discover the first somewhat plausible answer to their query. It may, indeed, be deeply rational to preserve ignorance, to experience its many benefits (Johnson, 1996).

One rich area for future research is how these patterns relate to the ways respondents cope with uncertainty surrounding conflicting and corroborating sources of information (Babrow, 2001; Brashers, Goldsmith, & Hsieh, 2002), especially since empirical studies indicate that respondents who use the Internet often have this express purpose in mind (Fox & Raine, 2002; Taylor & Leitman, 2002). The literature's near ideological commitment to rational information seeking has been likened to people's (and to researchers') socially desirable responses to reports of their TV watching—they recognize what is good for them, but they don't follow it in practice (Talja et al., 1999). Indeed, some very prominent re-

searchers choose to be irrational, or at least to develop highly novel approaches to information seeking, in the face of an overwhelming glut of information (Perrow, 1989). One of the dicta of consumer health information is the model of an informed decision maker weighing conflicting choices in consultation with a doctor; but while some patients prefer this model, many would just as soon not be presented with choices or conflicting information (Rimal, 2001). Some people only search long enough to find a plausible answer; others wait until they have corroborating information; while, sadly, others hope for inconsistency as an excuse for delaying action (Johnson, 1996, 1997).

Ignorance persists because it is useful on several levels, if not a necessity, and in this way more deeply, subversively rational. Indeed, the forces preserving ignorance may be far more compelling than those resulting in knowledge acquisition (Hersberger, 2005; Johnson, 1996). All of this suggests that ignorance may be sustained because of a deeper underlying rationality associated with its many benefits.

As we have seen, a major trend in the decision-making literature has been toward more and more irrational views of human behavior. Somewhat similarly, a major trend in social science research over two decades has been to more subjective, post-modern conceptions. A focus on the technological tools available for modern information searches, however, may reintroduce the logical and rational, since these systems often demand very logical approaches (e.g., keyword searches) by users and a focus on information as a thing, an objective, manipulable entity (Buckland, 1991). In fact, they are often very mechanistic, an approach that clearly has gone out of fashion.

Information Seeking Provides a "Teachable Moment"

> Our data indicate that patients who make their own medical decisions will be faithful to them, that they will do what they *tell themselves* to do (Slack, 1997, p. 42, italics in the original).

The perception of a gap and resulting active search process may lead individuals to be much more receptive to any information they acquire (Atkin, 1973), leading to greater likelihood of knowledge gain, attitude change, or behavior modification from the resulting "teachable moments." There is a growing recognition that the channels used in health communication campaigns can be easily avoided by large segments of the public since they are not a captive audience, "but it is highly probable that information which is *sought* will have a greater impact than that which is merely offered" (Swinehart, 1968, p. 1265). This is somewhat akin to the process of individuals seeking medications for what ails them. Information seeking represents the pull (receiver) side of the equation (Nelson et al., 2004) with people drawn to information because of their concerns. However, it is possible

the pendulum may be swinging back with the advent of the Affordable Care Act, tort reform, and doctor shortages all acting to impede the development of more participation on the part of patients in health care.

In general, people who go through a great deal of trouble to attain something value it more highly—the scarcer a piece of information is, the more likely it is to be persuasive (Cialdini, 2001). With some parallels to information-seeking findings, passive knowledge transfer only works when recipients are highly motivated, rewards for finding information are high, and there is a relatively small pool of information that minimizes search costs (Lomas, 1993). Another way of segmenting audiences might be to give information to those who are not seeking it (Taylor et al., 2010) and encourage them to seek, since once they do so they are more likely to do it again (Galarce, Ramanadhan, & Vishwanath, 2011).

Agencies, such as those that run hotlines, can take advantage of "teachable moments" at the intersection of persuader and persuadee (Davis & Fleisher, 1998), by supplying additional messages related to their objectives at the moment someone exposes themselves to information they sought. Indeed, knowledge acquisition often increases the likelihood that someone can be persuaded, as they now have the requisite knowledge base to appropriately comprehend messages (McGuire, 1989). People who actively seek information are more likely to develop organized cognitions and attitudes and, as a result, change their behaviors (Aldoory & Austin, 2011). It is also associated with the most potential for change, the central policy issue in administrative research, since active search processes may lead individuals to be much more receptive to any information they acquire, resulting in a greater likelihood of knowledge gain, attitude change, or behavior modification (Johnson, 1996, 1997). In turn, seekers can influence others, even health professionals, by facilitating the dissemination of innovations (Johnson, 2005).

Does Information Seeking Make a Difference?

As in other areas of research, there are often hidden, latent ideologies that govern research questions that are explored. So the model for information-seeking behavior is dogged persistence until a high-quality answer is found as the ideal search behavior. This is also the realm of curiosity (and even of obsession). In general, avoidance is seen as almost cowardly, and at the very least slothful. It is also often implicitly presumed that information seeking will result in positive outcomes: by acquiring knowledge one will engage in more appropriate actions and ultimately improve his or her life.

But as we have detailed, especially in Chapter Six, the avoidance of information, albeit sometimes only temporarily, can also result in outcomes that from the perspective of the individual may be positive. There also is an increasing body of evidence that the act of information seeking, something for which most individu-

als are inadequately trained, is as likely to lead to erroneous conclusions as it is to correct ones. For example, in a recent study involving science-magnet high school students focusing on Internet searches for vaccine information, it was found that students often left a search with inaccurate information from sites they perceived to be accurate (Kortum, 2008). Perhaps more disturbing, confidence is not a good predictor of accuracy (Lau & Coiera, 2008); searching online often results in incorrect, erroneous information (Sundar, Rice, Kim, & Sciamanna, 2011).

An Emerging Profession

The focus on health has grown in recent years in nearly all social science disciplines, in part because of its ever-growing role in our economy. At the same time, there has been an increasingly disciplinary focus on fields related to information seeking such as health communication and health informatics. Increasingly, for example, health communication is a part of the curricula and accreditation requirements of a number of health professions (Bernhardt, 2004; Egbert, Query, Quinlan, Savery, & Martinez, 2011), and there has been a proliferation of websites dedicated to translation and dissemination of communication science related to public health (Bernhardt, 2004).

Health communication as an emerging, separate discipline has seen an explosive growth in undergraduate and graduate programs (Query, Wright, Bylund, & Mattson, 2007). (For a listing of graduate programs, mostly those located at Research I institutions, see: www.healthcommunication.net/CHC/gradprograms/grad%20programs.htm.) For research outlets, one can turn to an ever-proliferating array of journals: *Journal of Health Communication*, *Health Communication,* and *Journal of Health and Mass Communication*. Health communication research has tended to be a U.S. and U.K. phenomenon, with some work also done in Australia and northern Europe.

HIT is also in the initial stages of developing a professional identity (Suchman & Dimick, 2010). It has seen a rapid growth of professional associations (e.g., American Health Information Management Association, Healthcare Information and Management Systems, American Medical Informatics Association, College of Healthcare Information Management Executives, the Association of Medical Directors of Information Systems, Health and Science Communications Association, Health on the Net Foundation, International Ehealth Association, the Society for the Internet in Medicine), professional journals (*Health Informatics Journal*, *Health Information Management Journal*, and the *Journal of Consumer Health on the Internet*), and associated degree programs across the U.S. It is also developing a training program and professional autonomy in universities.

However, the proto-professional moves in HC and HIT have yet to establish other characteristics of professions, such as certification and associated jurisdic-

tion. It is also unclear if they can determine a professional identity in the form of a code of ethics that is enforceable and a determination of who is able to identify themselves as an HC or HIT professional. But these fields are being recognized increasingly as "hot" career choices (Dalyrymple, 2011).

There has also been increasing demand for work across disciplines with movement to team, truly transdisciplinary approaches to health problems (Parrott & Kreuter, 2011), and reducing unnecessary duplication of research efforts, each with its own vocabulary for similar constructs. Everyone in the health professions must confront the hegemony of physicians and define themselves in juxtaposition to their traditional dominance. Certainly they are the legal, bureaucratic gatekeepers to professional medical services. The role of physicians in the emerging world of personalized medicine, and ready access to a variety of information sources, is going to be substantially evolving. Since physicians are unlikely to have more time with patients in the future, their role in imparting increasingly complex information is an important policy issue (Niederdeppe, Frosch, & Hornik, 2008). Their informatic skills are going to be critical to the effective delivery of health services. But as Slack (1997) long ago observed, any doctor who can be replaced by a computer deserves to be. Ultimately, a doctor may become more of a coach, evaluator of information that a patient has acquired, serving as the ultimate arbiter of what actions patients should take as a result of their information seeking (Longo et al., 2010). This raises a number of issues related to developing ethical standards that are as key to any emerging profession as is its own unique methodological tool kit with which it can confront problems.

Ethical Issues

One of the first moves in any professional field is to establish its own ethical guidelines and a set of mechanisms for enforcing them. Five guiding ethical principles relating to consumer health have been identified (Jimison, 2005). The five principles include patient autonomy, honesty in the patient-caregiver relationship, beneficence towards the patient, avoidance of harm, and fairness. Several of these five elements echo the traditional Hippocratic Oath sworn by many medical school graduates.

First, the autonomy and self-determination of patients should be paramount while protecting their right to privacy and informed consent. However, often the informed-consent process provides more information than patients want to know (Degerliyurt, Gunsolley, & Laskin, 2010), obscuring its intent. Only a tiny proportion of patients (one in every 100,000 medical visits) have filed complaints about privacy violations under HIPAA, while complaints about Medicare are 1,800 times that rate; this pattern implies that HIPAA guidelines are highly effective (McDonald, 2009), although the low rate may also reflect disinterest among the public.

Second, veracity should be a cornerstone of open patient-physician relationship. Both doctor and patient need to be truthful and open about sharing information relevant to the patient's health status and behaviors. Yet, patients are often less than completely frank in the medical interview, avoiding embarrassing admissions, while physicians are tempted to soften bad news (Collins, 1999). Strategic avoidance of information is often important in maintaining hope and preserving the family as a social system (Caughlin, Mikucki-Enyart, Middleton, Stone, & Brown, 2011).

The third and fourth principles paraphrase the traditional obligations of the physician. The third principle, that beneficence should be a guiding force, means that doctors must help those in need and should actively promote the patient's well-being. Principle four, nonmaleficence (avoiding harm to others), incorporates the Hippocratic notion that professionals should "do no harm" to their patients. Interestingly, modern versions of the Hippocratic Oath suggest that "over-treatment" may be as bad as no action at all.

Finally, principles of justice and fairness should drive an equitable allocation of resources. Needless to say, this is a critical issue in the U.S. health-care system, where treatment decisions and policy often rest on profit-driven concerns (Parrott, 2011). Scientific advances constantly produce new and expensive treatments that must be rationed (Rescher, 1999). Ironically, the more personalized the medicine, the smaller the target group, the less likely there will be a commercial motivation for developing treatments. Even the development of informatics tools like the personal health record is often driven by commercial considerations.

The rise of the consumer movement in health has raised questions that often become the subject of legal contention. What should health professionals do when patients make the "wrong" choices (Berry, 2007)? Don't tell relatives of genetic issues? Choose inappropriate treatments, especially for their children? Deny themselves necessary treatments? Avoid critical issues? Wish to maintain ignorance? How does a health profession both guide and empower at the same time?

Methods

The development of its own unique methods is another critical step in the development of a profession. Unfortunately there is not yet consensus in the research community focusing on broader issues of health communication on methodological approaches and standards by which to evaluate this research (Thorne, Bultz, & Baile, 2005). Studies tend to focus on a narrow range of stages of particular diseases, with no study, for example, systematically examining all stages of the cancer continuum (Ankem, 2006). The continuing evolution of new media also leads to particularistic, ad hoc approaches; it is also often difficult to assess online knowledge and information acquisition (Murero & Rice, 2006). Several larger general methodological issues have been identified: typically small size of unknown rep-

resentativeness, lack of longitudinal research, focus on single-method research designs, poor conceptualizations and operationalizations of information needs, lack of theoretical and conceptual framework underpinning empirical work, and use of single items or scales with dubious psychometric properties (Adams, Boulton, & Watson, 2009; Rutten, Arora, Bakos, Aziz, & Rowland, 2005). Few information-seeking studies have large enough samples to capture naturally occurring information seeking on specific topics and specific media (Johnson, 1993b; Johnson & Meischke, 1993b; Niederdeppe et al., 2008). People tend to either forget or underreport search activities, which is coupled with a reliance on retrospective studies of questionable reliability and validity (Lenz, 1984); leading to a concern that if we are to focus on actions, can we really trust self-reports? There is a classic temptation to slide back into other more dominant, established disciplines that focus on intentions and attitudes; however, information-seeking research needs to do the hard work of focusing on actions, especially their persistence and dosage.

LONGITUDINAL DYNAMIC ISSUES. The processual nature of information seeking, especially in terms of its sequencing and staging, will be a rich area for future information-seeking studies such as those focusing on pathways (Johnson et al., 2006). However, surface actions are more fluid and changeable than underlying ones, such as the forces that constitute a field (Johnson, 1984c). Clearly, information seeking related to chronic diseases like diabetes is often a very dynamic, nonlinear process, with people changing their information fields to suit their current needs and questions (Longo et al., 2010). The time lags between felt need, stimulus, and actually seeking information are also difficult to deal with empirically (Niederdeppe, 2008).

MEASUREMENT. Slater (2004) and Stephenson, Southwell, and Yzer (2011) identify improving the measurement of exposure as one of the most critical needs confronting health communication. As a social scientific concept, information seeking is underdeveloped (Kahlor, 2010), in part because of the ever-shifting contexts in which it takes place (Galarce et al., 2011). This is particularly true when it comes to measurement issues. There is little consensus in how to measure certain constructs (Galarce et al., 2011; Kelly, Niederdeppe, & Hornik, 2009). There is a common use of single-item measures that increases error variances and attenuate effects (Rains, 2007). For example, Kahlor (2007, p. 429) points to "minimally acceptable reliabilities" as a problem in her prior tests of risk information-seeking and processing and its variants.

DIFFERENTIATING EXPOSURE FROM SEEKING. Whether the encounter with information is purposive or accidental is a recurring issue in information-seeking research (Case, 2002, 2006, 2012; Johnson, 1996; Kahlor et al., 2006; Longo et al.,

2009; Williamson, 2005). Operationally, disentangling passive acquisition of information, not to mention retrieval of information from memory for experienced individuals (Connolly, 1977), from information that has been actively sought, has been one of the most ticklish tasks for information-seeking research (Case, 2012; Longo, 2005). Historically, mass-media scholars have questioned just how active the audience really is (Ruben, 1986), distinguishing between accidental (ritualized) and motivated (instrumental) exposure (McLeod, Bybee, & Durall, 1982). Reflecting this, only insignificant to weak correlations are found between gratifications sought and exposure measures (Lin, 1993). Further complicating this is the disinterest in, and at times active avoidance of health information, among some sectors of the population (Rakowski et al., 1990).

Passive-versus-active considerations particularly interact with staging, in which early stages are nearly equivalent to classic exposure approaches, and to whether a health problem is chronic or episodic/acute, with people with chronic diseases gradually changing their information fields to address their concerns. As suggested by J. D. Johnson (1988), information needs based on more of an abstract general threat may not, unless one also feels highly susceptible, present a strong impulse for a rational, specific information search (e.g., consulting a health professional), making it more likely that individuals "float" from medium to medium with changing needs depending on the satisfactions obtained. In this sense, the need for information would depend on increased levels of perceived threat of the disease per se but also the type of threat response perceived by the individual.

In part to confront this problem in his research stream on information seeking in interpersonal contexts, Berger (1979) identified three general strategies individuals have for information acquisition: passive (e.g., unobtrusive observation), active (e.g., reading a brochure), and interactive (e.g., talking to a doctor). It could be argued that individuals have more investment in active strategies and that, therefore, any information that is gathered by them also would be more likely to be considered relevant (Connolly, 1977). So, interestingly, one uses the Internet rather than being exposed to it. In addition, active information acquisition might have secondary impact on an individual, such as promoting a sense of efficacy and control, which isn't provided by being the passive recipient of information (Morrison, 1993a). In the situational theory of the publics, modern public relations theory stresses three factors that determine whether people passively process or actively seek information: problem recognition, construct recognitions, and level of involvement, since "… people seldom seek information about situations that do not involve them" (Aldoory & Austin, 2011, p. 138). Very little research has addressed the issue of the varying impact of information acquired under these different conditions.

More recently, scanning has been used to describe accidental, passive receipt of information (Shim, Kelly, & Hornik, 2006), although this would seem to im-

ply a much more active role for audience members than has traditionally been assumed, and as a result it may result in less clear, more muddy distinctions than for traditional focuses on information seeking. The argument runs that scanning involves people paying attention to information they encounter incidentally. While one may be exposed to more sources of information passively or by scanning (B. J. Kelly et al., 2009), the information may not be relevant to one's particular concerns or needs.

Scanning does capture the critical problem that people are exposed to information that they don't intentionally try to obtain. Indeed, passive receipt of information plays an important role in diabetes self-management, interacting with more active searches (Longo et al., 2010). Clearly information acquired in this way and information that is purposively sought after both have implications for people's health behaviors (Shim et al., 2006).

Acquisition is typically privileged in Western, especially U.S. cultures, with action seen as more virtuous than passivity, two keywords in T. D. Wilson's (2000) definition of human information behavior. The tendency to avoid, ignore, or deny information has always been somewhat of an anomaly in human behavior. The idea of "selecting" exposure to messages in purposive, planned ways naturally emphasizes the information that is *selected*, not that which is *ignored*, thus we have the classic figure/ground issues related to context, only we find that which is ignored is a much larger corpus than that to which we attend.

Conclusion

> Moreover, high-quality information by itself will not produce high-quality care, but it generally is a prerequisite for it (Seidman, 2006, p. 200)

We live in exciting times, where the ability of people to assimilate information they find into coherent personal strategies is perhaps the critical modern survival skill. Never have the possibilities, the potential to gather information, been greater. Increasingly, the limits that exist are human ones. As we expand our inquiries into human information behavior across a wide variety of contexts, we will have to increasingly understand our limits, which are directly related to the benefits of ignorance and our often seemingly irrational information behavior. Our theorizing has focused on intentional actions in part because that is where the light is, especially in terms of technology and its latent assumptions of rationality, that often overwhelm broader views of everyday human information behavior. In part because of this, we have slighted central issues, often raised by empirical findings, relating to accessibility, persistence, and avoidance.

Many of the problems of avoidance, persistence, and accessibility can be addressed by improving an individual's self-efficacy, a major element of how people

respond to threats by improving information literacy and expanding possibilities. In addressing these issues, we must remember that first and foremost, people want answers; while researchers and theorists are often more concerned with process. Ultimately society wants knowledge that can be acted on. It is only when our everyday life models fail that we are motivated into sense making, and our goal is often to return quickly to a state where we have a few fundamental principles to guide us (that we do not have to think consciously about). Maybe the central question for us is, taking into account our perhaps naïve model of human beings and the ideologies we possess—as researchers, do we project onto others our own aberrant values and behavior?

In sum, information seeking is critical to a number of theoretical, policy, and pragmatic issues. Maybe in the end, Kant will be proven correct again and there will be nothing so useful to our society as a good theory that promotes deeper understanding of these issues (Stonier, 1991). The task ahead is a daunting one for, as we have seen, information seeking is "the result of a complex set of interactions among multiple variables each with differing capacities to predict information source use" (Summers, Matheson, & Conry, 1983, p. 85). As this book has illustrated, on many levels, health information seeking continues to be a compelling focus for future study and research.

Further Reading

Johnson, J. D. (2003). On contexts of information seeking. *Information Processing and Management, 39,* 735–760.

Johnson compares three senses of the term "context"—as situation, as contingency, and as frameworks—in terms of five dimensions of contrast: explanatory power, the role of the individual, subjectivity, duality, and theoretic orientation. He then examines the CMIS as an example of a contingency view and studies of organizational interactions as an example of a framework approach. Information seeking is then used as a lens to compare these two different contexts.

Pescosolido, B.A. (1992). Beyond rational choice: The social dynamics of how people seek help. *American Journal of Sociology, 97,* 1096–1138.

Sociologist Bernice Pescosolido recommends a shift away from a focus on individual decisions to one that views them as socially constructed patterns. In her view, the choices that people make about health care, including consultations with others, are interactions that play out through social networks. For medical advice, consumers may turn to a variety of sources, only one of which are health professionals. They may rank their sources according to certain common patterns, turning in order to family-friends-physicians or instead to clergy-family-homeopath-faith healer or alternatively to nurse hotline-medical doctor,

etc. Their patterns of help-seeking are shaped by many factors: economic, educational, locational, psychological, etc. By emphasizing social organization and interaction, rather than rational choice theories, a better understanding of patient behavior may be achieved.

Slater, M. D. (2004). Operationalizing and analyzing exposure: The foundation of media effects research. *Journalism and Mass Communication Quarterly, 81,* 168–183.

Michael Slater offers a very readable explanation of the notion of exposure to a message, raising issues regarding attention, processing, recall, and reporting of content in studies of media effects. He reviews methods that have been used to assess exposure, discussing the tradeoffs in validity and reliability that result from each approach. Among the key problems are the unreliability of recall and recognition, the fact that messages are selected by some individuals and not by others (rather than being administered to them uniformly), and related issues of message salience (which may be determined by unmeasured characteristics of individuals). Each study design and its associated statistical analysis have weaknesses that pose problems for assessing effects of campaigns. While experimental designs offer ways of demonstrating causal relationships, they typically leave out considerations that loom large in the real world (e.g., competition with other messages, social sharing, and discussion of information). The "gold standard" has been randomized field experiments in which entire communities are the unit of analysis, yet these are costly and have small effect sizes. Cross-over quasi-experiments with time series data analysis, like tracking studies in advertising, can be implemented at a lower cost, among other advantages, and are an attractive alternative.

References

Abrahamson, J. A., Fisher, K. E., Turner, A. G., Durrance, J. C., & Turner, T. C. (2008). Lay information mediary behavior uncovered: Exploring how nonprofessionals seek health information for themselves and others online. *Journal of the Medical Library Association, 96*(4), 310–323.

Acker, S. R., & Calabrese, A. M. (1987). *The changing environment for scholarly research: Media technologies and the velocity of information*. Paper presented at the International Communication Association, Montreal, Canada.

Adams, E., Boulton, M., & Watson, E. (2009). The information needs of partners and family members of cancer patients: A systematic literature review. *Patient Education and Counseling, 77,* 179–186. doi: 10.1016/j.pec.2009.03.027

Adams, J. S. (1980). Interorganizational processes and organizational activities. In S. B. Bacharach (Ed.), *Research in organizational behavior* (Vol. 2, pp. 321–355). Greenwich, CT: JAI Press.

Adelman, M. B., Parks, M. R., & Albrecht, T. L. (1987). Beyond close relationships: Support in weak ties. In T. L. Albrecht & M. B. Adelman (Eds.), *Communicating social support* (pp. 126–147). Newbury Park, CA: Sage.

Adler, N. E., & Stewart, J. (2009). Reducing obesity: Motivating action while not blaming the victim. *Milbank Quarterly, 87,* 49–70.

Afifi, T. D., & Afifi, W. A. (2009). Introduction. In T. D. Afifi & W. A. Afifi (Eds.), *Uncertainty, information management, and disclosure decisions: Theories and applications* (pp. 1–5). New York: Routledge.

Afifi, W. A. (2009a). Uncertainty management theories. In S. W. Littlejohn & K. A. Foss (Eds.), *Encyclopedia of communication theory* (pp. 973–976). Los Angeles, CA: Sage.

Afifi, W. A. (2009b). Uncertainty management theories. In S. W. Littlejohn & K. A. Foss (Eds.), *Encyclopedia of communication theory* (Vol. 2, pp. 973–976). Los Angeles, CA: Sage.

Afifi, W. A., Morgan, S. E., Stephenson, M. T., Morse, C., Harrison, T., Reichert, T., & Long, S. D. (2006). Examining the decision to talk with family about organ donation: Applying the theory of motivated information management. *Communication Monographs, 73,* 188–215.

Afifi, W. A., & Weiner, J. L. (2004). Toward a theory of motivated information management. *Communication Theory, 14,* 167–190.

Ajzen, I. (1987). Attitudes, traits, and actions: Dispositional prediction of behavior in personality and social psychology. *Advances in Experimental Social Psychology, 20*, 1–63.

Ajzen, I. (1991). The theory of planned behavior. *Organizational Behavior and Human Decision Processes, 50*, 179-211.

ALA. (2011). Number of libraries in the United States. *ALA library fact sheet 1.*Available at http://www.ala.org/ala/professionalresources/libfactsheets/alalibraryfactsheet01.cfm

Albrecht, T. L. (1982). Coping with occupational stress: Relational and individual strategies of nurses in acute health care settings. In M. Burgoon (Ed.), *Communication yearbook 6* (pp. 832–849). Beverly Hills, CA: Sage.

Albrecht, T. L., & Adelman, M. B. (1987a). Communication networks as structures of social support. In T. L. Albrecht & M. B. Adelman (Eds.), *Communicating social support* (pp. 40–63). Newbury Park, CA: Sage.

Albrecht, T. L., & Adelman, M. B. (1987b). Dilemmas of supportive communication. In T. L. Albrecht & M. B. Adelman (Eds.), *Communicating social support* (pp. 240–254). Newbury Park, CA: Sage.

Albrecht, T. L., & Adelman, M. B. (1987c). Rethinking the relationship between communication and social support: An introduction. In T. L. Albrecht & M. B. Adelman (Eds.), *Communicating social support* (pp. 13–16). Newbury Park, CA: Sage.

Alcalay, R. (1983). The impact of mass communication campaigns in the health field. *Social Science and Medicine, 17*, 87–94.

Aldoory, L., & Austin, L. (2011). Relationship building and situational publics: Theoretical approaches guiding today's public relations. In T. L. Thompson, R. Parrott, & J. F. Nussbaum (Eds.), *The Routledge handbook of health communication* (2nd ed., pp. 132–145). New York: Routledge.

Allen, D., Karansios, S., & Slavova, M. (2011). Working with activity theory: Contexts, technology, and information behavior. *Journal of the American Society for Information Science and Technology, 62*(4), 776–788. doi: 10.1002/asi.21441

Allen, T. J. (1977). *Managing the flow of technology: Technology transfer and the dissemination of technological information within the R&D organization*. Cambridge, MA: MIT Press.

Altman, D. G. (1985). Utilization of a telephone cancer information program by symptomatic people. *Journal of Community Health, 10*, 156–171.

American Cancer Society. (1992). *Medical affairs newsletter*. Atlanta, GA.

American Medical Association. (1999). Health literacy: Report of the Council on Scientific Affairs. Ad hoc Committee on Health Literacy for the Council on Scientific Affairs. *Journal of the American Medical Association, 281*, 552–557.

Anderson, D. M., Meissner, H. I., & Portnoy, B. (1989). Media use and the health information acquisition process: How callers learned about the NCI's Cancer Information Service. *Health Education Research, 4*, 419–427.

Andrews, J. E., Johnson, J. D., Case, D. O., Allard, S. L., & Kelley, K. (2005). Intention to seek information on cancer genetics. *Information Research, 10*. Available athttp://informationr.net/ir/10-4/paper238.html

Ankem, K. (2006). Use of information sources by cancer patients: Results of a systematic review of the research literature. *Information Research, 11*(3), 1–18.

Archea, J. (1977). The place of architectural factors in behavioral theories of privacy. *Journal of Social Issues, 33*, 16–37.

Arkin, E. B., Romano, R. M., Van Nevel, J. P., & McKenna, J. W. (1993). Effect of the mass media in promoting calls to the Cancer Information Service. *Journal of the National Cancer Institute, 14*, 35–44.

Armstrong, K., Schwartz, J. S., & FitzGerald, G. (2002). Effect of framing as gain versus loss on hypothetical treatment choices: Survival and mortality curves. *Medical Decision Making, 21*, 76–83.

Arora, N. K., Hesse, B. W., Rimer, B. K., Viswanath, K., Clayman, M. L., & Croyle, R. T. (2007). Frustrated and confused: The American public rates its cancer-related information-seeking experiences. *Journal of General Internal Medicine, 22*, 223–228.

Arrington, M. I. (2005). "She's right behind me all the way": An analysis of prostate cancer narratives and changes in family relationships. *Journal of Family Communication, 5*, 141–162. doi: 10.1207/s15327698jfc0502_5

Ashford, S. J., Blatt, R., & VandeWalle, D. (2003). Reflections on the looking glass: A review of research on feedback-seeking behavior in organizations. *Journal of Management, 29*, 773–799.

Ashford, S. J., & Tsui, A. S. (1991). Self-regulation for managerial effectiveness: The role of active feedback seeking. *Academy of Management Journal, 34*, 251–280.

Atkin, C. (1973). Instrumental utilities and information seeking. In P. Clarke (Ed.), *New models in mass-communication research* (pp. 205–242). Beverly Hills, CA: Sage.

Atkin, C. (1979). Research evidence on mass-mediated health communication campaigns. In D. Nimmo (Ed.), *Communication yearbook 3*. New Brunswick, NJ: Transaction Books.

Atkin, C. (1992). Designing persuasive health messages. In L. Sechrest, T. E. Backer, E. M. Rogers, T. F. Campbell, & M. L. Grady (Eds.), *Effective dissemination of clinical and health information* (pp. 99–107). Rockville, MD: Agency for Health Care Policy and Research.

Atkin, C., & Arkin, E. B. (1990). Issues and initiatives in communicating health information to the public. In C. Atkin & L. Wallack (Eds.), *Mass communication and public health: Complexities and conflicts* (pp. 13–40). Newbury Park, CA: Sage.

Atkin, C. K. (1981). Mass communication research principles for health education. In M. Meyer (Ed.), *Health education by television and radio: Contributions to an international conference with a selected bibliography* (pp. 41–55). New York: K. G. Saur.

Atkin, C. K. (1985). Consumer and social effects of advertising. In B. Dervin & M. Voight (Eds.), *Progress in communication sciences* (Vol. 4, pp. 205–247). Norwood, NJ: Ablex.

Axley, S. R. (1984). Managerial and organizational communication in terms of the conduit metaphor. *Academy of Management Review, 9*, 428–437.

Aydin, C. E., Ball-Rokeach, S. J., & Reardon, K. K. (1991). *Mass-media resources for social comparison among breast cancer patients.* Paper presented at the International Communication Association, Chicago, IL.

Babrow, A. S. (1992). Communication and problematic integration: Understanding diverging probability and value, ambiguity, ambivalence and impossibility. *Communication Theory, 2*, 95–130.

Babrow, A. S. (2001). Guest editor's introduction to the special issue on uncertainty, evaluation, and communication. *Journal of Communication, 51*, 453–455.

Babrow, A. S., Kasch, C. R., & Ford, L. A. (1998). The many meanings of uncertainty in illness: Toward a systematic accounting. *Health Communication, 10*(1), 1–23.

Baker, L. M. (2005). Monitoring and blunting. In K. W. Fisher, S. Erdelez, & E. F. McKechnie (Eds.), *Theories of information behavior* (pp. 239–241). Medford, NJ: Information Today.

Baker, L. M., & Pettigrew, K. E. (1999). Theories for practitioners: Two frameworks for studying consumer health information-seeking behavior. *Bulletin of Medical Library Association, 87*(4), 444–450.

Bandolier. (2004). Patient compliance with statins. *Bandolier.* Available at http: //www.medicine.ox.ac.uk/bandolier/booth/cardiac/patcomp.html

Bandura, A. (1997). *Self-efficacy: The exercise of control.* New York: W. H. Freeman.

Baquet, C. R., & Ringen, P. H. (1986). Cancer control in blacks: Epidemiology and NCI program plans. In L. E. Mortensen, P. F. Engstrom, & P. N. Anderson (Eds.), *Advances in cancer control: Health care financing and research* (pp. 215–227). New York: Alan R. Liss.

Barak, A., Boniel-Nissim, M., & Suler, J. (2008). Fostering empowerment in online support groups. *Computers in Human Behavior, 24*, 1867–1883.

Barinaga, M. (1994). Biomedicine: Americans don't get it. *Science, 263*, 1225–1226.

Barnett, G. A., Danowski, J. A., & Richards, W. D., Jr. (1993). Communication networks and network analysis: A current assessment. In W. D. Richards, Jr. & G. A. Barnett (Eds.), *Progress in communication science* (Vol. VIII, pp. 1–19). Norwood, NJ: Ablex.

Bates, M. J. (1989). The design of browsing and berrypicking techniques for the online search interface. *Online Review, 13*, 407–424.

Bates, M. J. (2005). An introduction to metatheories, theories, and models. In K. E. Fisher, S. Erdelez, & L. McKechnie (Eds.), *Theories of information behavior* (pp. 1–24). Medford, NJ: Information Today.

Bateson, G. (1972). *Steps to an ecology of mind.* New York: Ballantine Books.

Bauer, R. A. (1972). The obstinate audience: The influence process from the point of view of social communication. In W. Schramm & D. F. Roberts (Eds.), *The process and effects of mass communication* (pp. 326–346). Urbana, IL: University of Illinois Press.

Beal, C. (1979). Studying the public's information needs. *Journal of Librarianship, 11*, 130–151.

Becker, M. H., Maiman, L. A., Kirsch, J. P., Haefner, D. P., & Drachman, R. H. (1977). The Health Belief Model and prediction of dietary compliance: A field experiment. *Journal of Health and Social Behavior, 18*, 348–366.

Becker, M. H., & Rosenstock, I. M. (1984). Compliance with medical advice. In A. Steptoe & A. Mathews (Eds.), *Health care and human behavior* (pp. 175–208). London, U.K.: Academic Press.

Becker, M. H., & Rosenstock, I. M. (1989). Health promotion, disease prevention, and program retention. In H. E. Freeman & S. Levine (Eds.), *Handbook of medical sociology* (pp. 284–305). Englewood Cliffs, NJ: Prentice-Hall.

Benaroia, M., Elinson, R., & Zarnke, K. (2007). Patient-directed intelligent and interactive computer medical history-gathering systems: A utility and feasibility study in the emergency department. *International Journal of Medical Informatics, 76*, 283–288.

Berelson, B., & Steiner, G. A. (1964). *Human behavior: An inventory of scientific findings.* New York: Harcourt, Brace & World.

Berger, C. R. (1979). Beyond initial interactions: Uncertainty, understanding, and the development of interpersonal relationships. In H. Giles & R. S. Clair (Eds.), *Language and social psychology.* Oxford, U.K.: Basil Blackwell.

Berger, C. R. (2011). From explanation to application. *Journal of Applied Communication Research, 39*(2), 214–222. doi: 10.1080/00909882.2011.556141

Berger, C. R., & Calabrese, R. J. (1975). Some explorations in initial interaction and beyond: Toward a developmental theory of interpersonal communication. *Human Communication Research, 1*, 99–112.

Berger, P. L., & Luckmann, T. (1967). *The social construction of reality.* Garden City, NY: Anchor Books.

Berkman, N. D., Davis, T. C., & McCormack, L. (2010). Health literacy: What is it? *Journal of Health Communication, 15*, 9–19.

Berlo, D. K. (1960). *The process of communication: An introduction to theory and practice.* New York: Holt, Rinehart &Winston.

Bernhardt, J. M. (2004). Communication at the core of effective public health. *American Journal of Public Health, 94*(12), 2051–2053.

Berry, D. (2007). *Health communication: Theory and practice.* New York: Open University Press.

Beth Israel. (1982). *Your rights as a patient.* Boston, MA: Beth Israel Hospital.

Bhavnani, S. K., & Peck, F. A. (2010). Scatter matters: Regularities and implications for the scatter of healthcare information on the web. *Journal of the American Society for Information Science and Technology, 61*(4), 659–676. doi: 10.1002/asi.21217

Biermann, J., Golladay, G., & Baker, L. (1999). Evaluation of cancer information on the Internet. *Cancer, 86*, 381–390.

Biesecker, A. E. (1988). Aging and the desire for information and input in medical decisions: Patient consumerism in medical encounter. *The Gerontologist, 28*, 330–335.

Biesecker, A. E., & Biesecker, T. D. (1990). Patient information seeking behaviors when communicating with doctors. *Medical Care, 28*, 19–28.

Biocca, F. (1998). Opposing conceptions of the audience: The active and passive hemispheres of mass communication theory. *Communication yearbook 11*, 51–80.

Bjorneborn, L. (2005). Small world network exploration. In K. E. Fisher, S. Erdelez, & L. McKechnie (Eds.), *Theories of information behavior* (pp. 318–322). Medford, NJ: Information Today.

Blau, P. M. (1955). *The dynamics of bureaucracy: A study of interpersonal relations in two government agencies.* Chicago, IL: University of Chicago Press.

Blumenthal, D. (2010). Expecting the unexpected: Health information technology and medical professionalism. In D. J. Rothman (Ed.), *Medical professionalism in the new information age* (pp. 8–22). New Brunswick, NJ: Rutgers University Press.

Blumenthal, D., & Glaser, J. P. (2007). Information technology comes to medicine. *New England Journal of Medicine, 356*, 2527–2534.

Boahene, M., & Ditsa, G. (2003). Conceptual confusions in knowledge management and knowledge management systems: Clarifications for better KMS development. In E. Coakes (Ed.), *Knowledge management: Current issues and challenges* (pp. 12–24). London, U.K.: IRM Press.

Bodenheimer, T. (2005a). High and rising health care costs. Part 1: Seeking an explanation. *Annals of Internal Medicine, 142*(10), 847–854.

Bodenheimer, T. (2005b). High and rising health care costs. Part 2: Technological innovation. *Annals of Internal Medicine, 142*(11), 932–937.

Boot, C. R. L., & Meijman, F. J. (2010). The public and the Internet: Multifaceted drives for seeking health information. *Health Informatics Journal, 16*(2), 145–156. doi: 10.1177/1460458210364786

Booth, A., & Babchuk, N. (1972). Seeking health care from new resources. *Journal of Health and Social Behavior, 13*, 90–99.

Borgatti, S. P., & Cross, R. (2003). A relational view of information seeking and learning in social networks. *Management Science, 49*(4), 432–445.

Boroch, R., & Boe, E. (1994). On "Good, certain, and easy government": The policy use of statistical data and reports. In L. Sechrest, T. E. Backer, E. M. Rogers, T. F. Campbell, & M. L. Grady (Eds.), *Effective dissemination of clinical and health information* (pp. 23–35). Rockville, MD: Agency for Health Care Policy Research, AHCPR Pub. No. 95 0015.

Boulding, K. E. (1966). The economics of knowledge and the knowledge of economics. *American Economic Review, 56*, 1–13.

Boulos, M. N. K., & Wheeler, S. (2007). The emerging Web 2.0 social software: An enabling suite of sociable technologies in health and health care education. *Health Information and Library Journals, 24*, 2–23.

Boyne, M. B., & Levy, M. (2011). Marketing for public health: We need an app for that. *Journal of Consumer Affairs, 45*(1), 1–6.

Bradac, J. J. (2001). Theory comparison: Uncertainty reduction, problematic integration, uncertainty management and other curious constructs. *Journal of Communication, 51*(3), 456–476.

Braman, S. (1994). The autopoietic state: Communication and democratic potential in the net. *Journal of American Society for Information Science, 45*, 358–368.

Brandon, D. P., & Hollingshead, A. B. (2004). Transactive memory systems in organizations: Matching tasks, expertise, and people. *Organization Science, 15*, 633–644.

Brashers, D. (2001). Communication and uncertainty management. *Journal of Communication, 51*(3), 477–497.

Brashers, D. E., Goldsmith, D. J., & Hsieh, E. (2002). Information seeking and avoiding in health contexts. *Human Communication Research, 28*, 258–272.

Brashers, D. E., Neidig, J. L., Haas, S. M., Dobbs, L. K., Cardillo, L. W., & Russell, J. A. (2000). Communication and the management of uncertainty: The case of persons living with HIV or AIDS. *Communication Monographs, 67*, 63–84.

Brett, J. M., Feldman, D. C., & Weingart, L. R. (1990). Feedback seeking behavior of new hires and job changers. *Journal of Management, 16*, 737–749.

Brittain, J. M. (1970). *Information and its users: A review with special reference to the social sciences.* Bath, U.K.: Bath University Press.

Brittain, J. M. (1985). Overview. In J. M. Brittain (Ed.), *Consensus and penalties for ignorance in the medical sciences: Implications for information transfer* (pp. 160–174). London, U.K.: British Library Board.

Broadbent, M., & Koenig, M. E. D. (1988). Information and information technology management. In M. E. Williams (Ed.), *Annual review of information science and technology* (Vol. 23). Amsterdam, Netherlands: Elsevier Science.

Broadstock, M. J., & Hill, D. (1997). Evaluation and impact of promotion of a cancer helpline to cancer patients through their specialists. *Patient Education and Counseling, 32*(3), 141–146.

Broadway, M. D., & Christensen, S. B. (1993, September/October). Medical and health information needs in a small community. *Public Libraries*, 253–256.

Broder, S. (1993). Foreword. *Journal of the National Cancer Institute, Monograph, 14*, vii.

Brooks, D. (2011). *The hidden sources of love, character, and achievement.* New York: Random House.

Brown, J. B., Stewart, M., & Ryan, B. L. (2003). Outcomes of patient-provider interaction. In T. L. Thompson, A. M. Dorsey, K. I. Miller, & R. Parrott (Eds.), *Handbook of health communication* (pp. 141–161). Mahwah, NJ: Lawrence Erlbaum.

Brownstein, C. A., Brownstein, J. S., Williams, D. S., III, Wicks, P., & Heywood, J. A. (2009). The power of social networking in medicine. *Nature Biotechnology, 27*, 888–890.

Buckland, M. (1991). *Information and information systems.* Westport, CT: Greenwood Press.

Buller, D. B., Callister, M. A., & Reichert, T. (1995). Skin cancer prevention by parents of young children: Health information sources, skin cancer knowledge, and sun-protection practices. *Oncology Nursing, 22*(10), 1559–1566.

Bundorf, M. K., Wagner, T. H., Singer, S. J., & Baker, L. C. (2006). Who searches the Internet for health information? *Health Services Research, 41*(3), 819–836. doi: 10.1111/j.1475-6773.2006.00510.x

Burgoon, J. K., & Burgoon, M. (1980). Predictors of newspaper readership. *Journalism Quarterly, 57*, 589–596.

Burgoon, M., & Burgoon, J. K. (1979). Predictive models of satisfaction with a newspaper. *Communication yearbook 3* (pp. 271–282). New Brunswick, NJ: Transaction Books.

Burke, R. J., & Bolf, C. (1986). Learning within organizations: Sources and content. *Psychological Reports, 59*, 1187–1196.

Burt, P. V., & Kinnucan, M. T. (1990). Information models and modeling techniques for information systems. In M. E. Williams (Ed.), *Annual review of information science and technology* (Vol. 25, pp. 175–208). Amsterdam, Netherlands: Elsevier.

Burt, R. S. (1992). *Structural holes: The social structure of competition.* Cambridge, MA: Harvard University Press.

Burton-Jones, A. (1999). *Knowledge capitalism: Business, work, and learning in the new economy.* New York: Oxford University Press.

Calle, E. E., Flanders, W. D., Thurn, M. J., & Martin, L. M. (1993). Demographic predictors of mammography and pap smear screening in U.S. women. *American Journal of Public Health, 83*, 53–60.

Calnan, M. W. (1984). The Health Belief Model and participation in programmes for the early detection of breast cancer: A comparative analysis. *Social Science and Medicine, 19*, 823–830.

Calloway, C., Jorgensen C. M., Saraiya, M., & Tsui, J. (2006). A content analysis of news coverage of the HPV vaccine by U.S. newspapers, January 2002–June 2005. *Journal of Womens Health, 15*(7), 803–809.

Cameron, K. S., Wolf, M. S., & Baker, D. W. (2011). Integrating health literacy in health communication. In T. L. Thompson, R. Parrott & J. F. Nussbaum (Eds.), *The Routledge handbook of health communication* (2nd ed., pp. 306–319). New York: Routledge.

Carley, K. (1986). An approach for relating social structure to cognitive structure. *Journal of Mathematical Sociology, 12*, 137–189.

Case, D. O. (2002). *Looking for information: A survey of research on information seeking, needs, and behavior.* New York: Academic Press.

Case, D. O. (2006). Information behavior. *Annual Review of Information Science and Technology, 40,* 293–328.

Case, D. O. (2007). *Looking for Information: A survey of research on information seeking, needs, and behavior* (2nd ed.).Bingley, U.K.: Emerald Group.

Case, D. O. (2012). *Looking for information: A survey of research on information seeking, needs, and behavior* (3rd ed.). Bingley, U.K.: Emerald Group.

Case, D. O., Andrews, J. E., Johnson, J. D., & Allard, S. L. (2005). Avoiding versus seeking: The relationship of information seeking to avoidance, blunting, coping, dissonance, and related concepts. *Journal of Medical Libraries Association, 93,* 353–362.

Case, D. O., Johnson, J. D., Andrews, J. E., Allard, S., & Kelly, K. M. (2004). From two-step flow to the Internet: The changing array of sources for genetics information seeking. *Journal of the American Society for Information Science and Technology, 55,* 660–669. doi: 10.1002/asi.20000

Cash Jr., J. I., Eccles, R. G., Nohria, N., & Nolan, R. L. (1994). *Building the information age organization: Structure, control, and information technologies.* Boston, MA: Irwin.

Cassileth, B. R., Volckmar, B. A., & Goodman, R. L. (1980). The effect of experience on radiation therapy patients' desire for information. *Journal of Radiation Oncology• Biology• Physics, 6,* 493–496.

Caughlin, J. P., Mikucki-Enyart, S. L., Middleton, A. V., Stone, A. M., & Brown, L. E. (2011). Being open without talking about it: A rhetorical/normative approach to understanding topic avoidance in families after a lung cancer diagnosis. *Commuication Monographs, 78*(4), 409–436.

Cegela, D. J. (2006). Emerging trends and future directions in patient communication skills training. *Health Communication, 20*(2), 123–129.

Cegala, D. J., & Broz, D. J. (2003). Provider and patient communication skills training. In T. L. Thompson, A. M. Dorsey, K. I. Miller, & R. Parrott (Eds.), *Handbook of health communication* (pp. 95–120). Mahwah, NJ: Lawrence Erlbaum.

Cegala, D. J., Street, R. L., Jr., & Clinch, C. R. (2007). The impact of patient participation on physicians' information provision during a primary care medical interview. *Health Communication, 21*(2), 177–185.

Chaffee, S. H. (1979). *Mass media vs. interpersonal channels: The synthetic competition.* Paper presented at the Annual Convention of the Speech Communication Association, San Antonio, TX.

Chaffee, S. H., & McCleod, J. M. (1973). Individual vs. social predictors of information seeking. *Journalism Quarterly, 50,* 237–245.

Chang, S. J., & Rice, R. E. (1993). Browsing: A multidimensional framework. In M. E. Williams (Ed.), *Annual Review of Information Science and Technology* (Vol. 28, pp. 231–276). Medford, NJ: Learned Information.

Chen, C., & Hernon, P. (1982). *Information seeking: Assessing and anticipating user needs.* New York: Neal-Schuman Publishers.

Cheney, G., & Ashcraft, K. L. (2007). Considering "the professional" in communication studies: Implications for theory and research within and beyond the boundaries of organizational communication. *Communication Theory, 17,* 146–175.

Chobot, M. (2004). The challenge of providing consumer health information services in public libraries. Washington, DC: American Academy for the Advancement of Science.

Choi, B. C. K. (2005). Understanding the basic principles of knowledge translation. *Journal of Epidemiological Community Health, 59,* 93.

Christakis, N. A., & Fowler, J. H. (2009). *Connected: The surprising power of our social networks and how they shape our lives.* New York: Little, Brown &Company.

Chung, D. S., & Kim, S. (2008). Blogging activity among cancer patients and their companions: Uses, gratifications, and predictors of outcomes. *Journal of the American Society for Information Science & Technology, 59*(2), 297–306.

Cialdini, R. B. (2001). *Influence: Science and practice* (4th ed.). Boston, MA: Allyn and Bacon.

Cimino, J. J. (2006). In defense of the Desiderata. *Journal of Biomedical Informatics*, *39*, 299–306. doi: 10.1016/j.jbi.2005.11.008

Clark, F. (1992). The need for a national information infrastructure. *Journal of Biomedical Communication*, *19*, 8–9.

Clarke, J. N., & Everest, M. (2006). Cancer in the mass print media: Fear, uncertainty and the medical model. *Social Science and Medicine*, *62*(10), 2591–2600.

Clayton, M. F., & Ellington, L. (2011). Beyond primary care providers: A discussion of health communication roles and challenges for health care professionals and others. In T. L. Thompson, R. Parrott, & J. F. Nussbaum (Eds.), *The Routledge handbook of health communication* (2nd ed., pp. 69–83). New York: Routledge.

Clifton, A., Turkheimer, E., & Oltmanns, T. F. (2009). Personality disorder in social networks: Network position as a marker of interpersonal dysfunction. *Social Networks*, *31*, 26–32.

Cline, R. J. W., & Haynes, K. M. (2001). Consumer health information seeking on the Internet: The state-of-the-art. *Health Education Research*, *16*(6), 671–692.

Coberly, E., Boren, S. A., Davis, J. W., McConnell, A. L., Chitima-Matsiga, R., Ge, B., . . . Hodge, R. H. (2010). Linking clinic patients to Internet-based, condition-specific information prescriptions. *Journal of the Medical Library Association*, *98*(2), 160–164.

Colditz, G. A., Emmons, K. M., Vishwanath, K., & Kerner, J. F. (2008). Translating science to practice: Community and academic perspectives. *Journal of Public Health Management Practice*, *14*(2), 144–149.

Cole, R. E., & Wagner, D. W. (1990). The pros and cons of the mass-media colorectal screening program. In P. F. Engstrom, B. Rimer, & L. E. Mortensen (Eds.), *Advances in cancer control: Screening and prevention research* (pp. 325–330). New York: Wiley.

Colineau, N., & Paris, C. (2010). Talking about your health to strangers: Understanding the use of online social networks by patients. *New Review of Hypermedia and Multimedia*, *16*(1–2), 141–160. doi: 10.1080/13614568.2010.496131

Collins, J. (1999). Should doctors tell the truth? In H. Kuhse & P. Singer (Eds.), *Bioethics: An anthology* (pp. 501–506). Oxford, U.K.: Blackwell.

Comer, D. R. (1991). Organizational newcomers' acquisition of information from peers. *Management Communication Quarterly*, *5*, 64–89.

Connolly, T. (1977). Information processing and decision making in organizations. In B. M. Staw & G. R. Salancik (Eds.), *New directions in organizational behavior* (pp. 205–234). Chicago, IL: St. Clair Press.

Connor, E. (2009). Taking the pulse of health information seeking. *Journal of Electronic Resources in Medical Libraries*, *6*(3), 230–235. doi: 10.1080/15420600903173111

Contractor, N. S., & Eisenberg, E. M. (1990). Communication networks and new media in organizations. In J. Fulk & C. Steinfield (Eds.), *Organizations and communication technology* (pp. 143–172). Newbury Park, CA: Sage.

Cool, C. (2001). The concept of situation in information science. *Annual Review of Information Science and Technology*, *35*, 5–42.

Cooper, C., & Mira, M. (1998). Who should assess medical students's communication skills: Their academic teachers or their patients? *Medical Education*, *32*, 419–421.

Cooper, P. D. (1979). What is health care marketing? In P. D. Cooper (Ed.), *Health care marketing: Issues and trends* (pp. 3–9). Germantown, MD: Aspen Systems.

Corman, S. R., & Scott, C. R. (1994). Perceived networks, activity foci, and observable communication in social collectives. *Communication Theory*, *4*, 171–190.

Cornwell, B. (2009). Good health and the bridging of structural holes. *Social Networks*, *31*, 92–103.

Cousins, N. (1979). *Anatomy of an illness as perceived by the patient: Reflections on healing and regeneration*. New York: Norton.

Craigie, M., Loader, B., Burrows, R., & Muncer, S. (2002). Reliability of health information on the Internet: An examination of experts' ratings. *Journal of Medical Internet Research*. Available at http://www.jmir.org/2002/1/e2/

Crespo, J. (2004). Training the health information seeker: Quality issues in health information web sites. *Library Trends, 53*(2), 360–374.

Croog, S. H., & Levine, S. (1989). Quality of life and health care interventions. In H. E. Freeman & S. Levine (Eds.), *Handbook of medical sociology* (4th ed., pp. 508–528). Englewood Cliffs, NJ: Prentice-Hall.

Cross, R., Rice, R. E., & Parker, A. (2001). Information seeking in social context: Structural influences and receipt of information benefits. *IEEE Transactions on Systems, Man, and Cybernetics–Part C: Applications and Reviews, 31*, 438–448.

Cross, R., & Sproull, L. (2004). More than an answer: Information relationships for actionable knowledge. *Organization Science, 15*, 446–462.

Culnan, M. J. (1983). Environmental scanning: The effects of task complexity and source accessibility on information-gathering behavior. *Decision Sciences, 14*, 194–206.

Culnan, M. J., & Markus, M. L. (1987). Information technologies. In F. M. Jablin, L. L. Putnam, K. H. Roberts, & L. W. Porter (Eds.), *Handbook of organizational communication: An interdisciplinary perspective* (pp. 420–443). Beverly Hills, CA: Sage.

Culver, J. D., Gerr, F., & Frumkin, H. (1997). Medical information on the Internet: A study of an electronic bulletin board. *Journal of General Internal Medicine, 12*, 466–470.

Cummings, K. M., Becker, M. H., & Maile, M. C. (1980). Bringing the models together: An empirical approach to combining variables used to explain health actions. *Journal of Behavioral Medicine, 3*, 123–145.

Cyert, R. M., Simon, H. A., & Trow, D. B. (1956). Observation of a business decision. *Journal of Business, 29*, 237–248.

Czaja, R., Manfredi, C., & Price, J. (2003). The determinants and consequences of information seeking among cancer patients. *Journal of Health Communication, 8*, 529–562. doi: 10.1080/1081073090250470

Daft, R. L., & Lengel, R. H. (1986). Organizational information requirements: Media richness and structural design. *Management Science, 32*, 554–571.

Dalyrymple, P. (2011). Data, information, knowledge: The emerging field of health informatics. *Bulletin of the American Society for Information Science and Technology, 37*(5), 41–44.

Dance, F. E. X. (1970). The "concept" of communication. *Journal of Communication, 20*, 201–210.

Davis, S. E., & Fleisher, L. (1998). Treatment and clinical trials decision making: The impact of the Cancer Information Service, Part 5. *Journal of Health Communication, 3*(Supplement), 71–86.

Dawes, M., & Sampson, U. (2003). Knowledge management in clinical practice: A systematic review of information-seeking behavior in physicians. *International Journal of Medical Informatics, 71*, 9–15. doi: 10.1016/S1386-5056(03)00023-6

Degerliyurt, K., Gunsolley, J. C., & Laskin, D. M. (2010). Informed consent: What do patients really want to know? *Journal of Oral and Maxillofacial Surgery, 68*(8), 1849–1852.

Degner, L. F., & Sloan, J. A. (1992). Decision-making during serious illness: What role do patients really want to play? *Journal of Clinical Psychology, 45*, 941–950.

Dervin, B. (1976). Strategies for dealing with human information needs: Information or communication? *Journal of Broadcasting, 20*, 324–351.

Dervin, B. (1980). Communication gaps and inequities: Moving toward a reconceptualization. In B. Dervin & M. J. Voight (Eds.), *Progress in communication sciences* (pp. 74–112). Norwood, NJ: Ablex.

Dervin, B. (1983). Information as a user construct: The relevance of perceived information needs to synthesis and interpretation. In S. Ward & L. Reed (Eds.), *Knowledge structure and use: Implications for synthesis and interpretation* (pp. 153–184). Philadelphia, PA: Temple University Press.

Dervin, B. (1989). Users as research inventions: How research categories perpetuate inequities. *Journal of Communication, 39*, 216–232.

Dervin, B. (1997). Given a context by any other name: Methodological tools for taming the unruly beast. In P. Vakkari, R. Savolainen, & B. Dervin (Eds.), *Information seeking in context* (pp. 13–38). London, U.K.: Taylor Graham.

Dervin, B. (2003). Human studies and user studies: A call for methodological inter-disciplinarity. *Information Research*, 9, 1–27.

Dervin, B., Harlock, S., Atwood, R., & Garzona, C. (1980). The human side of information: An exploration in a health communication context. In D. Nimmo (Ed.), *Communication yearbook 4* (pp. 591–608). New Brunswick, NJ: Transaction Books.

Dervin, B., Jacobson, T. L., & Nilan, M. S. (1982). Measuring aspects of information seeking: A test of quantitative/qualitative methodology. In M. Burgoon (Ed.), *Communication yearbook 6* (pp. 419–444). Beverly Hills, CA: Sage.

Dervin, B., & Nilan, M. S. (1986). Information needs and uses. In M. A. Williams (Ed.), *Annual review of information science and technology* (Vol. 21, pp. 3–33). Medford, NJ: Knowledge Industry Publications.

de Tocqueville, A. (1966). *Democracy in America*. New York: Harper & Row.

Diamond, G. A., Pollock, B. H., & Work, J. W. (1994). Clinical decisions and computers. In M. M. Shabot & R. M. Gardner (Eds.), *Decision support systems in critical care* (pp. 188–211). New York: Springer-Verlag.

DiClemente, C. C., & Prochaska, J. O. (1985). Processes and stages of self-change: Coping and competence in smoking behavior change. In S. Shiffman & T. A. Wills (Eds.), *Coping and substance use* (pp. 319–343). New York: Academic Press.

Dietz, D., Cook, R., & Hersch, R. (2005). Workplace health promotion and utilization of health services: Follow-up data findings. *Journal of Behavioral Health Services & Research*, 32, 306–319.

Dijkstra, M., Buijtels, H. J. J. M., & VanRaaij, W. F. (2005). Separate and joint effects of medium type on consumer responses: A comparison of television, print, and the Internet. *Journal of Business Research*, 58, 377–386.

Dillard, J. P. (1994). Rethinking the study of fear appeals. *Communication Theory*, 4, 295–323.

DMOZ. (2011). Open Directory–Health.Available at http: //www.dmoz.org/Health/

Dobos, J. (1988). Choices of new media and traditional channels in organizations. *Communication Research Reports*, 5, 131–139.

Doctor, R. D. (1992). Social equity and information technologies: Moving toward information democracy. In M. E. Williams (Ed.), *Annual review of information science and technology* (pp. 44–96). Medford, NJ: Learned Information.

Donat, J. F., & Pettigrew, K. E. (2002). The final context: Information behaviour surrounding the dying patient. *The New Review of Information Behaviour Research: Studies of Information Seeking in Context*, 3, 175–186.

Donohew, L., Helm, D. M., Cook, P. L., & Shatzer, M. J. (1987). *Sensation seeking, marijuana use, and responses to prevention campaigns*. Paper presented at the International Communication Association, Montreal, Canada.

Donohew, L., & Tipton, L. (1973). A conceptual model of information seeking, avoiding and processing. In P. Clarke (Ed.), *New models for mass communication research* (pp. 243–269). Beverly Hills, CA: Sage.

Donohew, L., Tipton, L., & Haney, R. (1978). Analysis of information seeking strategies. *Journalism Quarterly*, 55, 25–31.

Donohew, R. L., Nair, M., & Finn, S. (1984). Automaticity, arousal, and information exposure. In R. N. Bostrom (Ed.), *Communication yearbook 8* (pp. 267–284). Beverly Hills, CA: Sage.

Doolittle, G. C., & Spaulding, A. (2005). Online cancer services: Types of services offered and associated health outcomes. *Journal of Medical Internet Research*, 7(3). Available at http: //www.jmir.org/2005/3/e35/

Downs, A. (1967). *Inside bureaucracy*. Boston, MA: Little, Brown.

Durlak, J. T. (1987). A typology of interactive media. In M. L. McLaughlin (Ed.), *Communication yearbook 10* (pp. 743–757). Beverly Hills, CA: Sage.

Dutta-Bergman, M. J. (2004). Primary sources of health information: Comparison of the domain of health attitudes, health cognitions, and health behaviors. *Health Communication*, 16(3), 273–288.

Dutta-Bergman, M. J. (2005). Developing a profile of consumer intention to seek out additional information beyond a doctor: The role of communicative and motivation variables. *Health Communication*, *17*(1), 1–16.

Dutta, M., & Basu, A. (2011). Culture, communication, and health. In T. L. Thompson, R. Parrott, & J. F. Nussbaum (Eds.), *The Routledge handbook of health communication* (2nd ed., pp. 320–334). New York: Routledge.

Dutta, M., & de Souza, R. (2008). The past, present, and future of health development campaigns: Reflexivity and the critical-cultural approach. *Health Communication*, *23*, 326–339.

Echlin, K. N., & Rees, C. E. (2002). Information needs and information seeking behaviors of men with prostate cancer and their partners: A review of the literature. *Cancer Nursing*,*25*(1), 35–41.

Egbert, N., Query, J. L., Jr., Quinlan, M. M., Savery, C. A., & Martinez, A. R. (2011). (Re)viewing health communication and related interdisciplinary curricula. In T. L. Thompson, R. Parrott, & J. F. Nussbaum (Eds.), *The Routledge handbook of health communication* (pp. 610–631). New York, NY: Routledge.

Eheman, C. R., Berkowitz, Z., Lee, J., Mohile, S., Purnell, J., Rodriguez, E. M., . . . Morrow, G. (2009). Information-seeking styles among cancer patients before and after treatment by demographics and the use of information sources. *Journal of Health Communication*, *14*, 487–502. doi: 10.1080/10810730903032945

Eisenberg, E. M. (1990). Jamming: Transcendence through organizing. *Communication Research*, *17*, 139–164.

Ellis, D. (1989). A behavioral model for information retrieval system design. *Journal of Information Science*, *15*, 237–247.

Ely, J. W. (2005). Answering physicians' clinical questions: Obstacles and potential solutions. *Journal of the American Medical Informatics Association*, *12*(2), 217–224.

Emery, F., & Trist, E. (1965). The causal texture of organizational environment. *Human Relations*, *18*, 21–32.

Emirbayer, M., & Mische, A. (1998). What is agency? *American Journal of Sociology*, *103*, 962–997.

Entman, R. M., & Wildman, S. S. (1992). Reconciling economic and non-economic perspectives on media policy: Transcending the "marketplace of ideas." *Journal of Communication*, *42*, 5–19.

Epstein, R. M., & Street, R. L., Jr. (2007). *Patient-centered communication in cancer care: Promoting healing and reducing suffering*. (NIH Publication No. 07-6225). Bethesda, MD: National Institutes of Health.

Erdelez, S. (2005). Information encountering. In K. E. Fisher, S. Erdelez, & L. McKechnie (Eds.), *Theories of information behavior* (pp. 179–184). Medford, NJ: Information Today.

Erskine, H. G. (1966). The polls: Cancer. *Public Opinion Quarterly*, *30*, 308–314.

Evans, S. H., & Clarke, P. (1983). When cancer patients fail to get well: Flaws in health communication. In R. N. Bostrom (Ed.), *Communication yearbook 7* (pp. 225–248). Beverly Hills, CA: Sage.

Eysenbach, G. (2003a). The impact of the Internet on cancer outcomes. *CA: A Cancer Journal for Clinicians*, *53*, 356–371.

Eysenbach, G. (2003b). The Semantic Web and healthcare consumers: A new challenge and opportunity on the horizon? *International Journal of Healthcare Technology and Management*, *5*, 194–212.

Eysenbach, G. (2005). Design and evaluation of consumer health information web sites. In D. Lewis, G. Eysenbach, R. Kukafka, P. Z. Stavri, & H. B. Jimison (Eds.), *Consumer health informatics: Informing consumers and improving health care* (pp. 34–60). New York: Springer.

Eysenbach, G., Powell, J., Englesakis, M., Rizo, C., & Stern, A. (2004). Health-related virtual communities and electronic support groups: Systematic review of the effects of online peer-to-peer interactions. *British Medical Journal*, *328*(7449), 1166–1176.

Falconer, J. (1980). Communication problems and perspectives: The patients' point of view. In M. G. Eisenberg, J. Falconer, & L. C. Sutkin (Eds.), *Communication in a health care setting* (pp. 35–57). Springfield, IL: Charles C. Thomas.

Farace, R. V., Monge, P. R., & Russell, H. (1977). *Communicating and organizing*. Reading, MA: Addison-Wesley.

Farace, R. V., Taylor, J. A., & Stewart, J. P. (1978). Criteria for evaluation of organizational communication effectiveness: Review and synthesis. In D. Nimmo (Ed.), *Communication yearbook 2* (pp. 271–292). New Brunswick, NJ: Transaction Books.

Faulkner, A. (1985). The consequences of ignorance: Nurse patient communication. In J. M. Brittain (Ed.), *Consensus and penalties for ignorance in the medical sciences: Implications for information transfer* (pp. 121–135). London, U.K.: Taylor Graham.

Feigenbaum, E., McCordick, P., & Nii, H. P. (1988). *The rise of the expert company: How visionary companies are using artificial intelligence to achieve higher productivity and profits*. New York: Times Books.

Feldman, M. S., & March, J. G. (1981). Information in organizations as signal and symbol. *Administrative Science Quarterly, 26*, 171–186.

Ferguson, T. (1991). The health-activated, health-responsible consumer. In A. M. Rees (Ed.), *Managing consumer health information services* (pp. 15–22). Phoenix, AZ: Oryx.

Ferguson, T. (2007). e-patients: How they can help us heal health careAvailable at http: //e-patientsnet_white_paper.pdf

Feriss, T. (2011). *The 4-hour body: An uncommon guide to rapid fatloss, incredible sex, and becoming superhuman*. New York: Crown Archetype.

Festinger, L. (1957). *A theory of cognitive dissonance*. Stanford, CA: Stanford University Press.

Fink, R., Shapiro, S., & Royster, R. (1972). Impact of efforts to increase participation in repetitive screening for early breast cancer detection. *American Journal of Public Health,62*, 328–336.

Finnegan, J., Jr. (1994). Communicating health information to the public: The problem of exposure. In L. Sechrest, T. E. Backer, E. M. Rogers, T. F. Campbell, & M. L. Grady (Eds.), *Effective dissemination of clinical and health information* (Vol. AHCPR Pub. No. 95 0015.). Rockville, MD: Agency for Health Care Policy Research.

Fintor, L. (1998). The Michigan Health Kiosk: Cancer info on the go. *Journal of the National Cancer Institute, 90*, 809–810.

Fioriglio, G. (2010). Legal issues in medical computer software and expert systems in the United States. Legislation and Practice *EUI Working Paper MWP 2010/11*. Florence, Italy: European University Institute.

Fishbein, M., & Ajzen, I. (1975). *Beliefs, attitudes, intention, and behavior: An introduction to theory and research*. Reading, MA: Addison-Wesley.

Fisher, K. E., Durrance, J. C., & Hinton, M. B. (2004). Information grounds and the use of need-based services by immigrants in Queens, New York: A context-based, outcome evaluation approach. *Journal of the American Society for Information Science and Technology, 55*, 754–766.

Fisher, K. E., Erdelez, S., & McKechnie, L. (Eds.). (2005). *Theories of information behavior*. Medford, NJ: Information Today.

Fisk, G. (1959). Media influence reconsidered. *Public Opinion Quarterly, 23*, 83–91.

Flay, B. R. (1987). Mass media and smoking cessation: A critical review. *American Journal of Public Health, 77*, 153–160.

Flay, B. R., & Burton, D. (1990). Effective mass-communication strategies for health campaigns. In C. Atkin & L. Wallack (Eds.), *Mass communication and public health: Complexities and conflicts* (pp. 129–146). Newbury Park, CA: Sage.

Flay, B. R., DiTecco, D., & Schlegel, R. P. (1980). Mass media in health promotion: An analysis using an extended information processing model. *Health Education Quarterly, 7*, 127–147.

Flay, B. R., McFall, S., Burton, D., & Warnecke, R. B. (1990). *Health behavior changes through television: The role of de facto and motivated selection processes*. Paper presented at the Speech Communication Association Annual Convention, Chicago, IL.

Fletcher, S. W., Harris, R. P., Gonzalez, J. J., Degnan, D., Lannin, D. R., Strecher, V. J., . . . Clark, R. L. (1993). Increasing mammography utilization: A controlled study. *Journal of the National Cancer Institute, 85*, 112–120.

Ford, L. A., Babrow, A. S., & Stohl, C. (1996). Social support messages and the management of un-
 certainty in the experience of breast cancer: An application of problematic integration theory.
 Commuication Monographs, 63, 189–207.

Fortner, R. S. (1995). Excommunication in the information society. *Critical Studies in Mass Com-
 munication, 12*, 133–154.

Fox, K. F., & Kotler, P. (1980). The marketing of social causes: The first 10 years. *Journal of Market-
 ing, 44*, 24–33.

Fox, S. (2011). Peer-to-peer healthcare. *Pew Internet*. Available at http: //www.pewinternet.org/
 Reports/2011/P2PHealthcare.aspx

Fox, S., & Jones, S. (2009). The social life of health information. Available at http: //www.pewin-
 ternet.org/~/media//Files/Reports/2009/PIP Health_2009.pdf

Fox, S., & Raine, L. (2002). How Internet users decide what information to trust when they or their
 loved ones are sick. Available at http://www.pewinternet.org/Reports/2002/Vital-Decisions-
 A-Pew-Internet-Health-Report/Summary-of-Findings/How-Internet-users-decide-what-in-
 formation-to-trust.aspx

Freeman, L. C. (1992). Filling in blanks: A theory of cognitive categories and the structure of social
 affiliation. *Social Psychology Quarterly, 55*, 118–127.

Freimuth, V. S. (1987). The diffusion of supportive information. In T. L. Albrecht & M. B. Adel-
 man (Eds.), *Communicating social support* (pp. 212–237). Newbury Park, CA: Sage.

Freimuth, V. S. (1990). The chronically uninformed: Closing the knowledge gap in health. In E.
 B. Ray & L. Donohew (Eds.), *Communication and health: Systems and applications* (pp. 171–
 186). Hillsdale, NJ: Lawrence Erlbaum.

Freimuth, V. S., Edgar, T., & Fitzpatrick, M. A. (1993). Introduction: The role of communication
 in health promotion. *Communication Research, 20*, 509–516.

Freimuth, V. S., Greenberg, R., DeWitt, J., & Romano, R. M. (1984). Covering cancer: Newspa-
 pers and the public interest. *Journal of Communication, 34*, 62–73.

Freimuth, V. S., Stein, J. A., & Kean, T. J. (1989). *Searching for health information: The Cancer
 Information Service model*. Philadelphia, PA: University of Pennsylvania Press.

Freitag, A. R., & Picherit-Duthler, G. (2004). Employee benefits communication: Proposing a PR-
 HR cooperative approach. *Public Relations Review, 30*, 475–482.

Freud, S. (1923). *The ego and the id*. New York: Norton.

Frické, M. (2009). The knowledge pyramid: A critique of the DIKW hierarchy. *Journal of Informa-
 tion Science, 35*(2), 131–142.

Froehlich, T. J. (1994). Relevance reconsidered towards an agenda for the 21st century: Introduc-
 tion to special topic issue on relevance research. *Journal of the American Society for Information
 Science, 45*, 124–134.

Frost, J., & Massagli, M. (2009). PatientsLikeMe: The case for a data-centered patient community
 and how ALS patients use the community to inform treatment decisions and manage pulmo-
 nary health. *Chronic Respiratory Disease, 6*(4), 225–229.

Fulk, J., & Boyd, B. (1991). Emerging theories of communication in organizations. *Journal of
 Management, 17*, 407–446.

Fulk, J., Schmitz, J. W., & Steinfield, C. W. (1990). A social influence model of technology use.
 In J. Fulk & C. W. Steinfeld (Eds.), *Organizations and Communication Technology*. Newbury
 Park, CA: Sage.

Fulk, J., Steinfield, C. W., Schmitz, J., & Power, J. G. (1987). A social information processing
 model of media use in organizations. *Communication Research, 14*, 529–552.

Fulton, C. (2005). Chatman's life in the round. In K. E. Fisher, S. Erdelez, & L. McKechnie (Eds.),
 Theories of information behavior (pp. 79–82). Medford, NJ: Information Today.

Galarce, E. M., Ramanadhan, S., & Vishwanath, K. (2011). Health information seeking. In T. L.
 Thompson, R. Parrott, & J. F. Nussbaum (Eds.), *The Routledge handbook of health communica-
 tion* (2nd ed., pp. 167–180). New York: Routledge.

Geist-Martin, P., Horsley, K., & Farrell, A. (2003). Working well: Communicating individual and collective wellness initiatives. In T. L. Thompson, A. M. Dorsey, K. I. Miller, & R. Parrott (Eds.), *Handbook of health communication* (pp. 423–443). Mahwah, NJ: Lawrence Erlbaum.

Gerbner, G., Gross, L., Morgan, M., & Signorielli, N. (1981). Special report: Health and medicine on television. *New England Journal of Medicine, 305*, 901–904.

Gerstberger, P. G., & Allen, T. J. (1968). Criteria used by research and development engineers in the selection of an information source. *Journal of Applied Psychology, 52*, 272–279.

Gillaspy, M. L. (2005). Factors affecting the provision of consumer health information in public libraries: The last five years. *Library Trends, 53*(3), 480–495.

Given, B. A., Given, C. W., & Kozachik, S. (2001). Family support in advanced cancer. *CA Cancer Journal for Clinicians, 51*(4), 213–231.

Given, L. M. (2005). Social positioning. In K. E. Fisher, S. Erdelez , & L. McKechnie (Eds.), *Theories of information behavior* (pp. 334–338). Medford, NJ: Information Today.

Glasgow, R. E., Marcus, A. G., Bull, S. S., & Wilson, K. M. (2004). Disseminating effective cancer screening interventions. *Cancer Supplement, 101*, 1239–1250. doi: 10.1002/cncr.20509

Gleick, J. (2011). *The information: A history, a theory, a flood*. New York: Pantheon Books.

Goffman, E. (1974). *Frame analysis: An essay on the organization of experience*. Cambridge, MA: Harvard University Press.

Goldbeck, L. (2001). Parental coping with the diagnosis of childhood cancer: Gender effects, dissimilarity within couples, and quality of life. *Psycho-Oncology, 10*, 325–335. doi: 10.1002/pon.530

Goldenson, R. M. (1984). *Longman dictionary of psychology and psychiatry*. New York: Longman.

Goldsmith, D. J., & Albrecht, T. L. (2011). Social support, social networks, and health: A guiding framework. In T. L. Thompson, R. Parrott, & J. F. Nussbaum (Eds.), *The Routledge handbook of health communication* (pp. 335–348). New York: Routledge.

Goldstein, W. M., & Hogarth, R. M. (1997). *Research on judgment and decision-making: Currents, connections and controversies*. New York: Cambridge University Press.

Gore, S. (1989). Social networks and social supports in health care. In H. E. Freeman & S. Levine (Eds.), *Handbook of medical sociology* (pp. 306–331). Englewood Cliffs, NJ: Prentice Hall.

Gotcher, J. M., & Edwards, R. (1990). Coping strategies of cancer patients: Actual communication and imagined interactions. *Health Communication, 2*, 255–266.

Gould, C. C., & Pearce, K. (1991). *Information needs in the sciences: An assessment*. Mountain View, CA: Research Libraries Group.

Granovetter, M. S. (1973). The strength of weak ties. *American Journal of Sociology, 78*, 1360–1380.

Granovetter, M. S. (1982). The strength of weak ties: A network theory revisited. In P. V. Marsden & N. Lin (Eds.), *Social structure in network analysis* (pp. 105–130). Beverly Hills, CA: Sage.

Green, L. W., & McAllister, A. L. (1984). Macro intervention to support health behavior: Some theoretical perspectives and practical reflections. *Health Education Quarterly, 11*, 323–339.

Green, L. W., & Roberts, B. J. (1974). The research literature on why women delay in seeking medical care for breast symptoms. *Health Education Monographs, 2*, 129–177.

Greenberg, R. H., Freimuth, V. S., & Bratic, E. (1979). A content analytic study of daily newspaper coverage of cancer. In D. Nimmo (Ed.), *Communication yearbook 3* (pp. 645–654). New Brunswick, NJ: Transaction Books.

Greer, A. L. (1994). "You can always tell a doctor...." In L. Sechrest, T. E. Backer, E. M. Rogers, T. F. Campbell, & M. L. Grady (Eds.), *Effective dissemination of clinical and health information* (Vol. AHCPR Pub. No. 95 0015). Rockville, MD: Agency for Health Care Policy Research.

Griffin, R. J., Dunwoody, S., & Neuwirth, K. (1999). Proposed model of the relationship of risk information seeking and processing to the development of preventive behaviors. *Environmental Research Section A, 80*, S230–S245.

Grol, R., & Grimshaw, J. (2003). From best evidence to best practice: Effective implementation change in patients' care. *The Lancet, 362*, 1225–1230.

Groopman, J. (2007). *How doctors think*. New York: Houghton Mifflin.

Guetzkow, H. (1965). Communication in organizations. In J. G. March (Ed.), *Handbook of organizations* (pp. 534–573). Chicago, IL: Rand-McNally.

Gurbaxani, V., & Whang, S. (1991). Knowledge flows and the structure of control within multinational organizations. *Communications of the ACM, 24*, 59–73.

Gustafson, D., Hawkins, R., McTavish, F., Pingree, S., Chen, W. C., Volrathongchai, K., . . . Serlin, R. C. (2008). Internet-based interactive support for cancer patients: Are integrated systems better? *Journal of Communication, 58*, 238–257.

Hagarstrand, T. (1953). *Innovation diffusion as a spatial process.* Chicago, IL: University of Chicago Press.

Haines, V. A., Beggs, J. J., & Hurlbert, J. S. (2002). Exploring the structural contexts of the support process: Social networks, social statuses, social support, and psychological stress. *Social Networks and Health, 8*, 269–292.

Hall, H. J. (1981). Patterns in the use of information: The right to be different. *Journal of American Society for Information Science, 32*, 103–112.

Hammond, S. L. (1987). Health advertising: The credibility of organizational sources. In M. L. McLauglin (Ed.), *Communication yearbook 10* (pp. 613–628). Newbury Park, CA: Sage.

Han, J. Y., Kim, E., Pingree, R., Wise, M., Hawkins, R. P., Pingree, S., . . . Gustafson, D. (2010). Factors associated with the use of interaction cancer communication system: An application of the Comprehensive Model of Information Seeking. *Journal of Computer-Mediated Communication, 15*, 367–388. doi: 10.1111/j.1083-6101.2010.01508.x

Hanneman, G. J. (1973). Communicating drug-abuse information among college students. *Public Opinion Quarterly, 37*, 171–197.

Hardy, A. (1982). The selection of channels when seeking information: Cost/benefit vs. least-effort. *Information Processing & Management, 18*(6), 289–293.

Hargittai, E., Fullerton, L., Menchen-Trevino, E., & Thomas, K. Y. (2010). Trust online: Young adults' evaluations of web content. *International Journal of Communication, 4*, 468–494.

Harlem, O. K. (1977). *Communication in medicine: A challenge to the profession.* New York: S. Karger.

Harrington, N. G., Norling, G. R., Witte, F. M., Taylor, J., & Andrews, J. E. (2007). The effects of communication skills training on pediatricians' and patients' communication during "sick child" visits. *Health Communication, 21*(2), 105–114.

Harris, L. M., Bauer, C., Donaldson, M. S., Lefebvre, R. C., Dugan, E., & Arayasirikul, S. (2011). Health communication and health information technology: Priority issues, policy implications, and research opportunities for Healthy People 2020. In T. L. Thompson, R. Parrott, & J. F. Nussbaum (Eds.), *The Routledge handbook of health communication* (2nd ed., pp. 482–497). New York: Routledge.

Harrison, D. E., Galloway, S., Graydon, J. E., Palmer-Wickham, S., & van der Bij, L. (1999). Information needs and preference for information of women with breast cancer over a first course of radiation therapy. *Patient Education and Counseling, 38*, 217–225.

Harvard Mental Health Letter. (2006). Resilience. *Harvard Mental Health Letter, 23*(6), 5–6.

Health Forum Journal. (1995). Consumer health informatics. *Health Forum Journal, 38*, 28–32.

Hersberger, J. (2005). Chatman's information poverty. In K. E. Fisher, S. Erdelez, & L. McKechnie (Eds.), *Theories of information behavior* (pp. 75–78). Medford, NJ: Information Today.

Hersh, W. R. (1998). How well do physicians use electronic information retrieval systems? *Journal of American Medical Association, 280*(15), 1347–1352.

Hersh, W. R. (2005). Ubiquitous but unfinished: Online information retrieval systems. *Medical Decision Making, 25*(2), 147–148.

Hersh, W. R., Crabtree, M. K. Hickam, D. H. Sacherek, L. Friedman, C.P. Tidmarsh, P. Mosbaek & D. Kraemer. (2002). Factors associated with success in searching MEDLINE and applying evidence to answer clinical questions. *Journal of the American Medical Informatics Association, 9*, 283–293.

Hertzum, M. (2008). Collaborative information seeking: The combined activity of information seeking and collaborative grounding. *Information Processing & Management, 44*, 957–962.

Hewes, D. E., & Planalp, S. (1987). The individual's place in communication science. In C. R. Berger & S. H. Chaffee (Eds.), *Handbook of communication science* (pp. 146–183). Newbury Park, CA: Sage.

Hibbard, J. H. (2003). Engaging health care consumers to improve the quality of care. *Medical Care, 41*, I-60–I-70.

Hibbard, J. H., & Weeks, E. C. (1987). Consumerism in health care. *Medical Care, 25*, 1019–1032.

Hickson, D. J. (1987). Decision making at the top of organizations. *Annual Review of Sociology, 13*, 165–192.

Hill, D., Gardner, G., & Rassaby, J. (1985). Factors predisposing women to take precautions against breast and cervix cancer. *Journal of Applied Social Psychology, 15*, 59–79.

Hines, S. C. (2001). Coping with uncertainties in advance care planning. *Journal of Communication, 51*(3), 498–513.

Hinton, J. (1973). Bearing cancer. *British Journal of Medical Psychology*, 105–113.

Hjorland, B. (2007). Information: Objective or subjective/situational? *Journal of the American Society for Information Science and Technology, 58*, 1448–1456.

Hoffman, G. M. (1994). *The technology payoff: How to profit with empowered workers in the information age*. New York: Irwin.

Hofstede, G. (1984). *Culture's consequences: International differences in work-related values*. Beverly Hills, CA: Sage.

Hofstede, G., Hofstede, G. J., & Minkov, M. (2010). *Cultures and organizations: Software of the mind* (3rd ed.). New York: McGraw-Hill.

Hollander, S. (2000). Providing health information to the general public: A survey of current practices in academic health sciences libraries. *Bulletin of the Medical Library Association, 88*(1), 62–69.

Holsapple, C. W. (2003). Knowledge and its attributes. In C. W. Holsapple (Ed.), *Handbook of knowledge management 1: Knowledge matters* (pp. 165–188). New York: Springer-Verlag.

Horowitz, G. L., Jackson, J. D., & Bleich, H. L. (1983). Self-service bibliographic retrieval. *Journal of the American Medical Association, 250*, 2494–2499.

Houston, T. K., & Allison, J. J. (2002). Users of Internet health information: Differences by health status. *Journal of Medical Internet Research, 4*(2), e7.

Hsia, H. J. (1987). The health-information seeking behavior of the Mexican Americans in West Texas. *Health Marketing Quarterly, 4*, 107–117.

Hu, Y., & Sundar, S. S. (2010). Effects of online health sources on credibility and behavioral intentions. *Communication Research, 37*(1), 105–132. doi: 10.1177/0093650209351512

Hubbard, S. M., Martin, N. B., & Thurn, A. L. (1995). NCI's Cancer Information Systems: Bringing medical knowledge to clinicians. *Oncology Nursing, 9*, 302–306.

Huber, G. P. (1990). A theory of the effects of advanced information technologies on organizational design, intelligence, and decision making. *Academy of Management Review, 15*, 47–71.

Huber, G. P., & Daft, R. L. (1987). The information environment in organizations. In F. M. Jablin, L. L. Putnam, K. H. Roberts, & L. W. Porter (Eds.), *Handbook of organizational communication: An interdisciplinary perspective* (pp. 130–164). Newbury Park, CA: Sage.

Hudson, J., & Danish, S. J. (1980). The acquisition of information: An important life skill. *Personnel and Guidance Journal, 59*, 164–167.

Huotari, M., & Chatman, E. (2001). Using everyday life information seeking to explain organizational behavior. *Library and Information Science Research, 23*, 351–366.

Hurley, R. J., Kosenko, K. A., & Brashers, D. (2011). Uncertain terms: Message features of online cancer news. *Communication Monographs, 78*(3), 370–390. doi: 10.1080/03637751.2011.565061

Hyman, H. H., & Sheatsley, P. B. (1947). Some reasons why information campaigns fail. *Public Opinion Quarterly, 11*, 412–423.

IMLS. (2011). Building digitally inclusive communities: A guide to the proposed framework doi: www.imls.gov/pdf/DIC-FrameworkGuide.pdf

Infante, D. A., Rancer, A. S., & Womack, D. F. (1993). *Building communication theory* (2nd ed.). Prospect Heights, IL: Waveland Press.

Jacobson, N., Butterill, D., & Goering, P. (2003). The development of a framework for knowledge translation: Understanding user context. *Journal of Health Services Research Policy, 8*(2), 94–99.

Jacoby, J., & Hoyer, W. D. (1987). *The comprehension and miscomprehension of print communications: An investigation of mass-media magazines.* Hillsdale, NJ: Lawrence Erlbaum.

Jadad, A. R., & Gagliardi, A. (1998). Rating health information on the Internet: Navigating to knowledge or to Babel? *Journal of the American Medical Association, 279,* 611–614.

James, W. (1890). *The principles of psychology.* New York: Henry Holt.

Janis, I., & Feshback, S. (1953). Effects of fear-arousing communications. *Journal of Abnormal and Social Psychology, 48,* 78–92.

Janz, N. H., & Becker, M. H. (1984). The Health Belief Model: A decade later. *Health Education Quarterly, 11,* 1–47.

Jayanti, R. K., & Burns, A. C. (1998). The antecedents of preventive health care behavior: An empirical study. *Journal of the Academy of Marketing Science, 26,* 6–15.

Jimison, H. B. (2005). Ethical issues in consumer health informatics. In D. Lewis, G. Eysenbach, R. Kukafka, P. Z. Stavri, & H. B. Jimison (Eds.), *Consumer health informatics: Informing consumers and improving healthcare* (pp. 143–149). New York: Springer.

Johnson, J. D. (1982). A model of social interaction: Tests in three situations. *Central States Speech Journal, 33*(1), 281–298.

Johnson, J. D. (1983). A test of a model of magazine exposure and appraisal in India. *Communication Monographs, 50,* 148–157.

Johnson, J. D. (1984a). International communication media appraisal: Tests in Germany. In R. N. Bostrom (Ed.), *Communication yearbook 8* (pp. 645–658). Beverly Hills, CA: Sage.

Johnson, J. D. (1984b). Media exposure and appraisal: Phase II, tests of a model in Nigeria. *Journal of Applied Communication Research, 12,* 63–74.

Johnson, J. D. (1984c). A model of social interaction,Phase III: Tests in varying media situations. *Communication Monographs, 51*(2), 168–184.

Johnson, J. D. (1985). A model of social interaction, Phase II: Further tests in radio and television situations. *Central States Speech Journal, 36,* 62–71.

Johnson, J. D. (1987). A model of international communication media appraisal: Phase IV, generalizing the model to film. *International Journal of Intercultural Relations, 11,* 129–142.

Johnson, J. D. (1988). *Cancer-related information seeking.* Paper presented at the Speech Communication Association Annual Convention, New Orleans, LA.

Johnson, J. D. (1993a). *Organizational communication structure.* Norwood, NJ: Ablex.

Johnson, J. D. (1993b). *Tests of a comprehensive model of cancer-related information seeking.* Paper presented at the Speech Communication Association, Miami, FL.

Johnson, J. D. (1996). *Information seeking: An organizational dilemma.* Westport, CT: Quoroum Books.

Johnson, J. D. (1997). *Cancer-related information seeking.* Cresskill, NJ: Hampton Press.

Johnson, J. D. (2003). On contexts of information seeking. *Information Processing and Management, 39,* 735–760.

Johnson, J. D. (2005). *Innovation and knowledge management: The Cancer Information Service Research Consortium.* Cheltenham, U.K.: Edward Elgar.

Johnson, J. D. (2009a). An impressionistic mapping of information behavior with special attention to contexts, rationality, and ignorance. *Information Processing and Management, 45,* 593–604.

Johnson, J. D. (2009b). Information regulation and work-life: Applying the Comprehensive Model of Information Seeking to organizational networks. In T. D. Afifi & W. A. Afifi (Eds.), *Uncertainty, information management, and disclosure decisions: Theories and applications* (pp. 182–199). New York: Routledge.

Johnson, J. D. (2009c). *Managing knowledge networks.* Cambridge, U.K.: Cambridge University Press.

Johnson, J. D. (2009d). Profiling the likelihood of success of electronic medical records. In S. Kleinman (Ed.), *The culture of efficiency: Technology in everyday life* (pp. 121–141). New York: Peter Lang.

Johnson, J. D., Andrews, J., & Allard, S. (2001). A model for understanding and affecting cancer genetics information seeking. *Library & Information Science Research*, *23*, 335–349.

Johnson, J. D., Andrews, J. E., Case, D. O., Allard, S. L., & Johnson, N. E. (2006). Fields and/ or pathways: Contrasting and/or complementary views of information seeking. *Information Processing and Management*, *42*, 569–582.

Johnson, J. D., Case, D. O., Andrews, J. E., & Allard, S. L. (2005). Genomics: The perfect information-seeking research problem. *Journal of Health Communication*, *10*, 323–329.

Johnson, J. D., Donohue, W. A., Atkin, C. K., & Johnson, S. H. (1995). A comprehensive model of information seeking: Tests focusing on a technical organization. *Science Communication*, *16*, 274–303.

Johnson, J. D., & Heeter, C. (1989). *Using interactive computer technologies to reach special populations*. Paper presented at the Healthy U Health Promotion Conference, East Lansing, MI.

Johnson, J. D., & Johnson, S. H. (1992). *Cancer-related media channel selection*. Paper presented at the Speech Communication Association Annual Convention, Chicago, IL.

Johnson, J. D., & Meischke, H. (1991). Cancer information: Women's source and content preferences. *Journal of Health Care Marketing*, *11*, 37–44.

Johnson, J. D., & Meischke, H. (1992a). Differences in evaluations of communication channels for cancer-related information. *Journal of Behavioral Medicine*, *15*, 1–17.

Johnson, J. D., & Meischke, H. (1992b). Mass-media channels: Women's evaluation for cancer-related information. *Newspaper Research Journal*, *12*, 146–159.

Johnson, J. D., & Meischke, H. (1993a). Cancer-related channel selection: An extension for a sample of women who have had a mammogram. *Women & Health*, *20*, 31–44.

Johnson, J. D., & Meischke, H. (1993b). A comprehensive model of cancer-related information seeking applied to magazines. *Human Communication Research*, *19*, 343–367.

Johnson, J. D., & Meischke, H. (1993c). Differences in evaluations of communication sources by women who have had a mammography. *Journal of Psychosocial Oncology*, *11*, 83–101.

Johnson, J. D., & Meischke, H. (1994). Factors associated with adoption of mammography screening: Results of a cross-sectional and longitudinal study. *Journal of Women's Health*, *3*, 97–105.

Johnson, J. D., & Oliveira, O. S. (1988). A model of international communication media appraisal and exposure: A comprehensive test in Belize. *World Communication*, *17*, 253–277.

Johnson, J. D., & Tims, A. R. (1981). Magazine evaluations and levels of readership: A cross-national comparison. *Journalism Quarterly*, *58*, 96–98.

Johnson, M. O. (2011). The shifting landscape of health care: Toward a model of health care empowerment. *American Journal of Public Health*, *101*(2), 265–270.

Johnson-Laird, P. N. (1983). *Mental models: Towards a cognitive science of language, inference, and consciousness*. Cambridge, U.K.: Cambridge University Press.

Jones, R. (2009). The role of health kiosks in 2009: Literature and informant review. *International Journal of Environmental Research and Public Health*, *6*, 1818–1855. Available at http: //www. mdpi.com/1660-4601/6/6/1818/

Kahlor, L. (2007). An augmented risk information-seeking model: The case of global warming. *Media Psychology*, *10*, 414–435. doi: 10.1080/15213260701532971

Kahlor, L. (2010). PRISM: A planned risk information seeking model. *Health Communication*, *25*(4), 345–356. doi: 10.1080/10410231003775172

Kahlor, L., Dunwoody, S., Griffin, R., & Neuwirth, K. (2006). Seeking and processing information about impersonal risk. *Science Communication*, *28*(2), 165–194. doi: 10.1177/1075547006293916

Kahneman, D., Slovic, P., & Tversky, A. (1982). *Judgment under uncertainty: Heuristics and biases*. New York: Cambridge University Press.

Kalman, M. E., Monge, P. R., Fulk, J., & Heino, R. (2002). Motivations to resolve communication dilemmas in database-mediated collaboration. *Communication Research*, *29*(2), 125–154.

Kari, J., & Hartel, J. (2007). Information and higher things in life: Addressing the pleasurable and profound in information science. *Journal of the American Society for Information Science and Technology*, *58*(8), 1131–1147.

Kasperson, C. J. (1978). An analysis of the relationship between information sources and creativity in scientists and engineers. *Human Communication Research, 4*, 113–119.

Katz, E. (1957). The two-step flow of communication: An up-to-date report on an hypothesis. *Public Opinion Quarterly, 21*, 61–78.

Katz, E. (1968). On reopening the question of selectivity in exposure to mass communications. In R. P. Abelson (Ed.), *Theories of cognitive consistency* (pp. 788–796). New York: Rand McNally.

Katz, E., Blumler, J. G., & Gurevitch, M. (1974). Uses of mass communication by the individual. In W. P. Davison (Ed.), *Mass communication research: Major issues and future directions* (pp. 11–35). New York: Praeger.

Katz, E., Gurevitch, M., & Haas, H. (1973). On the use of mass media for important things. *American Sociological Review, 38*, 164–181.

Katz, E., & Lazersfeld, P. F. (1955). *Personal influence: The part played by people in the flow of mass communications.* New York: Free Press.

Katzer, J., & Fletcher, P. T. (1992). The information environment of managers. *Annual review of information science and technology* (pp. 227–263). Medford, NJ: Learned Information.

Kaye, B. K., & Johnson, T. J. (2003). From here to obscurity? Media substitution theory and traditional media in an on-line world. *Journal of the American Society for Information Science and Technology, 54*(3), 260–273.

Keen, P. G. W. (1990). Telecommunications and organizational choice. In J. Fulk & C. Steinfield (Eds.), *Organizations and communication technology* (pp. 295–312). Newbury Park, CA: Sage.

Keen, P. G. W., & Morton, M. S. S. (1978). *Decision support systems: An organizational perspective.* Reading, MA: Addison-Wesley.

Kegeles, S. S. (1980). Review of the "Health Belief Model and personal health behavior." *Social Science Medicine C, 14*, 227–229.

Kellerman, K., & Reynolds, R. (1990). When ignorance is bliss: The role of motivation to reduce uncertainty in uncertainty-reduction theory. *Human Communication Research, 17*, 5–75.

Kelly, B. J., & Hornik, R. C. (2009). Validating measures of scanned information exposure in the context of cancer prevention and screening behaviors. *Journal of Health Communication, 14*, 721–740. doi: 10.1080/10810730903295559

Kelly, B. J., Niederdeppe, J., & Hornik, R. C. (2009). Validating measures of scanned information exposure in the context of cancer screening behaviors. *Journal of Health Communication, 14*, 721–740.

Kelly, D. (2006). Measuring online information seeking context, Part 1: Background and method. *Journal of the American Society for Information Science and Technology, 57*(13), 1729–1739.

Kelly, K., Andrews, J. E., Case, D. O., Allard, S. L., & Johnson, J. D. (2007). Information seeking and intentions to have genetic testing for hereditary cancers in rural and Appalachian Kentuckians. *Journal of Rural Health, 23*, 166–172.

Kelly, K. M., Sturm, A. C., Kim, K., Holland, J., & Ferketich, A. K. (2009). How can you reach them? Information seeking and preferences for a cancer family history campaign in underserved communities. *Journal of Health Communication, 14*, 573–589. doi: 10.1080/10810730903089580

Kerwin, A. (1993). None too solid: Medical ignorance. *Knowledge: Creation, Diffusion, Utilization, 15*, 166–185.

Kessler, L. (1989). Women's magazines' coverage of smoking-related health hazards. *Journalism Quarterly, 66*, 316–322, 445.

Kiel, G. C., & Layton, R. A. (1981). Dimensions of consumer information-seeking behavior. *Journal of Marketing Research, 18*, 233–239.

Kim, S. H., & Willis, L. A. (2007). Talking about obesity: News framing of who is responsible for causing and fixing the problem. *Journal of Health Communication, 12*, 359–376.

Kindermann, T. A., & Valsiner, J. (1995a). Directions for the study of developing person-context relations. In T. A. Kindermann & J. Valsiner (Eds.), *Development of person-context relationships* (pp. 227–240). Hillsdale, NJ: Lawrence Erlbaum.

Kindermann, T. A., & Valsiner, J. (1995b). Individual development, changing contexts and the co-construction of person-context relations in human development. In T. A. Kindermann & J.

Valsiner (Eds.), *Development of person-context relationships* (pp. 1–9). Hillsdale, NJ: Lawrence Erlbaum.

Kiousis, S. (2002). Interactivity: A concept explication. *New Media & Society, 4*, 355–383.

Kivits, J. (2009). Everyday health and the Internet: A mediated health perspective on health information seeking. *Sociology of Health and Illness, 31*(5), 673–687. doi: 10.1111/j.1467-9566.2008.01153.x

Klein, G. (2009). *Streetlights and shadows: Searching for the keys to adaptive decision making.* Cambridge, MA: MIT Press.

Klonglan, G. E., & Bohlen, J. M. (1976). Adoption of innovations related to cancer control techniques. In J. W. Cullen, B. H. Fox, & R. N. Isom (Eds.), *Cancer: The behavioral dimensions* (pp. 243–254). New York: Raven Press.

Koehly, L. M., Peters, J. A., Kenen, R., Hoskins, L. M., Ersig, A. L., Kuhn, N. R., . . . Green, M. H. (2009). Characteristics of health information gatherers, disseminators, and blockers within families at risk of hereditary cancer: Implications for family health communication interventions. *American Journal of Public Health, 99*(12), 2203–2209.

Kohane, I. S., Masys, D. R., & Altman, R. B. (2006). The incidentalome: A threat to genomic medicine. *Journal of the American Medical Association, 296*(2), 212–215.

Konigsberg, R. D. (2011). The refuseniks: Why some cancer patients reject their doctor's advice. *Time*, 72–77.

Koop, C. E. (1995). Editorial: A personal role in health care reform. *American Journal of Public Health, 85*, 759–760.

Kortum, P. (2008). The impact of inaccurate Internet health information in a secondary school learning environment. *Journal of Medical Internet Research, 10*(2), e17.

Kossek, E. E., & Lambert, S. J. (Eds.). (2006). *Work and life integration: Organizational, cultural, and individual perspectives.* Mahwah, NJ: Lawrence Erlbaum.

Krackhardt, D. (1994). Constraints on the interactive organization as an ideal type. In C. Heckscher & A. Donnelon (Eds.), *The post-bureaucratic organization: New perspectives on organizational change* (pp. 211–222). Thousand Oaks, CA: Sage.

Kramer, M. W. (2004). *Managing uncertainty in organizational communication.* Mahwah, NJ: Lawrence Erlbaum.

Kreps, G. L. (2009). Applying Weick's model of organizing to health care and health promotion: Highlighting the central role of health communication. *Patient Education and Counseling, 74*, 347–355. doi: 10.1016/j.pec.2008.12.002

Kreps, G. L., Hibbard, S. M., & DeVita, V. T. (1988). The role of the Physician Data Query online cancer system in health information dissemination. In B. D. Ruben (Ed.), *Information and behavior* (Vol. 2, pp. 362–374). New Brunswick, NJ: Transaction Books.

Kreuter, M., Black, W., Friend, L., Booker, A., Klump, P., Bobra, S., & Holt, C. (2006). Use of computer kiosks for breast cancer education in five community settings. *Health Education and Behavior, 33*, 625–642.

Krikelas, J. (1983). Information seeking behavior: Patterns and concepts. *Drexel Library Quarterly, 19*, 5–20.

Krippendorf, K. (1986). *Information theory: Structural models for qualitative data.* Newbury Park, CA: Sage.

Krupinski, E. A. (2009). Virtual slide telepathology workstation of the future: Lessons learned from teleradiology. *Human Pathology, 40*(8), 1100–1111.

Kuhlthau, C. C. (1991). Inside the search process: Information seeking from the user's perspective. *Journal of the American Society for Information Science and Technology, 12*, 361–371.

Kuhn, T. S. (1970). *The structure of scientific revolutions* (2nd ed.). Chicago, IL: University of Chicago Press.

Kukafka, R. (2005). Tailored health communication. In D. Lewis, G. Eysenbach, R. Kukafka, P. Z. Stavri, & H. B. Jimison (Eds.), *Consumer health informatics: Informing consumers in improving healthcare* (pp. 22–33). New York: Springer.

Kurke, L. B., Weick, K. E., & Ravlin, E. C. (1989). Can information loss be reversed? Evidence for serial construction. *Communication Research, 16*, 3–24.

Kutner, M., Greenberg, E., Ying, J., Boyle, B., Hsu, Y.-C., Dunleavy, E., & White, S. (2003). *Literacy in everyday life: Results from the 2003 National Assessment of Adult Literacy.* Washington, DC: National Center for Education Statistics.

LaFollette, M. C. (1993). Editorial. *Knowledge: Creation, Diffusion, Utilization, 15*, 131–132.

Lalor, J. G., Begley, C. M., & Galavan, E. (2008). A grounded theory study of information preference and coping styles following antenatal diagnosis of foetal abnormality. *Journal of Advanced Nursing, 64*(2), 185–194.

Lambert, S. D., & Loiselle, C. G. (2007). Health information-seeking behavior. *Qualitative Health Research, 17*, 1006–1019. doi: 10.1177/1049732307305199

Lammers, J. C. (2011). How institutions communicate: Institutional messages, institutional logics, and organizational communication. *Management Communication Quarterly, 25*(1), 154–182. doi: 10.1177/0893318910389280

Lammers, J. C., & Barbour, J. B. (2009). Exploring the institutional context of physicians' work: Professional and organizational differences in physician satisfaction. In D. Brashers & D. Goldsmith (Eds.), *Communicating to manage health and illness: Communication, relationships, and identity* (pp. 91–112). Mahwah, NJ: Erlbaum.

Lane, S. D. (1983). Compliance, satisfaction, and physician-patient communication. In R. N. Bostrom (Ed.), *Communication yearbook 7* (pp. 772–799). Beverly Hills, CA: Sage.

Lau, A. Y. S., & Coiera, E. W. (2008). Impact of web searching and social feedback on consumer decision making: A prospective online experiment. *Journal of Medical Internet Research, 10*(1), e2.

Lawrence, D. (2002). *From chaos to care: The promise of team-based medicine.* Cambridge, MA: Perseus.

Lee, G. K. (2007). The significance of network resources in the race to enter emerging product markets: The convergence of telephony communications and computer networking, 1989–2001. *Strategic Management Journal, 28*, 17–37.

Lee, S. Y., & Hawkins, R. (2010). Why do patients seek an alternative channel? The effects of unmet needs on patients' health-related Internet use. *Journal of Health Communication, 15*, 152–166.

Lee, S. Y., Hwang, H., Hawkins, R., & Pingree, S. (2008). Interplay of negative emotion and health self-efficacy on the use of health information and its outcomes. *Communication Research, 35*(3), 358–381.

Lefebvre, R. C., & Flora, J. A. (1988). Social marketing and public health intervention. *Health Education Quarterly, 15*, 299–315.

Lengel, R. H., & Daft, R. L. (1988). The selection of communication media as an executive skill. *Academy of Management Executive, 2*, 225–232.

Lentz, R. G. (2000). The e-volution of the digital divide in the U.S.: A mayhem of competing metrics. *Info: The Journal of Policy, Regulation and Strategy for Telecommunications Information and Media, 2*, 355–377.

Lenz, E. R. (1984). Information seeking: A component of client decisions and health behavior. *Advances in Nursing Science, 6*,(3), 59–72.

Lerman, C., Rimer, B., & Engstrom, P. F. (1989). Reducing avoidable cancer mortality through prevention and early detection regimens. *Cancer Research, 49*, 4955–4962.

Leutwyler, K. (1995, April). The price of prevention. *Scientific American*, 124–129.

Leventhal, H., Safer, M. A., & Panagis, D. M. (1983). The impact of communications on the self-regulation of health belief, decisions and behavior. *Health Education Quarterly, 10*, 3–29.

Levy, M., & Royne, M. B. (2009). The impact of consumers' health literacy on public health. *Journal of Consumer Affairs, 43*(2), 367–373.

Lewis, T. (2006). Seeking health information on the Internet: Lifestyle choice or bad attack of cyberchondria? *Media, Culture & Society, 28*, 521-539. doi: 10.1177/0163443706065027

Leydon, G. M., Boulton, M., Moynihan, C., Jones, A., Mossman, J., Boudioni, M., & McPherson, K. (2000). Cancer patients' information needs and information seeking behaviour: In-depth interview study. *British Medical Journal, 320*, 909–913.

Lichtenstein, E., & Glasgow, R. E. (1992). Smoking cessation: What have we learned over the past decade? *Journal of Counseling and Clinical Psychology, 60*(4), 518–527.

Lichter, I. (1987). *Communication in cancer care.* New York: Churchill Livingstone.

Lieberman, D. A. (2012). Digital games for health behavior change: Research, design, and future directions. In S. M. Noar & N. G. Harrington (Eds.), *e-Health applications: Promising strategies for behavior change* (pp. 164–193). New York: Routledge.

Lieberman, M. A., & Goldstein, B. A. (2005). Self-help on-line: An outcome evaluation of breast cancer bulletin boards. *Journal of Health Psychology, 10*, 855–862.

Lievrouw, L. A. (1994). Information resources and democracy: Understanding the paradox. *Journal of the American Society for Information Science, 45*, 350–357.

Lievrouw, L. A., & Carley, K. (1991). Changing patterns of communication among scientists in an era of "telescience." *Technology in Society, 12*, 457–477.

Lievrouw, L. A., & Farb, S. (2003). Information and equity. *Annual Review of Information Science & Technology* (Vol. 37, pp. 499–540). Washington, DC: American Society for Information Science & Technology.

Lin, C. A. (1993). Modeling the gratification seeking process of television making. *Human Communication Research, 20*, 224–244.

Lindberg, D. A. B., & Humphreys, B. L. (2008). Rising expectations: Access to biomedical information. *Yearbook of Medical Informatics, 3*, 165–172.

Lindberg, D. A. B., Siegel, E. R., Rapp, B. A., Wallingford, K. T., & Wilson, S. R. (1993). Use of Medline by physicians for clinical problem solving. *Journal of the American Medical Association, 269*, 3124–3129.

Littlejohn, S. W. (1992). *Theories of human communication* (4th ed.). Belmont, CA: Wadsworth Publishing.

Littlejohn, S. W., & Foss, K. A. (2011). *Theories of human communication* (10th ed.). Long Grove, IL: Waveland Press.

Loader, B., Muncer, S., Burrows, R., Pleace, N., & Nettleton, S. (2002). Reliability of health information on the Internet: An examination of experts' ratings. *Social Science & Medicine, 29*, 225–232.

Loehrer, P. J., Greger, H. A., Weinberger, M., Musick, B., Miller, T., Nichols, C., . . . Brock, D. (1991). Knowledge and beliefs about cancer in a socioeconomically disadvantaged population. *Cancer, 68*, 1665–1671.

Lomas, J. (1993). Diffusion, dissemination, and implementation: Who should do what? *Annals of New York Academy of Sciences, 703*, 226–235.

Lomas, J., & Haynes, R. B. (1988). A taxonomy and critical review of tested strategies for the application of clinical practice recommendations: From "official" to "individual" clinical policy. *American Journal of Preventive Medicine, 4*, 77–94.

Longo, D. R. (2005). Understanding health information, communication, and information seeking of patients and consumers: A comprehensive and integrated model. *Health Expectations, 8*, 189–194.

Longo, D. R., Ge, B., Radina, M. E., Greiner, A., Williams, C. D., Longo, G. S., . . . Salas-Lopez, D. (2009). Understanding breast-cancer patients' perceptions: Health information-seeking behaviour and passive information receipt. *Journal of Communication in Healthcare, 2*(2), 184–206.

Longo, D. R., Schubert, S. L., Wright, B. A., LeMaster, J., Williams, C. D., & Clore, J. N. (2010). Health information seeking, receipt, and use in diabetes self-management. *Annals of Family Medicine, 8*(4). Available at http://www.annfammed.org/content/8/4/334.full

Lord, R. G., & Maher, K. J. (1990). Alternative information processing models and their implications for theory, research, and practice. *Academy of Management Review, 15*, 9–28.

Lowery, W., & Anderson, W. B. (2002). *The impact of web use on the public perception of physicians.* Paper presented at the Association for Education in Journalism and Mass Communication, Miami Beach, FL.

Lu, L., & Yuan, Y. C. (2011). Shall I Google it or ask the competent villain down the hall? The moderating role of information need in information source selection. *Journal of the American Society for Information Science and Technology, 62*(1), 133–145. doi: 10.1002/asi.21449

Lukasiewicz, J. (1994). *The ignorance explosion: Understanding industrial civilization.* Ottawa, Canada: Carlton University Press.

Luscombe, B. (2010, November 22) Woman power: The rise of the sheconomy. *Time Magazine,* 61.

Lustria, M. L.A., Cortese, J., Noar, S. M., & Glueckauf, R. L. (2009). Computer-tailored health interventions delivered over the web: Review and analysis of key components. *Patient Education and Counseling, 74,* 156–173. doi: 10.1016/j.pec.2008.08.023

Lustria, M. L.A., Kazmer, M. M., Glueckauf, R. L., Hawkins, R. P., Randeree, E., Rosario, I. B.,... Redmond, S. (2010). Participatory design of a health informatics system for rural health practitioners and disadvantaged women. *Journal of the American Society for Information Science and Technology, 61*(11), 2243–2255. doi: 10.1002/asi.21390

MacCrimmon, K. R., & Taylor, R. N. (1976). Decision making and problem solving. In M. D. Dunnette (Ed.), *Handbook of industrial and organizational psychology.* Chicago, IL: Rand McNally.

MacDougall, J., & Brittain, J. M. (1994). Health informatics. In M. E. Williams (Ed.), *Annual review of information science and technology* (Vol. 29, pp. 183–217). Medford, NJ: Learned Information.

Maddox, G. L., & Glass, T. A. (1989). Health care of the chronically ill. In H. E. Freeman & S. Levine (Eds.), *Handbook of medical sociology* (4th ed., pp. 236–261). Englewood Cliffs, NJ: Prentice Hall.

Maddux, J. E., & Rogers, R. W. (1983). Protection motivation theory and self-efficacy: A revised theory of fear appeals and attitude change. *Journal of Experimental Social Psychology, 19,* 469–479.

Maes, P. (1995, September). Intelligent software. *Scientific American,* 84–86.

Malenka, D. J., Baron, J. A., Johansen, S., Wahrenberger, J. W., & Ross, J. (1993). The framing effect of relative and absolute risk. *Journal of General and Internal Medicine, 8,* 543–548.

Manfredi, C., Czaja, R., Price, J., Buis, M., & Janiszewski, R. (1993). Cancer patients search for information. *Journal of the National Cancer Institute, Monograph, 14,* 93–104.

March, J. G. (1994). *A primer on decision making: How decisions happen.* New York: Free Press.

March, J. G., & Simon, H. A. (1958). *Organizations.* New York: John Wiley.

Marchibroda, J. M. (2009). Engaging consumers in health care advocacy using the Internet. In J. C. Parker & E. Thorson (Eds.), *Health communication in the new media landscape* (pp. 267–282). New York: Springer.

Marchionini, G. (1992). Interfaces for end-user information seeking. *Journal of the American Society for Information Science, 43,* 156–163.

Marcus, A. C., Woodworth, M. A., & Strickland, C. J. (1993). The Cancer Information Service as a laboratory for research: The first 15 years. *Journal of the National Cancer Institute, Monograph, 14,* 67–79.

Markus, M. L. (1994). Electronic mail as the medium of managerial choice. *Organization Science, 5,* 502–527.

Marteau, T. M., & Croyle, R. T. (1998). The new genetics: Psychological responses to genetic testing. *British Medical Journal, 316,* 693–697.

Mason, R. O. (1987). The value of information: Towards a model of values and costs. In H. K. Achleitner (Ed.), *Intellectual foundations for information professionals* (pp. 39–67). New York: Columbia University Press.

Matthews, J. J. (1983). The communication process in clinical settings. *Social Science and Medicine, 17,* 1371–1378.

Mauboussin, M. (2007). *More than you know: Finding financial wisdom in unconventional places.* New York: Columbia University Press.

McCaughan, E., & McKenna, H. (2007). Never-ending making sense: Toward a substantive theory of the information-seeking behaviour of newly diagnosed cancer patients. *Journal of Clinical Nursing, 16,* 2096–2104. doi: 10.1111/j.1365-2702.2006.01817.x

McClung, H. J., Murray, R. D., & Heitlinger, L. A. (1998). The Internet as a source for current patient information. *Pediatrics, 101*(6), E2.

McCormack, A., & Coulson, N. (2009). Individuals with eating disorders and the use of online support groups as a form of social support. *Cyberpsychology: Journal of Psychosocial Research on Cyberspace, 3*(2). Available at http: //cyberpsychology.eu/view.php?cisloclanku=2009112402 &article=1

McDonald, C. (2009). Protecting patients in health information exchange: A defense of the HIPAA privacy rule. *Health Affairs, 28*(2), 447–449.

McGee, J. V., & Prusak, L. (1993). *Managing information strategically.* New York: John Wiley.

McGuire, W. J. (1983). A contextualist theory of knowledge: Its implications for innovation and reform in psychological research. In L. Berkowitz (Ed.), *Advances in experimental social psychology* (Vol. 16, pp. 1–47). Orlando, FL: Academic Press.

McGuire, W. J. (1989). Theoretical foundations of campaigns. In R. E. Rice & C. K. Atkin (Eds.), *Public communication campaigns* (pp. 43–66). Newbury Park, CA: Sage.

McGuire, W. J. (1994). Using mass-media communication to enhance public health. In L. Sechrest, T. E. Backer, E. M. Rogers, T. F. Campbell, & M. L. Grady (Eds.), *Effective dissemination of clinical and health information* (pp. 125–151). Rockville, MD: Agency for Health Care Policy Research, AHCPR Pub. No. 95 0015.

McIntosh, J. (1974). Processes of communication, information seeking and control associated with cancer: A selective review of the literature. *Social Science and Medicine, 8,* 167–187.

McKinlay, J. B. (1973). Social networks, lay consultation, and help seeking behavior. *Social Forces, 51,* 275–292.

McKinnon, S. M., & Bruns Jr., W. J. (1992). *The information mosaic.* Boston, MA: Harvard Business School Press.

McLeod, J. M., Bybee, C. R., & Durall, J. A. (1982). Evaluating media performance by gratifications sought and received. *Journalism Quarterly, 59,* 3–12.

Meischke, H., & Johnson, J. D. (1993). *Using the Health Belief Model to predict breast cancer-related information seeking from physicians and other health professions.* Paper presented at the International Communication Association Annual Convention, Washington, DC.

Menon, A., & Varadarajan, P. R. (1992). A model of marketing knowledge use within firms. *Journal of Marketing, 56,* 53–71.

Messerli, M. L., Garamendi, C., & Romano, J. (1980). Breast cancer: Information as a technique of crisis intervention. *American Journal of Orthopsychiatry, 50,* 728–731.

Metoyer-Duran, C. (1993). Information gatekeepers. In M. E. Williams (Ed.), *Annual review of information science and technology* (Vol. 28, pp. 111–150). Medford, NJ: Learned Information.

Meyers, R. A., & Seibold, D. R. (1985). Consumer involvement as a segmentation approach for studying utilization of health organization services. *The Southern Speech Communication Journal, 50,* 327–347.

Mikhail, B. (1981). The Health Belief Model: A review and critical evaluation of the model, research, and practice. *Advances in Nursing Science, 4,* 65–82.

Miller, G. A., Galanter, E., & Pribram, K. H. (1960). *Plans and the structure of behavior.* New York: Holt.

Miller, G. R. (1969). Human information processing: Some research guidelines. In R. J. Kibler & L. L. Barker (Eds.), *Conceptual frontiers in speech communication* (pp. 51–68). New York: Speech Communication Association.

Miller, J. D. (1994). Public attentiveness to and attitudes toward health care issues. In L. Sechrest, T. E. Backer, E. M. Rogers, T. F. Campbell, & M. L. Grady (Eds.), *Effective dissemination of clinical and health information* (AHCPR Pub. No. 95 0015 ed., pp. 83–98). Rockville, MD: Agency for Health Care Policy Research.

Miller, N., Tyler, R. J., & Backus, J. E. B. (2004). MedlinePlus: The National Library of Medicine brings quality information to health consumers. *Library Trends, 53,* 375–388. Available at http: //www.nlm.nih.gov/pubs/staffpubs/lo/LibraryTrends_fall2004.pdf

Miller, R. A. (1994). Medical diagnostic decision support systems past, present, and future: A threaded bibliography and brief commentary. *Journal of American Medical Informatics Association, 1*, 8–27.

Miller, S. M. (1979). Coping with impending stress: Psychophysiological and cognitive correlates of choice. *Psychophysiology, 16*, 572–581.

Miller, S. M. (1987). Monitoring and blunting: Validation of a questionnaire to assess styles of information seeking under threat. *Journal of Personality and Social Psychology, 52*(2), 345–353.

Miller, V. D., & Jablin, F. M. (1991). Information seeking during organizational entry: Influences, tactics, and a model of the process. *Academy of Management Review, 16*, 92–120.

Minsky, M. (1974). A framework for representing knowledge. In P. Winston (Ed.), *The psychology of computer vision* (pp. 211–277). New York: McGraw-Hill.

Mintzberg, H. (1975). *Impediments to the use of management information.* New York: National Association of Accountants.

Mintzberg, H. (1976). Planning on the left side and managing on the right. *Harvard Business Review, 54*, 49–58.

Mitchell, G. W., & Glicksman, A. S. (1977). Cancer patients: Knowledge and attitudes. *Cancer, 40*, 61–66.

Mitchell, O. S. (1988). Worker knowledge of pensions provisions. *Journal of Labor Economics, 6*, 21–39.

Molleman, E., Krabbendam, P. J., Annyas, A. A., Koops, H. S., Sleijfer, D. T., & Vermey, A. (1984). The significance of the doctor-patient relationship in coping with cancer. *Social Science and Medicine, 18*, 475–480.

Mooney, K. H., Beck, S. L., Freidman, R. H., & Farzanfar, R. (2002). Telephone-linked care for cancer symptom monitoring: A pilot study. *Cancer Practice, 10*(3), 147–154.

Moore, W. E., & Tumin, M. M. (1949). Some social functions of ignorance. *American Sociological Review, 14*, 787–795.

Moorman, C. (1994). An innovation adoption approach to the dissemination of health information to consumers. In L. Sechrest, T. E. Backer, E. M. Rogers, T. F. Campbell, & M. L. Grady (Eds.), *Effective dissemination of clinical and health information.* Rockville, MD: Agency for Health Care Policy Research AHCPR Pub. No. 95 0015.

More, E. (1990). Information systems: People issues. *Journal of Information Science, 16*, 311–320.

Morley, D. (1993). Active audience theory: Pendulums and pitfalls.*Journal of Communication, 43*, 13–19.

Morra, M. E., Van Nevel, J. P., Nealon, O'D.E., Mazan, K. D., & Thomsen, C. (1993). History of the Cancer Information Service. *Journal of the National Cancer Institute, Monograph, 14*, 7–34.

Morris, L. A., Grossman, R., Barkdoll, G., Gordon, E., & Chun, M. Y. (1987). Information search activities among elderly prescription drug users. *Journal of Health Care Marketing, 7*, 5–15.

Morris, L. A., Tabak, E. R., & Olins, N. J. (1992). A segmentation analysis of prescription drug information seeking among the elderly. *Journal of Public Policy & Marketing, 11*, 115–215.

Morrison, E. W. (1993a). Longitudinal study of the effects of information seeking on newcomer socialization. *Journal of Applied Psychology, 78*, 173–183.

Morrison, E. W. (1993b). Newcomer information seeking: Exploring types, modes, sources, and outcomes. *Academy of Management Journal, 36*, 557–589.

Morrison, E. W., & Bies, R. J. (1991). Impression management in the feedback seeking process: A literature review and research agenda. *Academy of Management Review, 16*, 522–541.

Mukherjee, S. (2010). *The emperor of all maladies: A biography of cancer.* New York: Scribner.

Mullen, P. D., Hersey, J. C., & Iverson, D. C. (1987). Health behavior models compared. *Social Science and Medicine, 24*, 973–981.

Murero, M., & Rice, R. E. (2006). E-health research. In M. Murero & R. E. Rice (Eds.), *The Internet and healthcare: Theory, research, and practice* (pp. 3–26). Mahwah, NJ: Lawrence Erlbaum.

Nagler, R. H., Romantan, A., Kelly, B. J., Stevens, R. S., Gray, S. W., Hull, S. J., . . . Hornik, R. C. (2010). How do cancer patients navigate the public information environment? Understanding patterns and motivations for movement among information sources. *Journal of Cancer Educa-*

tion: The Official Journal of the American Association for Cancer Education, 25, 360–370. doi: 10.1007/s13187-010-0054-5

Nahl, D., & Bilal, D. (2007). *Information and emotion.* Medford, NJ: Information Today.

Napoli, P. M. (2001). Consumer use of medical information from electronic and paper media: A literature review. In R. E. Rice & J. E. Katz (Eds.), *The Internet and health communication: Experiences and expectations* (pp. 79–98). Thousand Oaks, CA: Sage.

National Cancer Institute. (2003). *The nation's investment in cancer research.* Rockville, MD: National Cancer Institute.

National Center for Health Services Research and Health Care Technology Assessment. (1988). *The role of market forces in the delivery of health care: Issues for research.* Rockville, MD: Public Health Service.

National Library of Medicine (NLM). (2012). About the National Library of Medicine. Available at http: //www.nlm.nih.gov/about/index.html

National Network of Libraries. (2011). National Network of Libraries of Medicine Fact Sheet Available at http: //www.nlm.nih.gov/pubs/factsheets/nnlm.html

Ndiaye, K., Krieger, J. L., Warren, J. R., & Hecht, M. L. (2011). Communication and health disparities. In T. L. Thompson, R. Parrott, & J. F. Nussbaum (Eds.), *The Routledge handbook of health communication* (pp. 469–481). New York: Routledge.

Nelson, D. E., Kreps, G. L., Hesse, B. W., Croyle, R. T., Willis, G., Arora, N. K., . . . Alden, S. (2004). Health Information National Trends Survey (HINTS): Development, design, and dissemination. *Journal of Health Communication, 9,* 443–460. doi: 10.1080/10810730490504233

Nemcek, M. A. (1990). Health beliefs and preventive behavior: A review of the research literature. *AAOHN Journal, 38,* 127–138.

Nicholas, D., Huntington, P., & Williams, P. (2004). Digital consumer health information and advisory services in the UK: A user evaluation and sourcebook. London, U.K.: City University Centre for information behaviour and the evaluation of research (CIBER).

Niederdeppe, J. (2008). Beyond knowledge gaps: Examining socioeconomic differences in response to cancer news. *Human Communication Research, 34,* 423–447.

Niederdeppe, J., Frosch, D. L., & Hornik, R. C. (2008). Cancer news coverage and information seeking. *Journal of Health Communication, 13,* 181–199. doi: 10.1080/10810730701855410

Nielsen-Bohlman, L., Panzer, A., & Kindig, D. A. (Eds.). (2004). *Health literacy: Prescription to end confusion.* Washington, DC: Institute of Medicine/National Academies Press.

Noar, S. M, (2005).A health educator's guide to theories of health behavior. *International Quarterly of Community Health Education,* 24(1), 75–92.

Noar, S. M. (2006). A 10-year retrospective of research in health mass media campaigns: Where do we go from here? *Journal of Health Communication, 11,* 21–42. doi: 10.1080/10810730500461059

Noar, S. M., Banac, C. N., & Harris, M. S. (2007). Does tailoring matter? Meta-analytic review of tailored print health behavior change interventions. *Psychological Bulletin, 133*(4), 673–693. doi: 10.1037/0033-2909.133.4.673

Noar, S. M., Pierce, L. B., & Black, H. G. (2010). Can computer-mediated interventions change theoretical mediators of safer sex? A meta-analysis. *Human Communication Research, 36,* 261–297. doi: 10.1111/j.1468-2958.2010.01376.x

Nohria, N., & Eccles, R. G. (Eds.). (1992). *Networks and organizations: Structure, form, and action.* Boston, MA: Harvard Business School Press.

Ochoa, E. M., Gomez-Acebo, I., Rodriguez-Cundin, P., Navarro-Cordoba, M., Llorca, J., & Dierssen-Sotos, T. (2010). Relationship between family history of breast cancer and health-related behavior. *Behavioral Medicine, 36,* 123–129. doi: 10.1080/0896-4289.2010.516783

O'Conner, B. C. (1993). Browsing: A framework for seeking functional information. *Knowledge: Creation, Diffusion, Utilization, 15,* 211–232.

Office of Rural Health Policy. (1994). *Reaching rural: Rural health travels the telecommunications highway.* Rockville, MD: Office of Rural Health Policy.

O'Hair, H. D., Villigran, M., Wittenberg, E., Brown, K. Ferguson, M., Hall, H., & Doty, T. (2003). Cancer survivorship and agency model: Implications for patient choice, decision-making, and influence. *Health Communication, 15,* 193–202.

O'Reilly, C. A., III. (1980). Individuals and information overload in organizations: Is more necessarily better? *Academy of Management Journal, 23,* 684–696.

O'Reilly, C. A., III, Chatham, J. A., & Anderson, J. C. (1987). Message flow and decision making. In F. M. Jablin, L. L. Putnam, K. H. Roberts, & L. W. Porter (Eds.), *Handbook of organizational communication: An interdisciplinary perspective* (pp. 600–623). Newbury Park, CA: Sage.

O'Reilly, C. A., III, & Pondy, L. R. (1979). Organizational communication. In S. Kerr (Ed.), *Organizational behavior* (pp. 119–150). Columbus, OH: Grid.

Orleans, C. T. (2005). The behavior change consortium: Expanding the boundaries and impact of health behavior change research. *Annals of Behavioral Medicine, 29,* 76–79.

Ozanne, J. L., Brucks, M., & Grewal, D. (1992). A study of information search behavior during categorization of new products. *Journal of Consumer Research, 18,* 452–463.

Paisley, W. (1980). Information and work. In B. Dervin & M. J. Voight (Eds.), *Progress in communication sciences* (Vol. II, pp. 114–165). Norwood, NJ: Ablex.

Paisley, W. (1984). Communication in the communication sciences. In B. Dervin & M. J. Voight (Eds.), *Progress in communication sciences* (Vol. V, pp. 1–43). Norwood, NJ: Ablex.

Paisley, W. (1993). Knowledge utilization: The role of new communication technologies. *Journal of the American Society for Information Science, 44,* 222–234.

Paisley, W. (1994). New media and methods of health communication. In L. Sechrest, T. E. Backer, E. M. Rogers, T. F. Campbell, & M. L. Grady (Eds.), *Effective dissemination of clinical and health information* (pp. 165–180). Rockville, MD: Agency for Health Care Policy Research, AHCPR Pub. No. 95 0015.

Palazzolo, E. T. (2006). Organizing for information retrieval in transactive memory systems. *Communication Research, 16,* 726–761.

Palazzolo, E. T., Serb, D. A., She, Y., Su, C., & Contractor, N. S. (2006). Coevolution of communication and knowledge networks in transactive memory systems: Using computational models for theoretical development. *Communication Theory, 16,* 223–250.

Palmgreen, P. (1984). Uses and gratifications: A theoretical perspective. In R. N. Bostrom (Ed.), *Communication yearbook 8* (pp. 20–55). Beverly Hills, CA: Sage.

Palmquist, R. A. (1992). The impact of information technology on the individual. In M. E. Williams (Ed.), *Annual review of information science and technology* (Vol. 27, pp. 3–42). Medford, NJ: Learned Information.

Parrott, R. (2009). *Talking about health: Why communication matters.* New York: Wiley-Blackwell.

Parrott, R. (2011). Point of practice: Keeping "health" in health communication research and practice. *Journal of Applied Communication Research, 39*(1), 92–102. doi: 10.1080/00909882.2010.536848

Parrott, R., & Kreuter, M. W. (2011). Multidisciplinary, interdisciplinary, and transdisciplinary approaches to health communication. In T. L. Thompson, R. Parrott, & J. F. Nussbaum (Eds.), *The Routledge handbook of health communication* (pp. 3–17). New York: Routledge.

Paulos, J. A. (1989). *Innumeracy: Mathematical illiteracy and its consequences.* New York: Hill & Wang.

Pecchioni, L. L., & Keeley, M. P. (2011). Insights about health from family communication theories. In T. L. Thompson, R. Parrott, & J. F. Nussbaum (Eds.), *The Routledge handbook of health communication* (2nd ed., pp. 363–376). New York: Routledge.

Pecchioni, L. L., & Sparks, L. (2007). Health information sources of individuals with cancer and their family members. *Health Communication, 21*(2), 143–151.

Pelikan, J. (1992). *The idea of the university: A re-examination.* New Haven, CT: Yale University Press.

Pendleton, D. (1983). Doctor-patient communication: A review. In D. Pendleton & J. Hasler (Eds.), *Doctor-patient communication* (pp. 5–53). New York: Academic Press.

Perin, C. (1991). Electronic social fields in bureaucracies. *Communications of the ACM, 34,* 75–82.

Perrow, C. (1989). On not using libraries. In B. P. Lynch (Ed.), *Humanists at work: Disciplinary perspectives and personal reflections* (pp. 29–42). Chicago, IL: University of Illinois.

Perse, E. M., & Courtright, J. A. (1993). Normative images of communication media: Mass and interpersonal channels in the new media environment. *Human Communication Research, 19,* 485–503.

Pescosolido, B. A. (1992). Beyond rational choice: The social dynamics of how people seek help. *American Journal of Sociology, 97,* 1096–1138.

Pescosolido, B. A., Croghan, T. W., & Howell, J. D. (2009). Unexamined discourse: The outcomes movement as a shift from internal medical assessment to health communication. In D. E. Brashers & D. J. Goldsmith (Eds.), *Communicating to manage health and illness* (pp. 41–64). New York: Routledge.

Pescosolido, B. A., Gardner, C. B., & Lubell, K. M. (1998). How people get into mental health services: Stories of choice, coercion, and "muddling through" from "first timers." *Social Science & Medicine, 46*(2), 275–286.

Pescosolido, B. A., & Levy, J. A. (2002). The role of social networks in health, illness, disease, and healing: The accepting present, the forgotten past, and the dangerous potential for a complacent future. *Social Networks and Health, 8,* 3–25.

Pettigrew, K. E. (2000). Lay information provision in community settings: How community health nurses disseminate human services information to the elderly. *Library Quarterly, 70*(1), 47–85.

Pettigrew, K. E., Fidel, R., & Bruce, H. (2001). Conceptual frameworks in information behavior. *Annual Review of Information Science and Technology, 35,* 43–78.

Pfeiffer, G. J. (1989). *Taking care of today and tomorrow: A resource guide for health, aging and long-term care.* Reston, VA: Center for Corporate Health Promotion.

Pharo, N., & Jarvelin, K. (2006). "Irrational" searchers and IR-rational researchers. *Journal of the American Society for Information Science and Technology, 57*(1), 222–232.

Phillips, G. M., & Jones, J. A. (1991). Medical compliance. *American Behavioral Scientist, 34,* 756–767.

Picherit-Duthler, G., & Freitag, A. (2004). Researching employees' perceptions of benefits communication: A communication inquiry on channel preferences, understanding, decision-making, and benefits satisfaction. *Communication Research Reports, 21,* 391–403.

Pinelli, T. E. (1991). The information-seeking habits and practices of engineers. In C. Steinke (Ed.), *Information seeking and communicating behavior of scientists and engineers* (pp. 5–25). New York: Haworth Press.

Pirolli, P., & Card, S. (1999). Information foraging. *Psychological Review, 106,* 643–675.

Politi, M., & Street, R. L., Jr. (2011). Patient-centered communication during collaborative decision making. In T. L. Thompson, R. Parrott, & J. F. Nussbaum (Eds.), *The Routledge handbook of health communication* (pp. 399–413). New York: Routledge.

Post, D. M., Cegala, D. J., & Miser, W. F. (2002). The other half of the whole: Teaching patients to communicate with physicians. *Family Medicine, 34*(5), 344–352.

Poverny, L. M., & Dodd, S. J. (2000). Differential patterns of EAP service utilization: A nine-year follow-up study of faculty and staff. *Employee Assistance Quarterly,* 29–42.

Powell, J., Inglis, N., Ronnie, J., & Large, S. (2011). The characteristics and motivations of online health information seekers: Cross-sectional survey and qualitative interview study. *Journal of Medical Internet Research.* Available at http: //www.jmir.org/2011/1/e20/

Powell, W. W. (1990). Neither market nor hierarchy: Network forms of organization. In S. B. Bacharach (Ed.), *Research in organizational behavior* (pp. 295–336). Norwich, CT: JAI Press.

Prevention Institute (2012). Teaching Prevention Webinar FINAL. PDF available at: http: //www.preventioninstitute.org/press/calendar/event/82.html

Prochaska, J. O., & DiClemente, C. C. (1983). Stage process of self-change of smoking: Toward an integrative model of change. *Journal of Consulting and Clinical Psychology, 51,* 390–395.

Prochaska, J. O., & DiClemente, C. C. (1985). Common processes of self-change of smoking, weight control, and psychological distress. In S. Shiffman & T. A. Wills (Eds.), *Coping and substance use* (pp. 345–363). New York: Academic Press.

Prochaska, J. O., & DiClemente, C. C. (1986). Toward a comprehensive model of change. In M. Hersen, R. M. Eisler & P. M. Miller (Eds.), *Progress in behavior modification* (pp. 3–27). New York: Plenum.

Prochaska, J. O., DiClemente, C. C., & Norcross, J. C. (1992). In search of how people change: Applications to addictive behaviors. *American Psychologist, 47*, 1102–1114.

Proctor, R. N. (1995, March/Apri). No time for heroes. *The Sciences*, 20–24.

Putnam, L. L., & Boys, S. (2006). Revisiting metaphors of organizational communication. *Sage handbook of organization studies* (pp. 541–576). Thousand Oaks, CA: Sage.

Query, J. L., Jr., Wright, K. B., Bylund, C. L., & Mattson, M. (2007). Health communication instruction: Toward identifying common learning goals, course content, and pedagogical strategies to guide curricular development. *Health Communication, 21*(2), 133–141.

Rains, S. A. (2007). Perceptions of traditional information sources and use of the worldwide web to seek health information: Findings from the Health Information National Trends survey. *Journal of Health Communication, 12*, 667–680. doi: 10.1080/10810730701619992

Rains, S. A. (2008). Seeking health information in the information age: The role of internet self-efficacy. *Western Journal of Communication, 72*(1), 1–18. doi: 10.1080/10570310701827612

Rains, S. A., & Young, V. (2009). A meta-analysis of research on formal computer-mediated support groups: Examining group characteristics and health outcomes. *Human Communication Research, 35*, 309–336.

Rakowski, W., Assaf, A. R., Lefebvre, R. C., Lasater, T. M., Niknian, M., & Carleton, R. A. (1990). Information-seeking about health in a community sample of adults: Correlates and associations with other health-related practices. *Health Education Quarterly, 17*, 379–393.

Ramanadhan, S., & Viswanath, K. (2006). Health and the information nonseeker: A profile. *Health Communication, 20*(2), 131–139.

Ravetz, J. R. (1993). The sin of silence: Ignorance of ignorance. *Knowledge: Creation, Diffusion, Utilization, 15*, 157–165.

Ray, E. B. (1987). Supportive relationships and occupational stress in the workplace. In T. L. Albrecht & M. B. Adelman (Eds.), *Communicating social support* (pp. 172–191). Newbury Park, CA: Sage.

Ray, E. B., & Miller, K. I. (1990). Communication in health care organizations. In E. B. Ray & L. Donohew (Eds.), *Communication and health: Systems and applications* (pp. 92–107). Hillsdale, NJ: Lawrence Erlbaum.

Reagan, J., & Collins, J. (1987). Sources for health care information in two small communities. *Journalism Quarterly, 64*, 560–563, 676.

Real, K. (2008). Information seeking and workplace safety: A field application of the risk perception attitude framework. *Journal of Applied Communication Research, 36*, 339–359. doi: 10.1080/00909880802101763

Real, K., & Street, R. L., Jr. (2009). Doctor-patient communication from an organizational perspective. In D. Brashers & D. Goldsmith (Eds.), *Communicating to manage health and illness* (pp. 65–90). New York: Routledge.

Reardon, K. K. (1989). The role of persuasion in health promotion and disease prevention: Review and commentary. In J. A. Anderson (Ed.), *Communication yearbook 11* (pp. 277–297). Newbury Park, CA: Sage.

Reardon, K. K. (1990). A sequel to the "false dichotomy" perspective: Applications to the challenge of teaching children about AIDS. *Information and Behavior, 3*, 95–116.

Reardon, K. K., & Buck, R. (1989). Emotion, reason, and communication in coping with cancer. *Health Communication, 1*(1), 41–54.

Reddy, M. C., & Spence, P. R. (2008). Collaborative information seeking: A field study of a multi-disciplinary patient care team. *Information Processing and Management, 44*, 242–255.

Reddy, M. J. (1979). The conduit metaphor: A case of frame conflict in our language about language. In A. Ortony (Ed.), *Metaphor and thought* (pp. 284–324). Cambridge, U.K.: Cambridge University Press.

Rees, C. E., & Bath, P. A. (2000a). Mass-media sources for breast cancer information: Their advantages and disadvantages for women with the disease. *Journal of Documentation, 56*(3), 235–249.

Rees, C. E., & Bath, P. A. (2000b). The psychometric properties of the Miller Behavioral Style Scale with adult daughters of women with early breast cancer: A literature review and empirical study. *Journal of Advance Nursing, 32*(2), 366–374.

Reeves, P. M. (2000). Coping in cyberspace: The impact of Internet use on the ability of HIV-positive individuals to deal with their illness. *Journal of Health Communication, 5*, 47–59.

Regen, M., Murphy, S., & Murphy, T. (2002). Drug users' lay consultation processes: Symptom identification and management. *Advances in Medical Sociology, 8*, 323–341.

Rescher, N. (1999). The allocation of exotic medical lifesaving therapy. In H. Kuhse & P. Singer (Eds.), *Bioethics: An anthology* (pp. 354–364). Oxford, U.K.: Blackwell.

Research!America. (1995, June 23). Press release. Alexandria, VA: Research!America.

Rice, R. E. (1993). Media appropriateness: Using social presence theory to compare traditional and new organizational media. *Human Communication Research, 19*, 451–484.

Rice, R. E. (2006). Influences, usage, and outcomes of Internet health information searching: Multivariate results from the Pew surveys. *International Journal of Medical Informatics, 75*, 8–28.

Rice, R. E., & Atkin, C. K. (1989). Preface: Trends in communication campaign research. In R. E. Rice & C. K. Atkin (Eds.), *Public communication campaigns* (pp. 7–11). Newbury Park, CA: Sage.

Rice, R. E., & Aydin, C. (1991). Attitude toward new organizational technology: Network proximity as a mechanism for social information processing. *Administrative Science Quarterly, 36*, 219–244.

Rice, R. E., & Katz, J. E. (Eds.). (2001). *The Internet and health communication: Experiences and expectations.* Thousand Oaks, CA: Sage.

Rice, R. E., McCreadie, M., & Chang, S. L. (2001). *Accessing and browsing information and communication.* Cambridge, MA: MIT Press.

Rice, R. E., & Shook, D. E. (1990). Relationships of job categories and organizational levels to use of communication channels, including electronic model: A meta-analysis and extension. *Journal of Management Studies, 27*, 196–229.

Rifkin, E., & Bouwer, E. (2007). *The illusion of certainty: Health benefits and risk.* New York: Springer.

Riley, M. W., & Riley, J. W. (1951). A sociological approach to communications research. *Public Opinion Quarterly, 15*, 445–460.

Rimal, R. N. (2000). Closing the knowledge-behavior gap in health promotion: The mediating role of self-efficacy. *Health Communication, 12*(3), 219–237.

Rimal, R. N. (2001). Perceived risk and self-efficacy as motivators: Understanding individuals' long-term use of health information. *Journal of Communication, 51*(4), 633–654.

Rimal, R. N., & Adkins, A. D. (2003). Using computers to narrowcast health messages: The role of audience segmentation, targeting, and tailoring in health promotion. In T. L. Thompson, A. M. Dorsey, K. I. Miller, & R. Parrott (Eds.), *Handbook of health communication* (pp. 497–513). Mahwah, N.J: Lawrence Erlbaum.

Rimer, B. K., Davis, S. W., Engstrom, P. F., Myers, R. E., & Rosan, J. R. (1988). Some reasons for compliance and noncompliance in a health maintenance organization's breast cancer screening program. *Journal of Compliance with Health Care, 3*, 103–113.

Rimer, B. K., Kaper-Keintz, M., Kessler, H. B., Engstrom, P. F., & Rosan, J. R. (1989). Why women resist screening mammography: Patient-related barriers. *Radiology, 172*, 243–246.

Roach, A. R., Lykins, E. L. B., Gochett, C. G., Brechting, E. H., Graue, L. O., & Andrykowski, M. A. (2009). Differences in cancer information-seeking behavior, preferences, and awareness between cancer survivors and healthy controls: A national, population-based survey. *Journal of Cancer Education: The Official Journal of The American Association for Cancer Education, 24*(1), 73–79.

Robert, S. A. (1999). Socioeconomic position and health: The independent contribution of community socioeconomic context. *Annual Review of Sociology, 25,* 489–516.

Robertson, T. S., & Wortzel, L. H. (1977). Consumer behavior and health care change: The role of mass media. *Consumer Research, 4,* 525–527.

Rogers, E. M. (1983). *Diffusion of innovations* (3rd ed.). New York: Free Press.

Rogers, E. M. (2003). *Diffusion of innovations* (5th ed.). New York: Free Press.

Rogers, E. M., & Kincaid, D. L. (1981). *Communication networks: Toward a new paradigm for research.* New York: Free Press.

Rogers, E. M., & Shoemaker, F. F. (1971). *Communication of innovations* (2nd ed.). New York: Free Press.

Rogers, E. M., & Storey, J. D. (1987). Communication campaigns. In C. R. Berger & S. H. Chaffee (Eds.), *Handbook of communication science* (pp. 817–846). Newbury Park, CA: Sage.

Rokeach, M. (1960). *The open and closed mind.* New York: Basic Books.

Rosenstock, I. M. (1974a). The Health Belief Model and preventive health behavior. *Health Education Monographs, 2,* 354–386.

Rosenstock, I. M. (1974b). Historical origins of the Health Belief Model. In M. H. Becker (Ed.), *The Health Belief Model and personal health behavior* (pp. 1–8). Thorofare, NJ: Charles B. Slack.

Rosenstock, I. M. (1990). The Health Belief Model: Explaining health behavior through expectancies. In K. Glanz, F. M. Lewis, & B. K. Rimer (Eds.), *Health behavior and health education: Theory, research and practice* (pp. 36–92). San Francisco, CA: Jossey-Bass.

Rosenstock, I. M., Strecher, V. J., & Becker, M. (1988). Social learning theory and the Health Belief Model. *Health Education Quarterly, 15,* 175–183.

Rouse, W. B., & Rouse, S. H. (1984). Human information seeking and design of information systems. *Information Processing and Management, 20,* 129–138.

Rowley, J. E., & Turner, C. M. D. (1978). *The dissemination of information.* Boulder, CO: Westview Press.

Rubin, A. M. (1986). Uses, gratifications, and media effects research. In J. Bryant & D. Zillmann (Eds.), *Perspectives on media effects* (pp. 281–301). Hillsdale, NJ: Lawrence Erlbaum.

Rubin, A. M. (2002). The uses-and-gratifications perspective of media effects. In J. Bryant & D. Zillman (Eds.), *Media effects: Advances in theory and research* (Vol. 2, pp. 525–548). Mahwah, NJ: Lawrence Erlbaum.

Rubin, B. D. (1992). The communication-information relationship in system-theorectic perspective. *Journal of the American Society for Information Science, 43,* 15–27.

Ruchinskas, J. E. (1983). *Predictors of media utility: Influence on managers' perception of business communication systems.* Paper presented at the International Communication Association, Dallas, TX.

Ruggiero, T. (2000). Uses and gratifications theory in the 21st century. *Mass Communication & Society,3*(1), 3–37.

Rutten, L. J. F., Arora, N. K., Bakos, A. D., Aziz, N., & Rowland, J. (2005). Information needs and sources of information among cancer patients: A systematic review of research (1980–2003). *Patient Education and Counseling, 57,* 250–261. doi: 10.1016/j.pec.2004.06.006

Rutten, L. J. F., Squiers, L., & Hesse, B. W. (2006). Cancer-related information seeking: Hints from the 2003 Health Information National Trends Survey (HINTS). *Journal of Health Communication, 11,* 147–156. doi: 10.1080/10810730600637574

Saarloos, D., Kim, J., & Timmermans, H. (2009). The built environment and health: Introducing individual space-time behavior. *International Journal of Environmental Research and Public Health, 6,* 1724–1743. doi: 10.3390/ijerph6061724

Salancik, G. R., & Pfeffer, J. (1977). An examination of need satisfaction models of job attitudes. *Administrative Science Quarterly, 22,* 427–453.

Salancik, G. R., & Pfeffer, J. (1978). A social information processing approach to job attitudes and task design. *Administrative Science Quarterly, 23,* 224–253.

Salmon, C. T. (1986). Perspectives on involvement in consumer and communication research. In D. Dervin & M. J. Voight (Eds.), *Progress in communication sciences* (Vol. VII, pp. 243–268). Norwood, NJ: Ablex.

Salmon, C. T. (1992). Bridging theory "of" and theory "for" communication campaigns: An essay on ideology and public policy. In S. Deetz (Ed.), *Communication yearbook 15* (pp. 346–358). Newbury Park, CA: Sage.

Salmon, C. T., & Atkin, C. (2003). Using media campaigns for health promotion. In T. L. Thompson, A. M. Dorsey, K. I. Miller, & R. Parrott (Eds.), *Handbook of health communication* (pp. 449–472). Mahwah, NJ: Lawrence Erlbaum.

Saracevic, T. (1975). Relevance: A review of and a framework for the thinking on the notion in information science. *Journal of the American Society for Information Science, 26*, 321–343.

Saracevic, T., Kantor, P., Chamis, A. Y., & Trivison, D. (1988). A study of information seeking and retrieving: I. Background and methodology. *Journal of American Society for Information Science, 39*, 161–176.

Sarasohn-Kahn, J. (2008). *The wisdom of patients: Health care meets online social media.* Oakland, CA: California Healthcare Foundation.

Saunders, C., & Jones, J. W. (1990). Temporal sequences in information acquisition for decision making: A focus on source and medium. *Academy of Management Review, 15*, 29–46.

Savolainen, R. (1993). The sense-making theory: Reviewing the interests of a user-centered approach to information seeking and use. *Information Processing & Management, 29*, 13–28.

Savolainen, R. (1995). Everyday life information seeking: Approaching information seeking in the context of "way of life." *Library and Information Science Research, 17*, 259–294.

Savolainen, R. (2008). *Everyday information practices: A social phenomenological perspective.* Lanham, MD: Scarecrow Press.

Sawhney, H. (2000). Universal service: Separating the grain of truth from the proverbial chaff. *The Information Society, 16*, 161–164.

Schamber, L. (1994). Relevance and information behavior. In M. E. Williams (Ed.), *Annual review of information science and technology* (Vol. 29, pp. 3–48). Medford, NJ: Learned Information.

Schatzki, T. R. (2005). Peripheral vision: The sites of organizations. *Organization Studies, 26*, 465–484. doi: 10.1177/0170840605050876

Schiavo, R. (2007). *Health communication: From theory to practice.* San Francisco, CA: John Wiley.

Schilling, C. (2002). Culture, the "sick role" and the consumption of health. *British Journal of Sociology, 53*, 621–636.

Schramm, W. (1972). The nature of communication between humans. In W. Schramm & D. F. Roberts (Eds.), *The process and effects of mass communication* (pp. 3–53). Urbana, IL: University of Illinois Press.

Schramm, W. S. (1973). *Men, messages, and media.* New York: Harper & Row.

Schuman, T. M. (1988). Hospital computerization and the politics of medical decision making. *Research in the Sociology of Work, 4*, 261–287.

Schwartz, B. (2004). *Paradox of choice: Why more is less.* New York: HarperCollins.

Schwartz, L. M., Woloshin, S., Black, W. C., & Welch, H. G. (1997). The role of numeracy in understanding the benefit of screening mammography. *Annals of Internal Medicine, 127*(11), 966–972.

Scott, J. (1991). *Social network analysis: A handbook.* Newbury Park, CA: Sage.

Scott, J. (2000). *Social network analysis: A handbook* (2nd ed.). Thousand Oaks, CA: Sage.

Sears, D. O., & Freedman, J. L. (1967). Selective exposure to information: A critical review. *Public Opinion Quarterly, 31*, 194–213.

Sechrest, L., Backer, T. E., & Rogers, E. M. (1994). Effective dissemination of health and clinical information. In L. Sechrest, T. E. Backer, E. M. Rogers, T. F. Campbell, & M. L. Grady (Eds.), *Effective dissemination of clinical and health information* (Vol. AHCPR Pub. No. 95 0015). Rockville, MD: Agency for Health Care Policy Research.

Seibold, D. R., Meyers, R. A., & Willihnganz, S. C. (1984). Communicating health information to the public: Effectiveness of a newsletter. *Health Education Quarterly, 10*, 263–286.

Seibold, D. R., & Roper, R. E. (1979). Psychosocial determinants of health care intentions: Test of the Triandis and Fishbein models. In D. Nimmo (Ed.), *Communication yearbook 3* (pp. 625–643). New Brunswick, NJ: Transaction Books.

Seidman, J. J. (2006). The mysterious maze of the world wide web: How can we guide consumers to high-quality health information on the Internet? In M. Murero & R. E. Rice (Eds.), *The Internet and health care: Theory, research, and practice* (pp. 195–212). Mahwah, NJ: Lawrence Erlbaum.

Senge, P. M. (1990). *The fifth discipline: The art and practice of the learning organization.* New York: Doubleday Currency.

Shaller, D., Sofaer, S., Findlay, S. D., Hibbard, J. H., Lansky, D., & Delbanco, S. (2003). Consumers and quality-driven health care: A call to action. *Health Affairs, 22*(2), 95–101. doi: 10.1377/hlthaff.22.2.95

Shannon, C. E., & Weaver, W. (1949). *A mathematical theory of communication.* Chicago, IL: University of Illinois Press.

Shapiro, R. (2010). *Health literacy: A bibliometric and citation analysis* (Master's thesis), University of Kentucky, Lexington, KY.

Sharf, B. F., & Freimuth, V. S. (1993). The construction of illness on entertainment television: Coping with cancer on *Thirtysomething. Health Communication, 5,* 141–160.

Shaw, B., Hawkins, R., McTavish, F., Pingree, S., & Gustafson, D. (2006). Effects of insightful disclosure within computer-mediated support groups on women with breast cancer. *Health Communication, 19,* 133–142.

Shaw, B. R., Dubenske, L. L., Han, J. Y., Cofta-Woerpel, L., Bush, N., Gustafson, D. H., & McTavish, F. (2008). Antecedent characteristics of online cancer information seeking among rural breast cancer patients: An application of the Cognitive-Social Health Information Processing (C-SHIP) model. *Journal of Health Communication, 13,* 389–408. doi: 10.1080/10810730802063546

Sherer, C. W., & Juanillo, N. K., Jr. (1992). Bridging theory and praxis: Reexamining public health communication. In S. A. Deetz (Ed.), *Communication yearbook 15* (pp. 312–345). Newbury Park, CA: Sage.

Sherr, L., & Hedge, B. (1990). The impact and use of written leaflets as a counseling alternative in mass antenatal HIV screening. *AIDS Care, 2*(3), 235–245.

Shim, M., Kelly, B. J., & Hornik, R. C. (2006). Cancer information scanning and seeking behavior is associated with knowledge, lifestyle choices, and screening. *Journal of Health Communication, 11,* 157–172.

Shortliffe, E. H. (2005). Strategic action in health information technology: Why the obvious has taken so long. *Health Affairs, 24*(5), 1222–1233. doi: 10.1377/hlthaff.24.5.1222

Siefert, M., Gerbner, G., & Fisher, J. (1989). *The information gap: How computers and other new communication technologies affect the social distribution of power.* New York: Oxford University Press.

Signorielli, N. (1990). Television and health: Images and impact. In C. Atkin & L. Wallack (Eds.), *Mass communication and health: Complexities and conflicts* (pp. 96–113). Newbury Park, CA: Sage.

Silk, K. J., Atkin, C. K., & Salmon, C. T. (2011). Developing effective media campaigns for health promotion. In T. L. Thompson, R. Parrott, & J. F. Nussbaum (Eds.), *The Routledge handbook of health communication* (pp. 203–219). New York: Routledge.

Simon, H. A. (1960). The executive as decision maker and organizational design: Man-machine systems for decision making. In H. A. Simon (Ed.), *The new science of management decision making* (pp. 1–8). New York: Harper & Row.

Simon, H. A. (1987). Making management decisions: The role of intuition and emotion. *Academy of Management Executive, 1,* 57–64.

Simonds, S. K. (1974). Health education as social policy. *Health Education Monograph, 2,* 1–25.

Simpkins, J. D., & Brenner, D. J. (1984). Mass-media communication and health. In B. Dervin & M. J. Voight (Eds.), *Progress in communication sciences* (Vol. 5, pp. 275–297). Norwood, NJ: Ablex.

Sitkin, S. B., Sutcliffe, K. M., & Barrios-Choplin, J. R. (1992). A dual-capacity model of communication media choice in organizations. *Human Communication Research, 18*, 563–598.

Slack, W. V. (1997). *Cybermedicine: How computing empowers doctors and patients for better health care.* San Francisco, CA: Jossey-Bass.

Slater, M. D. (2004). Operationalizing and analyzing exposure: The foundation of media effects research. *Journalism and Mass Communication Quarterly, 81*, 168–183.

Slater, M. D., Long, M., Bettinghaus, E. P. & Reineke, J. B. (2011).News coverage of cancer in the U.S.: A national sample of newspapers, television and magazines. *Journal of Health Communication, 13*(6), 523-537.

Sligo, F. X., & Jameson, A. M. (2000). The knowledge-behavior gap in use of health information. *Journal of American Society for Information Science, 51*(9), 858–869.

Smalligan, R. D., Campbell, E. O., & Ismail, H. M. (2008). Patient experiences with MedlinePlus. gov: A survey of internal medicine patients. *Journal of Investigative Medicine, 56*(8), 1019–1022.

Smith, C. A., & Stavri, P. Z. (2005). Consumer health vocabulary. In D. Lewis, G. Eysenbach, R. Kukafka, & P. Z. Stavri (Eds.), *Consumer health informatics: Informing consumers and improving healthcare* (pp. 122–128). New York: Springer.

Smithson, M. (1989). *Ignorance and uncertainty: Emerging paradigms.* New York: Springer-Verlag.

Smithson, M. (1993). Ignorance and science: Dilemmas, perspectives, and prospects. *Knowledge: Creation, Diffusion, Utilization,15*, 133–156.

Sneiderman, C. A., Hood, A. F., & Patterson, J. W. (1994). Evaluation of an interactive computer video tutorial on malignant melanoma. *Journal of Biomedical Communication, 21*, 2–5.

Snyder, L. B., & Hamilton, M. A. (2002). A meta-analysis of U.S.health campaign effects on behavior: Emphasize enforcement, exposure, and new information and beware the secular trend. In R. C. Hornik (Ed.), *Public health communication: Evidence for behavior change.* Mahwah, NJ: Lawrence Erlbaum.

Solomon, D. S. (1989). A social marketing perspective on communication campaigns. In R. E. Rice & C. K. Atkin (Eds.), *Public communication campaigns* (pp. 87–104). Newbury Park, CA: Sage.

Solomon, P. (2002). Discovering information in context. *Annual Review of Information Science and Technology, 36*, 229–264.

Sonnenwald, D. H., Wildemuth, B. M., & Harmon, G. L. (2001). A research method to investigate information seeking using the concept of information horizons: An example from a study of lower socio-economic students' information seeking behavior. *New Review of Information Behavior Research, 2*, 65–85.

Sontag, S. (1978). *Illness as metaphor.* New York: Farrar, Straus, and Giroux.

Sontag, S. (1988). *AIDS and its metaphors.* New York: Farrar, Straus, and Giroux.

Sorrentino, R. M., & Roney, C. J. R. (2000). *The uncertain mind: Individual differences in facing the unknown.* Philadelphia, PA: Psychology Press.

Spink, A., & Cole, C. (2006). Human information behavior: Integrating diverse approaches and information use. *Journal of the American Society for Information Science and Technology, 57*, 25–35.

Stasser, G., Taylor, L. A., & Hanna, C. (1989). Information sampling in structured and unstructured discussions of three and six person groups. *Journal of Personality and Social Psychology, 57*, 67–78.

Stavri, Z. (2001). *Personal health information seeking: A qualitative review of the literature.* Paper presented at Medinfo 2001Tenth Conference on Medical Informatics, Amsterdam, Netherlands.

Staw, B. M., Sandelands, L. E., & Dutton, J. E. (1981). Threat rigidity effects in organizational behavior: A multilevel analysis. *Administrative Science Quarterly, 26*, 501–524.

Steen, R. G. (1993). *A conspiracy of cells: The basic science of cancer.* New York: Plenum Press.

Steinfeld, C. W., Jin, B., & Ku, L. L. (1987). *A preliminary test of a social information processing model of media use in organizations.* Paper presented at the International Communication Association annual conference, Montreal, Canada.

Stephenson, M. T., Southwell, B. G., & Yzer, M. (2011). Advancing health communication research: Issues and controversies in research design and data analysis. In T. L. Thompson, R. Parrott, & J. F. Nussbaum (Eds.), *The Routledge handbook of health communication* (2nd ed., pp. 560–577). New York: Routledge.

Stocking, S. H., & Holstein, L. W. (1993). Constructing and reconstructing scientific ignorance: Ignorance claims in science and journalism. *Knowledge: Creation, Diffusion, Utilization, 15,* 186–210.

Stoddard, A. M., Zapka, J. G., Schoenfeld, S., & Costanza, M. E. (1990). Effects of a news event on breast cancer screening survey responses. In P. F. Engstrom, B. Rimer, & L. E. Mortenson (Eds.), *Advances in cancer control: Screening and prevention research* (pp. 259–268). New York: John Wiley.

Stokes, J. P. (1983). Predicting satisfaction with social support from social network structure. *American Journal of Community Psychology, 11,* 141–152.

Stonier, T. (1991). Towards a new theory of information. *Journal of Information Science, 17,* 257–263.

Strecher, V. J. (2008). Interactive health communications for cancer prevention and control. In S. M. Miller, D. J. Bowen, R. T. Croyle, & G. H. Rowland (Eds.), *Handbook of cancer control and behavioral science: A resource for researchers, practitioners, and policymakers* (pp. 547–558). Washington DC: American Psychological Association.

Su, C., & Contractor, N. (2011). A multidimensional network approach to studying team members' information seeking from human and digital knowledge sources in consulting firms. *Journal of the American Society for Information Science and Technology, 62*(7), 1257–1275. doi: 10.1002/asi.21526

Substance Abuse and Mental Health Services Administration (SAMHSA). (2011). *Results from the 2010 National Survey on Drug Use and Health: Summary of national findings,* NSDUH Series H-41, HHS Publication No. (SMA) 11-4658. Rockville, MD: Substance Abuse and Mental Health Services Administration Available at http: //www.samhsa.gov/data/NSDUH/2k10NSDUH/2k10Results.htm#3.1.7

Suchman, E. A. (1965). Stages of illness and medical care. *Journal of Health and Human Behavior, 6,* 114–121.

Suchman, M. C., & Dimick, M. (2010). A profession of IT's own: The rise of health information professionals in American healthcare. In D. J. Rothman & D. Blumenthal (Eds.), *Medical professionalism in the new information age* (pp. 132–173). New Brunswick, NJ: Rutgers University Press.

Sullivan, C. B. (1995). Preferences for electronic mail in organizational communication tasks. *Journal of Business Communication, 32,* 49–65.

Sullivan, C. F., & Reardon, K. K. (1985). Social support satisfaction and health locus of control: Discriminators of breast cancer patients' styles of coping. In M. L. McLaughlin (Ed.), *Communication yearbook 9* (pp. 707–722). Beverly Hills, CA: Sage.

Sullivan, H. W., & Rutten, L. J. F. (2009). Cancer prevention information seeking: A signal detection analysis of data from the Cancer Information Service. *Journal of Health Communication, 14,* 785–796. doi: 10.1080/10810730903295534

Summers, E. G., Matheson, J., & Conry, R. (1983). The effect of personal, professional and psychological attributes, and information seeking behavior on use of information sources by educators. *Journal of the American Society for Information Science, 34,* 75–95.

Sundar, S. S., Rice, R. E., Kim, H., & Sciamanna, C. N. (2011). Online health information: Conceptual challenges and theoretical opportunities. In T. L. Thompson, R. Parrott, & J. F. Nussbaum (Eds.), *The Routledge handbook of health communication* (2nd ed., pp. 181–202). New York: Routledge.

Surowiecki, J. (2004). *The wisdom of crowds: Why the many are smarter than the few and how collective wisdom shapes business, economies, societies, and nations.* New York: Random House.

Sussman, S., Valente, T. W., Rohrbach, L. A., Skara, S., & Pentz, M. A. (2006). Translation in the health professions: Converting science into action. *Evaluation & the Health Professions, 29*(7), 7–32. doi: 10.1177/0163278705284441

Swanson, D. R., Smalheiser, N. R., & Torvik, V. I. (2006). Ranking indirect connections in literature-based discovery: The role of medical subject headings. *Journal of the American Society for Information Science & Technology, 57*(11), 1427–1439.

Swinehart, J. W. (1968). Voluntary exposure to health communications. *American Journal of Public Health, 58,* 1265–1275.

Talja, S., Keso, H., & Pietilainen, T. (1999). The production of "context" information seeking research: A metatheoretical view. *Information Processing and Management, 35,* 751–763.

Tan, A. S. (1985). *Mass communication theories and research.* New York: Wiley.

Tang, P. C., Ash, J. C., Bates, D. W., Overhage, J. M., & Sands, D. Z. (2006). Personal health records: Definitions, benefits, and strategies for overcoming barriers to adoption. *Journal of the American Medical Informatics Association, 13*(2), 121–126.

Taylor, H., & Leitman, R. (2002). Four-nation survey shows widespread but different levels of Internet use for health purposes. *Health Care News.* Available at http://www.prnewswire.com/news-releases/four-nation-survey-shows-widespread-but-different-levels-of-internet-use-for-health-purposes-77647692.html

Taylor, K. L., Davis, K. M., Lamond, T., Williams, R. M., Schwartz, M. D., Lawrence, W., . . . Dritschilo, A. (2010). Use and evaluation of a CD-ROM-based decision aid for prostate cancer treatment decisions. *Behavioral Medicine, 36,* 130–140. doi: 10.1080/08964289.2010.525263

Taylor, R. S. (1968). Question negotiation and information seeking in libraries. *College & Research Libraries, 29,* 178–194.

ter Huurne, E. F. J., Griffin, R. J., & Gutteling, J. M. (2009). Risk information seeking among U.S. and Dutch residents: An application of the model of risk information seeking and processing. *Science Communication, 31*(2), 215–237. doi: 10.1177/1075547009332653

Thayer, L. (1988). How does information "inform"? In B. D. Ruben (Ed.), *Information and behavior* (Vol. 2, pp. 13–26). New Brunswick, NJ: Transaction Books.

Thomas, J. B., Clark, S. M., & Gioia, D. A. (1993). Strategic sensemaking and organizational performance: Linkages among scanning, interpretation, action, and outcomes. *Academy of Management Journal, 36,* 239–270.

Thompson, S., & O'Hair, H. D. (2008). Advice-giving and the management of uncertainty for cancer survivors. *Health Communication, 23,* 340–348.

Thompson, T. L. (2006). Seventy-five (Count 'em—75) issues of *Health Communication*: An analysis of emerging themes. *Health Communication, 20*(2), 117–122.

Thompson, T. L., Whaley, B. B., & Stone, A. M. (2011). Explaining illness: Issues concerning the co-construction of explanations. In T. L. Thompson, R. Parrott, & J. F. Nussbaum (Eds.), *The Routledge handbook of health communication* (2nd ed., pp. 293–305). New York: Routledge.

Thorelli, H. B., & Engledow, J. L. (1980). Information seekers and information systems: A policy perspective. *Journal of Marketing, 44,* 9–27.

Thorne, S. E. (1999). Communication in cancer care: What science can and cannot teach us. *Cancer Nursing, 22*(5), 370–378.

Thorne, S. E., Bultz, B. D., & Baile, W. F. (2005). Is there a cost to poor communication in cancer care?: A critical review of the literature. *Psycho-oncology, 14,* 875–884. doi: 10.1002/pon.947

Thorne, S. E., Hislop, T. G., Kuo, M., & Armstrong, E. (2006). Hope and probability: Patient perspectives of the meaning of numerical information in cancer. *Qualitative Health Research, 16,* 318–336. doi: 10.1177/1049732305285341

Thorngate, W. (1995). Accounting for person-context relations and their development. In T. A. Kindermann & J. Valsiner (Eds.), *Development of person-context relations* (pp. 39–54). Hillsdale, NJ: Lawrence Erlbaum.

Tian, Y., & Robinson, J. D. (2008). Media use and health information seeking: An empirical test of complementarity theory. *Health Communication, 23,* 184–190. doi: 10.1080/10410230801968260

Tichenor, P. J., Donohue, G. A., & Olien, C. N. (1970). Mass media and differential growth in knowledge. *Public Opinion Quarterly, 34,* 158–170.

Tilley, C. B. (1990). Medical databases and health information systems. In M. E. Williams (Ed.), *Annual review of information science and technology* (Vol. 25, pp. 313–382).Amsterdam, Netherlands: Elsevier Science.

Toch, H., Allen, T., & Lazer, W. (1961). The public image of cancer etiology. *Public Opinion Quarterly, 25,* 411–414.

Tomes, N. (2010). The "information Rx." In D. J. Rothman & D. Blumenthal (Eds.), *Medical professionalism in the new information age* (pp. 40–65). New Brunswick, NJ: Rutgers University Press.

Trevino, L. K., Daft, R. L., & Lengel, R. H. (1990). Understanding managers' media choices: A symbolic interactionist perspective. *Organizations and communication technology* (pp. 71–94). Newbury Park, CA: Sage.

Trevino, L. K., Lengel, R., & Daft, R. L. (1987). Reasons for media choice in management communication: A symbolic interactionist perspective. *Communication Research, 19,* 539–573.

Trevino, L. K., & Webster, J. (1992). Flow in computer-mediated communication: Electronic mail and voice mail evaluation and impacts. *Communication Research, 19,* 539–573.

Trust for America's Health (2008). Prevention for a healthier America. Available: http://healthyamericans.org/reports/prevention08/

Turner, M. M., Rimal, R. N., Morrison, D., & Kim, H. (2006). The role of anxiety in seeking and retaining risk information: Testing the risk perception attitude framework in two studies. *Human Communication Research, 32,* 130–156. doi: 10.1111/j.1468-2958.2006.0006.x

Turner, M. M., Skubisz, C., & Rimal, R. N. (2011). Theory and practice in risk communication: A review of the literature and visions of the future. In T. L. Thompson, R. Parrott, & J. F. Nussbaum (Eds.), *The Routledge handbook of health communication* (2nd ed., pp. 146–164). New York: Routledge.

Turvey, M. D., & Olson, D. H. (2006). *Marriage and family wellness: Corporate America's business?* Minneapolis, MN: Live Innovations.

Tustin, N. (2010). The role of patient satisfaction in online health information seeking. *Journal of Health Communication, 15,* 3–17. doi: 10.1080/108107309003465491

TVB. (2010). 2010 media comparisons study. New York: Television Advertising Bureau.

Twine, C., Barthelmes, L., & Gateley, C. (2006). Kylie Minogue's breast cancer: Effects on referrals to a rapid access breast clinic in the U.K. *The Breast, 15,* 667–669.

U.S. Department of Health & Human Services. (1990). *Healthy people 2000: National health promotion and disease prevention objectives.* Washington, DC: Government Printing Office.

U.S. Department of Health & Human Services. (2009). America's health literacy: Why we need accessible health information. Available at http://www.health.gov/communication/literacy/issuebrief

U.S. Department of Health & Human Services. (2010). *National action plan to improve health literacy.* Available at http://www.health.gov/communication/HLActionPlan/pdf/Health_Lit_Action_Plan_Summary.pdf

U.S. Department of Health and Human Services (2011). *Healthy people 2020.* Washington, DC: US Department of Health and Human Services. Available at http://www.healthypeople.gov/2020/default.aspx

UCLA. (2003). UCLA Internet Report: Surveying the Digital Future. Retrieved January 31, 2003, from http://www.ccp.ucla.edu

Valente, T. (2011). Social networks and health communication. In T. L. Thompson, R. Parrott, & J. F. Nussbaum (Eds.), *The Routledge handbook of health communication* (pp. 519–531). New York: Routledge.

Van de Ven, A. H. (1986). Central problems in the management of innovation. *Management Science, 32,* 590–607.

Varlejs, J. (1986). Information seeking: Changing perspectives. In J. Varlejs (Ed.), *Information seeking: Basing services on users' behaviors* (pp. 67–82). London, U.K.: McFarland & Co.

Veenstra, M., & Hofoss, D. (2003). Patient experiences with information in a hospital setting: A multilevel approach. *Medical Care, 41*(4), 490–499.

Veinot, T. C. (2009). Interactive acquisition and sharing: Understanding the dynamics of HIV/ AIDS information networks. *Journal of the American Society for Information Science and Technology, 60*(11), 2313–2332. doi: 10.1002/asi.21151

Viswanath, K., Finnegan, J. R., Jr.,, Hannan, P., & Luepker, R. V. (1991). Health and knowledge gaps. *American Behavioral Scientist, 34*, 712–726.

Viswanath, K., Kahn, E., Finnegan, J. R., Jr., Hertog, J., & Potter, J. D. (1993). Motivation and the knowledge gap: Effects of a campaign to reduce diet-related cancer risk. *Communication Research, 20*, 546–563.

Wade, S., & Schramm, W. (1969). The mass media as sources of public affairs, science, and health knowledge. *Public Opinion Quarterly, 33*, 197–209.

Walker, K. N., MacBride, A., & Vachon, M. L. S. (1977). Social support networks and the crises of bereavement. *Social Science and Medicine, 11*, 35–41.

Wallack, L. (1989). Mass communication and health promotion: A critical perspective. In R. E. Rice & C. K. Atkin (Eds.), *Public communication campaigns* (pp. 87–104). Newbury Park, CA: Sage.

Wallack, L. (1990). Improving health promotion: Media advocacy and social marketing approaches. In C. Atkin & L. Wallack (Eds.), *Mass communication and public health: Complexities and conflicts* (pp. 147–163). Newbury Park, CA: Sage.

Walther, J. B. (1994). Anticipated ongoing interaction versus channel effects on relational communication and computer-mediated interaction. *Human Communication Research, 20*, 473–501.

Walther, J. B., Pingree, S., Hawkins, R. P., & Buller, D. B. (2005). Attributes of interactive online health information systems. *Journal of Medical Internet Research, 7*(3), E33.

Ward, J., & Hansen, K. A. (1993). *Search strategies in mass communication* (Vol. 2). New York: Longman.

Ward, S. (1987). Consumer behavior. In C. R. Berger & S. H. Chaffee (Eds.), *Handbook of communication science* (pp. 651–674). Newbury Park, CA: Sage.

Wathen, C. N. (2006). Health information seeking in context: How women make decisions regarding hormone replacement therapy. *Journal of Health Communication, 11*, 477–493. doi: 10.1080/10810730600751979

Wathen, C. N., & Burkell, J. (2002). Believe it or not: Factors influencing credibility on the web. *Journal of the American Society for Information Science and Technology, 53*(2), 134–144. doi: 10.1002/asi10016

Watts, D. J. (2003). *Six degrees: The science of the connected age.* New York: W. W. Norton.

Weaver J. B., III, Mays, D., Weaver, S. S., Hopkins, G. L., Eroğlu, D., & Bernhardt, J. M. (2010). Health information-seeking behaviors, health indicators, and health risks. *American Journal of Public Health, 100*(8), 1520–1525.

Wegner, D. M. (1995). A computer network of model of human transactive memory. *Social Cognition, 13*, 319–339.

Weick, K. E. (1969). *The social psychology of organizing.* Reading, MA: Addison-Wesley.

Weijer, C. (1995, May/June). Our bodies, our science. *The Sciences*, 41–44.

Weinstein, N. D. (1978). Cognitive process and information seeking concerning an environmental health threat. *Journal of Human Stress, 42*, 32–42.

Weinstein, N. D. (1979). Seeking reassuring or threatening information about environmental cancer. *Journal of Behavioral Medicine, 2*, 125–139.

Welch, D. (1980). *Needs of families of adult cancer patients.* Paper presented at the Second Annual Cancer Nursing Symposium, Fred Hutchinson Cancer Center, Seattle, WA.

Wertz, D. C., Sorenson, J. R., & Heeren, T. C. (1988). Communication in health professional lay encounters: How often does each party know what the other wants to discuss? In B. D. Ruben (Ed.), *Information and behavior* (Vol. 2). New Brunswick, NJ: Transaction Books.

West, A. (2008). Coming soon to a location near you. *Government Information Quarterly, 25,* 61–65. doi: 10.1016/j.giq.2007.09.004

Westbrook, J. I., Gosling, A. S., & Coiera, E. W. (2005). The impact of an online evidence system on confidence in decision making in a controlled setting. *Medical Decision Making, 25*(2), 178–185.

White, M. D. (2000). Questioning behavior on a consumer health electronic list. *Library Quarterly, 70,* 302–334.

Whitten, P., Cook, D., & Cornacchione, J. (2011). Telemedicine: Reviewing the past, looking toward the future. In T. L. Thompson, R. Parrott, & J. F. Nussbaum (Eds.), *The Routledge handbook of health communication* (2nd ed., pp. 84–99). New York: Routledge.

Wicks, P., Massagli, M., Frost, J., Brownstein, C., Okun, S., Vaughan, T., . . . Heywood, J. (2010). Sharing health data for better outcomes on PatientsLikeMe. *Journal of Medical Internet Research, 12*(2). Available at http://www.ncbi.nlm.nih.gov/pmc/articles/PMC2956230/?tool=pubmed

Widman, L. E., & Tong, D. A. (1997). Requests for medical advice from patients and families to health care providers who publish on the world wide web. *Archives of Internal Medicine, 157,* 209–212.

Wilkinson, S. (1991). Factors which influence how nurses communicate with cancer patients. *Journal of Advanced Nursing, 16*(6), 677–688.

Williamson, K. (1998). Discovered by chance: The role of incidental information acquisition in an ecological model of information use. *Library & Information Science Research, 20,* 23–40.

Williamson, K. (2005). Ecological theory of human information behavior. In K. E. Fisher, S. Erdelez, & L. McKechnie (Eds.), *Theories of information behavior* (pp. 128–132). Medford, NJ: Information Today.

Wilson, D. O., & Malik, S. D. (1995). Looking for a few good sources: Exploring the intraorganizational communication linkages of first line managers. *Journal of Business Communication, 32,* 31–48.

Wilson, P. (1977). *Public knowledge, private ignorance: Toward a library and information policy.* Westport, CT: Greenwood Press.

Wilson, S. E., Andersen, M. R., & Meischke, H. (2000). Meeting the needs of rural breast cancer survivors: What still needs to be done? *Journal of Women's Health & Gender-Based Medicine, 9*(6), 667–677.

Wilson, T. D. (1997). Information behaviour: An interdisciplinary perspective. *Information Processing and Management, 33*(4), 551–572.

Wilson, T. D. (1999). Models in information behaviour research. *Journal of Documentation, 55*(3), 249–270.

Wilson, T. D. (2000). Human information behaviour. *Informing Science, 3*(2), 49–55.

Winker, M. A., A. , Flanagin, A., Chi-Lum, B., White, J., Andrews, K., Kennett, R., . . . Mussacchio, R. (2000). Guidelines for medical and health information on the Internet. *Journal of the American Medical Association, 283,* 1600–1603.

Witte, K. (1992). Putting the fear back into fear appeals: The extended parallel process model. *Communication Monographs, 59,* 329–349.

Witte, K. (1994). Fear control and danger control: A test of the Extended Parallel Process Model (EPPM). *Communication Monographs, 61,* 113–134.

Wood, E. H. (1994). Medline: The options for health professionals. *Journal of the American Medical Informatics Association, 1,* 372–380.

Wood, F. B., Lyon, B., & Schell, M. B. (2000). Public library consumer health information pilot project: Results of a National Library of Medicine evaluation. *Bulletin of the Medical Library Association, 88*(4), 314–322.

World Health Organization. (2003). *Adherence to long-term therapies: Evidence for action.* Geneva.

Worsley, A. (1989). Perceived reliability of sources of health information. *Journal of Communication, 25,* 171–173.

Wright, K. (2002). Social support within an online cancer community: An assessment of emotional support, perceptions of advantages and disadvantages, and motives for using the community. *Journal of Applied Communication Research, 30*, 195–209.

Wright, K., & Bell, S. (2003). Health-related support groups on the Internet: Linking empirical findings to social support and computer-mediated communication theory. *Journal of Health Psychology, 8*, 9–54.

Wright, K. B., & Frey, L. R. (2008). Communication and care in an acute cancer center: The effects of patients' willingness to communicate about health, healthcare environment perceptions, and health status on information seeking, participation in care practices, and satisfaction. *Health Communication, 23*, 369–379. doi: 10.1080/10410230802229886

Wright, K. B., Frey, L., & Sopory, P. (2007). Willingness to communicate about health as an underlying trait of patient self-advocacy: The development of the willingness to communicate about health (WTCH) measure. *Communication Studies, 58*(1), 35–51.

Wright, K. B., Johnson, A. J., Bernard, D. R., & Averbeck, J. (2011). Computer-mediated social support: Promises and pitfalls for individuals coping with health concerns. In T. L. Thompson, R. Parrott, & J. F. Nussbaum (Eds.), *The Routledge handbook of health communication* (pp. 349–362). New York: Routledge.

Wright, K. B., & Miller, C. H. (2010). A measure of weak-tie/strong-tie support network preference. *Communication Monographs, 77*(4), 500–517. doi: 10.1080/03637751.2010.502538

Wright, K. B., Rains, S. A., & Banac, J. (2010). Weak-tie support network preference and perceived life stress among participants in health-related, computer-mediated support groups. *Journal of Computer-Mediated Communication, 15*, 606–624.

Wright, K. B., Sparks, L., & O'Hair, H. D. (2008). *Health communication in the 21st century*. Malden, MA: Blackwell.

Wright, W. R. (1975). Mass media as sources of medical information. *Journal of Communication, 25*, 171–173.

Yoo, S., & Robbins, L. S. (2008). Understanding middle-aged women's health information seeking on the web: A theoretical approach. *Journal of the American Society for Information Science and Technology, 59*(4), 577–590. doi: 10.1002/asi.20766

Zajonc, R. B., & Wolfe, D. M. (1966). Cognitive consequences of a person's position in a formal organization. *Human Relations, 19*, 139–150.

Zemore, R., & Shepel, L. F. (1987). Information seeking and adjustment to cancer. *Psychological Reports, 60*, 874.

Zey, M. (Ed.). (1992). *Decision making: Alternatives to rational choice models*. Newbury Park, CA: Sage.

Zimmerman, R. S., & Vernberg, D. (1994). Models of preventive health behavior: Comparison, critique, and meta-analysis. *Advances in Medical Sociology, 4*, 45–67.

Zook, E. G. (1994). Embodied health and constitutive communication: Toward an authentic conceptualization of health communication. In S. Deetz (Ed.), *Communication yearbook 17* (pp. 344–377). Thousand Oaks, CA: Sage.

Zuboff, S. (1988). *In the age of the smart machine: The future of work and power*. New York: Basic Books.

Zweizig, D., & Dervin, B. (1977). Public library use, users, uses: Advances in knowledge of the characteristics and needs of the adult clientele of American public libraries. In M. J. Voigt & M. H. Harris (Eds.), *Advances in librarianship* (Vol. 7, pp. 231–255).

INDEX

ignorance, 10, 21–22, 24, 43, 56, 58, 69,
99–100, 119, 123, 126, 131–133, 141,
143, 145–151, 154, 156, 161, 165,
180–181, 217–218, 225
impediments. See barriers
Indian Health Service, 175. *See also*
ethnicity
inertia, 149, 162–163, 182
information
agent, 13, 68
and Communication Technologies
(ICT), x, 63, 77–83, 94, 139
behavior, ix, 110, 112, 118, 211–212,
214, 216–217, 225
carriers, 14–19, 22, 25, 30–34, 54, 62–
95, 112, 119, 149, 186, 188–189,
206–207
carrier factors, 40, 88–89, 105, 114,
115, 119
definition of, 26–27
fields, 5, 18, 24–35, 46, 48, 53, 55, 84,
86, 92–93, 96–97, 101, 103, 110,
115–117, 128–129, 140, 142, 185,
189–190, 197, 199, 212–213, 217,
223–224
importance of, 4, 16–17, 22, 55, 199
load, 26–27, 13–, 154
matrix, 33–34, 97
meta-, 31
overload, 2, 5, 16, 19, 130, 142, 150,
162, 165–167, 177
pathways, 30, 33–35, 54, 96, 98, 106,
117, 127, 213, 223
pollution, 192
poverty, 138–139, 155
processing technologies, 127, 198–202
Search Process (ISP), x, 106, 114, 121,
132–133, 161, 173, 218–219
senses of, 18
styles, 22, 96, 101–104, 186, 202, 204,
207
types of, 14, 33, 96–97
informed consent, 221
innumeracy, 11
interactivity, 79, 163, 173, 184, 196, 201
Internet, xi, xiv, 3, 5, 15, 25, 30–35, 48,
50, 52, 64, 67–68, 72, 76–84, 95,
100, 122, 131, 137–139, 143, 153,

167–169, 174, 176–178, 181, 189,
191–196, 201–202, 208, 216–217,
220, 224
interpersonal communication, 15, 29, 33,
47, 52, 54, 58, 60, 64, 67, 72, 78, 80–
81, 83–86, 90, 92, 97–101, 114, 129,
133, 161–164, 168, 176–177, 182,
185, 189, 203, 206, 210, 214–215, 224

kiosks, 79–80, 95, 201
knowledge
gaps, 5, 53, 57, 87, 105, 115, 124–126,
138–146, 150, 155, 171, 206, 211
management, x, xiii, 100, 207–208
management systems, 207–208

laws
Least Effort, 165
Mooer's, 165
libraries, xiii, 10, 54, 77, 79, 81, 136, 140,
249, 155, 165, 193–194, 197, 201,
214, 216
literacy. *See* health literacy
locus of control, 42, 59, 61, 102, 204
Lorenzo's Oil, 204

mammography. *See* screening tests
mass media, xiii, xiv, 14, 64–65, 79–80,
83, 88, 90, 83, 88, 90, 90–92, 97, 116,
122, 131, 140–142, 152, 173, 176,
184–185, 204, 214, 217, 224
matching, 49, 84, 86, 117, 125, 186, 195,
200–201, 203, 207
Media Exposure and Appraisal (MEA), x,
88–89, 95, 105, 110, 112, 114, 119
media richness, 85–87, 93
Medical Library Association (MLA), 10,
194
MEDLINE, 10, 15, 25, 81, 169, 174,
193, 196–197,
MedlinePlus®, 15, 25, 197
men. *See* gender
mental health, 69, 126, 205
messages, xiii, 17–18, 22, 25–26, 31–34,
44, 49, 55, 62–65, 77–79, 83–94, 100,
137, 141, 152–153, 166, 176, 181,
183–189, 196, 202–204, 208, 211–
213, 219, 225, 227